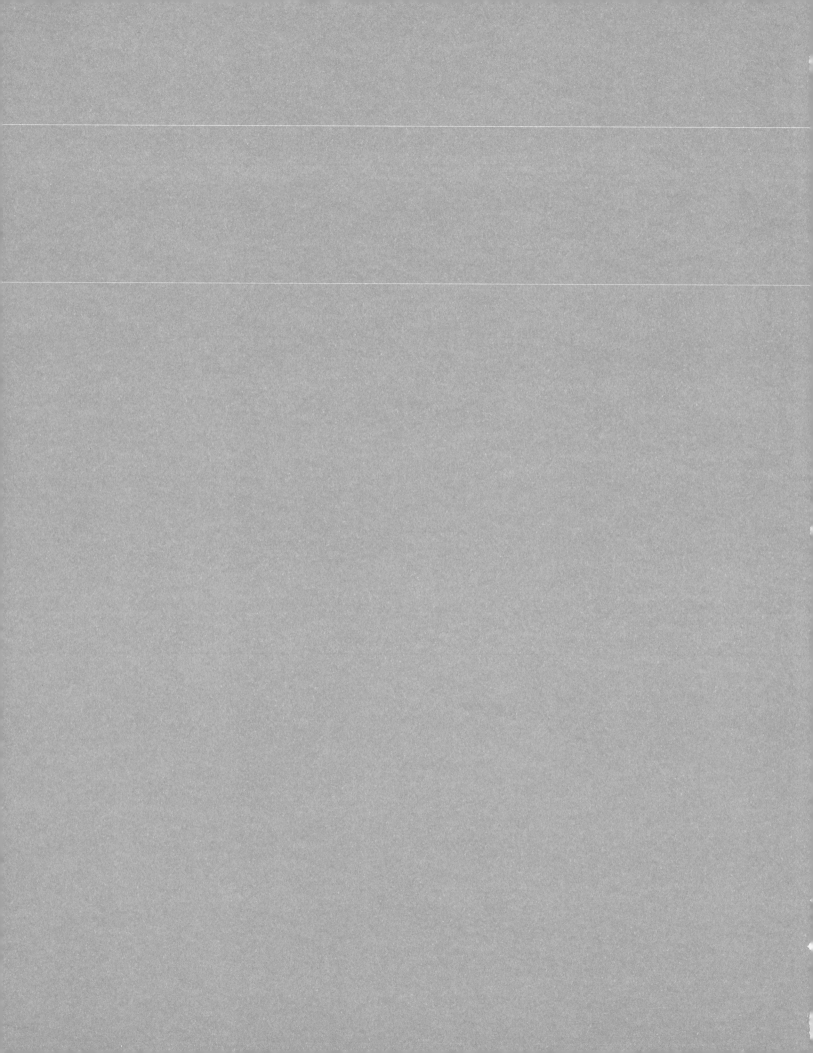

PORTRAIT PAINTING ATELIER

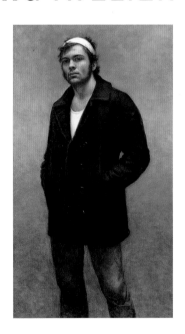

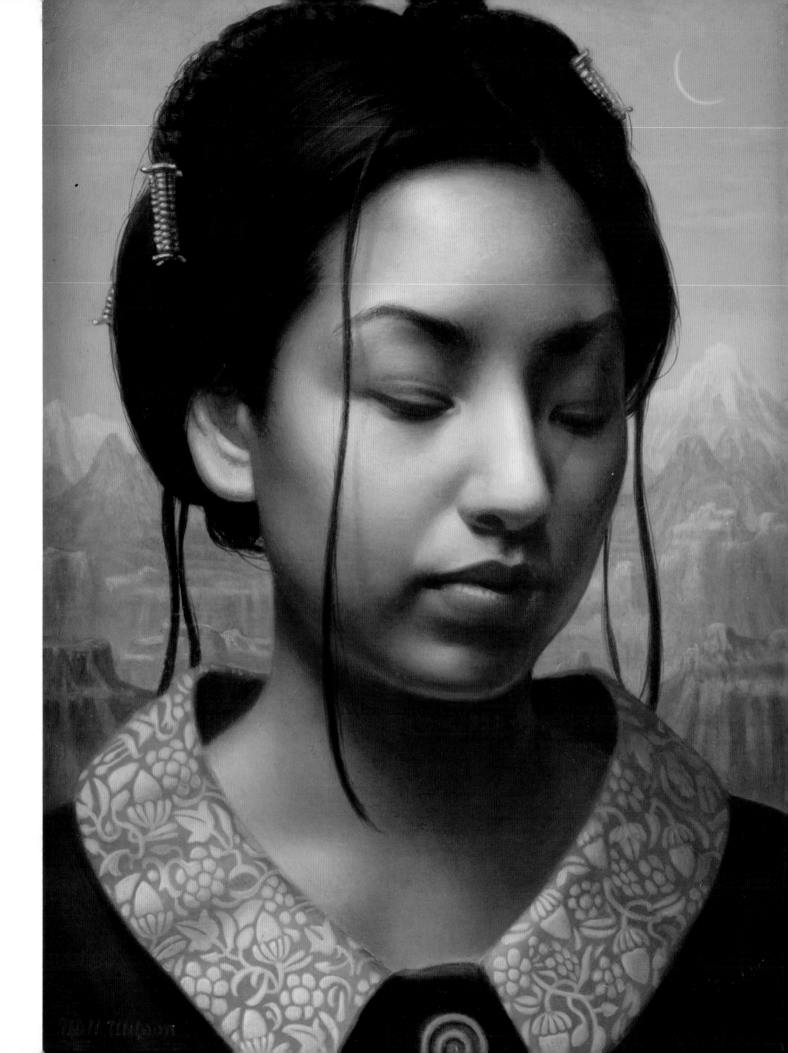

PORTRAIT PAINTING ATELIER

OLD MASTER TECHNIQUES
and CONTEMPORARY APPLICATIONS

SUZANNE BROOKER

foreword by DOMENIC CRETARA

WATSON-GUPTILL PUBLICATIONS
NEW YORK

HALF-TITLE PAGE:

Kate Lehman, *Michael,*
1999, oil on canvas, 56 x 32 inches (142.2 x 81.3 cm)

TITLE PAGE:

Will Wilson, *Fancy,*
2000, oil on linen, 8¾ x 6¾ inches (22.2 x 17.1 cm)

Published in the United States by Watson-Guptill Publications, an imprint of the Crown Publishing Group, a division of Random House, Inc., New York.

www.crownpublishing.com

www.watsonguptill.com

WATSON-GUPTILL is a registered trademark and the WG and Horse designs are trademarks of Random House, Inc.

Library of Congress Cataloging-in-Publication Data

Brooker, Suzanne.

 Portrait painting atelier : old master techniques and contemporary applications / Suzanne Brooker.

 p. cm.

ISBN 978-0-8230-9927-6

1. Portrait painting--Technique. I. Title. II. Title: Old master techniques and contemporary applications.

ND1302.B76 2010

751.45'42--dc22

 2009009647

Printed in China

Designed by **Karla Baker**

10 9 8 7 6 5 4 3 2 1

First Edition

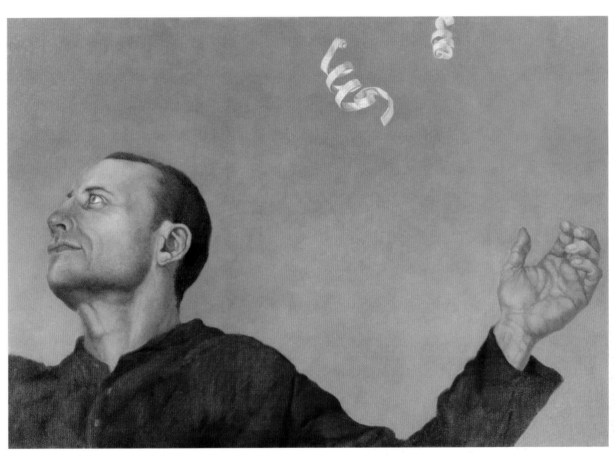

Suzanne Brooker, *Portraits of Men, Metaphors of Wood: Revelation,*
2003, oil on canvas, 22 x 32 inches (55.9 x 81.3 cm)

A portrait can take on the quality of a metaphor when it is combined with an object on a field of abstracted space. The gesture of the model is further heightened by its cropping and placement within the canvas, creating a dynamic tension between the model and the background.

To students who strive with passion and persistence to master the art of painting

ACKNOWLEDGMENTS

This book was made possible by the generous support of friends, family, students, and colleagues, with special thanks to James Maloney. To Ron Dalton, for his patience as my photographer. Many thanks are also due to the Gage Academy of Art, whose encouragement in my role as an instructor over the last decade is greatly appreciated. To all the artists who so graciously donated their paintings to this book project, thank you. And most of all, to all my teachers, who inspired me with your own books and patient teaching, your insight and guidance should appear on these pages.

CONTENTS

Details of Will Wilson's paintings (from left to right): *Roy, Pablo, and Valencia.* The full images can be seen on pages 55, 97, and 59, respectively.

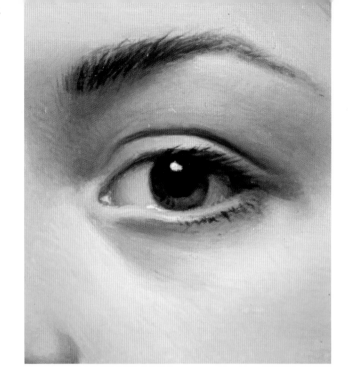

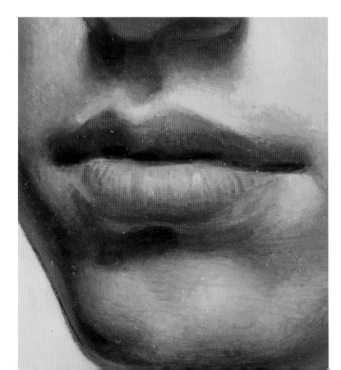

FOREWORD

by DOMENIC CRETARA

Although I have been continuously involved with art since childhood, I date the beginning of my career as a painter to when I graduated from the Art Department of Boston University in 1970. When I first entered school I had no intention of becoming an academic, but a few months into the program I discovered that I was an acute observer of my own education and that my visual perceptions and studio habits were being subtly but inexorably modified by my courses of study. I caught a glimpse of some overall plan. Furthermore, every member of the faculty—despite having diverse opinions, teaching methods, and stylistic preferences—were all somehow acting in concert to realize that plan.

The overall strategy consisted of an approach to form based on looking at nature. This may seem at first deceptively simple; but when looking is carried out with a pencil or a brush in hand it becomes close observation. So what might be called "a rational way" of seeing is still completely perceptual. This method is enhanced by informing what one sees with centuries-old traditions that exist within Western art and culture. One could say that seeing is a continuous process where the ideas create the perceptions but the perceptions in turn alter the ideas: First you draw what you see, then you draw what you know, and finally you know what you see.

One of the implications of this idea is that, while art may remain mysterious in its essence, painting and drawing are rational activities and therefore teachable. There is something intellectually and emotionally satisfying about clearing away the sickly miasma of subjectivity that is generally assumed as the artist's way of thinking and feeling. What an experience! The ultimate goal may be indescribable, but the means for getting there, though difficult to master, are clear and demonstrable. This vision has guided me through

nearly forty years of painting, exhibiting, and teaching. It comes as no surprise, therefore, that one of my former students, Ms. Suzanne Brooker, has taken up this mission of teaching not as a mere passive imparting of formulas but as an approach to life—a revealing explication of what it means to think like a painter.

So often I hear artists who are also professors of painting and drawing evaluate student work by saying, "They've got great skills, but it's too bad they can't think." It is as if visual ideas preexisted in the mind, and skills were simply the means by which to make them visible. As soon as the apparently plausible notion that skills and ideas are separate entities is conceded, the argument is lost and skills are relegated to an inferior, merely manual status. However, if skills and ideas are one and the same, why do we persist in separating them, and what measures can we take to correct this fallacy? Suzanne Brooker's book, *Portrait Painting Atelier*, provides a long overdue solution to this problem.

Painters think with their eyes and hands as well as with their pigments, brushes, and palettes. Just as we walk with our whole body, and not just with our feet, painters' brains process the world through their

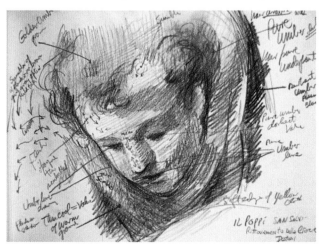

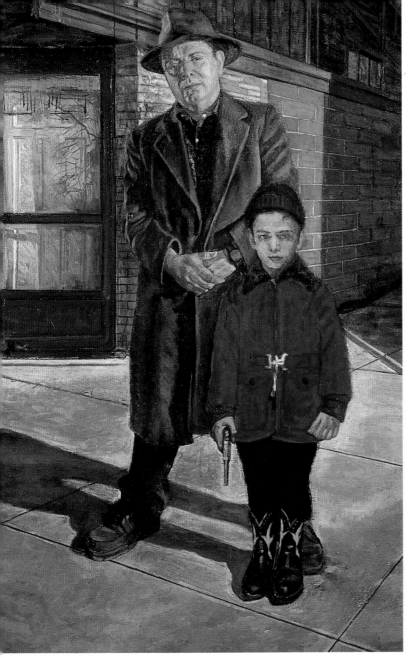

Domenic Cretara,
Father and Son,
2001, oil on canvas, 72 x 48 inches (182.9 x 121.9 cm)

Melding a childhood photograph with memory, the artist staged this scene on a neighborhood street corner, capturing in this double portrait the subtle relationship between a father and his child.

OPPOSITE:

Domenic Cretara, *Italian Sketchbook Page (from Ritrovamento de la Croce by Il Poppi)*
2006, graphite pencil on paper, 7¾ x 10¾ inches (19.7 x 27.3 cm)

Creating study drawings from Old Master paintings brings fresh insight on compositional design, color palettes, paint handling, and a model's gesture. A sketchbook can become a powerful tool that documents a painter's observations.

bodies and their materials. Doing is thinking. By making the reader sensitive to the subtlest behaviors of pigments and media, by explaining how the artist can take something as immaterial and private as one's own optical sensations and create an objective (and objectively verifiable) equivalent of those sensations on canvas, Ms. Brooker seamlessly connects thinking with craftsmanship. For example, when the author describes the construction of the root of the nose, she isn't giving a formula for how to draw that anatomical detail. Instead, she invites the reader/artist to notice that particular form and to see how it is connected to the other forms of the head. She gently guides the reader's attention by describing and having them perform specific tasks in a sequence of operations, which when done with care will lead to critical understanding. This understanding provides insight into how the generalized notions of the human head and face that we have acquired in our minds are related to and corrected by specific instances of those forms as we see them and think about them when we draw and paint.

All of this can be learned, and, because it can be learned, it can also be taught. By doing the exercises so lovingly explained in the text, the student/painter will discover how this complex series of processes becomes the embodiment of content—the expression of feelings and ideas, which in the end must be its goal. Something as inherently difficult as painting cannot be made simple, however, it can be made clear. That is what *Portrait Painting Atelier* does. Furthermore, it vividly communicates the unbridled passion for craft, for a life dedicated to the solitary task of pushing paint around on the canvas, which is the essence of being a painter.

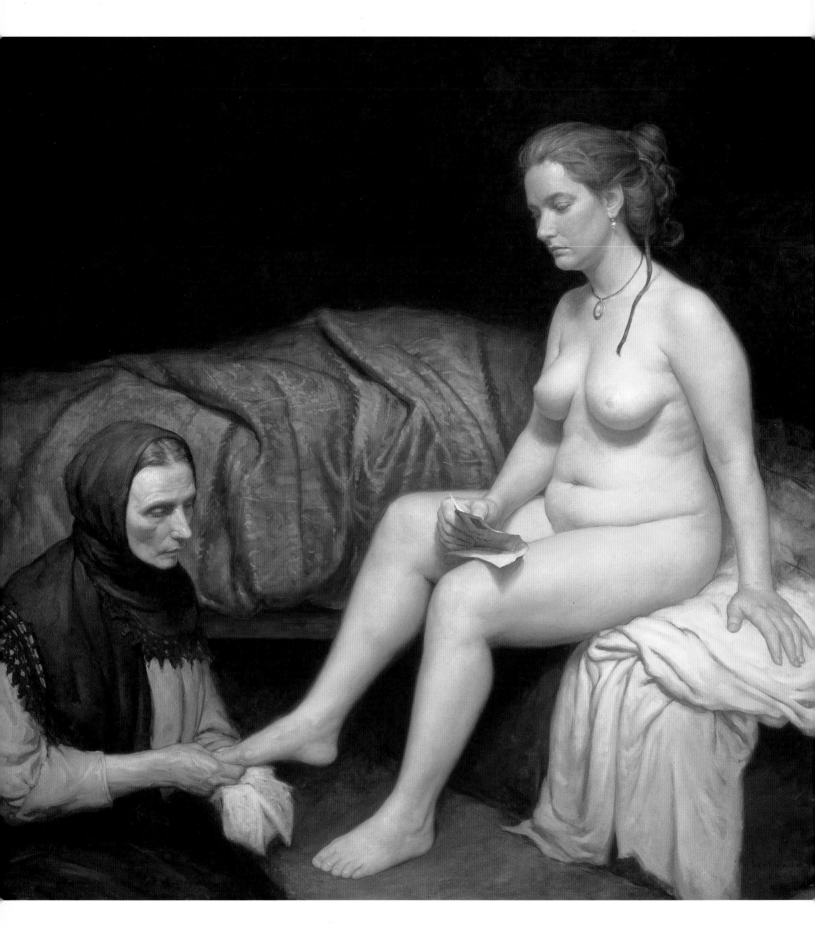

INTRODUCTION Thinking as a Painter

THIS MAY NOT BE THE BOOK YOU WERE EXPECTING. There are no easy instructions on how to mimic the appearance of an Old Master painting, no ready-to-go recipes for their color palettes or painting techniques. Instead, this book is presented as a course of study to develop and train the artist's sensibilities through traditional painting skills. Therefore, an emphasis has been placed on the thinking behind the process, with as much in-depth, practical information as possible.

The painting process, regardless of subject matter, is both compelling and daunting; it may take years of practice and discipline to master. However, the very complexity of the process can pull us in—honing our perceptual and drawing skills, refining our dexterity and sensitivity in handling materials, crafting the image that expresses our artistic vision. Painting requires the ability to focus and yet remain fluid in shifting modes of thinking—from engaging in analytical thought to melding conceptual ideas and intuitive responses to a subject through the concrete expression of these ideas in oil paint medium.

Contemplating the human face is a universally compelling activity. Portrait painting has traditionally depicted important members of society—the saint, the noble, the hero, the statesmen—in the form of patron-supported commissions. But artists have also been interested in faces of character—the beggar, the bootblack, the poet, the muse, the absinthe drinker, the streetwalker. Beginning with the post-1840s Romantic artists, these painters increased the expressive force of color and a direct, painterly handling of the medium that embraced the emerging notions of "art for art's sake." As contemporary painters, we have the richness of art history from which to draw in creating our own personal style and approach toward portraiture.

The term "Old Master" is given to artists working from 1400 to 1840 within Western Europe. Although the names of notable artists

OPPOSITE:

Patricia Watwood,
Homage to Rembrandt,
2001, oil on canvas, 46 x 46 inches (116.8 x 116.8 cm)

This re-creation of Rembrandt's *Bathsheba* is not simply a copy of the original but a reinterpretation that helped the painter understand the composition of the image, the gesture and lighting of the models, and the process of achieving certain painterly effects.

(Titan, Velázquez, Rembrandt) are easily recognized, many other artists contributed to the exchange of ideas and methods within the guilds, workshops, or academies of their times. The idea of painters working in isolation (keeping their techniques secret) is a romantic, twentieth-century notion rather than a true reflection of what was then considered the shared craft of painting. Nevertheless, because these techniques were never recorded by the artists themselves, the best historical analysts of Old Master painting methods can only speculate about the actual working methods of individual artists, which leaves contemporary painters to reinterpret these practices using modern materials.

Oil painting began as a means to enhance, through glazing, the quality of egg tempera paintings. The first true oil paintings closely resembled egg tempera paintings—featuring smooth, wood panel supports that were primed with white grounds and underpaintings that developed the value structure before transparent layers of color were applied. This approach to painting demanded a precise drawing and plan for developing the painting to ensure the transparency of the paint applications. In addition, it offered little flexibility in overpainting (for alterations) or fusing edges. With the change to using canvas as a support, a more flexible method of painting was embraced, one that realized the potentials of painting on a rougher, textured, and potentially larger surface. Instead of thinly applying paints with soft brushes, artists explored the use of stiffer brushes that allowed for scrubbing or rubbing paint over the surface (scumbling), moving the paint in a wet-on-wet manner, and diffusing edges for greater atmospheric effects. Combined with the use of toned grounds, these new techniques facilitated a greater capability to express painterly effects.

The stylistic interpretations of the oil painting medium by innovative artists, during any time period, resist classification. However, reviewing both Old Master and modern portrait painting reveals stylistic differences that can be interpreted in terms of four variables: value or tonal paintings versus those organized by color contrast and linear approaches versus those that employ diffused paint handling. (A linear approach denotes a sensitive firmness of the edges and blending of forms as opposed to a more painterly handling with looser, wet-on-wet, open brush marks.) Each of these elements can be observed to combine together in subtle ways over the course of art history.

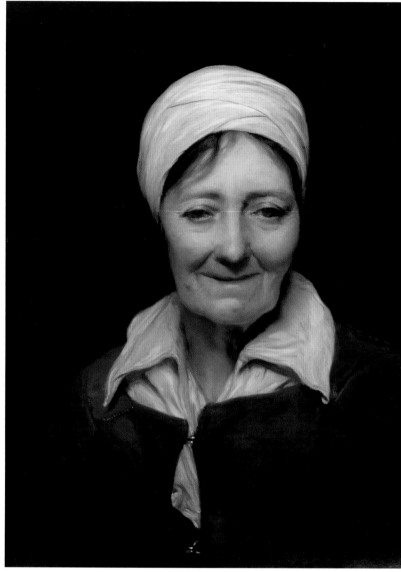

Michael Sweerts,
Head of an Old Woman,
circa 1655, oil on panel, 19⅜ x 15¹/₁₆ inches (49.2 x 38.3 cm).
Courtesy of the J. Paul Getty Museum, Los Angeles

Sweerts portrays neither beauty nor wealth but the modest frankness of an older woman. These kinds of character studies allowed painters to further their skills for commissioned portraits.

When comparing the two Old Master painters Rembrandt and Frans Hals, noticeable connections can be made in their use of limited palettes of earth tones and their open brush handling. Likewise, the organization of their paintings in terms of value is similar, with both artists positioning the light and dark contrasts for maximum effect. However, their individual styles are instantly recognizable by each artist's treatment of soft and crisp edges, wet-on-wet paint handling, passages that lead from transparent to opaque, and impasto paint texture. Contrast these characteristics to a painter such as Holbein the Younger, who painted with a subtle palette of orangey-reds and blue-greens in a crisp, linear fashion and who used minimal light/dark contrast.

A comparison could be made in examining French, Italian, or Spanish painting. How does Ingres compare to Delacroix or Manet? Caravaggio to Titian or Bronzino? De Ribera to Velázquez or Goya to El Greco? In each instance, we recognize the particular signature of the artist to command the paint medium for expressive purpose regardless of his limited color palette. In the same way we could also compare color-oriented painters such as Bonnard, Matisse, and Picasso to Beckman and Neel for their strength of line, or compare Freud to Wyeth for their depiction of skin tones. With each of these painters, the artist's stylistic impulse or temperament is guided and expressed through the craft of painting, weighing the strength of color and value against the individual treatment of the paint handling.

Head of an Old Woman by Michael Sweerts, a Flemish painter working in the mid-seventeenth century, is a sensitive character study that uses a limited palette of flesh tones over the gray toned ground. The diffused overhead lighting is captured in the highlights of the headscarf and the up-turning planes of the face, while the shapes of the white garments contrast with the overall dark of the background, emphasizing the hesitant smile of the model. The compositional design of the painting balances softly blended transitions of light and shadow of the features with crisp handling of the light-to-dark edges.

Compare it to Jean-François Millet's portrait, *Louise-Antoinette Feuardent*, painted nearly two hundred years later. Executed in the "Flemish style" and featuring both a limited neutral palette and crisply defined forms, the bolder, self-assured pose of the model nevertheless belies a more contemporary approach toward portraiture—where the status of the secular, social world has replaced a pious depiction of the

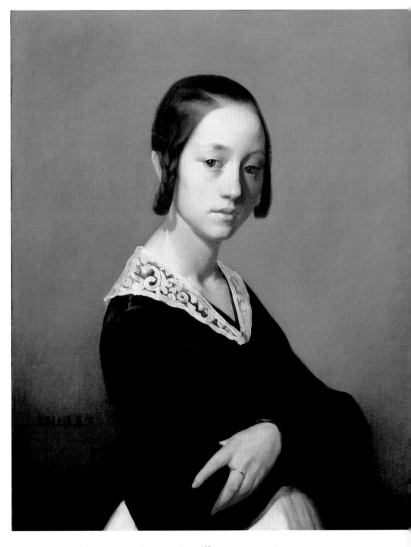

Jean-François Millet,
Louise-Antoinette Feuardent,
1841, oil on canvas, 28⅞ x 23⅞ inches (73.3 x 60.6 cm).
Courtesy of the J. Paul Getty Museum, Los Angeles

The posture of the model creates a delicate play of S curves; follow the shadow line along the front of the face and neck, against the back of the shoulder, and down the (implied) line of the front edge of her skirt.

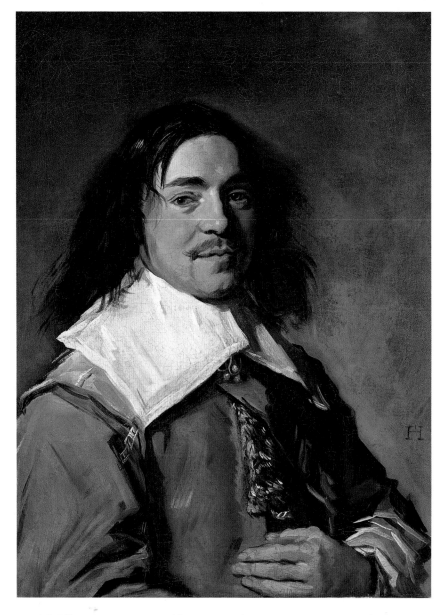

model. This painting resembles many of Ingres's portraits, with the exacting details rendered in a carefully blended paint surface and crisp linear drawing.

Frans Hals, a portrait painter of the seventeenth century, was renowned for bringing his portraits to life through lively paint handling of a very limited analogous earth palette. Although the paint surface seems to imply a direct paint handling, alla prima, these works are the result of careful planning and a mastery of wet-on-wet painting techniques often associated with more contemporary artists, such as John Singer Sargent. Notice how the crispness and animation of the brush marks lie within the forms rather than defining the outline contours.

Portrait Study by Théodore Géricault employs an overall painterly handling of the medium. From the thin wash of raw umber over the form of the shirt to the opaque calligraphic marks of the lights of the

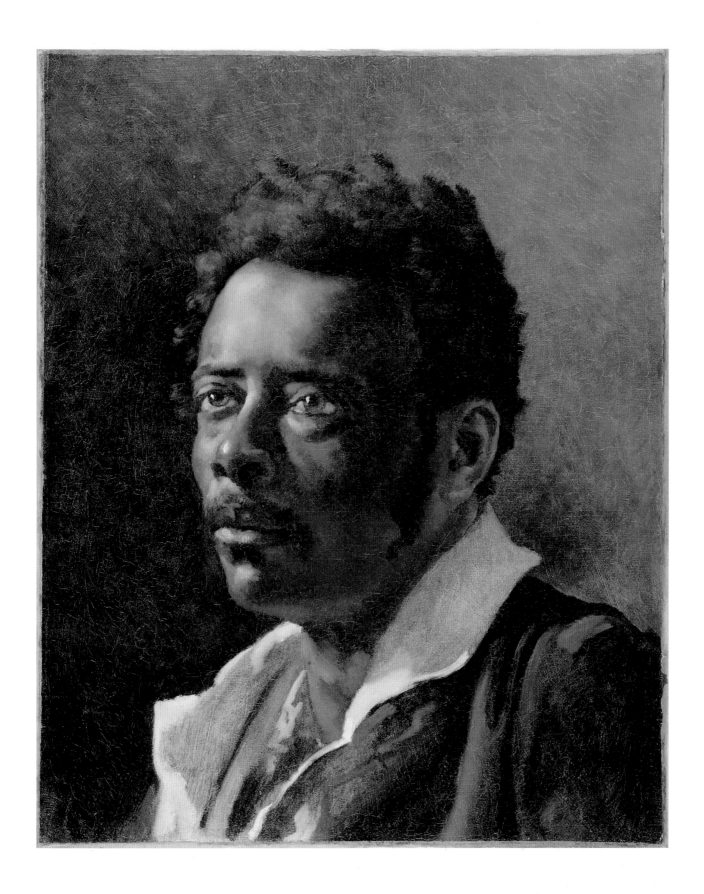

INTRODUCTION: THINKING AS A PAINTER

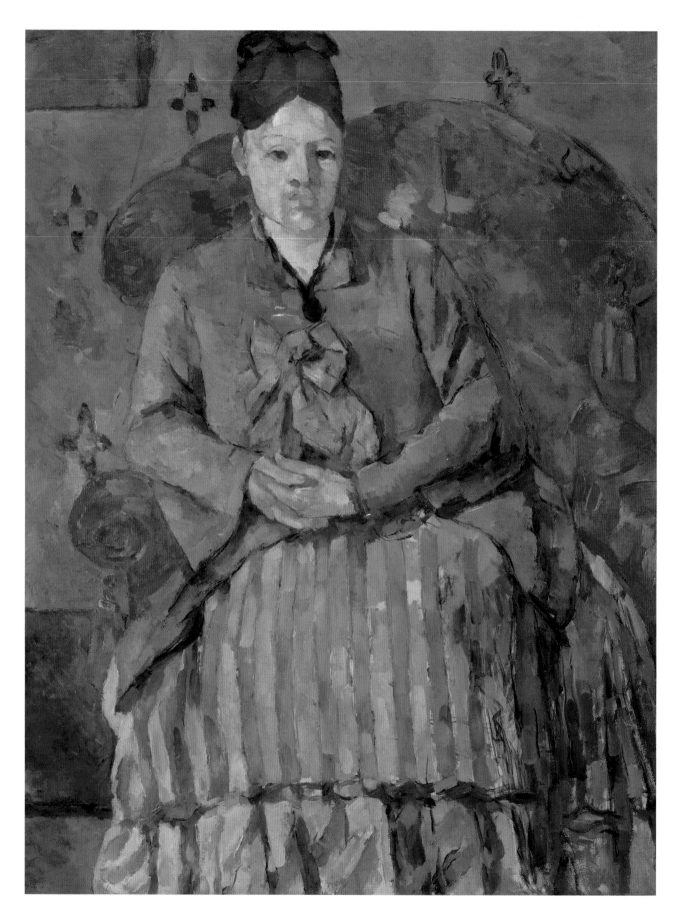

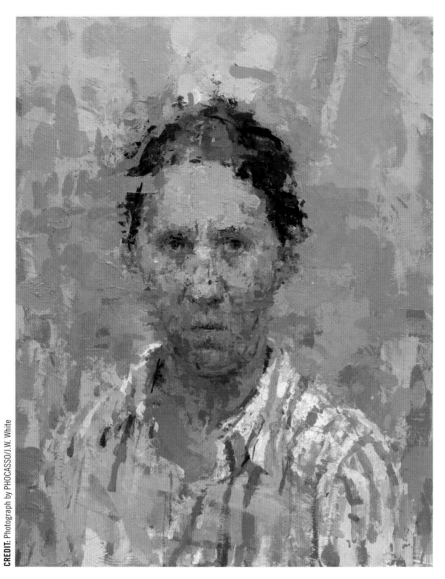

OPPOSITE:

Paul Cézanne, *Madame Cézanne in a Red Armchair,*
circa 1877, oil on canvas, 28 ½ x 22 inches (72.4 x 55.9 cm).
Courtesy of Museum of Fine Arts, Boston, Bequest of Robert
Treat Paine, 2nd

A color-organized painting, this image
replaces value with color temperature as a
tool for rendering form and space.

LEFT:

Ann Gale, *Self Portrait with Blue Stripes,*
2007, oil on Masonite panel, 14 x 11 inches (35.6 x 27.9 cm).
Courtesy of the artist and Hackett-Freedman Gallery, San
Francisco.

This self-portrait features a complex surface
that documents the reality of a presence
rather than conveying a realistic resem-
blance. The discreet "tashes" of carefully
modulated (mid-value) temperatures of color
owe homage to Paul Cézanne's chisel-like
brushstrokes.

shirt, the link between the color (highlights) in the eyes and the dash of
red on his shoulder is contrasted with the modulated form of the fea-
tures. (Notice how the light pigments of the skin tones are placed over
the accumulating layers of middle and dark values.) At this time, oil
sketches and studies were beginning to be appreciated in their own right,
being viewed as Romantic signatures of the artistic impulse in contrast
to formally resolved academic paintings.

This nineteenth-century value-oriented approach to painting can be
contrasted with a painting organized by color, such as Paul Cézanne's
Madame Cézanne in a Red Armchair. Cézanne's innovative approach
to rendering form through color temperature encouraged generations
of painters to rethink the dynamics of color to describe form and space
within a painting. Carefully modulated middle values of warm and cool
hues are placed with distinct brush marks, building up the rendering
of the model. The visual melding of the color notes replaces the seam-
less blending of pigments featured in value-based paintings. Notice how

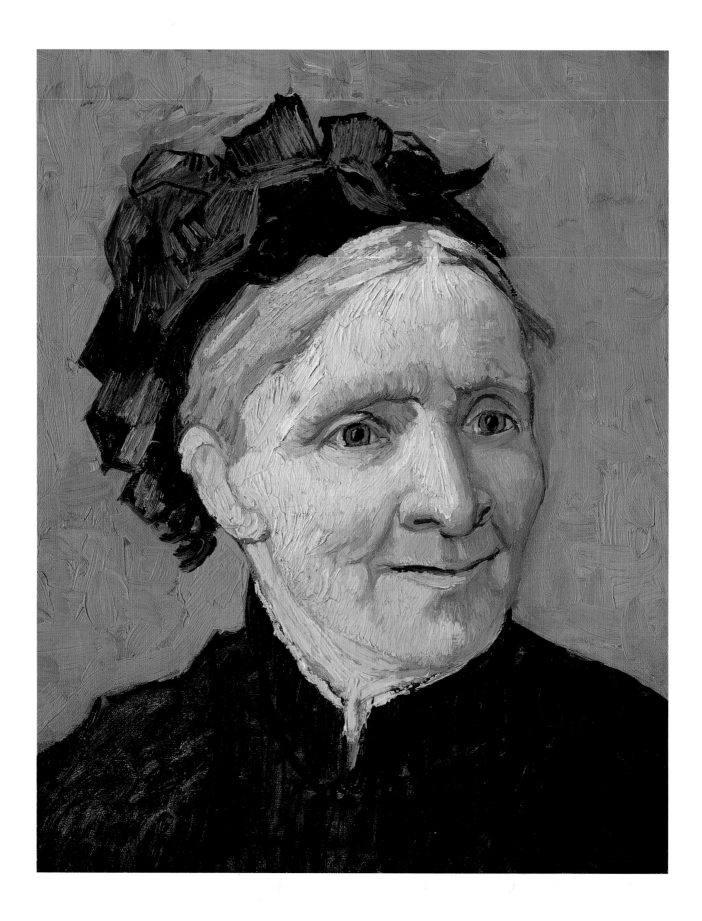

green functions throughout the painting in various ways—to neutralize (when mixed with red) the shadow on the chair, cool the skin tones, and provide a temperature contrast (as in the background and over the lap of the skirt).

Likewise, Vincent van Gogh's *Portrait of the Artist's Mother* utilizes warm and cool relationships of color temperature to define the forms of the model. This painting can be seen as almost a parody on traditional green underpaintings. The skin tones are rendered in intense, yellowy-lime greens, set against cooler, minty greens and with very little fleshy pink tones. The distinct paint handling sculpts the surface contours of the face to reinforce solidity of the forms. Notice the thinly scumbled texture of the garment, a brownish red that complements the overall green elements of the painting.

A portrait painting is compelling not because we recognize the identity of the sitter or the stylistic concerns of the époque, but because the artist has melded painting methods to the underlying humanity of the face, recording the mobile history of humanity. Traditional painting techniques initiated by the Old Masters create a certain quality in the paint surface, an optical glow of light and color, that expresses more than a mere rendering of the features. This approach is underlined by the structure of this book, from preparing a ground, to mixing colors, handling a brush, and using mediums, to combining perspective and anatomical structure to express the feeling and ideas of the final painting.

All traditional painting methods emphasize the practice of sound drawing skills and composition, combined with painting strategies, for arriving at the final work "indirectly." The term "indirect painting" is used to describe the building up of an image—from the drawing stages to underpainting to the incremental, layered applications of color, and then to the final glaze layers of pigment. Direct painting methods, on the other hand, are used when the artist's intention is to achieve final results in a single, more thickly applied layer of paint, as in alla prima techniques. To capture a spontaneous impression of the subject, this approach demands that the painter have an exact eye for color mixing combined with experienced brush handling.

Old Master paintings employed indirect painting methods that utilized the underpainting to provide a transition from drawing to painting. Color in a painting then established the meaning, or focal point, in a work, such as a moment of saturated red in an otherwise tonal painting. Color palettes for paintings were based more on invention rather than on direct observation. The limited range of available color pigments meant that artists were forced to interpret the visual world and organize color within the composition toward their intended meaning. In practical terms, color helped to clarify the pictorial elements when seen from afar or under dim lighting.

Color pigments for the Old Masters were determined by the costs

OPPOSITE:

Vincent van Gogh,
Portrait of the Artist's Mother,
1888, oil on canvas, 15½ x 12¼ inches (39.4 x 31.1 cm).
Courtesy of Norton Simon Art Foundation, Pasadena, CA

The use of thick, impasto paint hides van Gogh's careful attention to the drawn, crisper edges of the model's features, the variation of shape, the contrast between light and dark, and the modulation of color temperature to create form.

and limitations of available colors. Inorganic "earth" pigments, such as yellow ocher, terre verte, burnt sienna, or umber, were literally ground rocks and minerals culled from different regions in Europe. However, not all pigments were equally available or uniform in hue from region to region. The limited range of pigments resulted in subtle color mixing skills to maximize the potential of each pigment. What was, for the Old Masters, a condition of the times, has evolved into a painting practice — a limited palette that promotes a unified harmony of color.

To optimize the most visual or colorful effects from a limited palette, Old Masters created rich color effects, or luster, by transparently layering one color pigment over another. Further, toned grounds heightened the optical effects of transparent or thinly applied pigments while unifying the overall composition. This indirect painting method was reconsidered with the discovery of more permanent, brighter pigments in the mid-nineteenth century. Such painters as Delacroix introduced the idea of visually blending colors, by juxtaposing one color next to another, rather than transparently layering one over another, an idea explored intensively in the era of Impressionism. A growing appreciation for the artist's oil sketch, an image that features open brush handling painted directly on a white ground, changed the emphasis from clearly defined edges and blended forms to discrete dashes of pigment that fused in the eye.

Our continued appreciation of the history of painting comes not only from the power of the image but from the skills employed to render a beautifully painted surface. In essence, we love the paint. The contemporary artist is challenged to have a broad vocabulary in painting techniques and approaches in order to respond to the individual. Some subjects may demand a bolder approach — the dynamic color of a Picasso, the subtle nuances of a Vermeer, or the lively gesture of a Frans Hals.

The techniques and concepts presented in *Portrait Painting Atelier* are one artist's interpretation of how to gain luminous color effects while working within traditional oil painting techniques — in other words, melding Old Master techniques with modernist sensibilities. In today's pluralistic art environment, the student should not ask which approach is more "correct" but which promotes his or her vision the best. This book is aimed at you, the intermediate painter. Unlike beginning painters (who have little experience painting) or advanced painters (who have been consistently well trained), intermediate painters are challenged to build upon a sound foundation and further their skills but also to become consciously aware of thinking as a painter. Hopefully, this book will be useful in accomplishing both of these goals.

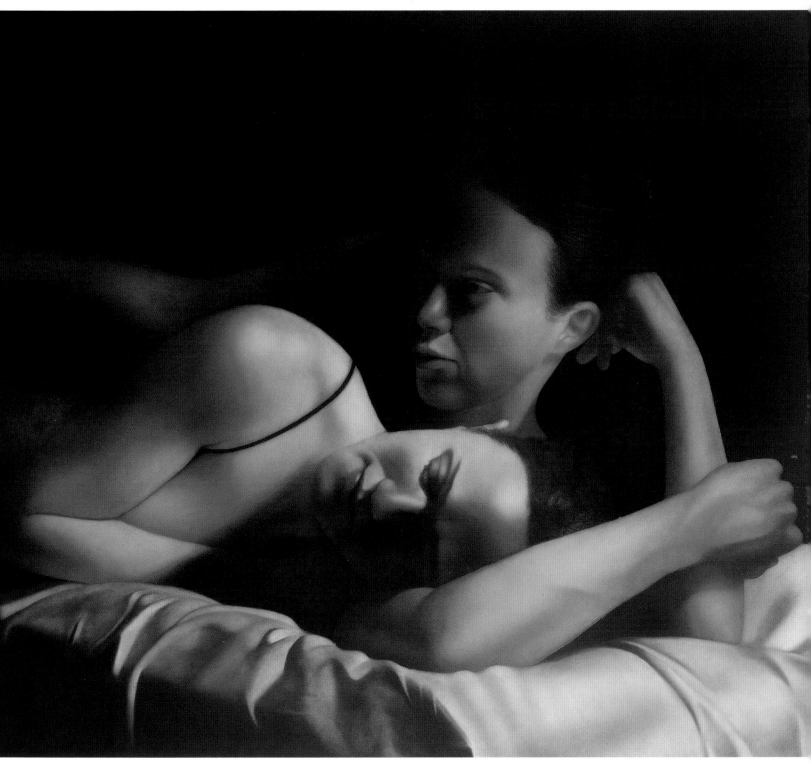

Gloria de Arcangelis, *Two Sisters,*
2007, oil on wood panel, 25 x 29 inches (63.5 x 73.7 cm)

Inspired by Caravaggio, this painter crafts
the drama of the image by staging the light
to caress the surface of the entwined figures.
What is revealed by the light is balanced by
what is concealed in the shadow.

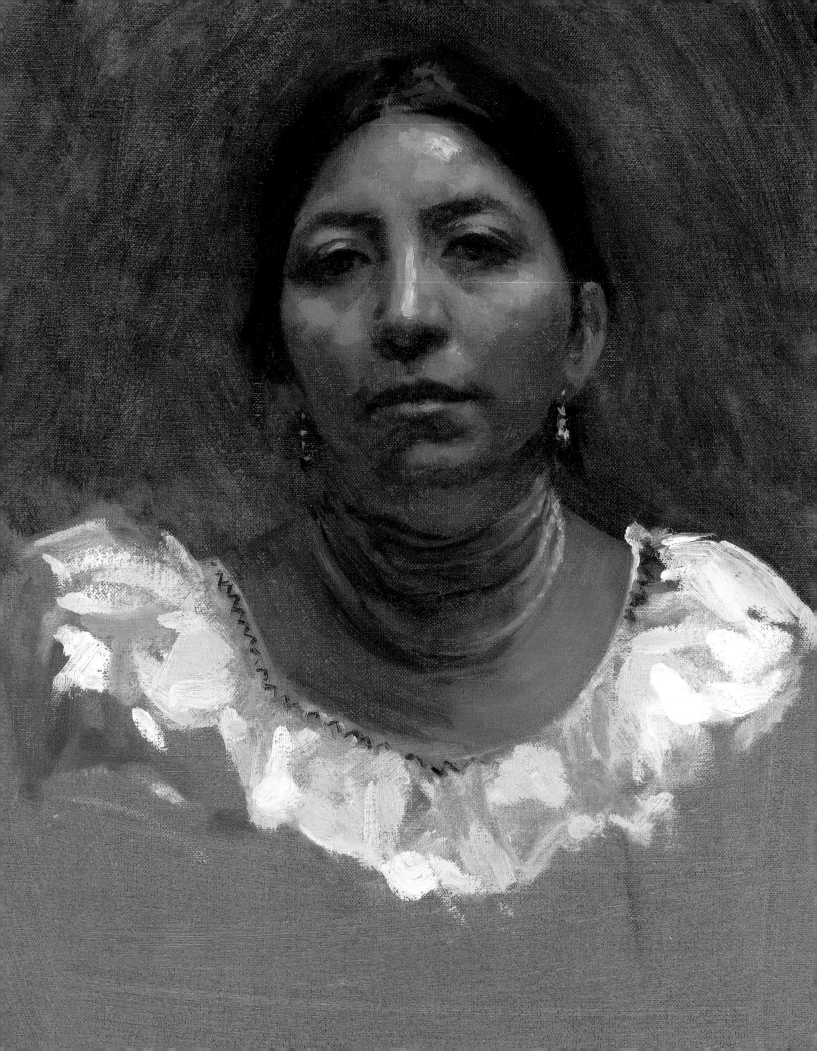

STUDIO PRACTICES CHAPTER ONE

CONSIDER YOUR STUDIO A SANCTUARY where the devotion of time and attention are always more important than the actual physical space. The process of painting requires a mind-set that puts aside the concerns of daily life in order to focus on the inner dialogue between yourself and your visual perceptions as an artist. Crafting this mental space may entail hanging work that is inspiring, surrounding yourself with art books, or playing music—anything that builds the atmosphere of your sanctuary.

The physical needs of a practical working space are simple: air, light, and space. Having the proper amount of air is not only a question of ensuring adequate ventilation for paint and solvent volatiles but also of establishing breathing room above your head. A window is not only useful as a source for natural light, but it also provides a moment to daydream and reflect between bouts of painting. Room to step back from the easel is as important during a painting session as storage space for materials or floor space to stretch and gesso canvases.

When setting up your studio, place your easel so that the light falls across (parallel to) the surface of your canvas. Avoid having the light fall directly onto the canvas or backlighting it from behind. Harsh lighting that falls directly on the canvas will cause cast shadows from your arm or glaring reflections from your clothes. Conversely, facing into the light will cause eyestrain and will place the canvas in shadow. The optimal situation is having even light from a northern exposure. However, natural lighting, from any window, can be used if it can be adjusted to provide a bright, indirect light source that falls parallel to the canvas that equally illuminates both the painting surface and the palette. Alternatively, light bounced off the ceiling with clamp lights and flood light bulbs can be used to enhance a dark space or when working at night.

Standing in front of the easel allows the most physical interaction with the painting. You can move your arm freely when painting and step

OPPOSITE:

Kate Lehman, *Ecuadorian Woman*, 2001, oil on canvas, 14 x 13 inches (35.6 x 33 cm)

Working with a live model demands skill in establishing resemblance and in color mixing. Having thoughtful studio practices solidly in place can greatly facilitate the process of making minute-by-minute decisions, maximizing your working time.

back frequently to view the entire canvas. Sitting in front of the canvas often leads to a crouched position, which strains your neck and back. Although painting fine details may demand close scrutiny of the canvas, painters who constantly paint from a seated position tend to see only the details and lose the overall effect that unifies the image.

Many fine painters began by painting on the kitchen table, and many continue to use their garage, basement, or a spare bedroom as their studios. Don't let the humble beginnings of your studio deter you from what could be the most engaging part of life—becoming a painter.

USING YOUR MATERIALS SAFELY

Painting in oils involves working with toxic ingredients. Therefore, it is important to understand the hazards and safety issues when using your materials. Specifically, the compounds that make up the pigments in oil paint are toxic (even when they are not lead-based pigments), so be sure to avoid getting paint into open cuts on your hands or inadvertently ingesting paint. For instance, placing the end of a paintbrush in your mouth and eating food with paint on your hands are both complete no-nos. Likewise, wearing a paint smock or apron can reinforce the habit of smearing paint on your clothing. It may seem artsy, but in fact you are wearing toxic chemicals.

For some painters, wearing latex gloves seems like the ideal solution, although this can generate a disregard for the presence of paint on your hands, which allows it to travel to every surface you touch. One solution is to apply a barrier hand cream that acts as invisible gloves, protecting your skin while still allowing you sensitivity to the brush. For messy painters, baby wipes are a convenient way to keep their hands clean.

Standing back from the easel during a painting session is critical to being able to distinguish the overall big effect from the small details.

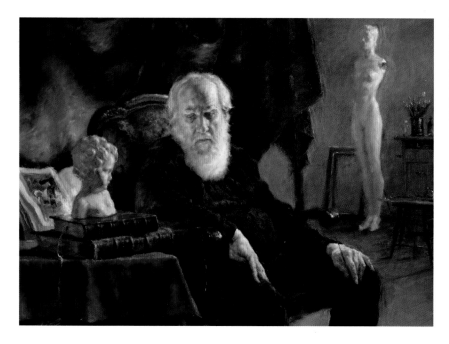

Robert Liberace, *John in Studio*, 2008, oil on canvas, 24 x 36 inches (61 x 91.4 cm)

In this painting the artist's studio provides a context for the posed model. This not only highlights the artistic process but also portrays the artist's sensibilities as much as the model's.

Keeping a ready supply of painting rags is also helpful. Painting rags should be made from lint-free cotton cloths that have been cut into squares no larger than 8 inches. Old undershirts, pillowcases, or sheets bought at thrift stores can be easily cut down to make painting rags. In addition to providing an easy solution for wiping off your brushes and palette knives, these rags are also useful for cleaning and oiling up your canvases.

To keep your working space clean, tape a plastic grocery bag onto the front of your easel shelf. This will allow you to easily dispose of paper towels or paint rags during a painting session. When you're finished painting, simply twist the plastic bag closed and dispose of it in the garbage. (Because they contain toxic elements, these materials cannot be recycled.) Alternatively, a tight-fitting lid on a trash can can help keep volatile elements at a minimum in the studio.

WORKING WITH SOLVENTS

Exposure to solvents should be kept to a minimum. All solvents should be stored in tight-sealing glass jars, even when in use. You may not be able to smell the solvent, but overexposure can eventually build up to an allergic reaction. Always provide good ventilation when working with paint thinned with solvents.

Odorless mineral spirits (or OMS) is the solvent used for removing oil paint from brushes and thinning oil paint. However, the quality of the refined mineral spirits determines its use in the studio. Odorless mineral spirits found at the hardware store should be used only for cleaning brushes; while the more expensive brands, such as Turpenoid, found in art supply stores are intended for mixing with oil pigments. Gum-based turpentine (which is highly volatile) is used only for specialized situations, such as mixing "classic" painting mediums with dammar varnish and stand oil or thinning wax mediums. Gamblin's Gamsol and Winsor & Newton's Sansodor provide the lowest amount of airborne volatiles, and both are appropriate to add into pigments.

RECYCLING USED SOLVENTS

Storage of dirty solvent involves a decanting process that recycles used solvent after the paint has settled to the bottom of a jar. The clarified solvent is then poured into a clean jar. To recycle old jars, use a paper towel to wipe out the paint sludge from the bottom. (The handle-end of a paintbrush can help move the paper towel around when your hand can't reach inside the neck of the bottle.) In this way, the same solvent and jars can be used over and over again for cleaning brushes.

If you find that your painting studio is constrained by your living space, you may want to use cheap cooking oil as an alterative to solvents for cleaning your brushes. The method described above can be used for separating the clarified oil from the paint sludge; however, it will take longer for the paint sediments to settle to the bottom of the oil.

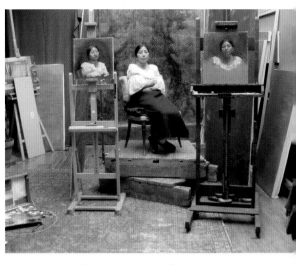

A view into a working studio where artists are painting from a live model. (See one final painting from this setup on page 22.) Standing away from the model allows an artist to compare both the larger forms as revealed by the light and the fine details.

CARING FOR YOUR BRUSHES

Selecting the correct brushes will have a significant impact on your brush-handling techniques. Brushes are made with three basic shapes: rounds with narrow pointy tips, flats with square tips (shorter flat brushes are called brights), and oval-headed filbert brushes. Each of these shapes creates a certain mark in the paint and is therefore useful for different areas of the painting. Consider the scale of the areas you'll be painting when choosing the size of your brushes. A basic brush collection for portrait painters should include one very pointy round brush (size 00 to size 1) for detailed areas, two or three filberts of different sizes (size 2 to size 6) for blending, and a larger flat for backgrounds.

At one time, boar-bristle brushes were the best buy, but today nylon brushes are the most practical choice, as they are both durable and inexpensive. With proper care, even inexpensive nylon brushes will keep their shape and flexibility. The abrasion created by rubbing across a canvas surface eventually wears down even the highest-quality brush. However, carefully cleaning your brushes after each painting session will guarantee a longer life.

Brushes should first be cleaned with solvent to break down the oil and pigment bond. Brushes should not be left standing in solvent for long periods of time, however, as the bristles will bend and decay. After wiping the solvent (or oil) and remaining paint off with a paper towel or rag, the brush should be cleaned with soap and water. Special brush-cleaning soaps work to remove paint, but a simple bar of Ivory also does the job.

Cleaning a brush is a two-step process: first to remove oil and paint from the ends of the bristles and second to remove oil and paint from where the bristles descend into the ferrule (the metal crimp that holds the bristles onto the handle). First, moisten the soap with warm (not

Not all brushes are made equally well, so test and compare different brush manufacturers for their stiffness or flexibility.

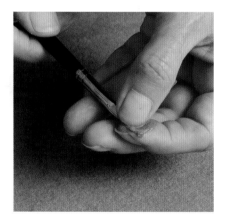

Cleaning a brush with soap and water after a painting session involves a two-step process. First, remove the paint from the brush tip.

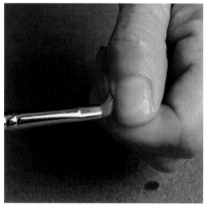

Second, manipulate the bristles at the ferrule by pinching the bristles together and rotating the brush handle.

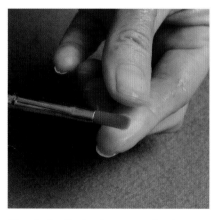

After rinsing the brush, press and reshape the bristles before allowing the brush to dry.

extremely hot) water and gently rub the brush across the top to make a lather. Warm water will help dissolve the oils and remove traces of soap without melting the glues used to hold the bristles together. Rub the tip of the brush between the thumb and index finger, rinsing as needed to remove the paint-stained soap. Repeat until the brush tip is clean.

Second, hold the tip of the soapy brush stationary in one hand and gently rotate the brush by the handle in a circular fashion with the other hand. This action will agitate the bristles inside the ferrule, releasing more paint and oil. Repeat as necessary to remove all the paint.

Getting the paint out of the entire brush will help it keep its shape and flexibility. Don't worry, however, if a high-staining pigment has tinted the bristles. (A phthalo blue brush will always be phthalo blue.) While the brush is wet, squeeze the bristles together to reinforce its original shape. Then store it on a flat surface or vertically with the handle at the bottom. Care should be taken when transporting brushes that their tips are not bent out of shape.

Look through your brush collection from time to time and discard those that are dried stiff with old paint. After a good cleaning, some well-worn brushes may still be usable for scumbling. Dipping a brush in Murphy's Oil Soap and letting it sit for an hour before cleaning can help restore a favorite brush. Examine the tips of the usable brushes to see if they retain their shapes and soft tips. A quick test: Can they still pull a thin line or blend without scratching the paint off? If the answer is no, then it's time to go shopping.

USING A **MAULSTICK**

Painters who feel that their hand is too shaky should invest in a maulstick—a wooden or metal rod with a soft pounce on one end. Because it braces your hand above the surface, a maulstick eliminates any tendency to place the side of your hand on the canvas. This is especially useful when painting fine details. A maulstick is easily made from a wooden dowel, a wad of cotton, a 6-inch square of fabric, and some string. Notice that the end of the stick rests on the edge of the canvas frame or on the easel but never on the canvas surface.

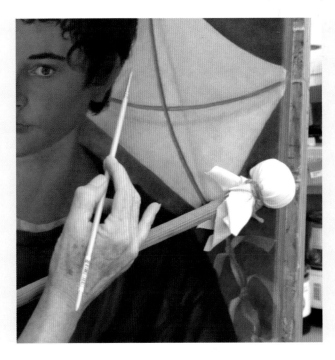

A maulstick is an effective tool for bracing your hand when painting fine details.

PREPARING YOUR PAINT SURFACE

Thinking as a painter, you'll want to have a number of various painting surfaces primed and ready for whatever need arises. A strip of watercolor paper or canvas paper is handy for testing color mixtures, canvas boards for a quick live-model painting session, and prestretched canvas for a moment of inspiration. The canvases you build and prime with care yourself are used for well-planned compositions, as these reflect your investment in the painting process.

CHOOSING YOUR SURFACE

The surface or support you choose at any particular moment will depend on several factors. Is this a study or a finished work? What scale is needed for the overall image? What surface responds best to your paint application techniques? Take the time to consider these things before you start. Realizing after the fact that you've made a fine work on a cheap, amateur-looking canvas is intensely disappointing. Likewise, experimenting with a new technique on an expensive canvas makes the painting process more stressful.

Today's painter is fortunate to be able to choose from a variety of surfaces, each of which offers a number of benefits: the convenience of prestretched canvases, the easy storage of primed watercolor paper, or the economy of canvas boards. However, each of these surfaces also has certain limits. Experiment on different surfaces to find the one that works best for you.

Prestretched Canvases

Because they are often made with inferior material, prestretched canvases lack the irregular texture and tooth of cotton duck canvas. However, once additional layers of gesso have been applied, they are good for quick study paintings. The more expensive brands, which have well-turned edges, give a more professional look.

Watercolor Paper

Cold-pressed watercolor paper (at least 140 lb.) provides a smooth surface, making brush marks visible. Works on paper have the benefit of being able to be cropped after the painting is finished and framed easily. Watercolor paper is not recommended for large-scale pieces or applications that involve thick paint, as crackling of the paint surface can occur unless the paper is mounted onto a stiff surface.

Canvas Boards

Canvas boards (even small ones) tend to warp, and although they have plenty of texture, the surfaces tend to exhibit a machine-stamped quality that only works well with many or thick applications of paint. (This is

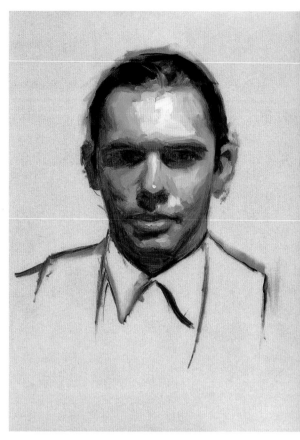

Kate Lehman, *Michael Grimaldi,* 1999, oil on paper, 12 x 12 (53.3 x 53.3 cm)

Careful preparation of the surface becomes critical when exposed areas of the ground appear as part of the final painting.

the same problem with canvas paper, which is more appropriately used for color studies.) Although canvas boards come preprimed, their surfaces are slick, so it's worth the time to recoat them with three coats of gesso to make the surface more adherent to the initial layers of paint.

Gesso Boards

These prepared wood panels come ready-made—either as smooth surfaces or with canvas glued onto the wood. These are acceptable surfaces for small-scale works. However, for paintings larger than 18 inches the gesso board needs to be mounted on cradles, wooden frames that provide a rigid support. Likewise, a piece of scrap canvas can be easily glued onto a Masonite or gator board (a denser version of foam core) with acid-free PVA Size (Gamblin), providing a suitable surface for a small study painting.

Stretched Canvases

Stretching your own canvases allows you to have control over the size and proportion of the canvas and the texture of the surface. The effort of creating your own canvas is rewarded in the finished product: your serious paintings have the look and feel of professional works. Painting over the edges and onto the sides of the canvas also removes the necessity of framing your work. To stretch your own canvases you need to procure canvas and stretcher bars.

Canvas cloth (as well as linen, which is more expensive) comes in various dimensions, textures, and weights. For the intermediate painter, a 10- or 11-lb. cotton duck canvas with a smooth finish provides an economical working surface. Be sure to check the canvas for any flaws, such as thread pulls, rips, or sewn edges. Return canvas that shows signs of having been pulled out of the "grain" (the true horizontal/vertical meeting of the warp and weft of the fabric), as this will later cause the stretcher bars to warp. Also, avoid buying preprimed canvas, as it is difficult to stretch over the bars to achieve the correct tautness. Drawing a layout of the frames you want to cover will help you determine how much canvas to buy. When choosing the width of the fabric, allow 3 to 4 inches beyond the dimensions on each side for wrapping the edges. Prepackaged canvas will have distinct folds. To relax the creases, roll the fabric onto a cylinder and allow it to sit for a few days before stretching onto frames. Extra canvas should be stored on a roll, flat on the ground.

Stretcher bars come in three weights: lightweight (for works up to 24 inches), middleweight (for works not bigger than 48 inches), and heavyweight. A rule of thumb: The more rigid the support, the greater the stability of the paint surface. Always check the wood bars for straightness by sighting down the lengths and for manufacturing flaws in the bevels or joints. Cross supports are recommended for formats larger than 24 inches.

MAKING TRIM CORNERS

Correctly folding the canvas corners is often the most difficult part of stretching your canvases. The illustrations on the facing page detail this step-by-step process that result in a professional look to your hand-built canvases. Besides canvas and stretcher bars, you'll need the following tools:

- staple gun
- staples with pointed ends
- canvas pliers
- needle-nose pliers
- flathead screwdriver
- small hammer
- scissors
- tape measure

Once the stretcher bars are assembled, make sure they are at 90-degree angles by using a measuring tape to check that they are the same length from corner-to-corner. Cut your canvas to the desired size, allowing 3 inches of overlap on each side. Lay the stretcher frame, beveled side facing down, over the canvas fabric, aligning the weave of the canvas with the length of the stretcher bars. Staple the center point of one side onto the wood bars. Using the canvas pliers, pull the fabric taut, opposite the first staple, and then staple the second edge at the center. Next, pull the two shorter widths and staple at the center of the bars in the same way, making sure the stretcher bars maintain their 90-degree angles.

Returning to the first side, firmly pull the fabric with your fingers against the bar and staple it in place every 2 inches close to the edges of the bars. Move from left and right of the center, leaving about 3 inches at the ends near the corners free. Next, rotate the canvas to the op-posite side, pull the canvas taut using the canvas pliers, staple the opposite length in the same manner, and finish similarly the shorter widths with the corners loose. Needle-nose pliers and a flathead screwdriver are useful tools for removing any staples that get bent during this process.

To fold the corners, raise the canvas so that the long side of the front is facing you and pinch the loose fabric on the top to make a 45-degree angle from where the bars meet at the corner. This will make the part of the corner that folds over. Like a hospital bed fold, when this flap is folded over the shorter side, the corner should be parallel with the width of the stretcher bar. Keep this fold tightly squeezed together as you wrap and pinch together the inside corner that will fold under. The pressed canvas can now be trimmed on a diagonal to remove the excess fabric and then repositioned, tucking the wedge of canvas under the inside fold. Each corner is prepared in the same fashion—the short sides folding under and the long sides overlapping at the corners. Place the canvas facedown on the table or floor before stapling the creased and trimmed corners, beginning with the short sides.

Use the pliers to tighten the canvas near the inside corner and then staple, leaving the corner wedge itself free. Once the corners on both ends of the shorter side are stapled, then roll the raw fabric edge under along the stretcher bar and staple to make a neat edge.

To complete the process, pull the overlapping corner on the long side using the canvas pliers and staple in position, leaving the raw edge to roll under. To finish, roll the raw fabric edge along the long side of the stretcher bar and staple it in place. Use a small hammer to pound in any raised staples. The resulting canvas should feel evenly tight with no visible puckers or creases. You're now ready to begin priming the canvas with gesso.

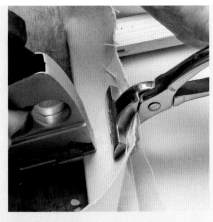

After stapling the center points on each side and carefully aligning the canvas along the length of the first side, use canvas pliers to draw the canvas tautly against the bars on the opposite long side and shorter widths of the canvas.

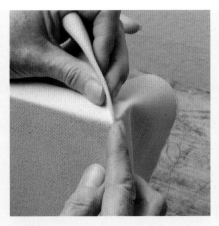

With the front of the canvas now facing you, crease a 45-degree angle from the front edge of the stretcher bar to create the overlapping fold of the corner.

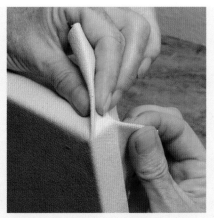

Then crease the second fold of the corner (that folds underneath on the shorter side) at a 45-degree angle from the backside of the bars.

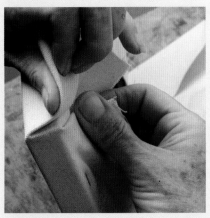

Tuck the second fold under the first fold.

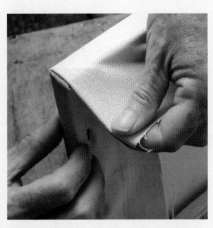

Make sure that the first fold aligns with the edge of the canvas.

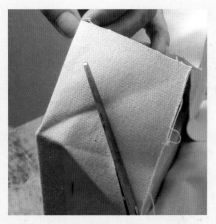

Open the creased folds and trim off excess fabric.

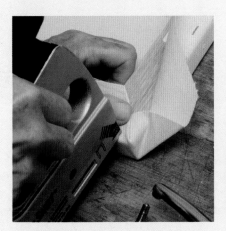

Pull the inside corner taut and staple both opposite ends of the shorter width.

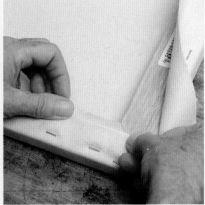

To finish the raw edges, roll the fabric under along the entire length of the short side and then finish the overlapping corners of the longer side.

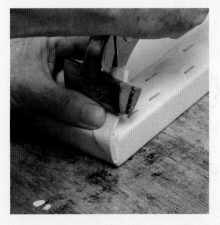

Pull the overlapping side of the corner taut and staple close to the edge. Roll the raw edge under and staple.

PRIMING THE SURFACE

There are two types of priming mediums or grounds: acrylic gesso and oil priming paint. The former gives the surface a chalky, matte finish, while the latter gives a smoother, "buttery" finish. Regardless of which surface you desire, the canvas must be treated with acrylic gesso (or two coats of PVA Size or rabbit skin glue) before adding a layer of oil priming paint.

Priming a painting surface with gesso provides two important functions: First, gesso acts as a protective layer that keeps the oil from corroding the surface, and second, it provides a physical tooth that creates a mechanical bond between the paint and the primer. Gesso itself is a mixture of acrylic polymer, a glue element, carbonate, and titanium white paint. Choose only professional-grade gesso; gallon-sized containers are more economical than pint jars in the long run. Any dry gesso product that needs water to be added and then to be heated over a double boiler should be used only on rigid surfaces such as panels.

Inexpensive nylon house painting brushes (1 inch for smaller works to 2½-inch brushes for larger surfaces) are used to apply gesso. Avoid cheaply made brushes that will leave their bristles on the surface. Any hairs or bristles that do attach to the surface must be removed immediately.

Because of the glue element in gesso, tabletop and floor surfaces should be protected with a plastic drop cloth before supports are gessoed. Gesso that splatters on shoes or clothing must be washed out immediately with soap and water. Likewise, make sure to wash brushes thoroughly at the end of every gesso "fest."

Stretched Canvases

For raw canvas, first apply a thin mixture of gesso (the consistency of 2% milk), beginning in the center and moving toward the edges and over the sides. This layer will moisten and shrink the fabric. Make sure that the watery gesso completely saturates the fabric. Gesso should also be applied to the sides of the canvas with the same degree of care. Allow the canvas to dry completely and then apply a second coat in a similar manner.

For the final coats, increase the consistency of the gesso to that of heavy cream. Cover the entire surface and then drag the flat tip of the brush lightly across the surface in one direction, parallel to the edge of the rectangle. This will remove any brush mark hickies, where the brush stroke begins in the middle of the wet paint. Gesso should also be applied to the sides of the canvas with the same degree of care. Let the gesso dry, usually 1 to 2 hours. Apply the next coat, now moving the brush so that it crosses the first coat at a 90-degree angle. It can take three to six layers of this thicker gesso to even out the texture and stiffen the flexible canvas enough to create a workable surface.

Sand the front and sides of the canvas with 200-grit sandpaper after each of the coatings of the "heavy cream" gesso. This process smoothes

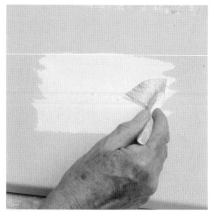

To prime a newly stretched canvas, cover the entire surface thoroughly with watery gesso by dragging the brush across the front surface.

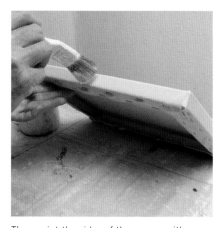

Then paint the sides of the canvas with care, particularly at the turning edge from the front to the sides, as most abrasion occurs here.

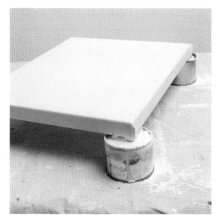

Use small metal cans (or plastic cups) to raise the canvas, which keeps the gesso from bonding to the drop cloth while the surface dries.

out the rough fibers of the canvas cloth, fibers that may not be visible but that can be felt with your fingertips. An unsanded canvas surface will destroy your paintbrushes and later create an uneven reflection. Use good safety precautions to avoid inhaling the dust created during the sanding process.

Occasionally, small thread knots occur in raw canvas. To solve this, place your fingertip, from the backside, underneath the knot and push out that area in order to carefully sand that spot. The same technique can be used to remove clots, brush bristles, or nuggets of gesso. If the finished canvas becomes slack, misting the backside with clean water can retighten the canvas, but make sure to allow it to dry before painting.

After priming the surface of your support, check for any roughness by lightly running the tips of your fingers over the surface. What your eyes won't see, your fingers will feel. Lightly sand the surface with 200-grit sandpaper and wipe it clean before applying new gesso or a toned ground.

Prestretched Canvases

For best results, surfaces that claim to be preprimed should be coated with three layers of gesso. Commercially prepared surfaces tend to have a large proportion of polymer, which makes the surface slick. The additional layers of gesso also help to break up the mechanical grid of the faux canvas surface and increase the dry adherence of the surface.

Other Supports

For watercolor paper, canvas boards, prestretched canvases, and Masonite boards, dilute the gesso to the consistency of heavy cream and apply it to the surface in even coats, as described above. (Note: Turning the support 90 degrees between coats will create a faux linenlike texture, which will help mechanically grip the paint to the surface.) By slanting the surface against the light, you'll be able to see any dry spots that you may have missed. This step is especially critical when applying gesso to an already white surface, such as paper. Watercolor paper also tends to curl. To avoid this, apply one thin coat of gesso to the entire back side; after it's dry, mark a small "x" with a pencil to indicate that it is the back.

USING **OIL PRIMING PAINT**

Oil priming paint is a lead-based, white oil paint mixture that provides a lean oil ground. (White oil paint pigment is not recommended as a substitute for an oil-primed ground.) Purchased ready-made (Gamblin), it is applied as is with a palette knife or scraper onto rigid supports or thinned with OMS and applied with a brush onto canvas. As mentioned earlier, any surface must first be prepared with PVA Size, rabbit skin glue, or two coats of gesso before the oil priming paint can be applied. Once the surface has been evenly coated with oil priming paint, it should dry horizontally for several days before recoating. This second coat will need an even longer time to dry before you can begin painting—two weeks to two months, depending on how thickly it is applied. This can result in the benefit of a surface that has less sinking in of pigment into the ground but also result in a more slippery surface.

TONING THE GROUND

Two different methods can be used to tone a canvas—acrylic pigment (or tinted gesso) and thinned oil paint. Either way, toned grounds can be applied as a smooth, even veil of transparent pigment or in a mottled fashion, using subtle changes in light/dark or warm/cool. Whichever materials and methods you use, make sure to paint the ground beautifully, giving just as much care to the sides as to the surface of the support. Also, before you start, be sure to mix a sufficient amount of paint. It is better to have too much paint mixture than too little. Leftover paint can always be used to tone watercolor paper for quick study paintings or test color swatches.

Acrylic Toned Grounds

The benefit of an acrylic toned ground is not only its fast (2-hour) drying time, but that it keeps the initial surface lean so that paint solvent can be used in moderation with the first layers of pigment. However, when an acrylic-toned ground has been applied, care must be taken to not scrub the surface during future paint sessions, as this can remove the ground. The acrylic paint for a toned ground should be matte, such as Golden Matte Acrylic. Glossy acrylic paint should be avoided, as this will make the final surface too slick, resulting in a poor bond between the oil paint and the canvas. Customized color mixtures can be made in small plastic containers that have tight-fitting lids.

Using a palette knife, thoroughly mix the paint with enough water to achieve a loose, creamy consistency. You do not want to cover the canvas with an opaque paint layer, but rather a thin, transparent stain of pigment that allows the white of the gesso to glow through.

Using a soft-bristled nylon acrylic brush at least 1 inch wide, brush the paint mixture across the entire short side of the rectangle with one stroke. Try to avoid leaving any brush marks, as brushing over areas that have already begun to dry will pull off the paint and leave blotches. If the color is too uneven or too pale, it is better to recoat the surface a second time once the paint has dried. Wash the palette knife and brush with soap and water immediately after use.

Alternatively, a prepared, tinted gesso can also be applied as a finishing coat to a well-primed white gesso canvas. Tinted gesso creates not only an opaque surface (due to the titanium white in the gesso) but also a lean surface, making oil pigments easier to apply in the first layers. Pouring acrylic pigment into a small container of gesso and mixing thoroughly is one way to customize the color of the tone ground.

The initial block-in of the underpainting shows how thinly applied paint can create a visual glow. Notice how the midvalue pigments take on a blue tendency when placed over the warm ground.

As the foundation for your painting, a toned ground should be delicious to the eye and painted with care.

Oil Toned Grounds

Oil toned grounds can be made in one of two ways: If your brand of paint is already very oily, then just add some solvent to thin it, but if your paint is tight or sticky, add both oil and solvent. Toned grounds are a perfect use for inexpensive brands of paint that you may have rejected from your palette.

Using only OMS creates a lean ground, which results in a faster-drying toned ground compared to pigment mixed with oil plus solvent. However, when taking this approach, make sure the mixture itself contains no more than 20% OMS, as this will break down the cohesion of the pigment particles to the gesso ground.

Using oil and solvent to create a toned ground acts much like an oil priming, allowing less of the paint to sink into the absorbent gesso ground. This surface will take longer than an acrylic toned ground to dry (usually four to seven days). To create an oil toned ground, mix the paint with an approximate 50/50 blend of OMS solvent and linseed oil. The solvent makes the paint more movable and the oil keeps the paint from becoming too lean. Blend the mixture together thoroughly with a palette knife on your glass palette before applying on the surface.

Whichever recipe you choose, the resulting mixture should appear midvalue when brushed evenly over the white priming and should have sufficient transparency to backlight the pigment from the white ground. Testing the transparency and color note in a small area is a good idea, especially when using high-staining or opaque pigments. Adding white will only dull the color intensity of the pigment and is reserved for semiopaque grounds using high-staining pigments such as phthalo green or midvalue gray.

Use a large nylon brush (at least 1 inch wide) to spread the paint across the surface, first working the thinned pigment thoroughly into the texture of the canvas. For an even toned ground, stroke the wide, flat tip of the brush in one direction across the entire wet surface, distributing the paint from edge to edge without leaving any brush marks. For a mottled surface, adjust part of the color mixture with a warmer or cooler pigment, and apply it with broader, broken brush strokes to create a dappled effect. Store the toned canvas tilted against a wall or flat on the floor till completely dry and then clean it with diluted ammonia water before painting. (See page 70 for instructions about cleaning the paint surface.)

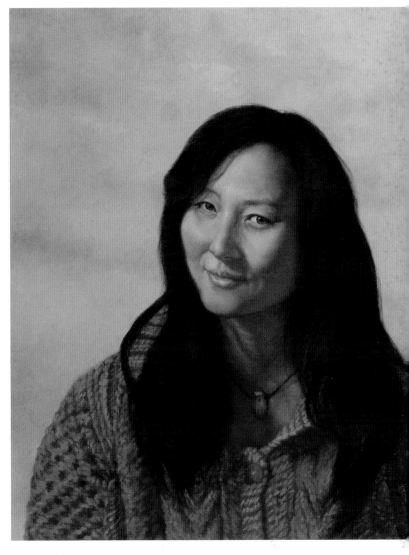

The final painting uses the toned ground to unify a sense of orange light in the sky as well as over the face and clothing of the model.

ORGANIZING YOUR PALETTE

The word *palette* not only describes the surface used to mix pigments but the arrangement of pigment hues. The selection of colors and their placement on the palette reflects the painter's sense of color relationships, either based on a light-to-dark arrangement or the contrast of warm-to-cool complements. The skill of mixing colors is easily acquired when combined with the practice of organizing your palette toward color relationships as recommended below.

CHOOSING YOUR PALETTE

Initially, the wooden oval palette was developed to allow painters to stand at their easel, palette in hand, and easily move forward and backward from the painting. Pigments were placed on the outer edge of the oval palette, making an arc of pigments that moved from lightest to darkest values. This system, although still useful for the experienced painter who has solid color-mixing skills, is not practical for intermediate painters. Rather, a rectangular palette that rests on a taboret or side table is preferable.

The palette surface is essential—not only for mixing paint, but also for storing pigments between painting sessions. A glass surface provides the most effective way to both mix and scrape up pigment using a metal palette knife. (Paper palettes tend to wear with the abrasion of the palette knife, and plastic palettes cannot be cleaned of dried paint with the razor blade of a paint scraper.) Here is the most efficient system I've found: a rectangular, 12 x 16–inch piece of glass placed within a Masterson palette box, as it provides an almost airtight container for storing or transporting your pigments.

To outfit the palette box, first place a piece of midtone gray mat board inside. This provides a neutral background that will help you judge the values of the paint mixtures. Second, purchase an inexpensive piece of glass, cut to fit, at a plate glass store. It is not necessary to tape the edges of the glass, because once it is in the box, you will never need to remove it. (Masking tape will also reduce the area for mixing colors as well as deteriorate when cleaned with solvents.) Paint that is stored in your palette box should last for two to three days; however, freezing your box will keep the paint wet much longer. Simply remove it from the freezer and allow the top to thaw for a few minutes before opening. Your paint will be ready to use.

For the right-handed painter, your palette box should sit on a low table at your right side. Make sure that you can comfortably look down onto the surface and that it shares the same light intensity as your canvas. Left-handed painters should use the opposite setup.

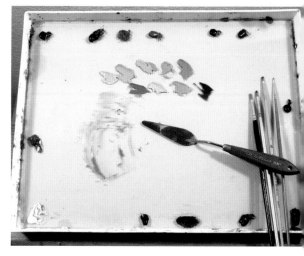

This palette shows a representative group of colors. Notice how the source colors are placed at the perimeter of the palette, leaving the center for mixing pigments. Keeping all pigments in tight lumps increases the longevity of paint by reducing the surface area that is exposed to air.

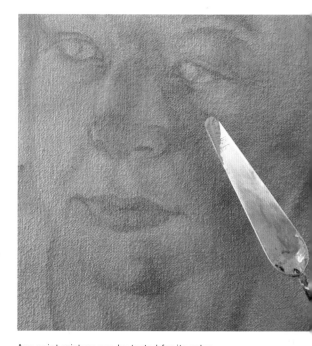

Any paint mixture can be tested for its value and temperature by holding the palette knife up to an area on the canvas and then comparing it to the model. The usefulness of a mixture can only be judged when seen in the context of the painting.

LAYING OUT PIGMENTS ON YOUR PALETTE

The rectangular palette lends itself to dividing the color spectrum into four groups: yellow/orange, red, blue/violet, and green. Orient the palette box so that the long sides are on the top and bottom. On the left-hand side place the yellow/orange family of pigments. Reserve the top for all the reds. (Pigments, such as burnt sienna, that you might have thought of as brown are now recognized as earth-based reds.) Position the blues and violets on the right side and place the green pigments, including raw umber, along the bottom. To complete the palette, place your white in the bottom left-hand corner, black in the opposite right-hand corner, burnt umber (the darkest of the earth reds) in the upper left-hand corner, and your coolest red (such as alizarin crimson) in the upper right-hand corner.

This layout emphasizes the color relationships of warm to cool temperature (yellow/orange to blue/violet) and complementary contrast (red/green). Placing your pigments in the same position each time you set up your palette is an important practice for keeping organized, regardless of whether you are using four hues or forty in a painting. Paint should be squeezed out of the tube to make a coinlike lump of pigment (at least ½ inch in diameter), positioned close to the edge of the glass.

MIXING PIGMENTS WITH A PALETTE KNIFE

The technique for using a palette knife begins with having the correct tool. The blade should be 3 to 4 inches long, oblong or teardrop in shape, with a rounded tip. (Pointed blades are not effective in mixing paint or scraping it together into a lump; small or short blades are more effective as a painting instrument than for mixing color.) The handle should feel comfortable in your hand, and there should be a slight bend from the blade to the handle. You may have to buy two or three different palette knives to find out which one works best for you.

To mix pigment together, use the tip of the knife to lift some paint from the first source color. To keep colors uncontaminated, wipe the palette knife off before getting the second color. Use the flat side of the knife to work the two colors together thoroughly. Paint tends to stick to the glass surface, so it's necessary to scrape the entire lump up during the process, so continue to mix it until the color appears even.

To scrape up the entire lump, lay the edge of the blade on the glass surface behind the mixture and press back on the handle until the blade bends. Now pull the knife toward you, keeping the edge of the blade in constant contact with the glass. All of the paint should lift from the glass surface. If streaks of paint remain on the glass, either the knife's edge is not entirely smooth or you have not placed enough pressure on the blade. Once all of the pigment is on the knife, turn the blade over and push downward in a rotating motion, letting the paint squeeze out. Finished mixtures should not have any streaks, like paint out of the tube. Between mixtures, wipe your palette knife clean.

To scrape up pigment mixtures—or to add linseed oil to tight paint, as shown here—first push back on the blade of the palette knife and then pull forward, gathering up all of the paint.

Next, turn the blade over and press down firmly in a rotating motion.

Once the full lump of paint is squeezed onto the glass palette surface, it can easily be repositioned on the palette.

STORING PAINT MIXTURES

At the end of a painting session, take the time to organize your palette. Scrape up all the color mixtures into lumps and move them to the sides. Keep the center area clean and ready for the next painting session using a razor paint scraper to remove wet or dried paint from the glass. This will help you steal time out of a busy day to paint. (If you only have 30 minutes, nothing will dissuade you more from beginning a short painting session than looking at a messy palette.)

A "live" palette can be easily stored in the freezer inside your palette box. Artist's material stores also carry smaller palette boxes specifically for this purpose. Alternatively, your paints can be transferred onto another surface, such as a piece of palette paper or even a basic picture frame that has raised edges that will keep the plastic wrap from touching the wet paint. One of the simplest ways to save large amounts of paint is in old-fashioned 35-mm film containers, which can be obtained for free at film processing outlets. Empty paint tubes can be purchased at a retail store such as Daniel Smith for the same purpose. Make sure to label each palette box or paint mixture so that you recognize which mixtures belong to what painting.

Insignificant lumps of leftover paint or color mixtures that proved unuseful during the creation of a painting can be mixed together with a little OMS and oil and then can be used to tone a gesso ground or applied on prepared canvas boards—vastly improving the surface.

RETURNING TO YOUR PALETTE

Very old paint—two weeks old or more that hasn't been kept in the freezer—will have begun to oxidize and lose its adhesive properties. Rather than struggle with unsuitable paint, it is better to remix new pigments to match the old mixtures, remove the old paint from the palette, and begin anew. However, wet paint inside a lump of "old" paint can be salvaged. It is important to recognize the difference between usable paint and paint that lost its ability to perform.

When you return to your paint box, test to see if a dried film of oil is covering the color mixtures by touching the top of the pigment with your knife. If the paint sticks to your knife, it is still wet enough to use. If the paint doesn't stick, slice under the entire lump of paint and gently turn it over without breaking the dried oil surface. Use the tip of the palette knife to scrape out the wet paint and place it on another spot on the palette. Then remove the oxidized oil film with the palette scraper (a house painter's tool found in hardware stores for scraping paint off window glass). Never chop up the dried paint into the wet paint; this results in nuggets ("nuggies") of dried paint, which, if transferred to the canvas, will compromise the longevity of the paint surface.

To retrieve the wet, usable paint under a dried skin, first position your palette knife under the entire lump of pigment.

Then scrape under the entire lump and roll it over.

Use the tip of your palette knife to remove the creamy paint and transfer it to another place on your palette.

EVALUATING THE NATURE OF PIGMENTS

Paint can be considered in two ways—both for the physical qualities of a pigment and for the visual effect of a color. Understanding both characteristics is essential for effective color mixing.

Two basic physical properties can be ascribed to a pigment: its density (i.e., its transparency or opacity) and its staining strength. The source material of a pigment (iron oxides, minerals, metals, or other materials) will determine its density. Although transparency is an inherent quality of a pigment, denser pigments can be made to act transparently, by adding an oil medium or by applying the paint very thinly. Staining or tinting strength is a measure of how a pigment will endure when mixed with other pigments. Each pigment will have its own distinct blend of these two qualities. For instance, terre verte is transparent and has a low tinting strength, while Indian yellow is transparent and high staining.

An opaque and a transparent color mixed together in equal quantities will result in the transparent hue being overcome by the stronger pigment. The same is true when mixing a high-staining pigment with ones that are low tinting and transparent. Opaque pigments can be mixed to infinite nuances (because of their opacity), whereas transparent colors are best mixed with other transparent pigments (thereby retaining their transparent character). Idenifying the temperature bias, value, and intensity of any given hue is further explored in Chapter 2. (See the color mixing exercises on pages 53 to 63.)

CHOOSING PIGMENTS

Old Master painters made their own paint mixtures from organic sources (such as insects, cow urine, burnt bones, plants, and minerals), which were ground and combined with various oils. However, the advent of lead tubes and emergence of commercial paint companies in the nineteenth century led to a consistency in painting mediums. The contemporary painter has the luxury of acquiring durable, lightfast pigments that now include many colors unknown to the Old Masters. The wide range of pigments available today includes dynamic cadmium colors as well as a full range of colors generated by chemical elements, such as the dioxazines (purples), pyrroles (red scarlet), and arylamides (yellows).

Basic Pigments

In short, a basic palette should include a warm and a cool variation of each of the primaries and green. The portrait painter should also select a range of earth-red pigments for the purpose of creating viable flesh tones. As each pigment has a distinct color note and characteristic, additional pigments are also recommended for their usefulness in color mixing.

Beginning with red hues, the basic palette includes such pigments as burnt umber, burnt sienna, Venetian red, and flesh ocher. Other addi-

A "peppercrumb" is a rough visual unit of measurement used when adding one pigment into another. "Adding a peppercrumb" means a tiny bit of a pigment—literally an amount no bigger than a peppercorn kernel lifted by the tip of a palette knife. This approach allows you greater control in adjusting the proportions between pigments.

Judging how much paint to mix at any time is determined by how large an area you are painting at the moment, how long you have for the painting session, and how soon will you return to painting after this session.

tions could include terre rosa, Indian red, English red, and Mars brown. Earth-red pigments provide a starting place for developing a flesh-tone palette (see page 52); these are often made from synthetic oxides, which lends them an opaque density from a plumy brick-like red to a more orangey red. (Earth reds that have an orangey undertone often replace orange pigments on the palette.) Alizarin crimson (or rose madder) is used for cooler red tones. Cadmium red is a good, all-purpose warm saturated red.

For yellow hues, yellow ocher and cadmium yellow are both useful. Yellow ocher, with its cool undertone of blue, can yield a warm but dulling effect when mixed with other opaque pigments. However, transparent yellow oxide is a better choice when mixing pigments for the light values. Other yellows, such as gold ocher, green ocher, or raw sienna, can be introduced when variations are needed. Cadmium orange provides a saturated intense color to the palette, whereas quinacridone gold has a subtle orangey effect.

On the blue and violet side of the palette, ultramarine blue is a bright, transparent cool blue, and phthalo blue or Prussian blue (both of which are high staining) offer a warmer blue. Indanthrene blue or indigo blue provide other options for a darker, "smoky" blue that is semitransparent. Cobalt blue, although expensive, is a good, midvalue blue pigment for mixing with cadmium red and cadmium yellow in a primary-based palette. Opaque Mars violet is very useful in rendering the dull violet note on the color of lips or the inside corner of the eye. A clear transparent violet is ultramarine violet, useful for rendering the coolness of shadows.

Green pigments are also a part of the four-sided "primary" palette. Although a green color can be created out of mixtures of yellow plus black, green pigments have their usefulness when working in a red-green palette. Terre verte is a neutral transparent green that dulls the intensity of red or orange like raw umber, which is a darker, transparent, and cooler green. Chrome oxide green is an opaque pigment that can generate endless variations of warm-to-cool greens. Viridian, green umber, and sap green lake extra are other possible additions.

Novice painters should start out with a limited number of pigments, introducing new colors with a specific need in mind, guided by what is useful rather than its novelty. A thorough understanding of your pigments is gained by doing the color mixing exercises presented on pages 53 to 63.

Glazing Pigments

Although any transparent pigments can be used for glazing, having three transparent primary pigments will allow you to mix any secondary colors. Pigments that are transparent but also high tinting, such as Indian yellow and many quinacridone pigments, are more difficult to control. A well-balanced selection would include lapis lazuli (a smoky dark blue),

Patricia Watwood, *Claudia*,
2001, oil on canvas, 30 x 20 (76.2 x 50.8 cm)

This portrait reflects the artist's sensitive use of black and white, contrasting the colorful richness in the dark background with the whites of the garment.

Intermediate painters will achieve the best results by using high-quality paint. Avoid student-grade paint (which often contains very little pigment) or colors labeled as a "hue" (as they often lack the characteristic qualities of the true pigment).

rose doré or rose madder (a blush of red), and transparent yellow oxide (a warm honey or amber).

Whites and Blacks

Your choice of white pigment will greatly impact the quality of the color tints you make. For example, mixing titanium white, which is very opaque, with pigments will create a dull, chalky effect in the lightest skin tones. Its opacity is better employed when used in an opaque underpainting or when defining white objects. Zinc white, on the other hand, is the most transparent of the white pigments. These two whites can be freely mixed together to create semiopaque to semitransparent whites.

Flake white is a semitransparent white, while cremnitz white, its denser cousin, is more opaque. Both whites are appealing in that they do not dull the color intensity of a pigment. However, since both whites are leadbased, they must be used with safe studio practices.

Black pigments can also be warm or cool in temperature, and some are more transparent or opaque, depending on the manufacturer. For instance, compare ivory black (a slightly cool transparent black) with Winsor & Newton's blue-black (which is cold). Slate black, Roman earth black, noir de pêche, Mars black, and lamp black all have their own subtle differences when mixed with other hues.

DISTINGUISHING AMONG THE BRANDS

Manufacturers of paint are generally concerned with the lightfastness, quality of pigment, viscosity, milling texture, and consistency of drying time between pigments. However, painters often focus on subjective differences, such as the feel of the paint, clarity of the hue, or color tendency (such as "toward reddish") when choosing pigments. It is important to know the key features to look for when selecting your paints.

Two crucial differences among brands are the ratio of pigment to oils/binders and the kind of oil used as the paint vehicle. More expensive paint brands generally have higher pigment-to-oil ratios (compared to student-grade paint, which has less pigment). Walnut, safflower, and linseed (cold-pressed, refined, and alkali-refined) oil are all used for milling oil paints. Pigments milled with refined linseed oil have the best workable properties: paints milled with cold-pressed oils are stiff or tight, and those made from alkali-refined linseed oils are generally sticky.

Two other factors are the expense of each pigment and its permanency. The expense of any given pigment is determined by the comparable rarity of its color source, with series 1 pigments being the least expensive and series 6 the most. Color permanency is usually marked on the tube by a letter designation, with "A" being permanent and "C" being fugitive, meaning that it will fade over time when exposed to light. Quality paints are labeled with either a chemical description (such as "synthetic iron oxide PR101") or a color code (such as "ASTM D-4236") that identifies the source of the pigment.

A comparison of black pigments shows very little difference when seen in their mass tone. With the addition of increasing amounts of flake white, however, each pigment reveals its color bias and tendency toward warmth or coolness. From top to bottom: noir de pêche (Sennelier), ivory black (Winsor & Newton), slate black (Willamsburg), and blue-black (Winsor & Newton).

Read the paint tube carefully, looking for the color permanency, pigment source, oil used in milling, and degree of transparency.

COLOR STRATEGIES AND CHAPTER TWO
COLOR MIXING

SELECTING A USEFUL COMBINATION of pigments is one of the most chal-
lenging aspects of creating a successful painting. It is not enough to
make beautiful color mixtures on the palette. A color schema includes
the entire painting, not just paint mixtures for creating flesh tones. Your
sensitivity to color nuances of value and temperature will grow as you
experiment with the pigments on your palette; however, mastering the
mixing of pigments is a skill that develops from practice and experience
when used in conjunction with an overall color schema.

OPPOSITE:

Patricia Watwood, *Semele*,
2005, oil on canvas with gold leaf, 36 x 24 inches
(91.4 x 60 cm)

Notice how red is used in this composition
to lead our eye from the fruit in her hand,
to the tie in her hair, to the crown delicately
balanced on her head. The muted green
background provides a complementary ele-
ment to the subtle flesh tones.

The visual sensation of a color in a painting is determined by the quan-
tity and quality of a pigment and its placement within a context of
adjacent hues. Therefore, it's important to understand the rationale
behind choosing color combinations and how best to organize their
effects within a composition. A color scheme based on a color contrast
can organize the composition to create harmony or visual tension. The
art of color mixing is demonstrated through a painter's skill in develop-
ing a rich variety of colors using a limited palette of pigments. Therefore
a keen understanding of a pigment's physical properties as well as the
visual effects of a hue is crucial to thinking like a painter.

In addition, this chapter features three essential color mixing exer-
cises. The first is structured to give you an overall sense for how each
pigment on your palette can be changed in terms of value and tempera-
ture as well as how it can be mixed with its complement to create a neu-
tral. The second exercise explores how to use a limited palette to create
flesh tones. The third exercise builds on the second, by teaching you
how to apply color mixtures onto toned grounds to create subtle optical
effects. Because color mixing has no easy formulas or recipes, these skills
are a struggle to master, and yet, once acquired, they endow the painter
with greater expressive potential.

MAXIMIZING YOUR USE OF COLOR CONTRASTS

A color scheme based on a color contrast can organize the composition, unifying the overall image as a cohesive whole. To do this effectively, however, you need to plan your overall strategy before your paintbrush touches the canvas. Start by asking yourself a series of questions: Is this painting going to be based on a strong value structure, using a black pigment? Or is this really a warm and cool painting, where color temperature is the focus? Does this painting need a palette of complements, with beautiful neutrals that can play against the contrast of color opposites? Or does it need a bolder approach, such as contrasting hues? Or does this painting need a harmony of analogous colors, with little contrast of hue? Each of these questions will challenge you to define what the organizing element behind your pigment choices will be.

Once you've established your overall approach and are at the point of selecting each hue, ask yourself: How will this pigment add to the range of my color mixtures? For instance, will this pigment be useful in describing the lightest lights on the hair or skin tones and also work into the background?

Developing a limited palette and a color strategy are the means for unifying a harmonious relationship throughout the painting. Pigment choices, such as a red, yellow, or blue palette, can still result in the overall effect of a secondary color contrast. Likewise, a value-oriented painting does not necessarily imply using only black and white pigments. Choosing a dominant color contrast of value doesn't mean that supportive contrast of saturation against neutrals or warm verses cool temperature is not present in a painting.

Although the perception of color is subjective, the interaction of color—from mixing pigments to organizing a color schema—is orchestrated by the painter toward his or her expressive purpose. The discussions about and examples of color contrasts on the pages that follow exemplify one means of building a unifying color strategy in your painting.

CONTRASTING VALUES

The contrast of value, or dark and light, can be thought of simply as the progression from black to white or from the dark of phthalo blue to the light of a bright Hansa yellow. Overall, value is the strongest and easiest element that can be used in a painting to create the volumes of forms and describe their relationship in space. The contrast of value (an extreme dark next to a white, for instance) can be used to guide the eye to an area of importance or focus. A close look at Old Master paintings will reveal that they used a range of values to create a sense of light from within the painting. Notice how, even though these images don't contain bright color, they remain satisfying to the eye. Furthermore, any intense pigment or high contrast between white and black was always staged for maximum effect.

Kate Lehman, *Sasha,*
1999, oil on canvas, 20 x 24 inches (50.8 x 60 cm)

A neutral toned ground provides an open field of negative space for this painting's evolution from sketched-in drawing to resolved form. This image also incorporates contrasting values, subtly blended on the left side of the face compared to the stark contrast on the right side of the portrait.

Domenic Cretara, *Self-portrait,*
2005, oil on paper, 30 x 24 inches (76.2 x 60 cm)

The strong contrast of light and dark within a limited palette sculpts the features in this self-portrait, intensifying the gaze from under the shaded eyes.

Patricia Watwood, *Flora Crowned,*
2001, oil on canvas, 30 x 20 inches (76.2 x 50.8 cm)

The delicate lighting on the fair skin of the model is conveyed with a subtle handling of warm and cool peachy skin tones rather than contrasting light and shadow. The background is carefully balanced to heighten the complementary contrast, enhancing the flesh tones and providing a calm environment that supports the model's quiet pose.

CONTRASTING COLOR TEMPERATURES

The contrast of temperature is an instant delight to the eye, especially when the colors are used at similar values. Blue and orange are one obvious example. (Think of the universal response evoked by a sunset sky.) However, the use of temperature in a painting can also be created by subtle mixtures of a warm pigment placed against a cooler one—such as one red tint warmed with yellow and the same tint cooled with blue. Both will generate the same effect. This color contrast can be used to describe form, as a cooled pigment will seem to recede in space just as a warmed hue will seem to advance. Color temperature can be utilized to great effect in rendering the delicate curving contours of the face.

CONTRASTING HUES

A contrast of hues is the use of many colors for an expressive purpose, such as creating a psychological portrait of the subject versus describing the colorfulness of a background scene or the pattern of a model's garment. This color contrast is most often associated with contemporary or expressionistic painting. However, Old Masters such as El Greco and Delacroix also used vivid colors for visual drama in their work. A single hue can be used in a symbolic way to designate meaning. For example, the purity and brilliance of the blue hue of the Madonna's mantle was used during the Renaissance as a means to designate her status, as it was made from the blue pigment lapis lazuli or natural ultramarine blue, which was expensive and rare.

CONTRASTING PRIMARY COLORS

A primary palette implies that all secondary colors (orange, violet, and green) are generated from three primary colors (red, yellow, and blue). The possibilities of this palette are endless in terms of the variations of color mixtures, especially when each primary has both a warm and cool pigment. One such palette might feature yellow ocher (cool) and cadmium yellow (warm) for the yellow primary, alizarin crimson (cool) and cadmium red (warm) for the red primary, and ultramarine blue (cool) and phthalo blue (warm) for the blue primary. A low-key R+Y+B limited palette might include flesh ocher, yellow ocher, blue-black, and white.

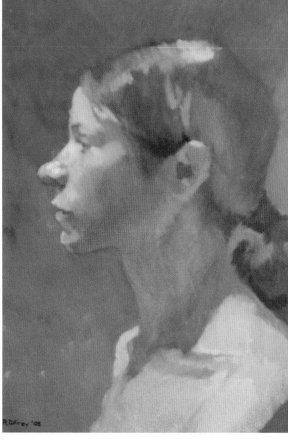

ABOVE:

Robin Frey, *Therese,*
2003, oil on canvas, 15 ½ x 11 ½ inches (39.4 x 29.2 cm)

Intense chroma and saturated colors replace value as an organizing principle in this portrait. The balance of warm-to-cool color temperature creates the contour of the form, with the violets serving as colorful darks.

LEFT:

Gary Faigin, *Man with Sailor Cap,*
2001, oil on canvas, 28 x 22 inches (71.1 x 55.9 cm)

The artist's direct painting of the model incorporates swift bold handling of thicker paint with blended values in the blue-to-orange color contrasts of the skin tones.

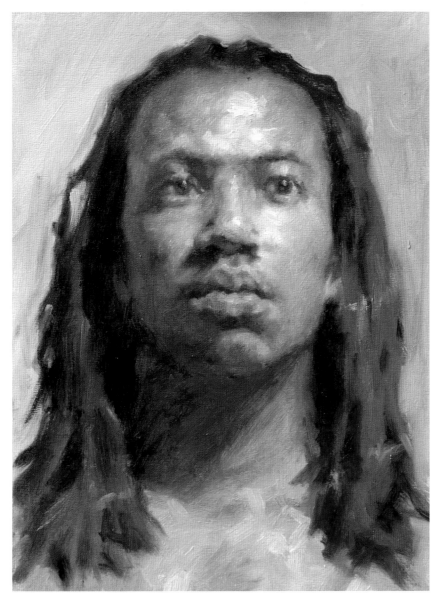

LEFT:

Robert Liberace, *Allan*,
2007, oil on panel, 8 x 10 inches (20.3 x 25.4 cm)

An intense secondary color palette places yellow-oranges against magenta-pinks and blue-greens in this lively portrait study. The diffused edges contrast the areas defined by gestural, thickly applied paint with those articulated with thinner, scumbled brush strokes.

BELOW:

Suzanne Brooker, *Alice*,
2006, oil on canvas, 24 x 18 inches (61 x 45.7 cm)

In this portrait, a palette of yellow and violets create flesh tones that provoke the sense of artificial lighting and contrast with the bolder hues used to render the fantasy objects above the model's head.

CONTRASTING SECONDARY COLORS

A secondary color palette utilizes mixtures made from orange, violet, and green pigments, with warm and cool versions of each hue. This can be a very subtle palette that uses the (hidden) yellow, blue, or red tendencies of the selected pigments to generate warmth in the color mixtures. This palette is most effective in describing the qualities of darker flesh tones or the coolness of the light. This limited palette might feature burnt sienna (which tends to have an orange undertone), Mars violet, and green umber as the core pigments mixed with additions of transparent red ocher, ultramarine violet, and terre verte.

CONTRASTING COMPLEMENTARY COLORS

Complementary colors offer another possibility in color contrast. Each pair of complements includes a certain dynamic: weight (red versus

green), temperature (orange versus blue), and light (yellow versus violet). These effects can be enhanced or diminished, depending on the intensity or dullness of the hues. Complements with equal intensity placed next to each other create a strong contrast; they vibrate against each other optically to generate a gray in the eye. But when they're mixed together they create a duller, neutral tone. Mixing compliments together is an alternate way of colorfully dimming a color (instead of using a black/white gray to tone a mixture). A true neutral (made from complements) will change its appearance depending on the context, so the same mixture may appear more orange in a blue context but bluish in an orange environment.

Split complements, such as red combined with yellow-green and blue-green, are another way of considering warm against cool within complements. There are also many possibilities for combining two pairs of complements, such as red/orange with green/blue, across the color wheel.

CONTRASTING ANALOGOUS COLORS

Analogous colors are ones that share a common denominator. For instance, a palette that includes violet, blue, and green has a common blue element. Using this approach can bestow a unified, harmonious feel to a painting, lessening the contrast between hues. However, adding a single note of yellow-red in a blue environment will charge the painting with a vivid color contrast. An analogous palette can also be built from a limited palette of earth tones, such as burnt umber, burnt sienna, yellow ocher, black, and white. The same harmonizing effect is also used when modifying an earth red that links all the color mixtures together.

CONTRASTING SATURATED COLORS

The contrast of saturation is when a pure color note is set within the context of tints and tones or neutrals. Even the smallest area of an intense color will gain greater power when used in this way. (Often in Corot's paintings you will find this moment of color saturation, such as a note of pure red, set against a field of neutrals.) The effect of saturated color is most effective when played against an overall neutral color scheme, as this maximizes the color contrast. In other words, a painting of all equally bright, intense color tends to deaden the viewer's eye, whereas a carefully placed note of pure color can spark an increased sense of color contrast.

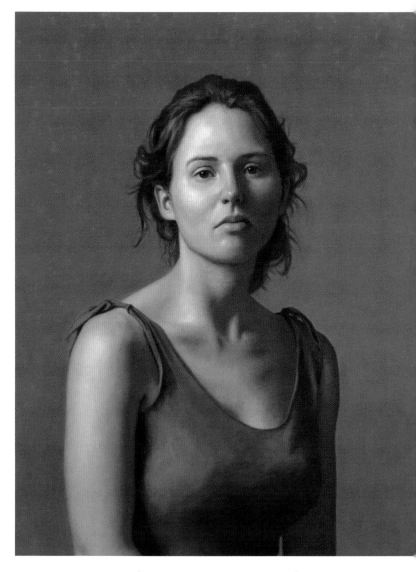

Robert Armetta, *Young Woman (Julie)*, 2006, oil on linen, 30 x 24 inches (76.2 x 60 cm)

The limited analogous earth palette used for this image generates a low-key contrast between colors, melding the model's flesh tones to the atmosphere of the background.

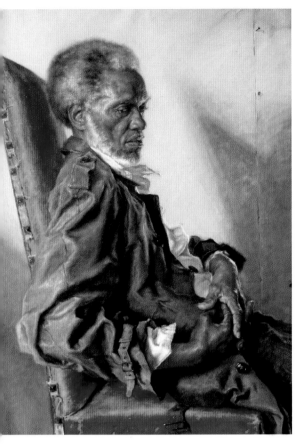

Robert Liberace, *Bill,*
2007, oil on canvas, 30 x 40 inches (76.2 x 101.6 cm)

The saturated red used to render the chair
contrasts the somber coloring of the model
and his garments. Notice how the L-bracket
of the chair reinforces the edges of the for-
mat of the canvas.

Robert Liberace, *John,*
2007, oil on panel, 8 x 10 inches (20.3 x 25.4 cm)

The small notes of intense red—in the
reflected light of the eye, fold of the cheek,
and tip of the nose—are heightened because
they appear within the overall context of rich
neutrals of the flesh tones.

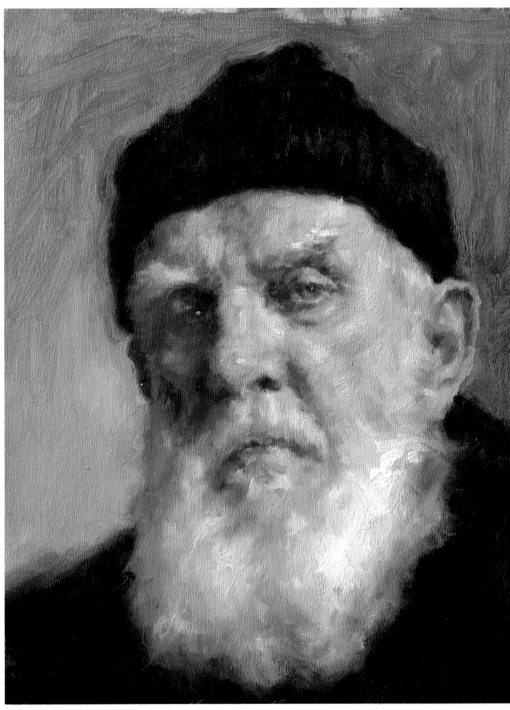

EXAMINING THE DYNAMICS BETWEEN **HUE, VALUE, AND CHROMA**

Color is a visual sensation that we identify by its hue (red versus blue), value (light versus dark), and chroma (intensity versus dullness). The interaction of these three qualities is balanced and controlled by color mixing; you cannot change one without affecting the other two. In other words, when you change the value of a pigment, you also change its hue and chroma. (For instance, adding white to a color will raise the value but it will also affect the hue and lower the intensity.) Likewise, when you dull a pigment, you also change its hue and value. (Adding green to red, for example, neutralizes the intensity of the color but also darkens its value and changes its hue.)

If you place a selection of pigments on a palette, you'll instantly recognize that each has a certain inherent value. For instance, phthalo blue is dark while yellow ocher is midvalue. The chroma (intensity or saturation) of a color is determined by its relative purity or grayness. Colors with a strong chroma (such as cadmium orange) appear as pure hues compared to those (such as Mars violet) that seem dull. The intensity of a pigment gives it an increased sense of having a higher value, appearing visually brighter.

Every pigment is defined by its mass tone (i.e., how it appears out of the tube), but each color also has a tendency toward either a warm or cool temperature, which is revealed by its undertone. Recognizing this bias in a

pigment can clarify the choices you make when selecting which colors to mix together for certain results. If you choose yellow ocher and cadmium red to make an orange hue, the undertone of blue in the yellow ocher will result in a duller orange than if you had used cadmium yellow. This is because you have, in fact, mixed three primaries (R+Y+B) together, therefore lowering its intensity by neutralizing the orange mixture.

Recognizing a pigment's tendency toward a warm or cool undertone will become clear after carefully examining the image below. Compare the three yellow pigments. How can you tell which is the warmest one? The key question to ask is: Which one has the most yellow? (Among yellows, ask yourself: Which is most "lemony"?) The cadmium yellow on the top is warmer and more intense in saturation than the yellow ocher on the bottom row, which has a blue undertone, giving it a dull, almost greenish bias. By comparison, the cadmium yellow medium in the center row has a tendency toward red, making it slightly more orange. Therefore, cadmium yellow is the warmest and most chromatic of these three yellows.

Blue pigments, which we generally think of as cooler than yellows, also have their bias toward warmth and coolness. Which of the three has the most yellow and therefore leans toward turquoise, teal, or greenish-blue? Of the three blue pigments, turquoise has the most warmth, while blue-black, although dark, is still the coldest blue.

The red pigments viewed in their "mass tone," right out of the tube, often hide the visual intensity of red pigments until a little white is added, as it opens the color intensity. Flesh ocher appears dull as a mass tone; in fact, it is the most intense of the three reds but not the warmest hue. The cadmium red is the warmest, most saturated color when seen opaquely in its mass tone, while alizarin crimson is the coolest red; however, this high-staining pigment also produces the most vivid cherry pinks when tinted with white.

Compare the intense warm primaries (turquoise blue, cadmium yellow, cadmium red) on the top row with both the cooler primaries (cobalt blue, cadmium yellow medium, alizarin crimson) on the second row and the more neutral primaries (blue-black, yellow ocher, flesh ocher) on the bottom row.

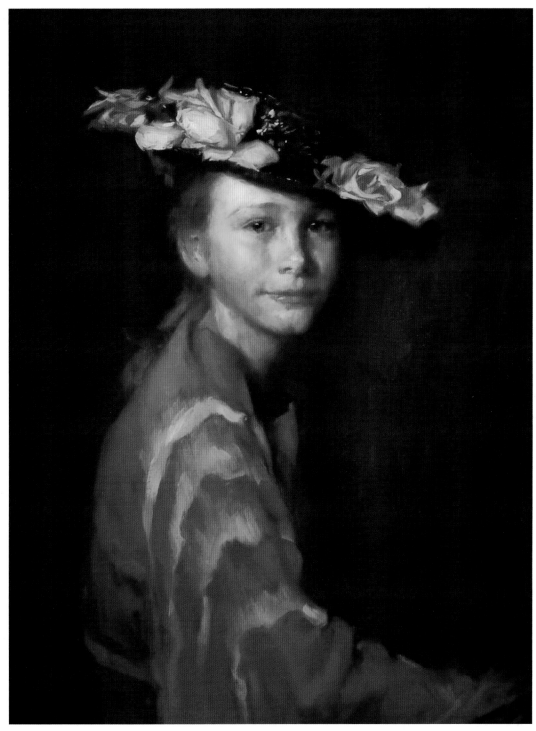

Glenn Harrington, *Rae's Hat,*
2004, oil on linen mounted on board, 30 x 24 inches
(76.2 x 71 cm)

The artist's skill in color mixing is the result
of understanding the interplay between hue,
value, and chroma to create a rich pictorial
dynamic.

DEVELOPING STRATEGIES FOR **MIXING FLESH TONES**

One strategy for building a palette of flesh tones begins with the choice of a red pigment. This unifying core pigment can be either an earth red or a more intense, contemporary red hue that underlies and unifies all the other flesh tone mixtures. The choice of red pigment should be based on what type of skin tone is being rendered within the context of the light source. Even an olive skin tone has an element of neutralized red as its base, while a ruddy or peachy skin tone will have a red with an orange tendency. For darker skin tones, burnt umber and sepia (plus Mars violet) are both good choices.

In the example shown here, terre rosa was mixed with flake white to a midvalue tint. This mixture, which is in the center of the palette, was then mixed (clockwise, starting from the left) with various yellows, reds, blues, and greens. The goal is to discover at least four

or five means of creating variations by warming, cooling, or neutralizing within the middle values, as they serve an important role as a bridge between the lights and the shadow hues. Some of the mixtures shown here may be considered high-middle value, moving toward lights, while other low-middle values move toward darker values. The range and number of variations is determined by how many color mixtures will be needed to describe the model when the lights or the shadows are more predominant. You will have an opportunity to practice mixing flesh tones in the exercise on pages 56 to 59.

Notice how a midvalue mixture based on terre rosa (shown in the center of the palette) can be changed to generate a number of different color variations. This strategy is useful in describing nuances in the flesh tones.

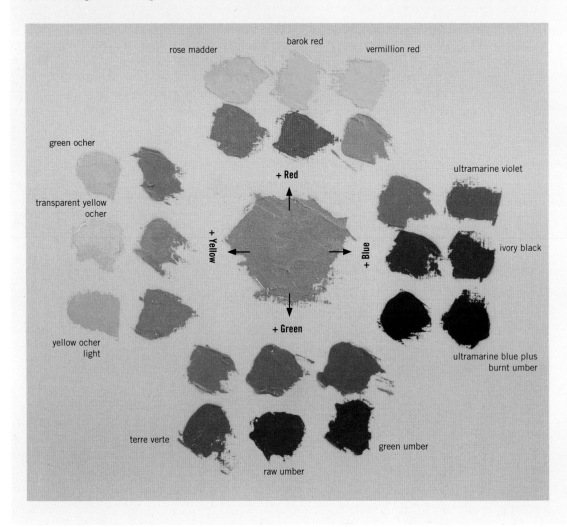

CREATING A **COLOR RECIPE BOOK**

The charts that you make when doing these color mixing exercises can be considered the first pages of your color recipe book, a lifelong inquiry into color mixing.

The earth reds may all seem similar when their mass tone is viewed, straight out of the tube. It is only when we add white that we see their tendency toward orangey warmth or plumlike coolness. In the same way, noticing the pigment source (iron oxide, cobalt, or cadmium) can add to your expectations about opacity versus transparency and tinting strength.

The yellows will pose the biggest challenge when mixing the tones and shades. Even a warm or neutral black will generate a green cast in yellow, so retaining the feel of the original source pigment is difficult. To warm a yellow pigment, try adding a peppercrumb of a warm red, such as cadmium red or vermillion. (Likewise, add a cool red for slightly cooling yellows rather than blue.) The same problem will occur when cooling the blue pigments. Try adding a peppercrumb of a cool red, such as alizarin crimson. To cool orange pigments, add a dot of cool red or cool green instead of blue, its complement. The key is to base your choices on what will be most useful toward future color mixing, or what will give the greatest amount of information about this family of hues.

EXERCISE *Focusing on Value, Temperature, and Neutrals*

The working properties (density and staining strength) and visual effects (hue, value, and chroma) of each pigment can only be understood through intensive, firsthand experimentation. The purpose of color mixing exercises is to build your visual memory of each pigment's characteristics. Making color charts is a labor of love that imbeds the experience of color mixing to your memory.

At minimum, make a chart for the colors that appear on each of the four sides of your palette (as discussed on page 52)—a page for yellows/oranges, reds, blues/violets, and greens. Depending on how many hues are in your arsenal of pigments, however, you may decide to make more than four charts—separating the earth reds from their brighter, contemporary red cousins, for instance, or the blues from the violets. If you only have two yellows, allow enough space to include the new pigments you will inevitably acquire.

Use a single, 16 x 12–inch canvas sheet (preprimed with gesso) for each chart. This will allow each swatch to be 1½ inches square, large enough for your eye to perceive the color note. With a straightedge and a hard graphite pencil, grid out the surface, allowing seven blocks across and roughly nine blocks down. Leave a white margin all around for labeling (hue, brand, and so forth).

Allow 30 minutes to paint each horizontal row. Using a long, flat brush (with soft nylon bristles) will help you make the edges straight and the corners tight. Paint each square as evenly as possible, and do not leave any white lines between the squares. For transparent pigments, take care to evenly distribute the paint by gently pulling the brush at a low angle to the canvas surface across the entire square.

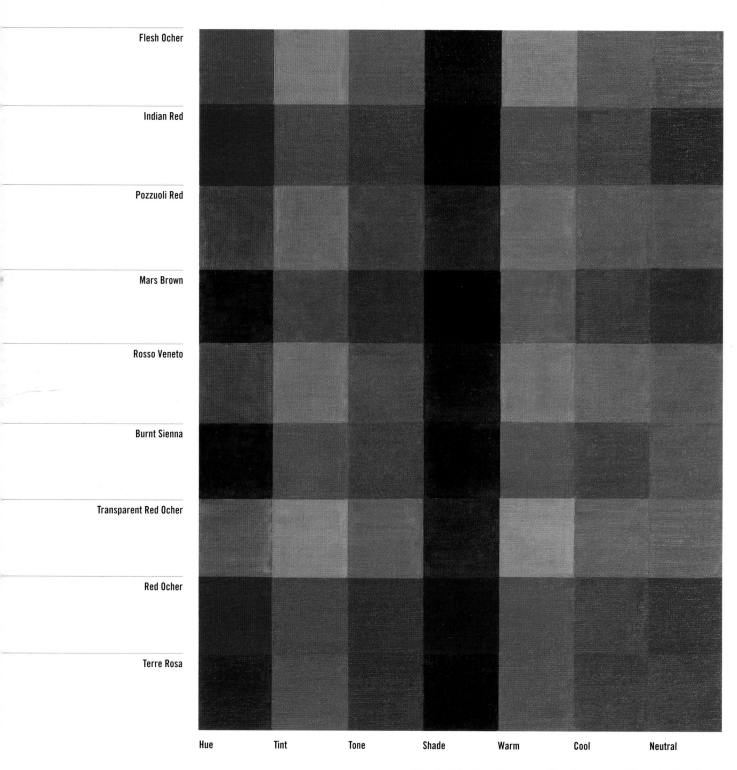

Flesh Ocher

Indian Red

Pozzuoli Red

Mars Brown

Rosso Veneto

Burnt Sienna

Transparent Red Ocher

Red Ocher

Terre Rosa

Hue	Tint	Tone	Shade	Warm	Cool	Neutral

This chart features the core earth red pigments. The main objective when making a color mixing chart is not to lose a sense of the source hue, while still creating variations in value (tints, tones, and shades) and temperature (warm and cool) as well as creating a neutral.

Square one is the pigment straight from the tube. Do not add any oil medium to the paint unless it is so stiff that it will not brush across the surface. Immediately you should notice if the source pigment is opaque, semitransparent, or transparent.

Changing Values

The tint, tone, and shade of a hue (squares two through four, respectively) represent the value changes of a pigment—from lightened to dulled to darkened. To create a tint, mix the hue with enough white to create a middle value. Use a mixing white (titanium plus zinc) or flake white, which will not dull the tint. Create an adequate quantity of the tint mixture, as you will also use it to make the warm, cool, and the neutral mixtures in squares five, six, and seven.

To create a tone, mix the hue with a midvalue gray. This gray can be mixed ahead of time using ivory, lamp, or Mars black and white.

To create a shade, mix the hue with ivory, lamp, or Mars black. If the hue is already dark in value or transparent, only a peppercrumb of black can be added before you begin to lose the color note of the pigment.

Changing Color Temperatures

To create the warm color note, mix some of the tint with yellow. (Although considered a cool yellow, yellow ocher is a traditional warming hue, particularly for mixing flesh tones.) The yellow needs to be subtly added so that this square does not become yellow but rather slightly warms the original tint.

To create the cool color note, mix some of the tint with blue. (Ultramarine blue or cobalt blue both perform this task well.) Again, a cooled tint should distinctly retain the original source hue.

Since the goal of any color chart is to extract the most information in mixing pigments, it is not always possible to provide universal instructions for every hue. Make sure to check the sidebar Creating a Color Recipe Book on page 53 for additional tips about warming and cooling particular colors.

Creating Neutrals

To create a neutral, mix the tint with the complement of the source hue. This mixture should attempt to neutralize the hue so that it wavers, becoming neither the hue nor its complement; however, the source color should still feel present. Choosing the right color complement, one that is equally weighted in terms of opacity or intensity, will take some experimenting. The neutral of a hue should be a beautiful color, and not appear as a dirty, muddy, or dead color.

Will Wilson, *Roy*,
2004, oil on linen, 19 x 16 inches (48.3 x 40.6 cm)

A flatly painted background enhances the dimensional presence of the model, revealed by the flow of light over the figure. What may seem like an all "brown" painting is in fact the artist's sensitive eye creating a colorful richness within the red earth palette.

An important concern for portrait painters is to achieve the quality of the flesh tones as revealed by the light source. However, trying to exactly match the color notes observed in the skin tones often distracts novice and intermediate painters. The subject represents a relationship of values and color temperatures. Thinking like a painter, these relationships are perceived and translated with pigment within a limited palette.

The goal in mixing flesh tones is to create as many subtle nuances as possible. The smaller the number of pigments, the greater the challenge to adjust the proportions between pigments to arrive at the full richness of any given color palette. Choosing the right palette becomes a matter of experience with color mixing. The color chart on page 57 offers a point of departure for experimenting with three different color schemes: analogous earth hues, warm and cool primaries, and warm and cool complementary palettes.

To create your chart, use a single, 16 x 12–inch canvas sheet (prep-primed with gesso). Draw a grid of seven rows, each 2 inches deep and 1 inch wide. This will allow you to make ten variations within each row of color mixtures, each of which will be large enough for your eye to perceive the color note. In the margin, write the pigments used in each row. Looking at the color chart on the facing page, you'll notice that each mixture could be further tinted with white for lighter values or combined with another mixture for more subtle transitions.

The objective of this chart is to create a wide variety of values as well as changes in color temperature. Since you won't be referencing any particular subject, these color studies are solely based on what various pigment combinations will yield toward developing a flesh-tone palette.

Allow 30 minutes to paint each row. Mix each of the ten variations before painting your chart and compare their value, temperature, and color intensity. Imagine where they might be useful in describing the lights, middle values, and shadows of a subject.

Analogous Earth Palette

The first row is based on a limited palette of earth tones: burnt umber, burnt sienna, yellow ocher, ivory black, and flake white. The resulting color mixtures represent possible combinations in hue and value. The strength of this combination of pigments is the range of values created by varying the proportion of black with any of the hues. (Note: Burnt sienna could be replaced with a number of other earth reds, such as terre rosa, red ocher, Indian red, Venetian red, or Pozzuoli red for varying effects, from cooler, more plumy or warmer, more orangey earth tones.)

Keep in mind that each mixture on your color chart is displayed in its opaque nature on a white ground. If the same pigment were painted thinly over a toned ground or placed transparently over another pigment mixture, it would have a different appearance.

Analogous Earth Palette:
yellow ocher
burnt umber
burnt sienna
ivory black
flake white

Modified Analogous Earth Palette:
yellow ocher
burnt umber
burnt sienna
ivory black
alizarin crimson
cadmium red
flake white

Low-key Primary Palette:
yellow ocher
flesh ocher
blue-black
flake white

Cool Primary Palette:
yellow ocher
alizarin crimson
ultramarine blue
flake white

Warm Primary Palette:
cadmium red
cadmium yellow
turquoise blue
flake white

Cool Complementary Palette:
alizarin crimson
raw umber
flake white

Warm Complementary Palette:
cadmium red
sap green lake extra
flake white

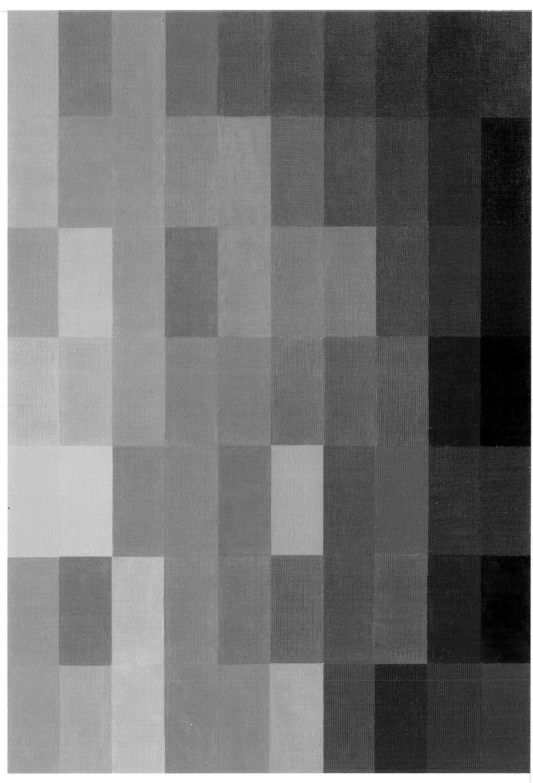

Although not all color mixtures on your flesh tones chart will appear fleshlike, they can still prove useful on the palette. The objective of this exercise is to become familiar with the possible range of color and value mixtures within a limited number of pigments.

Modified Analogous Earth Palette

The second row is the same palette as above with the addition of cadmium red and alizarin crimson as the warm and cool reds. A touch of cadmium red into the light mixtures gives a blush of redness to the warm lights just as alizarin generates a purple, cooler note to darker values. (Note: The addition of a green pigment, such as raw umber, terre verte, or sap green, would broaden the effects of dulling the red and introduce a subtle complementary effect to the overall color strategy.)

Low-key Primary Palette

The third row features a palette of flesh ocher, yellow ocher, blue-black, and white. When flesh ocher is mixed with white it reveals its color intensity; when it is mixed with blue-black it generates many beautiful shades of violet. The blue-black serves as an extremely dark blue pigment; when mixed with yellow it produces a green. A slight touch of this green mixture is used to dull the intensity of the tints made with flesh ocher. Yellow ocher can also dull the violet mixtures of red plus blue-black but also make many subtle mixtures of orange when combined with the pink tints of flesh ocher. (Note: Either ivory black or blue-black can also be used with similar effectiveness.)

Cool Primary Palette

Row four features flake white plus alizarin crimson, yellow ocher, and ultramarine blue, all cool primary hues. The darks of this palette are based on the inherent values of the source pigments, combined together without white. Remember that mixing three primaries together is the equivalent of mixing complements (G [B + Y] + R), which creates a dark neutral. This primary palette could be extended with black pigment to create additional tones or shades of each pigment.

Warm Primary Palette

Row five features flake white plus cadmium red, cadmium yellow, and turquoise blue, all warm hues. As with the previous one, the darks of this palette are based on the inherent values of the source pigments. Without the addition of black, the warm primary palette may not create genuine dark values. Both this and the cool primary palette above could be further extended with the addition of a green pigment, such as terre verte, or the introduction of another earth red pigment. Yet again, combining together the warm and cool primary palettes would yield another set of infinite possibilities.

The key to color mixing is striking the subtle proportion of any two hues, keeping in mind the tinting strength of both pigments.

Cool Complementary Palette

Row six features the cool red-green complements of alizarin crimson and raw umber plus flake white. (Note: Variations of cool complements could include Venetian red, Indian red, or red ocher plus green umber, sap green lake extra, or raw umber) Because cool complements lack a yellow component, paintings made with this palette are very often glazed over with a transparent yellow to transform the coolness in the pink lights.

Warm Complementary Palette

Row seven features the warm red-green complements of cadmium red and sap green lake extra plus flake white. (Note: Different warm reds, such as scarlet, vermillion, or transparent red oxide, could be substituted.) When the shadows are glazed with a veneer of blue, this palette achieves greater contrast in the darks.

The goal of these color-mixing exercises is to gain an intimate understanding of the character of each pigment in modulating its hue, value, and intensity. It is only through the felt experience of mixing pigments that you'll acquire the skills for generating subtle variations in color temperature and mixing beautiful neutrals. Applying pigments over toned grounds offers yet another possibility in creating luminous color effects that extend the expressive range in a portrait painting

Will Wilson, *Valencia,*
2006, oil on linen, 9 x 7 inches (22.9 x 17.8 cm)

A contemporary model takes on the qualities of an ageless beauty when placed with a Renaissance-like context. Notice how the artist has modified the color notes in the flesh tones—from the warm glow on her face to the cooler palette used on the neck and shoulders.

The color mixtures developed in the previous exercise were thickly painted on a white ground. However, as we will soon discover, when these similar color mixtures are thinly applied over a toned ground, different optical effects are created, as the color and the value of the ground influences our perception of the flesh tones. This exercise is a sampling of how a toned ground interacts with a limited palette of pigments. It is just one place to begin exploring combinations of grounds and color mixtures—and, hopefully, it will stimulate your curiosity to experiment further. For instance, variations could include working with the same palette over many different toned grounds or changing the pigment mixtures applied on the same ground.

To create your chart, use a single, 16 x 12–inch canvas sheet (pre-primed with gesso). Draw a grid of four bars, each 3 inches deep and 10 inches across. Leave a white margin on all four sides for your color and brand notations. Cover each of the four bars completely with its respective toned ground pigment and allow the entire sheet to dry. (Note: White should not be added to any ground mixture unless specifically indicated; instead draw the pigment thinly across the surface, allowing the white ground to lighten the mixture.) On the left side of each bar, leave a 1-inch section that shows only the color of the ground.

Equally divide the remaining 9 inches into 1-inch sections for the mixtures of dark, middle, and light values of the overpainted color mixtures. Allow 30 to 40 minutes to mix and paint each row. Always apply the palette pigments thinly over the ground, so that a hint of the ground tone shows through. (The pigments should not be thinned with solvent or oil unless it is too tight.) At the bottom of each bar, paint a smaller square opaquely to see the mixture's true color note.

Low-key Primary Palette on a Golden Ground

To create the golden ground, mix yellow ocher and a peppercrumb of raw umber. The palette features flesh ocher, blue-black, and yellow ocher plus flake white, which provides a semitransparent quality to the mixtures. For the first three bands, create various dark mixtures with flesh ocher and blue-black, altering the ratios. For the center bands, explore three middle values (such as one warm, one cool, and one neutral mixture). Notice how when flake white is added to the pigments the true intensity of flesh ocher comes alive. For the lighter values, increase the ratio of white and yellow ocher. Each of these should retain a distinct color note. Remember this exercise is also a means to discovering viable flesh tones, so control how much yellow appears in the light mixtures.

When selecting colors for toned grounds and palettes, consider the flesh tones under any given light source to determine which hues will generate the greatest variations while unifying the overall image.

EXAMINING THE **TONED GROUNDS OF THE OLD MASTERS**

Certain hues are traditionally associated with the toned grounds of paintings by the Old Masters. The color mixtures listed below are derived from Old Master paintings. While they provide a source for exploration, always remember that contemporary painters have the option of experimenting with variations of hue and intensity. The more intense the ground hue is, however, the harder it will be to anticipate and control the effects of the succeeding paint layers.

Burnt Sienna Ground

The classic combination of burnt sienna and burnt umber (or raw umber) gives the surface a quality of warm, cherry wood. Just a touch of the umber is needed to slightly darken and dull the orange of the burnt sienna. Your burnt sienna pigment should be semitransparent out of the tube. If it isn't, add a 50/50 mixture of oil and solvent to the paint.

Gray Ground

This cool, semiopaque midvalue gray ground is best made from Windsor & Newton's blue-black and either titanium

This sampler shows various toned grounds, reflective of Old Master traditions. Top row, from left to right: gray ground (ivory black and flake white), burnt sienna ground (with a touch of burnt umber), and red-green ground (terre rosa neutralized with a double tone of transparent phthalo green). Second row, from left to right: golden ground (yellow ocher plus raw umber), green ground (terre verte and raw umber), and burnt umber ground (with a touch of alizarin crimson).

white or flake white. Lamp, ivory, or Mars black can also be used, but a touch of ultramarine blue may be needed to cool the final mixture. Another option is double-toning this ground to create a warm-over-cool effect. The cool ground must dry completely before a second ground of thinned burnt sienna or Mars brown is added as a sheer layer. This exquisite ground is often the basis for a subtle effect in the middle-value shadow areas.

Red-Green Ground

This ground is a balanced mixture of complements, where the hue hovers between red and green. Alizarin crimson and raw umber make a good combination; however, take care to adjust the ratio, as alizarin crimson is highly staining. Alternatively, phthalo green, green umber, or raw umber can be applied transparently over an earth red stained ground.

Golden Ground

Dull yellows, such as yellow ocher, gold ocher, and raw sienna, are good choices for the basis of a golden ground. Small portions of burnt umber, raw umber, or violet can be added to neutralize the hue. Think of golden wheat or straw when mixing the final pigment. This ground is useful for emphasizing the presence of a strong, warm light.

Green Ground

A green ground provides a complementary contrast for very pink skin types or paintings using a secondary color palette. Generally a cool or neutral midvalue pigment, such as viridian green or phthalo green, works best when mixed with white. Alternatively, terre verte mixed with raw umber will make a beautiful transparent darker green color. Yellow ocher added to a midvalue gray mixture also results in a green effect.

Burnt Umber Ground

Burnt umber grounds or darker grounds are generally used for grisaille underpaintings when a dark-to-light approach is required. Since burnt umber is a rather flat color, alizarin crimson, phthalo green, or ultramarine blue can be added to provide a richer undertone of color. Van Dyke brown or warm sepia can replace burnt umber.

Low-key Primary Palette on a Golden Ground

Ground:
yellow ocher
raw umber

Palette:
flesh ocher
yellow ocher
blue-black
flake white

Alternate Low-key Primary Palette on a Red Ground

Ground:
burnt sienna

Palette:
burnt sienna
yellow ocher
ultramarine blue
burnt umber
flake white

Complementary Palette on a Cool Green Ground

Ground:
phthalo green
flake white

Palette:
alizarin crimson
sap green lake extra
raw umber
flake white

Warm-Cool Complementary Palette on a Double-Toned Ground

Ground:
ivory black
flake white
Mars brown

Palette:
Mars brown
ultramarine blue
ivory black
flake white

The value and color temperature of the toned ground has a great effect on the thinly applied paint, provoking optical color mixtures. This exercise will help you plan where to best utilize these effects—in the transparent darks or reflected lights, in the small shadow areas (forehead and cheeks) or the transitions between values.

Alternate Low-key Primary Palette on a Red Ground

To create the red ground, mix burnt sienna and a peppercrumb of burnt umber so that it evokes cherrywood. The palette features burnt sienna, ultramarine blue, burnt umber, yellow ocher, and flake white. Without black on the palette, burnt umber and ultramarine blue are mixed together to make a colorful dark.

Next, explore mixing the yellow ocher and ultramarine blue to create a green that can act as a complement to neutralize the tint of the burnt sienna. Just a crumb of blue in the red/orange tint generates a violet or neutralizing effect. A middle value of burnt umber and white can be warmed with burnt sienna.

You may notice how surprisingly cool the light values appear when thinly applied over the red ground, and yet they appear brighter and warmer in the opaque squares. This visual cooling effect can be heightened by altering the density of the pigment, from thick to thin, and applying it over darker or lighter colors.

Complementary Palette on a Cool Green Ground

To create the ground, mix phthalo green with flake white; add a dot of raw umber to dull the color intensity. Unlike the first two warmer grounds, a cool green ground offers a surprisingly vivid effect using a simple red-green palette. Use two equally weighted complementary pigments, chosen for their tinting strength and transparency: alizarin crimson and sap green lake extra (Old Holland) or raw umber for a dark but transparent green/brown color note. Create the darks by varying the ratios among the three pigments. The middle values allow the brighter-toned ground to reveal itself. Notice how even a dull mixture appears exciting over the green, while with the lighter values, which now match the value of the toned ground, the reverse seems true.

Warm-Cool Complementary Palette on a Double-Toned Ground

This ground involves a two-step process. First, apply a cool, midvalue gray ground, made from ivory black and flake white. After it dries completely, apply a thin veneer of Mars brown. The coolness of the gray can be accentuated by mixing a peppercrumb of ultramarine blue.

This palette is based on the warm-cool complements Mars brown and ultramarine blue along with ivory black (which helps connect the palette to the first layer of the toned ground) and flake white. (Note: If burnt sienna had been used to double tone the ground, then it would be the pigment of choice for building the color palette.)

The same method of experimentation used for the first three bands should be taken here. Notice how cooling or toning the Mars brown can lead to many distinct color notes in the middle and light values.

Suzanne Brooker, *Jarrett* (detail), 2009, oil on panel, 12 x 12 inches (30.5 x 30.5 cm)

A double-toned ground (created by applying a transparent Mars brown over a cool gray) is prepared on a smooth wood panel, allowing for a buildup of transparent paint layers without the influence of a textured, canvas surface. Careful planning permits the value and temperature of the ground to act as a transition between the light and shadows.

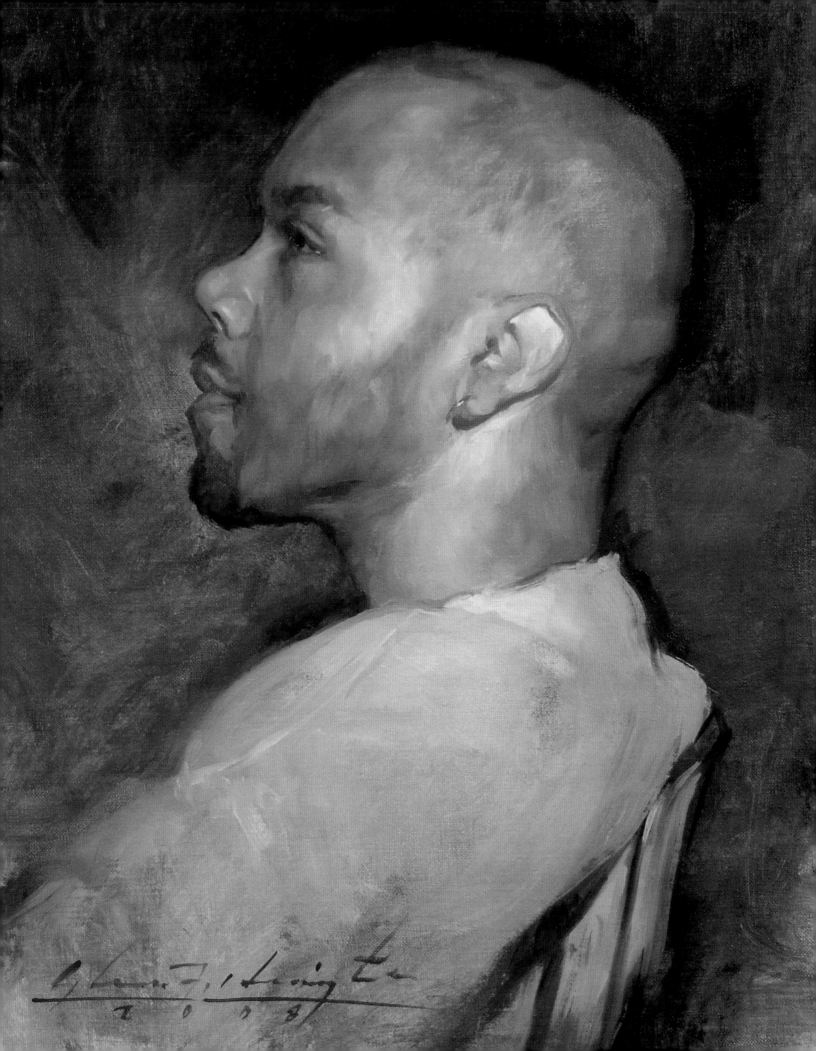

ESSENTIAL TECHNIQUES CHAPTER THREE

BUILDING UP THE PAINT LAYERS requires planning to achieve different effects. Will your toned ground shine through transparent, thinly applied paint to create the reflected light? If you scumble similar values behind the figure, will your background recede in space? Do you want the animation of the hair to feel spontaneous with the wet-on-wet flow of your brush? A close examination of Old Master paintings reveals the variety of brushwork from transparent, optically blended areas to a rich accumulation of dense paint, from vigorous wet-on-wet paint to dry-brush scumbling. Thinking as a painter requires that you be able to adjust the movement and mark of your brush to obtain the desired effect.

The process of painting involves the interaction between the brush, the paint, and the surface. For novice painters, this often means finding the right combination through trial and error. Answering questions such as how many coats of gesso on what surface with these brushes and that kind of paint will give you the best results. Gaining control over these key elements provides the basis upon which you build a greater command of rendering surfaces and expressive brushwork. Although each of these elements has been previously discussed in earlier chapters, it's important to remember that the tools of painting should not be the things that are holding you back.

We begin with a discussion on mediums and their uses to alter the viscosity of paint over the canvas, continue with the effect of glazing, and then conclude with different brush handling techniques that are used to render a full range of effects, including the specific techniques for rendering hair, clothing, and backgrounds.

OPPOSITE:

Glenn Harrington, *Darius,*
2008, oil on linen mounted on board, 16 x 20 inches
(40.6 x 50.8 cm)

This sensitive portrait reveals a variety of paint handling. Notice the emphasis on the crisp line of the contour edges, the carefully modeled forms of the features, the thickly painted brushwork on the shirt, and the thinly scumbled paint of the background.

GETTING THE MOST OUT OF PAINT MEDIUMS

Mediums are prepared additives that alter the characteristic of paint. The purpose of adding a medium into paint mixtures is to adjust its working properties, such as changing the viscosity of the paint to increase its flow over the surface of the canvas, increasing the transparency, adding gloss or texture, and speeding (or slowing) the drying time. Traditional oil paint mediums are made from a combination of oils, solvents, and (for some mediums) natural resins, while the more contemporary alkyd mediums are composed of soy-oil modified resins and solvents.

The secret of Old Master painting techniques is often mistaken for being *what* was added to the paint rather than *how* the mediums were used in the work. Striving for certain visual effects, the Old Masters often experimented in creating their own customized mediums. (The results have sometimes left modern conservators trying to literally keep the paintings from falling apart.) The novice painter should attempt formulating painting mediums from scratch only after exploring the wide range of commercially available mediums. Experimentation is necessary to test the effects of various mediums and how they combine together in the painting process; this will be your means to discovering the differences in the feel of the paint and the resulting effects. Keep in mind, however, that the most permanent paintings (in terms of the surface integrity of the paint film) are made with professional-quality paint from the tube using the least amount of additives.

The key to using mediums successfully is knowing when and how to use any given medium. Add mediums to the paint when you have a specific need—more flow, a buttery consistency, more transparency, or a chunkier texture for instance.

Kate Lehman, *Self Portrait,*
2003, oil on canvas, 14 x 16 inches (35.6 x 40.6 cm)

The vigorous paint handling in this self-portrait chisels the face with boldly placed brush strokes to finely blended areas. Notice the length and direction of each stroke in crafting the modeling of the form.

COMPARING **TRADITIONAL AND CONTEMPORARY MEDIUMS**

Intermediate painters make their choice of what mediums to add based on subjective experience and by comparing the documented longevity of traditional oils versus the reported benefits of contemporary mediums. Traditional oils used as mediums include a number of products derived from linseed: cold pressed (which is conducive to creating smooth, blendable paint), refined (which is less expensive, yet effective for modifying the viscosity of tight paint), and sun thickened (which has a quick drying time). The less refined oils have a longer molecular structure, which allows a longer pull of the brushstroke (making them perfect for blending), compared to alkali-refined linseed oil, which is shorter. Slower drying oils (oils to which no driers or petroleum distillates have been added) allow a longer working time before paint mixtures become tacky.

Venice turpentine (a natural balsam) gives pigment a blendable quality that also diffuses edges when dry. This is a bodied medium that becomes more liquid when it is mixed with pigments and worked onto the surface when blending. Maroger medium (which is toxic and often darkens with age) can be substituted with Neo Megilp (Gamblin) for a silky, buttery quality in paint blending. Stand oil (which is slow drying, thick, but flexible) adds texture to paint when used at the end of a painting. It is also the key ingredient of glazing mediums.

The misnamed product called "Classic Paint Medium" (Daniel Smith) is composed of a varying ratio of dammar varnish, stand oil, and pure gum turpentine—the components of a glaze medium. Used as a paint medium it provides an overall glossier surface with less sink-in of the darks. As a painting medium, a better choice would be Artists' Painting Medium (Winsor & Newton), which mixes stand oil, solvent, and driers that speed drying while keeping the paint film flexible and non-yellowing. This medium also works well for oiling up and the final glazing layers of a finished painting without the yellowing effects of a varnish. (However, make sure to use proper ventilation when using any medium with pure turpentine or distilled petroleum driers.)

Contemporary alkyd resin-based paint mediums (Gamblin and Winsor & Newton) offer the benefits of modern technology, providing higher cohesion and durability but with lower toxicity (compared to Maroger medium and paint driers). However, these products also require good ventilation when used during painting sessions, and they should not be mixed with pigments in large quantities, as they tend become tacky and unworkable when a palette is stored for future use. The guidelines for the use of alkyd mediums are similar to the ones for oil mediums. Because these mediums are essentially oil based, they can be used to transition from the quick-drying (lean) underpainting to traditional oil mediums (fat) as the painting process advances through the middle layers to the final glaze coats. For instance, Galkyd or Liquin can be added for a quick-drying underpainting, with refined linseed oil added into paint mixtures during the middle values and then slow-drying oil mediums used in the finishing layers.

For specific effects, such as drawing fine lines or creating thick, chunky textural effects, Liquin Fine Detail and Galkyd or Liquin Impasto, respectively, are most effective.

Because of their shorter molecular structure and enhanced drying time, alkyd mediums are not useful for blending but rather for quicker applications of color in a more direct painting approach. Alkyd mediums also leave a glossier surface compared to linseed oil, reducing the effect of color sinking in, but at the same time making further paint handling difficult over the slicker paint surface. More information on individual products can easily be found on each manufacturer's Web site.

> *When we say that a painting is drying, we really mean that the oil in the paint is oxidizing (absorbing molecules of oxygen). Without sufficient oil, the pigment particles will not bond to the surface. The drying process cannot be rushed by applying heat.*

USING MEDIUMS EFFECTIVELY

There are a few important rules to consider when adding mediums to your paint. The basic guiding rule is "fat over lean" (which means that the bottom layers should contain less oil than the top layers). In addition, thick layers should be applied over thinly applied layers and slow-drying paint over fast-drying. Cracking or wrinkling of the paint film occurs when leaner, thinly applied, and faster-drying paint is applied over fatter, thicker, and slower layers. Never apply paint that has been thinned only with solvent over thick or oily layers of paint.

Pigments that have been thinned with a solvent such as odorless mineral spirits (OMS) are considered the most lean. This thinned paint should be used only in the bottom layers of painting—for instance, the block-in drawing. (Beware, however, that mixing more than a 1:5 ratio of solvent with the paint will result in lowering the adhesion of paint to the surface.) In general, adding a small portion of solvent to linseed oil (mixed thoroughly with pigment) will create a lean oil blend that can be used to thin paint during this stage of the block-in or underpainting; oilier paints, however, may require just a touch of OMS solvent for this purpose. Paint that is already buttery in consistency right out of the tube can be thinly applied to create a lean layer. In this way, several layers of pigment can be built up before any paint medium is added.

The following guidelines should be noted when using all mediums:

- A mixture should contain no more than 20% (or a 1:5 ratio) of any paint solvent; more than that will compromise the endurance of the paint film.

- Adding any medium to a pigment will increase its transparency by dispersing the pigment particles.

- Choose the medium that has exactly the working properties you want (paint flow, drying time, transparency, or luster, for example) so as to avoid blending together conflicting ingredients.

- Before using fast-drying mediums during a long painting session, consider the open time that you will need for blending; the quicker the mediums dries, the more the paint will resist prolonged handling.

- Decide which mediums you will use at the outset and then be as consistent as possible throughout the entire painting process.

- Mix all mediums thoroughly into the paint, either with a palette knife for larger mixtures or with a brush for discrete mixtures.

- Glazing mediums should include a portion of flexible stand oil over fat or thick paint layers.

This chart compares the differences in visual weight when the same pigment is placed (from top to bottom): opaquely (creamy paint, straight from the tube), transparently (oil medium added), and thinned (with OMS solvent). Notice the difference in value and transparency as the pigment changes viscosity from thick to oily to thinned paint.

OPPOSITE:

Suzanne Brooker, *Portraits of Men, Metaphors of Wood: Innocence,* 2002, oil on canvas, 32 x 24 inches (81.3 x 61 cm)

A simple portrait can be enhanced by introducing another element that creates a visual metaphor or narrative. Here, a dreamy-looking Scott is also Adam, unaware of his fate, growing above his head.

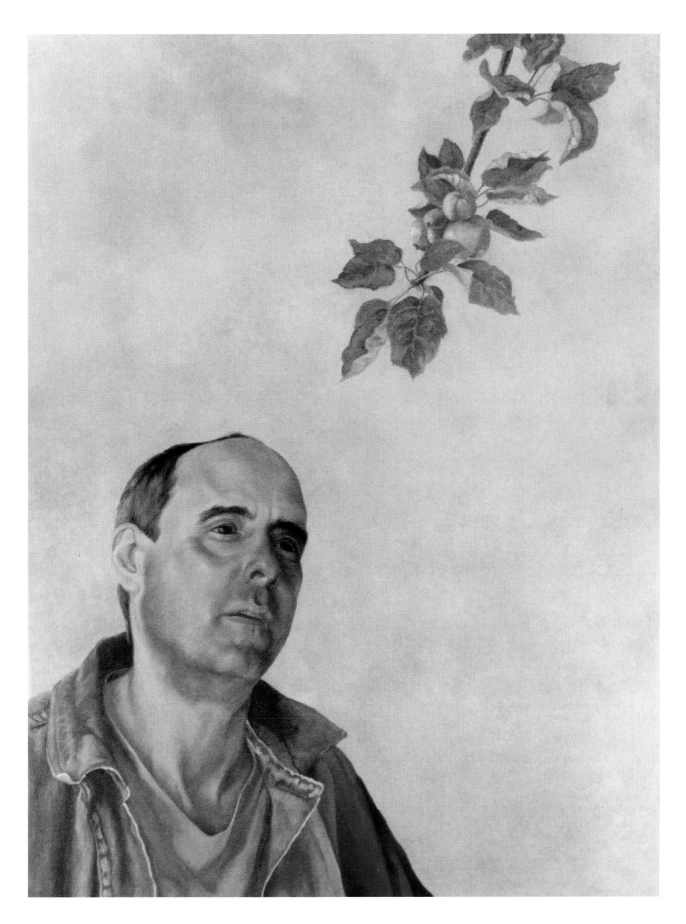

CLEANING THE **PAINT SURFACE**

Preparing the surface for glazing, oiling out the darks, or rewetting the surface with oil begins with cleaning the dried paint surface. This helps the dried paint film receive more oil and reduces the beading up of oil over the surface. (Beads of oil should never be allowed to dry on the surface.)

Make sure your painting is more than dry-to-the-touch before beginning the cleaning process. Then test the paint surface for its resistance to oil by dragging a brush saturated with linseed oil over the surface. Any place where the oil pools or beads together will need careful attention. Simply wipe off this oil and clean the paint surface with a mixture of ammonia and water.

In a cup or jar, mix 1 part ammonia to 5 parts water (roughly ⅓ cup of ammonia to 1 pint of water). If the mixture is too strong, it may remove delicate paint layers from the surface; too weak, it will not rough the surface of the dried paint film (mostly in the lights) to receive more oil. Between glazing layers, you may also need to clean the surface again if certain areas are resistant to adhering the next coating of the glaze medium and pigment.

Use lint-less swatches of fabric to clean the canvas. Do not use paper towels, as they will leave fibers when rubbed over the texture of the canvas. Old cotton fabric (whether pillowcases, sheets, or T-shirts) cut into 6-inch squares is recommended for cleaning. Create a pounce by holding the cut edges together with your fingertips so that no fabric morsels or fibers are rubbed on the surface.

Moisten the pounce with the diluted ammonia-water mixture and wipe it gently over the surface of the canvas in a thorough manner. Do not abrade the surface with excessive pressure or scrubbing. If you see color on the pounce, then you are taking pigment off the surface—which signals that either your paint is not dry enough or the middle to last layers of paint are missing sufficient oil to adhere to the surface. As with any oil paint, the surface skin dries quickly, leaving the underneath paint to dry more slowly. Test for dryness by feeling with your fingertips for any coolness on the surface, which signals that the paint is still drying. Likewise, if your last thin layers of paint lacked sufficient oil, they can easily tear off during the cleaning process.

Allow the ammonia to dry for 2 to 3 minutes. Then apply the oil medium using a brush or another clean pounce. Imagine you are polishing expensive Italian shoes by gently applying a thin layer of oil that effectively re-moisturizes the surface.

A third pounce of fabric can be used to dry or remove extra oil from the surface. It is critical that no excess oil remains on the surface. You want just the thinnest veneer of oil possible. Check the canvas surface again for resistant spots (where the oil is beading up) or resistant dry areas by holding it tilted toward the light. Reclean or re-oil as necessary.

Once a canvas has been oiled, it must be dried horizontally (even after a painting session). Although only a thin layer of oil is covering the surface, it is still viscous and will pull together to form drip marks. This will ruin your painting, as it is practically impossible to remove hardened oil drips.

Paintings that have been set aside, even for periods as short as week, may need cleaning. (Check for things such as dust, spiderwebs, and cat hair.) Repainting over abandoned canvases first requires lightly sanding the surface (with 200-grit sandpaper) to remove any lumps or textured paint and then a thorough cleaning. (Be sure not to inhale the paint dust, and wash the table and your hands afterward.) Then retone the canvas using titanium white and a pigment. (Never apply gesso over an oil-painted surface.) Midvalue mixtures of cool/warm gray or mixing a neutral green or yellow ocher into a gray will opaquely cover the painting underneath and provide a useable working surface. Remember, using paint mixed with solvent for an underpainting as an oil-toned ground is not advised.

When a small area needs to be sanded—for instance, an unfortunate dried lump of paint on the cheek—use a small piece of 600-grit sandpaper, which can be rolled on your fingertip. Press gently from behind the canvas to raise the trouble spot and sand lightly. Clean this area well and let dry before mending with new paint.

OILING OUT THE CANVAS

During the process of building up the paint layers, the oil in the pigment can sink as it adheres to the gesso ground. Oiling out the entire surface with linseed oil after the paint has dried (past the dry-to-touch stage) allows the pigment to regain its vibrancy and contrast. To keep the fat-over-lean layers from building up evenly, avoid oiling up isolated spots. This is also a good time to look carefully at the blended edges, which can appear rougher or with more contrast than they did when the paint was first applied. After oiling out the entire surface, new paint can be blended easily onto the older, dried pigment. (Note: The surface needs to be cleaned before oil is added; see sidebar on the facing page.) Remember that the canvas will need to dry horizontally, even after a painting session.

This same process is also used to "oil out the darks" in a painting. As you look askance across the painted surface, some parts may appear shiny, while others are matte. Often it is the darks that appear to have become more matte, less dark than when the paint was wet. Adding a layer of linseed oil or classic paint medium over the sunken matte areas at the finish of a painting allows the darker pigments to gain the same sheen or reflective surface as the lighter pigments. Renewing the darkness of dark pigments helps determine the value contrasts before applying the lightest lights at the end of a painting.

Oiling out a painting can also be used as a means to add a protective finishing coat that replaces varnish. The advantage of a finishing coat of oil is that it will allow you to return to the painting for any last revisions. Simply clean the surface and apply additional (fat) paint. It is worth noting, however, that the skin of oil dries quickest, which slows the drying process for the paint underneath, especially in thicker applications of pigment. It may take up to one or two years to complete the oxidation process. At this point a finishing varnish can be applied.

A solid paint film requires oil in order for the pigment to properly adhere to the surface. During the painting process a canvas may need to be oiled out more than once, as the oil is absorbed or "sinks" into the ground as it dries (or oxidizes).

Create a pounce by gathering the rough edges of a lint-less cloth together. A pounce can be used either for cleaning the paint surface or for applying or removing excess oil.

When a cloth pounce dipped in oil medium is gently wiped over the matte finish of a paint surface, the resulting thin veneer of oil helps restore the saturation of the pigment, refreshing the color note.

Compare the difference between the areas where additional oil has renewed the vitality of the color to the sunken-in pigment.

MIXING **PIGMENTS AND GLAZE MEDIUMS**

First, assemble your pigments. Although any transparent pigments can be used in glazing, having three transparent primary colors, matched for equal color intensity and tinting strength, means that you can also create any secondary colors. Never mix white pigment, even transparent white, with any glazing pigments, since the white or lightest color values should be already established in the final painting or grisaille.

Second, select which glazing medium is appropriate: a quick-drying stand oil for additional paint layers or a classic glazing medium with dammar varnish as a finishing coat. Since the glaze medium is added at the end of a painting, it is important not only that it be flexible (in other words, contain thick, slow-drying oils such as stand oil) but also that it won't be affected by additional varnishes or by later cleaning.

A good, all-purpose glazing medium can be created by mixing 1 ounce dammar varnish, 1 ounce stand oil, and 5 ounces of pure gum turpentine. A slower-drying, glossier glazing medium is made from mixing a portion of Venice turpentine with an equal portion of sun-thickened linseed oil and gum turpentine for thinning. A faster-drying alkyd medium can replace a classic glazing medium; however, fast-drying glazes should not be applied over thick, fat paint that has not completely dried.

Additional formulas can be found in Ralph Mayer's *The Artist's Handbook of Materials and Techniques.* Regardless of which recipe you select, make sure to choose a glazing medium that is consistent (in terms of traditional oil mediums versus contemporary alkyds) with the overall approach to the painting's structure.

Finally, using a palette knife, mix the transparent pigment thoroughly with the glazing medium on the palette. Dragging the glazed pigment thinly over the glass palette with the palette knife can help determine the density of the oil-to-pigment strength. Avoid applying a thick layer of glaze to gain the correct pigment strength. Choose an inconspicuous area on the canvas to test the glaze. Then ask yourself: Is the glaze too strong or weak in pigment for the desired effect? If so, in either case you can simply wipe off the glaze with a lint-less cloth or a brush moistened with solvent, and then adjust the ratio of pigment to oil medium as required.

Horizontal bands of glazing pigments (transparent yellow oxide, rose doré, lapis lazuli, and terre verte) are painted over four successively darker vertical bands of gray mixed from flake white and ivory black. Notice how the brightness of the color diminishes as the value of the gray increases.

When a warm-cool gray grisaille over a neutral green ground (gray plus yellow) is glazed in rose doré the final layer gives the delicate features of the model a blush of pinkness.

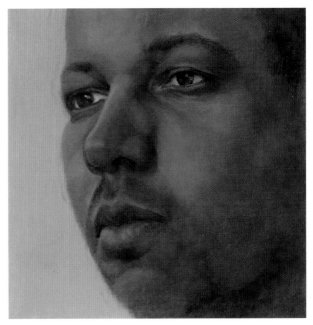

A transparent glaze of Mars brown heightens the color note over the cheeks and creates a transition from the light values into the shadows on a warm-cool gray grisaille over a golden ground (a mixture of yellow ocher and gray).

USING GLAZES FOR MAXIMUM EFFECT

Glazing can be thought of as tinting the underlying layers of paint, which creates an effect like stained glass or colored cellophane. With a glaze, pigments are suspended or stretched out in a glazing medium and applied over a completely dried, cleaned painting. A glaze is not a thick, syrupy coating but a thin layer applied carefully with a brush or pounce.

Glazing can be applied as an overall treatment (if, for instance, the whole painting needs more warmth) or as a moment-by-moment consideration (when this part needs cooling, and this a blush of redness). Varying the ratio of pigment to glazing medium changes the strength of the glazing tint (as in one part needs more color intensity and another only a breath of color). Glazing over a large area, such as the background or clothing, with the same hue can yield a richer, deeper colorfulness while at the same time oiling out any sunken areas on the paint surface.

When used in an area of a painting that is very light in value, multiple layers of glaze can produce optical color effects. (For instance, a red glaze over a yellow glaze appears orange.) Likewise, an area that appears too pink can be altered optically by applying a glaze of yellow, creating an orange effect. Without considerable planning, however, multiple layers of glaze can result in murky or dirtied colors, especially when they are applied over middle or dark values.

And finally, remember that the same holds true for glazing as oiling up a canvas—a glazed painting must be dried horizontally, otherwise oil drips will form.

To preserve the light value of an area that has darkened during glazing, apply a semiopaque or opaque white (or light) pigment mixture over the first layer of glaze, let dry, and then reglaze the area. Even a transparent yellow glaze will darken the value of any color.

INTERNALIZING THE PAINT APPLICATION TECHNIQUES

Stylistic brushwork and paint handling are a means of gaining the most visual effects from the painted surface. A close examination of Old Master paintings reveals the variety of paint density—from the thinly painted, transparent darks to the richly textured, built-up lights. Within a single painting, brushwork often varies from a controlled, highly blended, and smoothly applied style to more openly expressive, wet-on-wet techniques. The discussions that follow describe the interaction between brush handling, paint consistency, and support surface.

HANDLING THE BRUSH

Brushwork is the signature of a painter. Every brushstroke interprets light, volume, space, movement, direction, or texture. This means that your intention must be clear before the brush touches the canvas. Are you describing the light on the edge of the cheek, the form of the nose, the air of the background, the flow of the hair, or the texture of the cloth? The brush is the link that connects our intention with the surface of the canvas.

Controlling the amount of paint that comes off the brush tip is the result of practice and experience. Learning the feel of the paint on the brush, how much paint is needed for a thick or thin stroke, is one aspect. However, it is just as important to develop a sensitivity to the touch in order to know how much pressure is necessary to place the paint on the canvas. And finally, it is critical to know how the directional pull of the stroke can lead our eye along the contour edges of a form or traverse across the surface contour of the form.

Become aware of how you hold the brush and its angle to the surface. Are you grasping the handle near the ferrule (the metal crimp that holds the bristles to the handle)? This leads to a constricted range of motion and the impulse to rest your hand on the canvas. By holding the brush at the extreme end, you'll find it much easier to vary the angle and pressure of each stroke. Painters who need additional support should use a maulstick. (See sidebar on page 27.) A stiff brush held at a 90-degree angle to the surface tends to scrape the paint off (especially in wet-on-wet applications) and is better utilized when rubbing the brush tip into the canvas texture, as in the initial scumbled layer of paint. Holding the brush at a 45-degree angle allows the paint on the tip of the brush to be deposited or placed onto the surface.

Always keep the finished work in mind when you paint. Do not carelessly apply paint and then plan to come back and fix it. If you are not satisfied once you make a brushstroke, scrape or wipe it off. Consider the pull of the brush mark as having a definite start and stop. Be careful not to use the brush to flick or scrub the paint, unless that is your intention. The push and pull of the brush can lend a painterly feel to the surface when

Rubbing the pigment over the canvas is achieved by moving the brush tip at a steep angle that disperses the paint in a thin layer.

Agitating the brush tip from side to side disperses the paint in a smooth manner, leaving few visible brush strokes.

Three factors come together in brush handling—the angle of the brush to the surface, the degree of pressure, and the action of the brush. The brush is the link that connects our intention through the paint and onto the surface.

painting wet-on-wet or when used as a method for subtle blending, but overworking the paint surface can also muddy the color.

The tools you use contribute to your progress in paint handling. A small investment in a new brush can make a big impact in the painting process. If you are not happy with a passage of your painting, you might not have selected the right brush for the job. Ask yourself: Is the brush hindering how the paint reacts to my touch? Is the brush too stiff, worn out, or large? Adjusting your brush may very well solve the problem.

APPLYING THE PAINT

An Old Master approach to painting is based on a layering of pigments over a toned ground, from the underpainting to the glazes to the final details. This is referred to as an indirect approach, where a painting is created by building up many layers of paint. In contrast, direct painting techniques, which are often used in plein air painting and when working with a live model, use faster painting approaches on a white ground with more opaque impasto paint. The difference is reflected in the techniques that are used to apply the paint to the surface.

Methods for manipulating the paint with the brush vary from thinly pulling the paint over the surface to more thickly placing the paint. This can change the appearance of a pigment mixture. Where the paint is applied more thickly, it will be more opaque, intense, and bright, revealing its color note. The thinner the paint layer is, the more transparent it will appear. A thin application of paint allows the previous pigment layer to influence its color and value, resulting in optical blending.

Paint applied over a poorly prepared surface is a hindrance to achieving a successful response between the brush and the paint. Slick canvas surfaces, overly textured applications of gesso on surfaces, or incompletely dried toned grounds often leave the artist struggling to control the initial applications of the paint, as he or she is compensating for the inadequacy of the ground. See chapter one for instructions on preparing painting surfaces.

Another variable is the use of mediums. Adding a few drops of oil to a tight pigment will make it creamy and easier to pull with a brush. Increasing the oil-to-paint ratio further will create a more transparent effect, as it diminishes the amount of pigment particles to oil. Changing the viscosity of the paint—from thinned with solvent to creamy in texture to oily but still not transparent to drier, chunkier paint—influences the feel of the paint as it moves over the surface and the resulting brush marks. Thinking as a painter will help you determine when you need to adjust the paint's viscosity to meet your needs, such as to pull thin lines for an area of detail or create the texture of woven cloth.

Placing the paint in a thicker manner involves drawing the brush at a low angle to discharge the nugget of paint on the tip.

When fine lines are needed, hold the brush upright at a 90-degree angle to the surface so that any change in pressure results in a change of the width of the line.

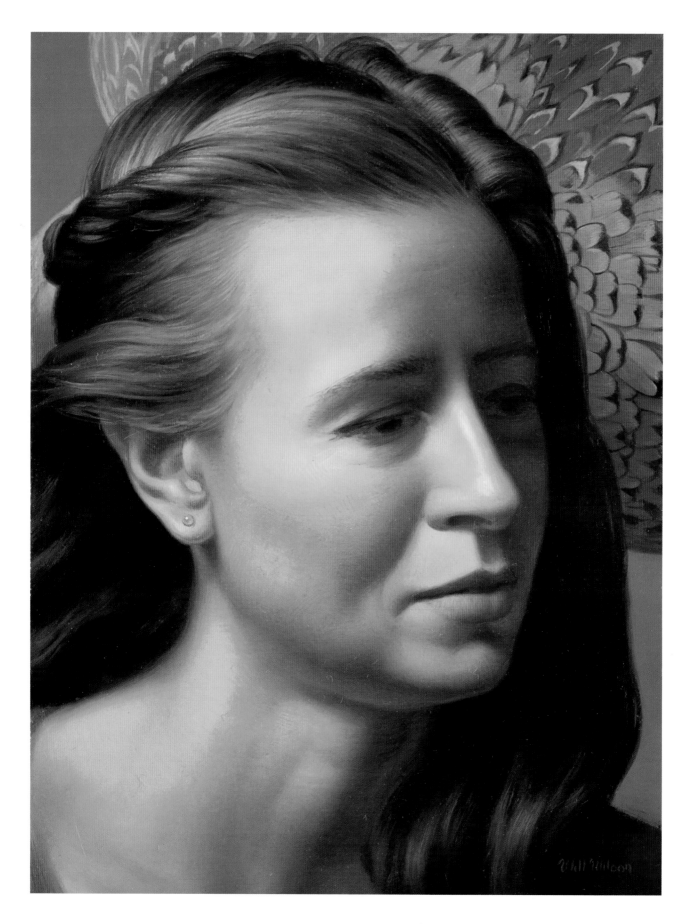

Hair grows in a pattern that varies with each individual. To successfully capture the impression of hair, the pull of the brushstroke should mimic the pattern of the hair as it curves or drapes over the skull: short, repeating strokes (short, thick hair or sideburns), pulled long lines (flowing hair), or quickly flicked strokes (curly hair).

Your model's hair is best painted once the background and the forehead have been established. This allows for hair to flow naturally and include flyaway wisps. Painting the forehead area beyond the hairline also allows the flesh color to appear in delicate areas, such as under bangs or at a distinct part.

Consider painting the hair with a dark-to-light approach and preparing lumps of pigment that match the local color of the hair in three values. Your paint application should depend on the texture of the hair you want to describe:

- Full, thick hair can easily be painted with a direct wet-on-wet approach or an impasto method, using creamy paint and a large brush.

- Thin, delicate, or wispy hair is better indicated with more oiled (semitransparent) pigment and the tip of a small round brush. (See sidebar on page 78.) This same technique can be used to create the soft hair of the eyebrows, eyelashes, or hairline at the temples.

- To render a five o'clock shadow, paint in the dark blue-black first when establishing the overall shadow values. Then over the dry surface thinly scumble the midvalue skin tones on top, allowing the haze of blue-black to speckle through from underneath.

- The sharp edge of a filbert brush works well to describe tight, curly hair. Change the pressure and roll the brush as it turns over the cylindrical form of the curls.

- Dreadlocks can be created with a scumbling technique that keeps the edges diffused by keeping the brush pressure uneven and random.

- Look for the weave when painting braided hair and draw in the overlapping shapes before establishing the darks where the forms overlap. The next layers of middle and light values will create the volume.

- Mustaches and beards are better painted after the forms of the mouth and chin are established. Oily, thin lines are pulled in the direction of hair tracks, especially along the delicate edges around the mouth and cheek where the color of skin is seen underneath.

Glenn Harrington, *Isabella,*
1998, oil on linen mounted on board, 14 x 11 inches
(35.6 x 27.7 cm)

The animated quality of the hair conveys the exuberant energy of this young model.

OPPOSITE:

Will Wilson, *Joy,*
2000, oil on linen, 8¾ x 6¾ inches (22.2 x 17.1 cm)

Sanding between paint layers enhanced the smoothly blended paint surface in this portrait. This, combined with the use of traditional oil mediums to modulate the pigments' transparency and blendability, aided the refined, soft transitions from the light to dark values.

Blending

Blending is an important technique for creating smooth transitions between color values and temperatures and at the edges of forms. Blending begins on the palette by mixing small brushfuls of color from the useful premixtures of pigment that reflect the transitions from warmer to cooler or lighter to darker. With this method, each brushful of paint can be adjusted on the palette. This approach avoids scrubbing or swishing the paint together on the canvas. It also encourages careful selection of a color before committing paint to canvas; holding up a loaded brush to the area you want to paint next will determine if it is the right color, value, and intensity.

Once these submixtures are placed on the canvas, adjoining areas can be blurred or fused together with the soft tip of the brush. When blending edges, use the tip of the brush to gently tease the edge of the brushstroke, pulling it so that only a thin veil of paint crosses over a previously painted area. (Visualizing a plane gently landing, moving across the ground, and then lifting off again is one way to think of the brush's movement across the paint surface.) This results in a smooth passage of paint. This technique can be used, for instance, at the edges of core shadows or over the subtle transitions of the forehead or cheeks. Your sensitivity of touch to the brush (and the angle of the brush) allows you not to dig up the previously painted wet paint.

Since blending is based on small, delicate brush movements, the choice of mediums is crucial. They should be fluid (not sticky), with enough open painting time (moderate drying time) to enable you to return to an area with any adjustments during that painting session. For instance, paint mediums such as Neo Megilp or Venice turpentine may increase the blending of edges, especially when thinned with cold-pressed linseed oil. Mediums that increase drying time in the early stages of a painting will often limit the open working time, becoming sticky and resisting further blending after an hour or two.

On the top, solid bars of paint mixtures are placed next to each other, showing a range from light to dark values. In the middle, blending with a brush blurs the edges of the colors but does not make a smooth transition. On the bottom, discreet mixtures between colors are applied and then blended with the brush, allowing for a more gradual transition between values and color temperatures.

FEATURE *Painting Fine Details*

Rolling the tip of a small round brush in oily pigment charges the brush in a manner that makes is suitable for drawing fine details, such as the crack between closed lips, eyelashes, or the shadow edge of the nostril. The addition of a medium makes the paint more fluid; whereby, making it easier to roll the tip of the brush into a sharp point. (Galkyd, Liquin Fine Detail, or cold-pressed linseed oil work well for this purpose.) The tip of a new filbert brush can also produce a thin, sharp line when the narrow side touches the canvas. For straight fine lines, use a metal ruler and lightly drag the edge of the brush along the side of the ruler.

Having a small puddle of medium on the palette allows the paint to be mixed to just the right consistency and transparency for fine detailed lines.

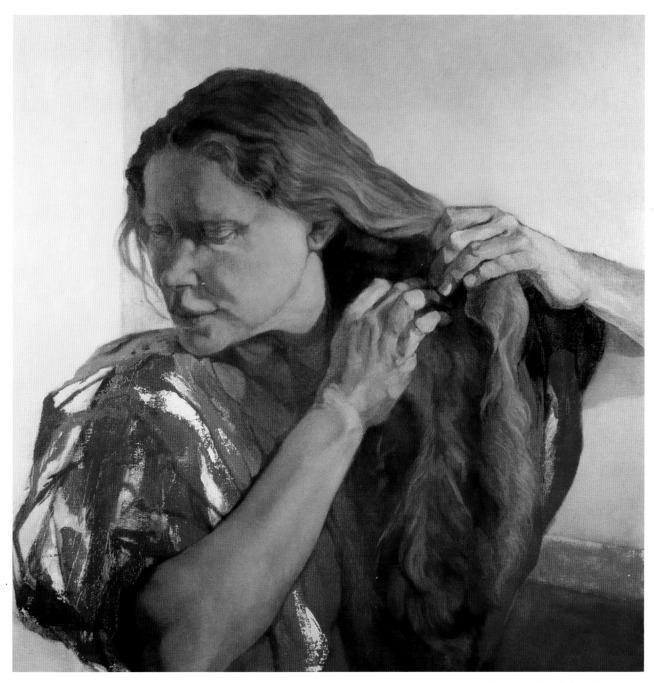

Suzanne Brooker, *Hands in Hair*,
2003, oil on canvas, 24 x 30 inches (61 x 76.2 cm)

A single painting can benefit from the use of varying brush handling—from thin lines placed on a wet paint surface (such as the hair) to dry scumbling over the background to direct, wet-on-wet paint (used to paint the hands). Notice the contrast between the blended contours of the face and the broader paint marks (impasto) used to describe the textural effect of the garment.

Scumbling

In contrast to blending, scumbling involves boldly painting areas by holding the brush at a low angle (less than 45 degrees to the surface) and gently rubbing or dragging the brush across the canvas surface. Depending on the texture of the canvas and the relative dryness of the paint, this gesture can leave a mildly to significantly textured deposit of paint as it glides over the bumps but doesn't sink into the depressions, leaving the underlying painted surface to speckle through in an irregular pattern. This technique is especially effective when a lighter pigment is scumbled over darker values.

This technique can also be used with larger brushes to fill in areas of the background space. When covering larger areas in this manner, make sure to change the direction of the strokes in order to break up the surface reflections. (Paint placed in horizontal strokes appears lighter due to light reflection off the painted surface than strokes placed vertically.) Scumbling can be done both with paint right from the tube or with paint that has been slightly thinned with oil medium.

Deliberately rubbing the pigment thinly into the texture of the canvas surface, with the brush tip between a 45- and a 90-degree angle, is a variation on scumbling. This approach can be especially helpful when starting on a white ground where the canvas surface is machine stamped, like the surface of canvas boards. Thinly applied paint will, once dry, create a less slick surface, making it easier to control additional pigments.

Wet-on-Wet Paint Handling

Wet-on-wet paint techniques are often employed when a flow or sense of movement is implied. The brush, charged with new pigment, glides over a previously painted (and still wet) area, making a gestural or calligraphic stroke that leaves a positive mark. This technique involves a sensitivity to the pressure used to apply paint in conjunction with a distinct directional pull of the brush. (A stiff brush tends to pull up previous layers of wet paint, while too much pressure or agitation of the brush will merely mix the two pigments together.) This technique is best employed when describing the flow of hair or the fluid folds of clothing. Adding a fluid medium, like linseed oil, to the pigment will give greater glide to brush, while a gel medium will increase the drag and texture of the brush mark. When passages are more directly painted, such as ears or the gesture of the hands, wet-on-wet techniques can give a spontaneous or out-of-focus effect. Here, new paint is carefully worked over the paint layer below, sometimes blending edges with the tip of the brush and other times working into the previous color to adjust its hue, value, or chroma. Since this is one of the most difficult brush techniques to master, at first you may find yourself scraping off areas where the color has become muddy or too thick in texture.

Scumbling involves applying paint by holding the brush at a low angle to the canvas and dragging or lightly rubbing over a dry paint surface. The resulting texture allows the paint underneath to show through intermittently.

Using wet-on-wet paint handling means pulling wet paint over a wet paint surface with a sensitive touch of the brush. Paint flows over the previous layer, giving paint strokes a distinct mark and direction.

Pigment thinly scumbled over a lighter color will optically acquire warmth but the same color applied over a darker pigment will appear cooler, regardless of its inherent temperature when seen in isolation.

Clothing provides a key element of a portrait. It is a visual clue that establishes the identity of an era and its fashion trends. It is also an outward expression of the personality of the individual that can both conceal or reveal the attitude of the model. Therefore, your treatment of the clothing can aggrandize or subdue its importance in a portrait, but essentially, it should describe the underlying form of the body. Observe closely the light and dark patterns of draped fabric as it moves over the contours of the body by first evaluating the overall form, particularly the differences in value from the shoulders compared to the angled front plane of the chest. Note any cast shadows that fall from the head over the shoulders. The folds are rendered with attention to their core and cast shadows and reflected lights to give them volume and dimension, just like the surface of any curving contour.

Before you begin, determine the level of detail needed for describing such details as buttons, zippers, or the pattern of the fabric. Are you trying to establish an illusion of realism or an overall impression?

Clothing details should be painted after the form of the figure (face and neck) is established by the middle values. This strategy leaves room for subtle changes in the contour edges around the neck and over the shoulder line where it meets the background. In addition, the color of the garment should work well with your overall palette strategy. Here are a few other things to keep in mind:

- A flowing drape of solid-colored cloth can often best be described in a direct, wet-on-wet paint technique that allows the brush to pull and blend colors in one seamless application of pigment.

- When painting pattern cloth (for example, checks, stripes, or plaids) it's better to establish the values of the folds first and then apply the pattern over the values of the form. Semitransparent pigments applied over the light and shadows will appear to lighten or darken in value.

- To create the shine of a fabric, such as satin, accent the highlights with pure white pigment, working directly into the wet paint.

- Once the initial paint layers have dried, glazes can be added to darken and cool shadows or warm highlights of the folds. Likewise, a transparent glaze of the same color (used to describe the local color of the fabric) adds richness to the surface, as when rendering velvet cloth.

- Texture of a rough fabric can be created by scumbling over the canvas using dry instead of oily paint that allows the toned ground or underlying paint color to show through.

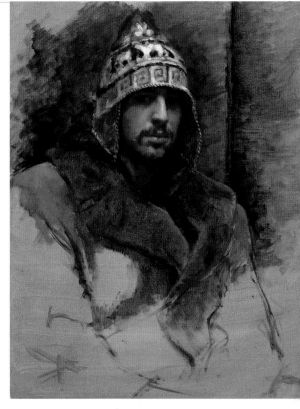

Kate Lehman, *Sam Linder with Hat,*
2000, oil on canvas, 20 x 24 inches (50.8 x 60 cm)

An article of clothing, such as a hat, can introduce humor or a sense of the character in a painting.

Impasto

Impasto techniques involve using the brush to create distinct marks and visible texture in the paint. Gels that enhance body and thickness are added to the pigment and then the pigment is placed generously with the tip of the brush on the surface. Being dimensional, the resulting ridges of the brush marks will have highlights and cast their own shadows. This technique should be reserved for the last stages of a painting, as the thick paint will need more time to dry. Also, only oilier paint (pigment mixed with stand oil) and glazes can be applied over a thick, impasto paint layer, so careful planning is needed to stage this effect while keeping the fat-over-lean rule in mind. When glazes are applied over textured paint, they have a unique way of pooling into the grooves of the paint, creating further dimension.

Texture on the paint surface will tend to come forward in a painting, rather than recede into space, making this technique difficult to control when painting backgrounds. Rembrandt often used this approach when painting the ornate jewelry of his models, while de Ribera found it helpful in creating the creased folds of the skin.

Sgraffito

Sgraffito, as the Italian word implies, is literally "scratching" through a layer of wet paint to reveal the dried pigment underneath. This technique is done with either the tip of the palette knife or the end of the brush handle. Sgraffito is another way of optically blending two colors together and enhancing a subtle texture in the paint surface. Within the painting process, scratching through the paint can also be a way of reestablishing or correcting the underlying drawing, which is then covered over with paint.

Stippling

Stippling is another method for creating optical color effects. It involves placing small dots or dashes of similar value (or subtle changes in color temperature) next to each other. Seen from afar, color and value changes fuse in the eye, but when viewed closely they remain as discrete marks. Applying several layers of semitransparent paint in this manner creates a shimmering quality when rendering certain light conditions and can serve as an alternative to blending.

This method of applying the paint in a dappled fashion is often combined with a scumbling action of the brush to describe air or sky behind the model or visually blend large areas such as the forehead. Once the paint mixtures have been applied, a clean soft brush can be used to soften edges where they appear too harsh.

Impasto or thick paint is applied at the end of a painting with generous amounts of paint charged on the brush tip. The dimensional quality of the paint reinforces the illusion of a textured surface.

Sgraffito is a technique for scratching through thick paint, revealing the dry color underneath. This can create the effect of additional texture or simply aid in redrawing.

Stippling involves small brush marks that accumulate over the surface to create a dappled, impressionistic effect, especially when pigments of similar value but different temperature are placed closely together.

FEATURE *Painting Backgrounds*

The background should be part of the overall compositional design of the painting and generate a context for the subject. The simplest background (air) provides a feeling of the atmosphere surrounding the figure, a sense of light. A more complex background may include elements that suggest interior spaces, outdoor landscapes, or objects that reflect the model's attributes. Drawing preliminary sketches or manipulating digital images allows you to plan out more complex background elements or how the model and the background can be collaged together from two different sources. Ideally the colors used in the background should be an extension of the overall color scheme of your palette, creating an overall pictorial unity.

Contrast is the key for determining the overall mood of a model within the background. When the overall background is darker than the model, the light on the subject in the painting will dominate. When the background and model share similar tones, the effect is quieter and color intensity, rather than value, is the point of accent. The background can also serve to provide a color or temperature contrast from the model's skin tone. (For instance, a greenish background promotes the peachy-pinks of the skin.) In addition, here are a few things to keep in mind:

- To create an airlike effect, thinly scumble layers of paint in similar values that transition across the canvas—from dark to light or warm to cool colors.

- To softly meld a figure to the background, allow the light side of the figure to fuse with the light of the background, keeping the values similar but the colors different. The same is for creating a lost edge on the shadow side of the figure. For greater contrast that separates the model from the ground, background light is applied on the shadow side and a darker hue is painted behind the figure on the light side.

- Applying the paint in short brushstrokes that constantly vary in direction (stippling) allows the light reflected from (literally) the paint surface to scintillate. The opposite effect (of flatness) is created when the same value of color is applied and then smoothed over with a fan brush or a wide flat brush.

- Employing the techniques of aerial perspective (dulling or graying background colors, blurring edges, or suppressing details) pushes the background further into space while keeping the background details from competing with the figure. The opposite effect can also be achieved, as in the image shown here.

Milo Duke, *Fermi's Question,*
2005, oil on canvas, 48 x 48 inches (121.9 x 121.9 cm)

The foreground of this image features several still-life scenarios that eventually lead our eye to the self-portrait, nestled and camouflaged within the background.

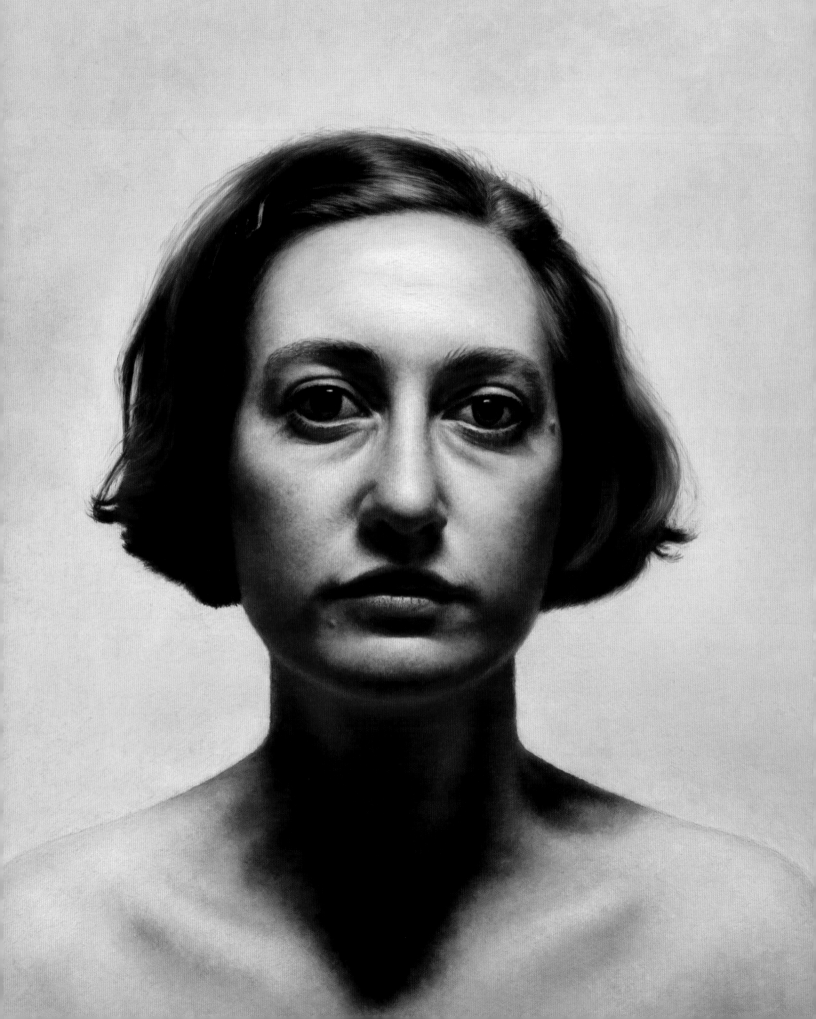

FACIAL ANATOMY CHAPTER FOUR

A PAINTER'S ABILITY TO CONVEY THE CHARACTER in a face involves more than a talent for rendering a superficial depiction of the surface features. Thinking as a painter requires having a working knowledge of the underlying structural forms, as this provides context for the smaller, detailed features of the face. As contemporary portrait painters, our concern is rendering the specifics of the individual—the individual quality of *this face* compared to the universal components of a face is revealed through close anatomical study.

Costa Vavagiakis, *Gioia VII* (detail), 2000, oil on panel, 13 x 13 inches (33 x 33 cm). Private collection

The symmetrical composition and overhead lighting on the model create a frontal starkness to the model that is softened by the artist's care in rendering the exact but subtle asymmetrical differences in the features. Notice how the shape of the strong cast shadow over the neck links with the shadow edges along the cheeks and hair to frame the model's face, creating a "circle" of dark centered within the square format.

Drawing the model from observation allows you to sharpen your perceptions and rendering skills—helping you to articulate what you *see.* When combined with an anatomical understanding, what you *know,* the drawing process is more fully informed: Now you see what you know. It should come as no surprise that the most experienced painters are continually practicing their drawing skills. Good painting is based on sound drawing.

The challenge in representing the human face begins with translating a complex, three-dimensional form onto a two-dimensional surface. The surface skin and underlying musculature are given dimension by the shape and construction of the skull. Elements of the skull (eye sockets, jaw, forehead) are present in all faces, although subtle differences will vary depending on age, ethnic type, and gender. For instance, the skull of a child is different in proportion from that of an adult; the angle of an Asiatic face will be different from that of a Caucasian face; a man may have a more prominent brow ridge than would a young girl. The portrait painter needs to learn to recognize and convey these differences.

We begin with a close examination of the skull and its planar structure, continue with the dynamics of perspective and foreshortening, and conclude with analyses of the features.

ANALYZING THE BASIC STRUCTURE OF THE SKULL

The skull is divided into two large forms: the front of the face plate (the symbolic oval of the face) where the features reside and the spherical ball of the skull that holds the mass of the brain. There is also the transitional plane, the sides of the head, which connects the front of the face to the back of the skull. Notice how the widest point of the skull is the midpoint of the width, just above the ear holes. The front (face plate) plane of the face is narrower in comparison.

The bony mass of the skull provides key facial landmarks. Feel your own skull with your fingertips. Notice, for instance, how the root of your nose begins as your forehead slopes between your eye sockets onto the bridge of your nose. Above the root of the nose is a key landmark called the glabella, which is bracketed by the inner corners of the curving eye sockets and the brow ridge between the eyebrows.

The eye sockets provide a bony cave for the eyeballs (which are held in position by internal muscles as well as the orbicular oculi muscles of the eyelids). The upper portion of the eye socket curves sharply onto the forehead, melding with the brow ridge. Take note of the delicate arch of the eye sockets' outside corners, zygomatic process, and its transition to the temple (or the temporal fossa). The bottom portion of the eye socket melds into the zygomatic frontal bone that curves from the front of the face to the side, in a thin bony arch (zygomatic arch) above the ear hole. This transition from the front to the side of the zygomatic is often called the cheek bone. (It's here that the zygomatic muscles are attached to the outside corners of the mouth to pull the mouth into the gesture of smiling.)

The root of the nose begins with the bone at the glabella and continues outward from the face with cartilage that defines the wedgelike shape and length of the nose and its tip. The base of the nose, as it curves under to meet the philtrum (the grooved fleshy area above the upper lip), is a short underturning plane that is critical in rendering the character of a nose. The wings of the nostrils flair out from the fleshy tip of the nose and wrap around to meet at either side of the philtrum. The intensely curving nature of the nose requires close observation in order to understand its form. Careful observation of your own nose is one sure means to gaining this insight.

The curving form of the top teeth is imbedded in the maxilla, while the lower teeth are part of the mandible of the jaw. It is important to note that the bottom edge of the jaw has a thickness and moves from the narrow front plane, the mentalis (what we think of as the chin), onto the sides of the jaw line.

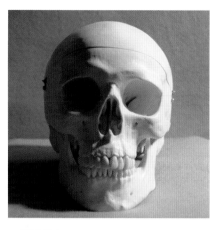

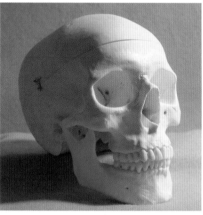

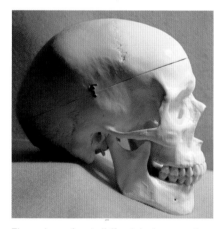

Three views of a skull (frontal, shown on the top; three-quarters, shown in the middle; and profile, shown on the bottom) reveal the subtle changes in the light and shadows when placed under an angled light source.

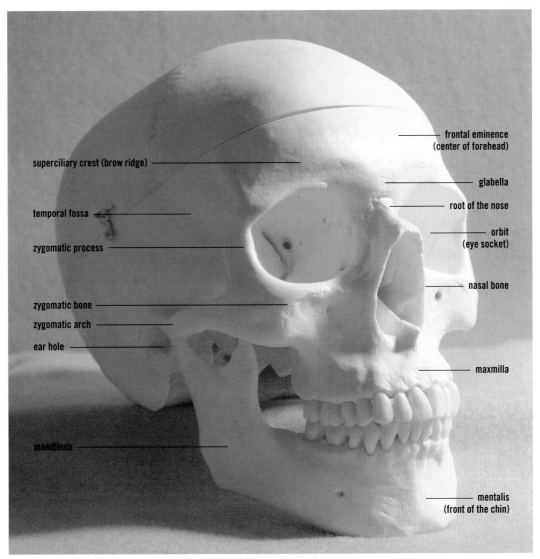

frontal eminence
(center of forehead)

superciliary crest (brow ridge)

glabella

root of the nose

temporal fossa

orbit
(eye socket)

zygomatic process

nasal bone

zygomatic bone

zygomatic arch

ear hole

maxmilla

mandibula

mentalis
(front of the chin)

Familiarity with anatomical descriptions of the skull allows a painter to connect the surface of the skin to exact locations on the skull. What was once thought of as the cheek bone is then understood as the underlying bone of the zygomatic. Drawing a model of a skull from varying perspectives gives a painter insight into perceiving the underlying bony structure of a face.

LEARNING TO SEE PLANAR STRUCTURES AND VALUES

Understanding the skull in terms of a simple planar mass is a concept-mode of thinking, one that is familiar to the sculptor and very useful to the painter. Since the form of the skull is a common denominator underlying every face, it is essential to perceive the head as a dimensional volume. To begin thinking in terms of planes, imagine simplifying the rounded contours of the head into flat, chiseled surfaces. If we constructed a skull with small pieces of wood, each flat piece could only angle or tilt to represent the curving surfaces. Assuming the light source is directed from above at an angle, some planes would then be tilting up toward the light source, others parallel or angle downward away from the light. Each change of angle would have a different value.

Even the large, smoother planes of the face, like the forehead and cheeks, can be divided into a planar structure. The simple schematic drawing of the face shown below illustrates the head seen as a planar structure. When light is cast on this head, a division of values can be clearly observed. Such questions as "How does the under plane of the nose differ in value from the narrow top plane of the nose?" can be answered. This concept can be used as a guide in determining where the intensity of light will fall on the surface of the face.

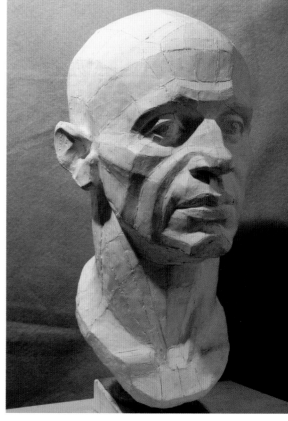

Leonid Lerman, *Plaster Cast Head.*
Courtesy of Mark Kang-O'Higgins

A life-size sculpture of the head shows the chiseled planes of the skull and features on the left side and the modeling of the curving surfaces on the right. This conceptual mode of thinking is utilized by painters to perceive the head as a dimensional mass or volume in space.

OPPOSITE:

Robert Liberace, *Russell,*
2001, oil on canvas, 18 x 24 inches (45.7 x 60 cm)

Close observation of the draped folds and creases of the skin over the form of the skull reveals both the age and character of the model. Notice the play between the introspective gaze of the model with the fragile connection of the coat's button silhouetted against the light background.

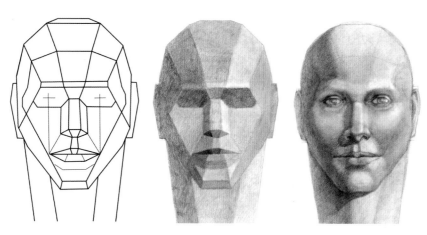

On the left, a schematic outline of the head shows its forms interpreted as simplified planes. The planes of the skull are then shaded as flat planes, revealing their angles to the light source, as in the center. When the flat planes are translated into the curving surface contours of a generic face, seen on the right, transitions in value become critical in distinguishing the cast shadows from the core shadows, the reflected light from the direct light.

SHADING THE CURVING FORM OF THE HEAD

When the surfaces of the head are simplified into planes, then shading those planes is fairly easy and logical. However, once the planar surfaces are replaced by their true, curving surfaces, the interaction of light and shadow becomes more complex. It is standard practice when studying the effect of light on curving forms to compare basic geometric forms, such as a cylinder or sphere in contrast to cubic forms such as a box or wedge. Because of the complex interplay among the forms on the face, it is often difficult but necessary to have a solid understanding of both the concepts (such as the theoretical shading of a sphere with its transitions from light to shadow) and the observed (actual tip of the nose, for example).

The shaded simplified planar head shows angular areas of flat, un-blended tones. When looking at the actual curving surfaces of the head, attention is directed toward the softer transitions on the curving forms and how these values define the form. The careful modeling of these transitions (both in drawing and painting) determines the success in creating the illusion of three-dimensional realism.

DEFINING LIGHT AND SHADOW

A source of strong light directed from above and at an angle helps reveal the most information about the form of the head (or any other object). What we see, when looking a head illuminated in this way, are general groupings of values: light, middle, and dark.

Upturning planes receive the greatest amount of light intensity and therefore are the lightest in value. The highlight, usually a very small moment within the light values, is the area that is closest and most perpendicular to the light source.

The middle values are those areas that are parallel in relation to the light, neither turning toward the light nor away. In these areas the light slants across the surface and often reveals the true local colors of an object, since it is neither darkened (as in the shadows) or bleached by strong light.

Shadow areas angle away from the light and are darker in value. Although the shadows are often illuminated by reflected light that is bouncing from another surface (and that determines its value and color note). Reflected light is helpful in modulating the values seen in the shadow areas, although they cannot be as bright or warm as any area in the light side. The value of the reflected light must stay in the general range of the shadow values.

OPPOSITE:

Costa Vavagiakis, *Yuko IX*, 2000, graphite on paper, 18 x 14 inches (45.7 x 35.6 cm). Private Collection

The carefully nuanced changes in value reveal the curving surfaces of the face in this portrait drawing. Notice the delicate transitional edge along the core shadow of the cheek; it indicates the planar change from the front to the side of the face.

ARTICULATING CORE SHADOWS AND CAST SHADOWS

The place on a form where the light meets the shadow is known as the core shadow or, more accurately, the "core of the shadow," which is the terminating edge between the light and dark values. This place signals the abrupt change in planes from upturning, toward the light, to downturning, away from the light. On spherical or cylindrical forms, both of which are defined by curves, the core shadow can be identified by a soft edge, as it melds the light to the shadows, but it is also the darkest place on the form, darker than the shadows themselves. The core shadow cannot be indicated as a dark stripe but a soft but swift transition from the rapidly diminishing intensity of light into the shadows. On the shadow side the core shadow slowly gains a lighter value as it meets the reflected light. In this way the darkness of the core shadow contributes to the varying range of values used to describe the shadows and reflected light.

Granted, the core shadow is difficult to perceive at first. Placing a simple curved object such as a pear under a strong, angled light (with no other competing light source) will help identify the terminating edge of the core shadow. By shifting the angle of the light you'll notice how the core shadow changes as it wraps and curves over the surface of the pear. Rendering the core shadow is key to creating the illusion of a three-dimensional object, as it is imbedded in our unconscious understanding of realistic painting. (Artists have used this method of rendering light and shadow in painting to create solidity of form since the Renaissance.)

Changes of value (or color temperature) in the shadows are often difficult to perceive without the presence of reflected light, which helps modulate its values. However, areas of reflected light can never be as light in value nor as warm in temperature as the light side of the face. Rather, they must remain within the grouping of the shadow values. Likewise, the shadow values must vary to some degree or a flattening of the form will occur. Look for the source of reflected light from a light value (such as the front of the chest) or from the color of the clothing.

The cast shadow occurs when an object is blocking out the light, like the shadow that falls across the cheek from the nose. A cast shadow will tend to have sharper edges than a core shadow, especially when it is close to the light source. The edges of a cast shadow will also seem to curve, bend, or flow over the surface contours upon which they fall. For instance, the cast shadow from the nose will curve over, revealing the surface contours of the mouth or cheek.

The cast shadow is also best described by transparent paint so that it neither becomes too dark or flat over the flowing contours of the model. Notice how the values of a cast shadow, such as the cast shadow of the head over the neck or shoulder, also tends be lightened by bouncing reflected light.

Gary Faigin, *Suzy,*
1986, charcoal on paper, 12½ x 9 ½ inches (31.8 x 24.1 cm)

A sketch of the model's head reveals a sumptuous feeling that is conveyed by a more-than-accurate recording of the features. The soft modeling of the subject renders the roundness of the forms with a suggestion of the diffused quality of the light.

OPPOSITE:

Will Wilson, *The Ceiling,*
2001, oil on linen, 9 x 7 inches (22.9 x 17.8 cm)

Viewing the model from a low point of view or when the model's head is tilted back provides a challenge in rendering the foreshortening of the features. Notice the changes of edges that signal shadows on the form versus the cast shadows.

STUDYING THE THREE AXES OF THE HEAD

In most reference material the artist is encouraged to regard the head from a frontal, symmetrical point of view and at a similar eye level as the viewer. Guidelines for the proportion of a face are established with this vantage point in mind. For instance, the idea that the center of the eyes is halfway from the top of the head to the bottom of the jaw is only true when there is no tilting, rotating, or slanting of the head. However, the natural and often characteristic gesture of the head includes some aspect of movement or change of angle from the viewer's eye level. To simplify, we can think of the mass of the head in terms of having three different directions or axes, all of which directly impact the rendering of the perspective and foreshortening of the face.

The first axis is articulated when a line is drawn from the pupil of one eye to the pupil of the other eye. If this line is not perfectly level, the head is tilting from side to side. (Ask yourself: Is one eye higher than another?) Sighting "across the pupils" provides a more reliable guide than noting slanting of the eyelids or the angle of eyes from inside to outside corners.

The second axis is viewed by looking at the centerline down the nose. If this line is not in the precise center of the face, then the head is rotated either left or right. (Ask yourself: Do I see one ear more than another? Is the inside corner of one eye hidden by the nose?)

The third axis is noted by examining the chin. Is it slanted upward or downward? Do you see the bottom plane of the jaw, or do you see the top of the skull or hairline part? (A change in eye level from your point of view will also be shown by this third axis, as in looking down on the subject versus looking upward, below the eye level of the model.)

Three axes are observed when viewing the head: tilting from side to side, which is measured across the eyes from pupil to pupil (top); rotating from left to right, which is sighted from the centerline along the nose (middle); and slanting from up to down, which is noted in the chin as it reveals or conceals the under plane of the jaw (bottom).

Each of these three axes reveals the position of the head in space as it turns and angles away from your plane of vision. When rendering facial features it is more important to focus on what you observe rather than any general rule of proportion.

Once the three axes have been carefully observed, simple construction lines can be drawn with thinned paint to help reinforce these angles. A single line drawn to represent the tilting angle of the eyes will help enhance the similar angle or a subtle change of angle across the bottom plane of nose, the outside corners of the mouth, or the front plane of the chin. Noting the rotation of the face—a straight construction line drawn from the root of the nose to its tip—can serve as a guide for seeing the overall angle of the nose (not its specific contour). Articulating the intersecting lines between the eyes and root of the nose begins to establish the keystone arch of the glabella and map out the key relationships of the features. (The features themselves will be discussed in greater detail on pages 106 to 123.)

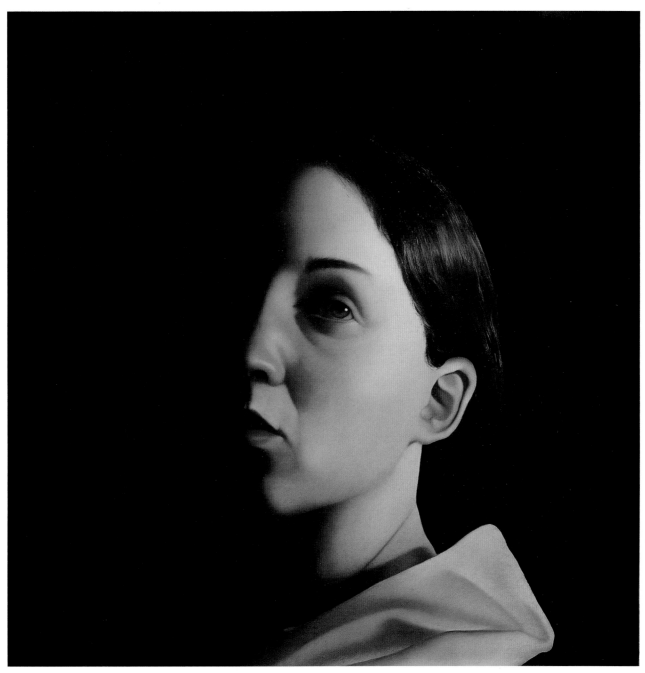

Gloria de Arcangelis, *Rachel Looking Up,*
2004, oil on wood panel, 18 x 18 inches (45.7 x 45.7 cm)

The dramatic lighting cuts across the face
of the model, highlighting the features in a
strong division of light and shadow. Notice
the tilting, rotating, and slanting angles of
the head—all of which generate a certain
psychological attitude.

MASTERING PERSPECTIVE

Drawing techniques used to create the illusion of three dimensions (credible forms that exist in a credible space) on a two-dimensional surface utilize both intuitive methods of perceiving space and the principles of linear perspective. These methods are imbedded in our Western visual language, making it easy to discern the difference between a form that appears realistic in space and a form that appears flat. The following summary reviews some of the techniques used to describe spatial relationships on a flat picture plane.

UTILIZING INTUITIVE METHODS OF PERSPECTIVE

Intuitive perspective translates the ways in which our eyes perceive objects dimensionally as volumes. Because human eyes tend to roam, automatically zooming in to focus at differing distances, these drawing techniques may not reflect exactly what you are seeing at any one particular point. However, as drawing (and painting) techniques, they are effective in communicating a realistic representation of forms—especially when they are combined with linear perspective techniques.

Intuitive perspective drawing techniques include such ideas as creating form through chiaroscuro (which literally means "light and shadow"). The visual effect of shading an illuminated object like the head means that darker values recede in space while lighter values advance.

The directional pull of a brush mark can help sculpt the dimensional qualities of the form by leading our eye over the surface of a form. Cross-contour lines are brush marks that move across the surface rather than along the outside contour edges. Contour lines along the edges of a form describe its length and direction, while cross-contour lines lead our eye over the surface of a form.

Variation in line width is another drawing technique that directs our eye from near to far. In one continuous line, if a part is drawn more thickly, it appears to be near, while the part that is drawn thinly appears to be moving back into space.

The treatment of edges can also have an impact on suggesting the depth of space—as sharp edges come forward, and soft edges recede in space. Edges can be defined by a change of value (the edge of a cast shadow on a bright cheek), color (the edge of a garment against the background), or texture (the texture of the hair as opposed to the hat).

Atmospheric (or aerial) perspective dictates that as objects recede from view or are deeper in space, both their details and their contrasts in value will diminish. Generally this technique is associated with landscape painting (as it can be used to depict great distances), but it can be effectively used to suggest the differences between the focal plane (depth of field) of the eyes versus the ears in a portrait.

Overlapping one object in front of another (like the hand in front of the body) immediately suggests the notion of space. Overlapping is

OPPOSITE:

Will Wilson, *Pablo,*
2000, oil on linen, 8¾ x 6¾ inches (22.2 x 17.1 cm)

This painting contrasts the close-up cropping of the model against a distant landscape, reminiscent of Renaissance portraits. The use of aerial perspective in the landscape provokes the feeling of deep space, emphasized by the model's presence in the foreground.

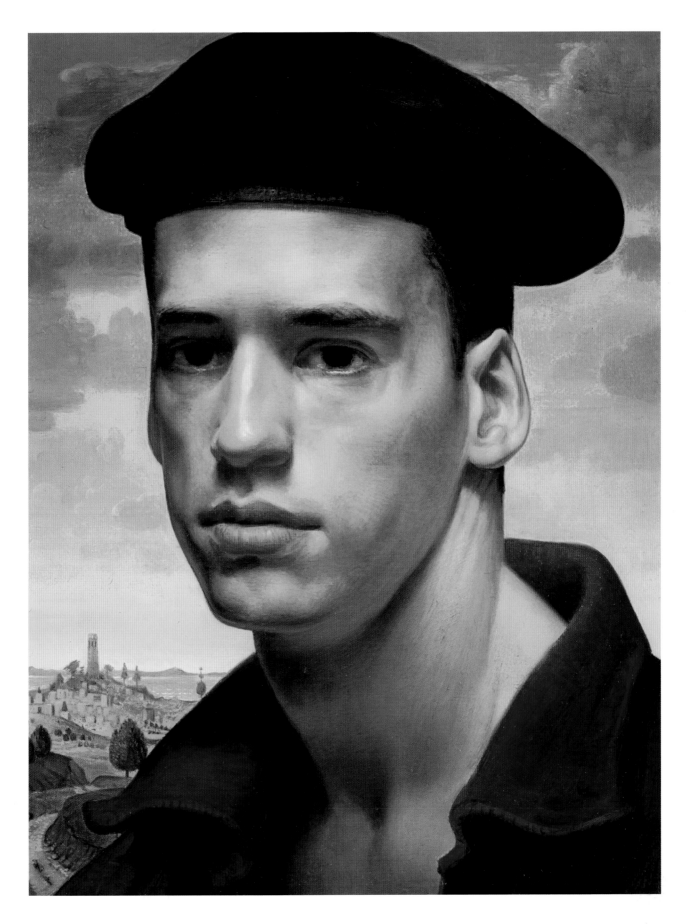

frequently and subtly employed throughout a portrait. For instance, in a frontal view, the drape of the hair may be in front of the forehead, or in a three-quarter view the edge of the nose may overlap the inside corner of the eye. Used separately, each of these drawing (and painting) techniques will provoke a sense of form in space, but used together they are even more effective in creating the illusion of three dimensions.

UTILIZING LINEAR PERSPECTIVE

The study of linear perspective is often associated with drawing still-life objects, interior spaces, or architecture. However, the same principles can be applied to rendering a singular object, such as the head. The principles of linear perspective rest on the assumption that there is one fixed point of view (the artist's) and that this viewpoint also establishes the eye level—literally, what is at the level of the artist's eyes.

One-point perspective involves the relationship of a flat plane directly in front of you and therefore horizontal to your point of view. The key word here is *frontal*. Imagine the face of your model at your eye level, symmetrically in front of you with no tilting, rotating, or slanting of the head.

Two-point perspective is evoked as soon as the front plane of the face rotates slightly to the left or right. Although the vertical lines will remain vertical, the horizontal lines (which had been parallel) will seem to diminish, slightly narrowing toward each other as they converge toward the vanishing point at your eye level. Although this dynamic is easier to observe on a large surface, like the side of a building, it is also subtly present across the frontal plane of the face.

Three-point perspective occurs when both vertical and horizontal lines are angled away from the viewer, as when a head is rotating away and the eyes are tilting at the same time that the chin is lifted away from your view. In this instance, no lines or planes of the head are parallel to your point of view.

Since the distance between features across the front plane of the face is relatively close, the impact of linear perspective is subtle but present. For example, when the face is rotated away from you, the distant eye or far corner of the mouth will be slightly smaller as it recedes into space. When the face is symmetrical (frontal, with no slanting or rotation), the side planes of the cheeks and forehead diminish back into space. Likewise, as the head is slanted upward, the scale of the jaw will seem more pronounced than the receding plane of the forehead.

When working with a live model, distortions in linear perspective occur if your angle of sight to the model changes or if the model moves. In addition, if you start a painting from observation by standing and then continue sitting down, distortions will occur because you have changed your eye level.

Gary Faigin, *Girl in Peasant Dress,* 1986, charcoal on paper, 12½ x 9½ inches (31.8 x 24.1 cm)

A contemporary model dressed as a peasant girl provokes the association of artists such as Bouguereau, Millet, and Pissarro. Notice how the overlapping forms of the figure, such as the knee in front of the elbow and arm crossing the shoulder, create not only the gesture but a sense of depth.

Glenn Harrington, *Max,*
2006, oil on linen mounted on board, 18 x 24 inches
(45.7 x 60 cm)

A strong diagonal line, created by a boy
reclining on the couch, contrasts with the
geometrical grid of the background window
elements. In addition, the back wall of
the room (which is governed by one-point
perspective) contrasts in scale with the large
shapes of the couch, generating a sense of
deep space.

UTILIZING FORESHORTENING

Foreshortening, like perspective, is a drawing concept used to render spatial relationships. Foreshortening is used to indicate the relationship of near to far, or what comes forward and what recedes in space.

This simply means that anything (lines or planes) at an angle to the viewer will seem shorter than its true length. A test of this dynamic can be done with a pencil. If you hold the pencil parallel before your eyes, you observe its true length. Now turn one end away from you so that it moves back into space. Squint your eyes and notice how the pencil immediately appears shorter. The more you rotate the pencil away from you, the shorter it becomes visually. At this point, your mind is challenged to separate what it knows (the true length of the pencil) from what it perceives. To depict the illusion of the pencil in space, it must be rendered as you are visually observing it, not as you tactually or mentally know the pencil.

This same principle holds true for observing vertical lines that are tipping back into space. For instance, when the chin is tilting upward (the third axis), the length of the nose will appear shorter than when seen from the front, with the tip of the nose surprisingly close to the eye. When the chin is tilted downward, the tip of nose seems to be much closer to the lips.

What is true for a length is also true for the width of a plane. Consider how the far side appears diminished in scale when a face is seen at a three-quarter view. Its width is reduced. To test this phenomenon of vision, hold an index card parallel to you and rotate it, slanting it away in space. Notice how the width of the plane is diminished? Now if you draw a dark line vertically down the center of the card (representing the centerline of the face), you'll notice how much closer the line is to the far edge.

The same phenomenon can be observed when looking at a round circular shape, such as the iris of an eye. When seen from an angle, the circle now appears as an ellipse. To visualize this effect, hold a circular object, such as a roll of masking tape, in front of your eyes and rotate one side away from you. Notice how the sides seem to narrow and squeeze together while the vertical distance remains the same?

When drawing the face, you should think of the head first as a mass in space, observing its perspective to you by noting the three axes. Foreshortening is the means for indicating the visual implications of perspective—the shortened lengths and widths of the features as they move from near to far in relation to your point of view. Intuitive drawing methods can then be used to further the illusion of a dimensional form on a flat surface.

Taking simple objects (such as a pencil, index card, or roll of masking tape) and turning them toward or away from you is one way to observe the dynamics of foreshortening.

ADOPTING A TECHNIQUE **USED BY OLD MASTERS**

The effect that perspective has on the head can be easily seen when we substitute it with a small box upon which parallel lines that demarcate the locations of key facial features are drawn, as shown in the illustrations below. This exercise allows us to simplify the (spherical) head to a geometrical form comprising flat planes. The facial features, which in a relaxed expression are considered to be parallel, reside on the front plane.

Anatomical understanding of the skull, the sculptural mass of the head, the interaction of light and shadow, and perspective as indicated through foreshortening are essential to thinking as a painter. These concepts were studied and well practiced by the Old Masters. In fact, they were not only understood but were at their command. Therefore, further independent study into drawing techniques, shading, and perspective is recommended. *Drawing from Observation* by Brian Curtis is an excellent guide for more detailed information.

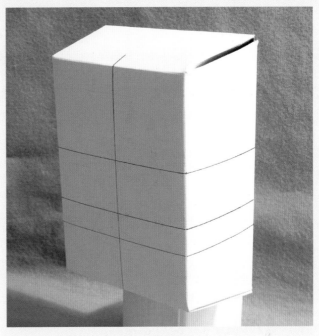

When the head is slightly tilted downward and rotated, the top plane of the head becomes more visible. The features on the front plane diminish as they recede into space toward the vanishing point.

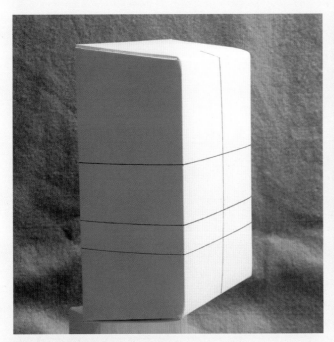

In a three-quarter view of the head, the edge of the box (usually thought of as the point of the cheekbone or zygomatic) divides between the front and side planes of the face. Notice how the front plane diminishes sharply into space.

When the box slants upward (while at the same time tilting and rotating), the under plane of the jaw becomes visible. This bottom plane also diminishes into space, according to the rules of three-point perspective.

MAPPING THE KEY RELATIONSHIPS OF THE FEATURES

Achieving a strong resemblance to your subject lies in establishing the relationship between the features rather than focusing on the details of the features themselves. In the diagram on the facing page, the face is symmetrical, looking forward. Notice the gray bar that runs vertically from the center plane of the forehead to the front plane of the jaw. This area is the narrow corridor where the most intense relationships occur between the features.

When rendering a face, many beginning artists first draw a symbolic oval shape, which they then fill in with the features. This approach leads to distortions, as features are often squeezed or stretched to fit inside the oval. An oval (or contour outline) is best used as a placeholder for determining the scale and placement of the head within the rectangular format of the canvas.

A better approach is to map out the key relationships between the features from the inside outward. This process involves observing the three axes of the head and placing two construction lines: one across the pupils of the eyes, and one down the center of the nose along the centerline of the face. From here, begin to carefully measure the features, starting at the glabella and moving downward and outward. Use the distances between the features to locate their positions so that the contour edge of the face is drawn last in relation to the features.

Specifically, starting at the base of the glabella (1), the root of the nose moves across the width of the nose and then turns downward to the inside corners of the eyes. Observe the depth from the top plane of the nose to the inside corners of the eyes (2). Measure the length of the nose from the root to the tip. Notice how the wings of the nose (3), or

It can be helpful to compare the angle of a feature (such as the difference between the inside and outside corner of the eye) to the hands of a clock. Does this angle look like "four o'clock" or "two o'clock"?

DEVELOPING A **MEASURING EYE**

When drawing the features of the face, three methods of observation are used to develop a measuring eye: finding the alignment of one feature to another (using horizontal/vertical lines), seeing from one point to another (using angled lines), and thinking in terms of height-to-width ratios (using shapes). These methods of observation, when combined with a comparative mode of thinking (Is it higher or lower, closer or farther way?), help sharpen the eye to notice key relationships.

For instance, when the head is sharply tilted to one side, a vertical straight line (such as a pencil or the brush handle) can determine if the wing of the nose is now aligned with the center of the eye rather than the inside corner. Likewise, a horizontal line can determine if one corner of the mouth is higher or lower than the other. This same process can be used to see the angle of the nose when the head is rotated or the angle of the eye from the inside to outside corners.

The cast shadows, such as those under the nose or the inside corner of the eye, can be seen as flat shapes just like the white of the eyes can be seen as triangles. Is the shape taller than wider, more of a square than a rectangle? Looking at the light and shadow shapes is like looking at pieces of a puzzle; they have to fit together.

side planes of the nostrils, curve around the tip. The distance between the inside corner of the eye and the wing of the nose (positions 2 and 3) is the first critical length in establishing a resemblance to the model.

The bottom plane of the nose is defined from the tip to the base of the nose (4), where it meets the groove of the philtrum. How much of the bottom plane is seen will be determined by the character of the nose cartilage and the tilting of the head.

The thickness of the lips is measured from the top edge of the top lip (5) to the bottom edge of the lower lip. The distance between the base of the nose and edge of the upper lip (the length of the philtrum between position 4 and 5) is the second critical length in establishing a resemblance to the model. The shadow below the bottom lip describes the downward tilting plane to the chin and the adjacent side planes, called the "columns of the lips." Remember that the outside corners of the lips often extend past the color of the lips.

The upward tilting plane of the chin (6) and the transition over the smoothly rolling edge of the jaw complete the form of the head. (Note: The chin, like the forehead, is sometimes interpreted as being smaller than it actually is because of its bland nature.)

Drawing the features as simple geometric shapes using straight line segments helps measure their lengths and angles. Contour edges can be refined after the proportions have been established.

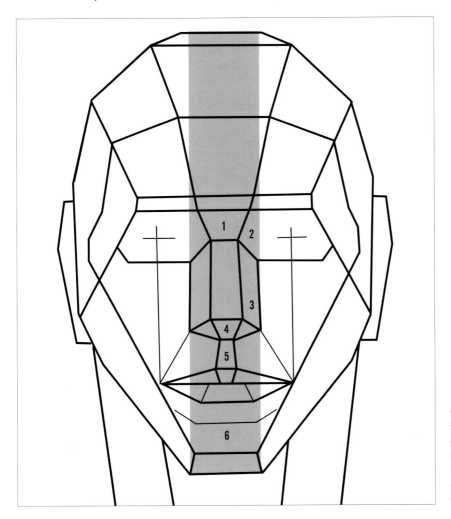

Capturing the relationships between important landmarks of the face—including the glabella (1), inside corner of the eye (2), wing of the nose (3), base of the nose (4), length of the philtrum to the top lip (5), and chin (6)—will result in a better resemblance to the model.

CAPTURING GESTURE AND EXPRESSION

Our understanding of human expression is keenly developed from an early age. We often read the nuances of expression without knowing the cause of the gestures. However, studying the musculature of the face helps us to recognize specific actions of the muscles—the pulling or compressing of the features into gestures of surprise, doubt, or sorrow, for example. This allows us to meld together what we see with what we know when conveying the complex emotions of the model.

The relationship of the features is most apparent when the face is resting in a neutral position, which often happens when working from a live model. When painting from photographs, however, the lively quality of expression captured by the camera comes into play. Understanding the influence of the musculature on facial expressions then becomes particularly important, as the complexity of an expression reflects how the muscles interact together.

The muscles of the face are classified as either deep or superficial, the latter being the muscles that control the subtly of expression. In the illustration on the facing page the muscles of expression are drawn with an earth-red pencil over a simple contour drawing of the skull. Creating your own facial muscular drawing is a valuable exercise for gaining an understanding of the muscles that govern expression. (For more detailed information, see *Human Anatomy for Artists: The Elements of Form* by Eliot Goldfinger.)

Let's examine the illustration. The thin sheath muscle, the frontalis, which covers the forehead, allows the eyebrows to be raised, relaying expressions of surprise, astonishment, or fright. Notice how the wrinkles of the forehead run perpendicular, across the forehead, opposite to the direction of these muscles.

The corrugator supercilii muscles run from the middle of the eyebrows to the inside of the eyebrows at the glabella. The contraction of these muscles is associated with negative feelings of anger and doubt or more subtle expressions of determination and concentration.

The circular muscles of the eye, orbicular oculi, are comprised of five portions, which together help form the shape of the eyelids by covering the orbits of the eye sockets. These muscles squeeze together to indicate expressions of confusion or concentration. Notice how the wrinkles around the eyes also run perpendicular to the curve of these muscles.

The action of the upper lid is aided by the levator palpebrae superioris, which raises the eyelids for expressions of surprise (both eyes) or skepticism (one eye).

Muscles that run along the outside length of the nose, levator labii superioris, flare and raise the nostrils for expressions of disgust or disapproval and even during a full smile.

The circular muscles that surround the mouth, orbicularis oris, do not attach onto bone but rather hinge from the outside nodes or corners

of the mouth, covering the teeth. As the most complex muscle group of the face, the muscles surrounding the mouth not only control the action of the lips to allow speech, kissing, and whistling, but they can also communicate expressions of disdain, grief, or restrained mirth, for example. Wrinkling of the mouth occurs in the same fashion as that of the forehead and eyes, perpendicular to the muscle direction.

The smiling muscles, zygomaticus major (in conjunction with the action of zygomaticus minor), pull from the outside corners of the mouth upward, bunching up the cheeks toward the outside corner of the eyes to the cheek bone.

Pulling the corner of the mouth outward, toward the side of the jaw, is the job of the risorius and platysma muscles, which create the distortion in the mouth when crying or expressing extreme grief. The platysma is a thin sheathlike muscle that attaches along the entire jawline and covers the neck. The platysma muscle on the neck drapes with old age, generating the "necklaces of Venus," or softening into a double chin.

The triangularis also attaches onto the outside corner of the mouth and pulls downward in expressions of sadness.

The lower lip is moved by the depressor labii inferioris, which pulls the bottom lip downward in the action of talking.

The mentalis also moves the outside corners of the mouth downward while lifting the center of the lower lip upward, creating a pouting gesture or expressions of sadness, grief, or disdain.

Each of these muscle groups can be witnessed in action with the aid of a mirror. When you mimic a certain expression, try to imagine what muscles and what actions (such as compressing, stretching, or pulling) come into play. Imagine what the interaction between the surface contours of the face and the underlying musculature might be. Thinking as a painter, these personal observations add to your empathic insights into interpreting the model's expression.

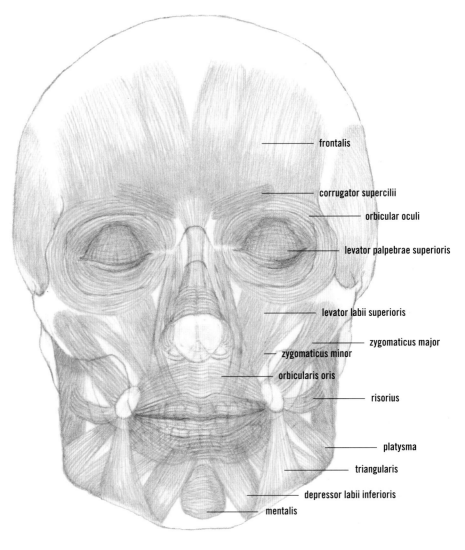

Drawing the superficial muscles of expression on an overlay of the skull can help you gain a deeper understanding of the relationship between the skull and the muscles.

frontalis

corrugator supercilii

orbicular oculi

levator palpebrae superioris

levator labii superioris

zygomaticus major

zygomaticus minor

orbicularis oris

risorius

platysma

triangularis

depressor labii inferioris

mentalis

EXAMINING AND EXECUTING FACIAL FEATURES

The ability to recognize human expressions is universal. As artists, this can either cloud our visual perceptions or provide us with insights about the individuals we portray in our paintings. No matter how realistically a painting is rendered, however, every portrait reveals the artist's interpretation of a person rather than a strictly objective reality. Ironically, the artist's ability to exaggerate the complex relationships between the features of the face (whether done consciously or unconsciously) is precisely what gives a portrait its expressive power. Thinking as a painter requires that we determine when to balance resemblance (accuracy) with the living, dynamic qualities of an individual.

On the pages that follow we will examine the major features of the face—eyes, nose, mouth, and ears—using an approach that emphasizes the underlying structures and then the painting methods. Having familiarity with the basic facial features then enables us to recognize the deviations from the "ideal" that make each face unique.

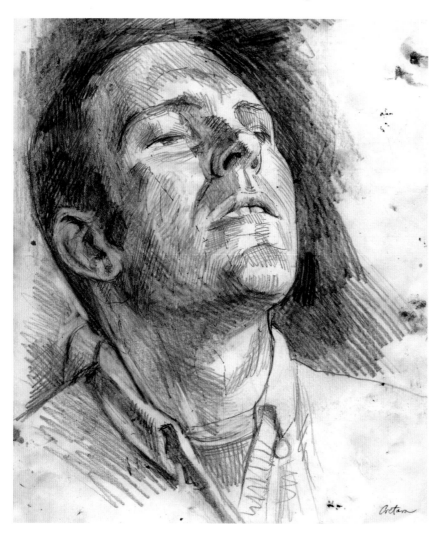

Domenic Cretara,
Study for the Gulf Study,
2006, graphite pencil on paper, 14 x 11 inches (35.6 x 27.7 cm)

An in-process study drawing is created from the painting, allowing the artist to further examine the relationship of the foreshortened features to the desired expression of the subject. Notice how the linear shading (lines) still indicate the plane changes as well as differences in value.

OPPOSITE:

Glenn Harrington, *Evan as a Pirate,*
1996, oil on linen mounted on board, 14 x 12 inches
(35.6 x 30.5 cm)

How does our understanding of Evan's expression read so clearly in this portrait? How does the tilt of the head combined with the droop of the eyelids and the open mouth all contribute to the feeling of his expression?

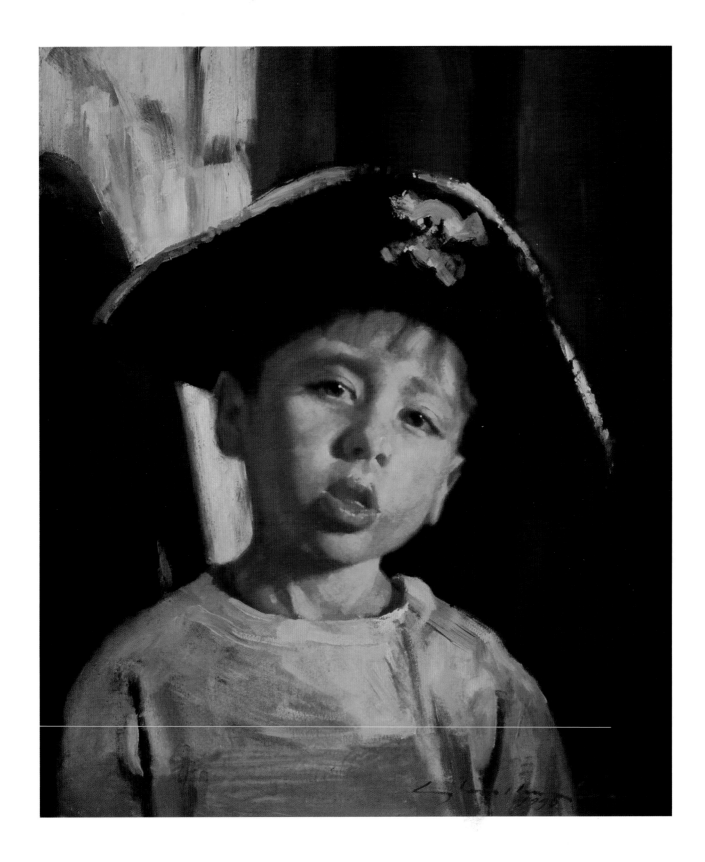

STUDYING THE EYES

Eye contact is primary to human interaction. Likewise, in a portrait the eyes are the first things a viewer notices. The physical size of the adult eyeball is nearly the same in all people and only slightly smaller at birth, which is why young children appear to have big eyes. The inset of the eyes, whether they are deep set or prominent, changes their appearance or relative scale, as does the drape of the upper eyelids (due to age or expression).

The greatest difficulty in drawing the eyes is relating them across the root of the nose. Any novice artist can draw one eye beautifully.

A small clay model of the eye, such as the one shown here, can be tilted and rotated for study drawings. When seen in profile, the exaggerated thickness of the eyelids reveals the cast shadow over the eyeball and the turning plane of the lower lid.

The trick is getting both eyes in the same perspective. Look for the first axis through the pupils of the eyes and then draw a line. Next, identify the angle down the center plane of the nose to determine the degree of rotation (second axis). Draw a line that represents the angle, not the contour, of the nose. The intersection of these two lines begins to define the keystone arch of the glabella. The eyes cannot be correctly spaced apart in perspective until the top plane (across the root of the nose) and the depth of the side of the nose to the inside corners of the eyes have been accurately established.

The inside corners or tear ducts of the eyes usually align across the nose (parallel to each other), even when the face is tilted from side to side. It is unusual for the inside corner of one eye to be higher than the other, although age has a way of dragging or pulling the skin downward. The tear duct is a transition from the slope of the nose to the curving form of the eye, but it rests neither on the plane of the nose nor on the curve of the eyeball itself.

Although the inside corners of the eyes may be aligned, the tilt of each eye may rise upward, rest horizontally, or slope downward. Placing a construction line from inside corner to outside corner of each eye can help determine this angle.

The eyelids cover the spherical form of the eyeball. The upper lid is thicker than the bottom lid and more active in opening and closing the eyes. This thickness (plus the lashes) casts a shadow over the white and iris of the eye. The edge of the lower lid is upward turning and often brighter in color than the skin tone. At the outer corners, the lids meet like a hinge so that the upper lid does not cover the lower lid, although the overlapping of the upper lashes makes it appear so.

Note that the inner corners are set deeper and the center of the eyelids advance forward as they curve over the eyeball. The eye shape is often simply drawn as an oval, but consider its form more like a six-sided football. Therefore, draw the opening of the eye with straight-line segments, looking for the subtle change in angles. The eye fold above the upper lid reinforces the shape of the eye, and the distance between the edge of the lid and the fold should be carefully noted. From the line of the eye fold, the distance to the bottom edge of eyebrow can be clearly measured. Note the change of angle in the eyebrow revealed in the change of direction of the hair pattern.

The iris of the eye is a circle when viewed straight on. However, when the eyes look to the side, the circle of the iris is foreshortened into an ellipse. This is also true for the pupil centered within the iris. Note how the lids often conceal the top and bottom edges of the iris in a relaxed gaze and even more when the eyes are smiling. The iris can be drawn too large when the opening of the lids is incorrect; look for the height-to-width proportions of the white triangles on either side of the iris.

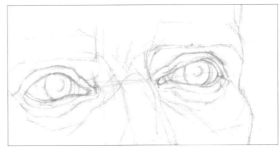

These schematic drawings map out the perspective of the eyes. First, short angled lines indicate the change of the curving planes of the eyelids. These construction lines measure the relationships between the forms.

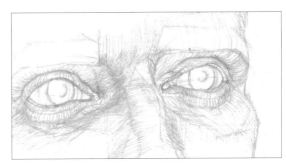

Next, cross-contour lines describe the transitions along the surface.

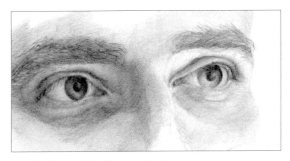

And finally, tonal shading reveals the contrasts of light and dark values, rendering the forms more dimensionally. Each of these stages gives the painter valuable information that informs the final painting.

PAINTING THE EYES

Painting the eyes begins with establishing the correct perspective and foreshortening of the eyes across the nose. The block-in drawing begins with a thinned mixture of middle-value pigment, slightly darker than the toned ground. Use a small round brush or the thin edge of a small filbert for crisp, thin lines. The strategy is to first paint in the eyelids and their context before adding any details of the iris and whites of the eyes.

Draw in the opening of the eyelids, noting the angles and checking the proportions. An oily mixture of a red-brown (Mars violet and burnt umber or an earth red plus black) is useful for describing the eye folds and edges of the eyelids. From the eye folds, this pigment can then be blended upward (following the surface contours) toward the arch of the eyebrow and downward to describe the form of the upper lid. This same pigment, mixed with a small amount of white, can also be used to paint the dull pinkish color inside the tear duct and the shadow side of the lower lids.

Observe the changing values over the eyelids. These are first painted with simplified value mixtures during the underpainting. The second layer of pigment further refines their value and local skin tones. Look for the yellow color note in the skin at the inside corners of the eyes. On the shadow side of the eye, look for the colors of the reflected light on the curving planes of the eyebrow. Careful blending is needed to keep transitions soft, especially when they are quickly changing, as in the transition from the inside corners of the eye up to the nose and eyebrow.

Once the lids of the eyes are established, it is easier to paint the whites of the eyes. Use a mixture of white, black, and a peppercrumb of burnt umber. The upper lid creates a shadow over the white of the eye, just as the inside and outside corners are slightly darker than that next to the iris. Any gleams of light on the iris or pupil will tell you where the brightest light should fall on the white of the eyeball.

Draw in the dark rim of the iris with an oily black, noting the subtle crescent shapes where the iris meets the white of the eyeball and the lower lid. Blend this oily mixture toward the pupil. Choose a pigment for the iris that matches the specific color note of the eye, even if it is not one of the colors on your palette. Notice how the iris (covered by the transparent cornea) is lighter in value, opposite to the direction of the source light even in dark brown eyes.

The pupil itself is best painted with a transparent oily black pigment so that the eye doesn't appear flat and opaque. The gleams of reflected light on the pupil and iris are best painted onto the wet black paint. Use a small brush to place and then slightly curve the stroke of the white paint over the contour of the eye, blurring the edges if needed. These highlights must be placed on the same angle on both eyes, even though one may be slightly darker in value.

For the upper lashes, use an oily mixture of brown-black rather than pure black or raw umber and yellow ocher (fair-skinned individuals). Pull

Painting the eyes in stages allows any misplaced paint on the dry paint surface to be "erased" without destroying previous layers.

A block-in "drawing" using a thinned mixture of pigment establishes the angles and position of the eye in relationship to the nose.

Using value helps to refine the forms of the eyelids and the context of the eyes.

Notice how the color of the iris is illuminated by the use of transparent paint over the toned ground.

Adding the final details, including lashes and eyebrows, involves a very small round brush and oily paint.

the paint from thick to thin strokes, from the edge of the lid outward, noting the curve of the eyelid. As the lower lashes are often more transparent, add additional oil. (These same mixtures can also be used to define the fine hairs of the eyebrows or the hairs of the mustache.) A dry brush can be used to blur the edges of the lashes if they appear too stark or dominant.

STUDYING THE NOSE

Compared to the eyes, with their many details, rendering the nose seems deceptively simple at first. However, the nose contains many swiftly changing and curving planes. In a portrait, the nose acts as a link between the expression of the eyes and the mouth. A badly painted nose can destroy this connection as well as distort the relationship between the features. For example, if the root of the nose is too narrow, the eyes will be placed too closely together; if the length of the nose is too long, it will exaggerate the size of the cheeks.

The nose begins at its root on the skull, a bony extension that rises outward from between the eye sockets. Rigid cartilage forms the bridge of the nose and the nasal passages to the tip of the nose. The tip and adjacent wings of the nose are made up of more flexible cartilage and vary greatly in shape and size from individual to individual. For example, in young children the bridge of the nose is underdeveloped, making the tip appear as a button nose, while in an Asian face, the bridge may slide in a slow arc to the rounded tip. The outward flaring of the nostrils may be affected by expression, age, or ethnic background.

The transition from the tip to the downward plane of the bottom of the nose is often marked by a core shadow or the highlight gleam (from oils on the nose). It is important to notice this transition from the top of the nose to the bottom plane.

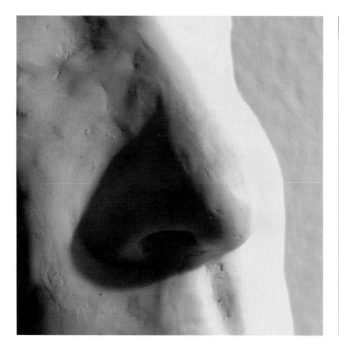
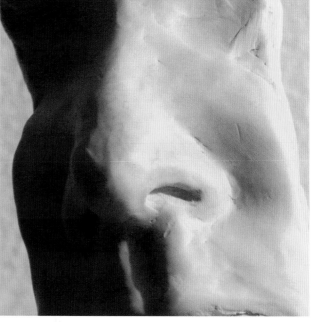

The wedgelike form of the nose is observed within the context of the sloping planes of the cheeks and the philtrum of the upper lip. When the clay model is tilted and rotated, the foreshortening of the nostrils can be clearly studied.

The angle of the nose is best observed by studying the three axes of the head, beginning with the angle of the eyes. Construction lines begin to define the wedge shape of the nose within the context of the surrounding planes of the face.

Next, cross-contour lines describe the subtle changes over the surface and details of the tip of the nose.

And finally, tonal shading defines the direction and strength of the light source on the nose, enhancing its form in perspective.

The openings of the nostrils are on this bottom plane, separated by the base of the nose (a blunt triangular shape), which sits between the depressions of the philtrum. The tilting or slanting of the head often determines how much of the nostril opening can be viewed. For instance, when the head is leaning forward, the bottom plane of the nose and nostrils will be foreshortened, barely visible. However, if the head is tipped backward, the bottom plane will be clearly observed.

Once the glabella and the root of the nose have been established, locate the side planes of the nose. Consider the nose like a simplified wedge with four planes: the top plane extends directly from the root of the nose; the two side planes slope downward into the corner of the eyes and along the cheeks; the fourth plane is the bottom wedge of the nose.

Observing the tilt or rotation of the head, draw a simple line (rather than a detailed contour edge) to establish the overall angle of the nose. The core shadow is one way of seeing this angle on the shadow side of the face. Alternatively, a bright gleam along the lit side of the nose can locate this angle. The length of the nose is extended to the highlight at the tip; however, as discussed on page 86, the key relationship is from the inside corner of the eye to the curling wing of the nose.

The shape of the nostrils should be rendered initially as straight-line angles to better observe their height and width proportions, while the opening of the nostrils can be thought of as the shape of a bent staple that hooks and curls at either end. The melding of the nostrils between the philtrum and onto the curving contours over the muzzle of the mouth requires close scrutiny.

PAINTING THE NOSE

After observing the perspective and foreshortening the nose, establish the block-in with the wedgelike planar structure of the nose in mind. During the underpainting stage, establish the light and dark transitions across the nose and define the bottom plane. At this time also paint the dark value of the cast shadow in a transparent manner. Use this stage to double-check the foreshortening. For example, if the head is rotated, the size and shape of the nostrils will be different. Focus attention on establishing the overall form in proportion and placement rather than details. Any paint should also be well blended, especially along the core shadow edge. The lightest value of the underpainting mixtures acts as a placeholder for the highlights; do not paint them now.

Refining the light and shadow values, begin with paint mixtures from the middle-value palette. Look for the subtle changes in the shadows that indicate reflected light as well as how the side planes of the nose transition onto the cheeks. Make any adjustments to the shape of the wings of the nose (where they meet the beginning crease of the cheeks) before defining the bottom plane. Avoid painting a thick, dark line to outline the wings of the nose; this is an intensely curving form, and the rapidly changing values need to be carefully blended with the tip of a small brush.

Closely examine the bottom plane of the nose, observing the core shadow at the tip of the nose and along the edges of the nostrils. Remember that the nostrils have a thickness that moves downward from the tip as well as inward. Do not indicate the opening of the nostrils with a solid dark shape. Rather, use a small round brush charged with an oily dark pigment (your shadow pigment) to draw the top and curling side edges. Then gently pull downward so that it is a transparent dark. The bottom opening of the nostril is rarely a solid line, even when it is in a cast shadow. Look for the presence of reflected light.

Paint the highlight last, layering the lightest value mixtures on top of the high middle values on your palette. The bright gleams on the tip of the nose should not be painted in a pure white as a dot, like a snowflake. Depending on the light source, a small peppercrumb of pigment (either a cool pink or warm yellow) should be added into the highlight and softly blended outward.

When painting the nose do not be surprised if it takes more than one painting session to achieve the subtle value changes and color notes in the reflected light. As the central feature of the face, the nose has many transitions—at the corner of the eyes onto the forehead, from the sides onto the cheeks, from the bottom plane onto the muzzle of the mouth. Painting the nose involves not just rendering its details but capturing its relationship within the context of the entire face.

Avoid painting the opening of the nostril as a solid dark shape; rather, draw in the upper edge with a crisp line and gently blend downward to a transparent soft edge.

During the initial layers of the underpainting, transparent darks are thinly applied over the block-in drawing.

Then middle values are used to define the plane changes across the wedge shape of the nose, onto the cheeks, and over the upper lip.

The reflected lights on the bottom plane of the nose were kept in balance with the light values created by the direct light.

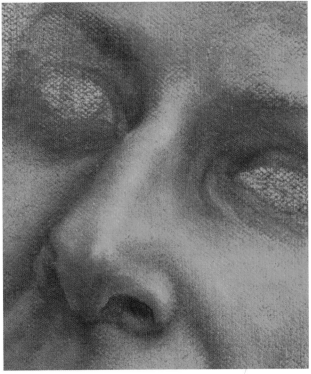

The lightest highlights were blended with soft, diffused edges.

STUDYING THE MOUTH

Painting the mouth presents its own set of challenges—rendering the texture of the lips, determining the right color note while describing its expression. The mouth is the most mobile of the facial features; the surrounding musculature allows the mouth to stretch and compress, as its fundamental role is shaping the sounds of speech. The mouth also reveals the most extreme emotions, from grief to joy, as well as the subtle nuances of physiological tension.

The mouth has a subtle way of re-enforcing the expression conveyed through the eyes as when the gleam of happiness seen in the eyes is reflected in the movement of the mouth. Likewise, ambivalent feelings can be conveyed when the eyes say one thing but the mouth is telling another story.

The area of the mouth includes more than simply the lips, but its surrounding context: the philtrum above the upper lip, the cheek folds and corners of the mouth, and the lower columns of the lips on each side of the lower lip. Much like the eyelids, which gain their form by covering the sphere of the eyeball, the mouth retains it form by curving over the teeth and the maxilla, the protruding muzzle of the mouth. Therefore, it is important not to draw the lips as a flat shape but as part of a curving cylinder.

Together the upper and lower lips comprise three planes (much like the six-sided hexagonal shape of the eye). Each of the side planes moves

The form of the lips wraps over the underlying teeth. These subtly curving surfaces create the framework for the mouth's expressive quality.

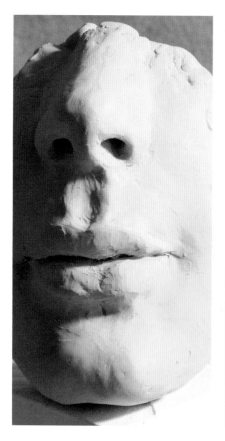
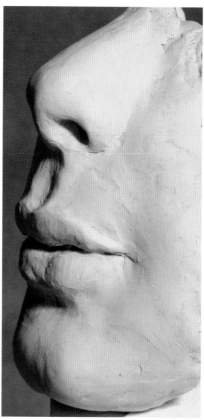
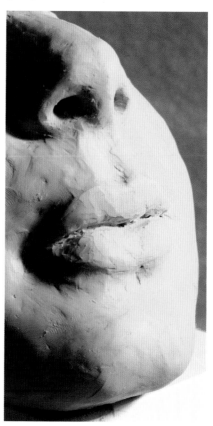

from the outside corners (deeper in space) to a center plane. (The latter can be seen on the lower lips as a horizontal oval.) The upper lip is a downward turning plane, often appearing darker in value, while the bottom lip is an upward turning plane, making it brighter with highlight gleams on its moist surface. At the corners, notice how the lips curve downward toward the crease of the mouth and that the corners of the mouth may extend past the color of the lips.

To achieve a convincing resemblance to your model, it is critical to accurately render the distance from the base of the nose to the color of the top edge of the upper lip. The thickness of the lips can then be measured from the edge of the top lip to the crack between the lips and then downward to the bottom lip. Drawing an imaginary line down the center of the philtrum helps to determine the foreshortening of the mouth as it rotates from side to side. The tubercle of the upper lip (a wedgelike shape that begins from the high points at the philtrum and goes to the center of the upper lip) is another landmark that reveals the foreshortening of lips. Likewise, notice any change of the angle of the mouth from corner to corner. For instance, a partially smiling mouth may have one side higher than the other. Notice how in a full, broad smile, the lips are stretched over the teeth, thinning the thickness of the lips and smoothing the contour edges.

The protruding lower lip will cast a shadow that helps define the volume of the lower lip—over the under plane that transitions from the context of the lip to the upward-tilting plane of the chin.

Rendering an open, smiling mouth requires careful observation of the distance between the edges and contours of the parted lips. The particular shape and tilting angle of the teeth must be noted as well as the dimensional quality of the front teeth (as each tooth has a front and a side plane). Foreshortening the teeth is accomplished by darkening or blurring the edges of the side molars as they recede into space. Making the white of the teeth too bright in value will tend to pull them forward, as they are rarely pure white save for a few highlight gleams. (A mixture of white, black, and a peppercrumb of burnt umber will generate a dirtied white rather than a steely gray for painting the color of the teeth.)

When the mouth is obscured by facial hair, such as a beard and moustache, careful observation is needed to perceive the underlying forms (context of the mouth and lips) before rendering the texture and pattern of the hair. These details are better placed afterward so that they appear a part of the overall surface forms.

Rendering an open and smiling mouth is especially challenging because the lips are pulled over the form of the teeth. First, short straight-line segments capture the subtle curves in the contour edge of the lips.

Next, cross-contour lines describe the changing directions of the surface over the forms.

And finally, tonal shading develops the texture of the lips and the cast shadow over the teeth.

PAINTING THE MOUTH

Once you've indicated the placement of the mouth with thinly painted lines, establish the context of the mouth with the underpainting paint mixtures, leaving the details of the lips for the middle-value palette. The initial painting stages establish the form of the lips by value changes; the latter establish the local color.

Evaluate the planes above the lips and the furrow of the philtrum for changes in value. The cast shadow from the nose will curve over this form (or the cheeks) and should be painted as a transparent dark. Often the folds of the philtrum will catch small shadows, which will curl as they meet the upward-turning edge of the lip color. Note how there is a brightening of the skin's flesh color just before it meets the edge of the upward-turning edge of the lip, but it darkens in value as the corners turn downward.

The lower lip usually has a soft transition where it meets the color of skin on the outward corners, but then it tends to curl more intensely in the center, creating a small shadow beneath the center of the lower lip. Matching the values between the skin color and the lip color at the outward bottom corners is one way to keep this transition soft. (This same idea can be used when there is no clear or sharp edge on the lower lip itself from the skin tone.)

Closely observe the corners of the mouth, specifically where the upper and lower lips meet the cheek folds. Use a small brush to carefully blend the swift transitions in value where these curving forms meet. This will help capture the hints of a wistful smile and the dimples at the corners of the mouth.

To paint the lips, first draw in the crack between the lips, using an oily dark tone (such as alizarin crimson and burnt umber or black) and a fine round brush. Look carefully at the subtle movement of the contour line over the fullness of the lips. This same oily paint can then be pulled over the cross-contours of the lips to create the textures or the core and cast shadows on the lips.

A dull violet (Mars violet and white) is a good base color for establishing the underlying color of the lips. It should be applied so that it blends into but does not cover the previously established darks on the lips. Then layer additional pigment, building the red-pink color variations and adding the highlight gleams last. Reinforce the cross-contours or texture of the lips by pulling your brush from the crease to the edge of each lip. (Avoid the temptation to pull your brush from side the side, which would flatten the form of the lips.) Notice how the upper lip of an opened mouth often casts a shadow onto the gums or teeth, much like the upper lid of the eye casts a shadow on the white of the eyeball. This should be rendered with a transparent, glazy paint once the teeth and lips are dry.

Define the lips by painting their surrounding context first: the curving surface between the nose and upper lip, the cheek folds, and the columns of the lower lips. Then focus on the texture and delicate curve of the lips.

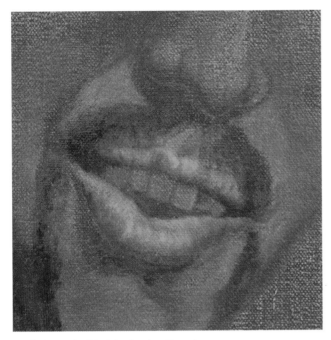

Applied over the block-in drawing, the value underpainting establishes the curling cross-contours form of the lips, subtle edge of the open mouth, and shapes of the teeth.

Middle values of thinly applied paint (gray plus a dot of burnt umber) begin to define the areas surrounding the mouth and blocked in teeth.

The volume of the lips is further developed using brighter pigments of the local color pulled along the cross-contours.

The highlights on the lower lip and teeth were painted by moving the brush with the cross-contour.

STUDYING THE EARS

Although the ears are rarely the focus of a portrait (especially when they are often partially covered with hair), it's still important to know how to paint them well. Before tackling the ears, it is best to first establish the width of the side planes of the face, as often the ears are placed too close (making them appear to grow out of the side of the cheek) or too far (which distorts the width of the side of the head). This is especially true when painting the face in a frontal view, where the foreshortened side plane of the face is moving swiftly back from the corner of the cheek to the ears.

In a profile, the ears rest at the center point on the skull from the face plate to the back of the skull. In a frontal view, the ears are visible as they protrude from the sides of the head, which slant from the narrow front of the face toward the wider back of the skull. The ears are located behind the hinge of the jaw and in front of the strong muscles of the neck. A general guideline for locating the placement of the ears is that the top should be in line with the eyebrow and the bottom of the nose. However, if the chin is slanting upward or downward, the placement of the ears will be unexpectedly higher or lower. The size of the ears varies between individuals (just as the earlobe can be attached to or separated from the side of the face). In addition, aging also often causes enlarging of the form of the ear.

When simplified, imagine the ear as a small bowl (the concha) surrounded by a broad rim of folded cartilage that arcs in a C shape ending

The structure of the ear is best memorized by making many study drawings, as it is often obscured by the model's hair or highly foreshortened. Clay models, such as this one, serve this purpose well.

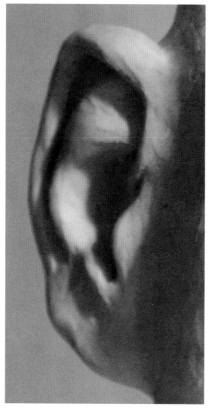
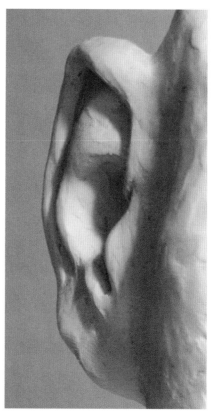

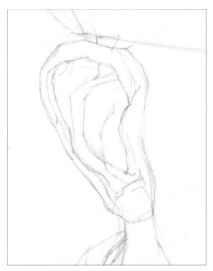

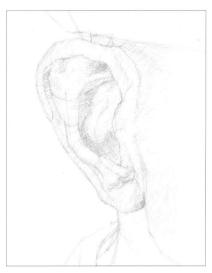

A schematic outline of the ear locates the proportions of the ear and indicates the overlapping of the forms, within the ear itself and onto the planes of the face.

Cross-contour lines reveal the folded surfaces of the ear, which range from convex to concave.

Tonal shading enhances the subtle transitions, such as the contrast between the convex and concave forms.

at the earlobe. The flap that covers the ear hole (the tragus) extends from the side of the cheek (below the zygomatic arch) and meets the lower rim of the ear at a notch just above the lobe. (We instinctively press on the tragus to discourage loud sounds or water from entering our ears.) The top rim of the ear (the helix) curls downward, behind the tragus, blending into the bottom of the concha's bowl shape. This overlapping of the two forms is key to making the ear appear convincing in perspective. The shape of the ear can simply be thought of as vertically divided into thirds: the top of the helix to the top of tragus, the length of the tragus, and from the bottom of the tragus to the end of the earlobe.

A good landmark to begin drawing the ear is where the tragus rises up from the side of the face, catching the light; it creates a strong line against the dark of the concha. Note its angle and length to the perspective of the face. The bowl shape of the concha can first be drawn with smaller, angled lines to establish its width and length (proportion); then the edge of the outer rim of the ear is drawn last. Begin with these larger forms, checking proportions, foreshortening, and angles before placing any details, such as the folds of the ear rim or the lobes of the ear.

Additional reference material (such as another photo of your model at a different angle, a sketch of your ear seen in a mirror, or a clay model held up at the same angle) may be needed to see how foreshortening affects the forms of the ear. Since the structure of the ear is made of cartilage (much like the tip of the nose), its shape and form are unpredictable, making it require further study in order to understand its structure. This becomes valuable information when the ear is partially covered with hair; paint the entire form and then paint the hair over the ear. The same strategy applies to earrings; paint the lobe of the ear and then the jewelry.

PAINTING THE EARS

Once the side planes of the face are clearly established, it becomes much easier to correctly position the placement of the ears in relationship to the side planes of the face and neck. Also consider their perspective: Will slightly blurring the edges help them recede into space? Drawing in the ears first with thinned paint is one method for establishing their perspective before proceeding with thicker applications of paint.

Overall, the ears can be painted using a wet-on-wet painting approach, working from dark to lights. A dark, plumy paint mixture (made of a cool red, black, and/or burnt umber, for instance) is first painted to outline the shadows of the helix, outward rim of the ear, and either the bowl of the concha or the notch between the tragus and the lobe. (The same paint mixture that is used to establish the shadow corners of the eyes, lips, or curl of the nostrils can also be used to paint in the darks of the ears.) Middle values are then applied to build the transitions into the lights and to sculpt the subtle folds of the ear. When the translucent ear is backlit, intense color will be noted (distinctly pink or reddish compared to the dull or dark purple in the shadows). This color is then placed and blended into the context of the surrounding values. The oily gleams on the ears (like the gleams on the nose) are painted last and should not appear as snowflakes.

Working in wet paint allows for a certain freedom in diffusing or blending edges, which keeps the ears at the appropriate amount of focus or level of detail when considering your point of view and perspective to the face. However, applying a thick or opaque layer of paint when the ear is partially hidden makes it more difficult to overpaint light or wispy strands of hair later.

Take note of the sharp-to-soft edges—the crisp edge against the tragus as it overlaps the concha and the soft edges as the concha rises up to the rim of the ear. The sharp, curving edges of the folds on the rim of the ear can also be painted with the same dark pigment mixtures, blending from a sharp edge to a softer, diffused transition over the ear folds.

Do not be surprised if certain details of the ears—such as the modeling of the tragus, the reflected light within the bowl of the ear, the curling contour of the outer helix of the ear rim, or the edges of the earlobe as it meets the side of the face—need further refinement.

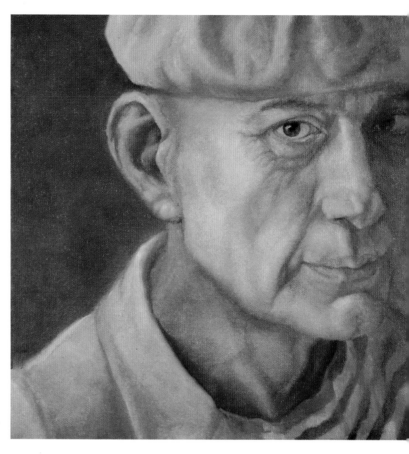

Suzanne Brooker, *Seth*,
2009, oil on canvas, 8 x 8 inches (20.3 x 20.3 cm)

Although the ear is rarely the focus of a portrait (particularly when compared to the dynamic of the eyes), it can become a strong element in the composition of a painting.

Paint the ears after the side plane of the cheeks, remembering their placement behind the jaw and before the strong muscles of the neck; otherwise the ear could appear to be growing out from the cheek.

From the block-in drawing, a thin layer of paint of dark pigment is used to sculpt the shadow forms of the ear.

Next comes the buildup of the middle values, with attention to the soft-to-crisp edges as the forms bend and curl.

Because the ear is translucent in nature, any observed intense color notes can now be added.

Final adjustments can be made in the wet paint to further blend edges, reinforce the darks, or add gleams of highlights.

THE **PAINTING PROCESS** CHAPTER FIVE

A PAINTING SESSION BEGINS with having all the physical elements of the studio in place—adjusting the easel so the center of the canvas rests at your eye level (whether you are standing or seated), setting the lighting so it is bright but indirect, and preparing and positioning the palette so it is at a comfortable height to your painting hand. In addition, your palette knife and brushes should be clean and ready to use, jars of OMS solvent or oil should be set out, and so on. The more orderly your working space is, the more you can ignore it and focus on the painting process.

OPPOSITE:

Robert Armetta, *Ted,*
2006, oil on linen, 36 x 27½ inches (91.4 x 69.9 cm)

For a contemporary artist, the painting process can benefit from a merging of Old Master techniques with a wet-on-wet, direct painting approach. This allows the artist a greater range of expression when responding to the unique characteristics of a model and his or her artistic intention.

Any study sketches or photographs should also be at hand for easy reference. This should include any color mixing studies or experiments done on gesso-prepared watercolor paper. A notebook can be helpful for recording pigment choices, organizing color recipes (as discussed on page 53), and helping you remember the limited palette for each painting. Having a swatch of watercolor paper (prepared with the same toned ground as your canvas) is another means for creating a visual record of your palette. These are aids for learning to anticipate the final effects of your limited palette on the toned ground.

As you sit before the canvas, take a moment to think about what you want to accomplish with the time you have allotted for the current painting session. This will help you establish what is most important at each step of the painting process. Is getting an accurate block-in drawing the priority, or are you creating the value structure of the forms? Is this the point where you should be considering the coolness of the shadows or focusing on the details of the features?

The crucial idea to keep in mind is that this a staged painting. In order to gain the most from the transparent layers of pigment and obtain the greatest optical color effects, one layer of pigment must influence the next. At the beginning stages of a painting, do not be disconcerted if the

skin tones look weird or unnatural. You are not trying to directly match the skin tones, but rather to arrive at the final effect indirectly through the transparent layers. Therefore, you need to apply each layer of paint with care, controlling the density of the paint and blending the transitions in value.

The following chapter describes the overall process in detail—how to build up the painting from the initial block-in drawing to the underpainting to the color effect over the toned ground. Refer to this section often as you marry your intellectual understanding with the felt experience of putting it into practice.

SELECTING A TONED GROUND

Choose a toned ground based on the quality of light of the image, as in direct sunlight (warm) versus diffused northern light (cool). A cool, dark ground (made from raw umber and alizarin crimson, for instance) will support the shadows and reflected lights; a cool ground (such as a midvalue gray) can be useful in describing the subtle shadows of indirect lighting; while a warm ground (based on burnt sienna or yellow ocher, for example) may help describe the warmth of light.

The value and temperature of a toned ground plays a particularly important role in the development of a portrait painting, as it interacts with the pigments that are chosen to render the skin tones. Consider how peachy-pink skin tones will contrast to a green toned ground or how warmer, ruddy flesh tones will be reinforced by a cherrywood-like ground. A toned ground generates a certain glow when the hue of the ground is backlit by the gesso. It is important to plan ahead and know where the toned ground should be painted more transparently so as to not lose this glow.

A prepared sheet of watercolor paper toned with the ground color is one way to anticipate the effect of a thinly painted color mixture: will a neutral gray appear more violet on a yellow ground or blue on an orangey ground? will a shade of dark pigment retain the luminous effect of the shadows? (You might want to review the exercise on pages 60 to 63.) Since the density of the paint layer effects the color note, how can the same pink mixture appear neutral when thinly painted over green and then brighter when thickly applied? The toned ground can also be useful in creating transitions between values when it is already exactly the right value and temperature. Reserving the ground for these moments is a combination of discipline (not painting everything opaquely) and experience.

The same model is interpreted using three different grounds and palettes. On the top, a cool gray ground was beneficial for rendering the soft transitions in the middle values using a palette based on Mars brown. In the middle, a strong warm light is implied when a cherrywood ground was used, and burnt sienna served as the core red of the flesh tone. On the bottom, alizarin crimson and raw umber were used to tone the ground and to provide the flesh tone palette with a final glaze of transparent yellow, transforming the pink-green tints with a golden glow.

Instructions for preparing the canvas and examples of toned ground can be found in chapter one on pages 28 to 35. Generally, a toned ground (even a golden yellow ground) is midvalue; whereas a toned ground that is dark in value is more useful as the basis for a grisaille approach, developing an underpainting in values using mixtures of ivory black, flake white, and raw umber and then glazing over in color. This is discussed in more detail on pages 130 to 131.

The interaction between the toned ground and limited palettes can be seen in the study paintings of Sarah on the facing page. A cool gray, burnt sienna, neutral red-green, and golden ground influence the intensity of the light on the model and the appearance of each palette. The luminous glow of the ground is preserved by the thinly applied layers of pigment, unifying the overall image. The gesture of the model changes with each new interpretation of value contrast, color temperature, and paint handling.

Having a test swatch of canvas paper on hand—one that features the same toned ground as your stretched canvas—can help you anticipate color effects during the painting process.

CREATING A **COMMISSIONED PORTRAIT**

A formal portrait commission requires a careful study of the model, including study drawings and oil color studies, before you are ready to execute the final work. Be aware that your patron may have a specific style in mind (formal or impressionistic)—and that sometimes he or she is not always able to articulate this desire until the painting is finished. Therefore, your personal, artistic expression will need to be put aside in favor of the patron's sense of taste and appropriateness, requiring the client's approval at each stage. This series of steps (creating study drawings of the face, testing color palettes to the final realized painting, etc.) can also be helpful for the creation of any portrait.

Patricia Watwood, *Clarence Harmon,* 2002, pencil and white chalk on toned paper, 14 x 10 inches (35.6 x 25.4 cm)

Preliminary study drawings help to capture the likeness of the subject.

Patricia Watwood, *Color Study for Clarence Harmon,* 2002, oil on paper, 10 x 8 inches (25.4 x 20.3 cm)

Oil studies help work out the palette and color choices necessary for rendering the exact skin tones.

Patricia Watwood, *The Honorable Clarence Harmon,* 2002, oil on canvas, 24 x 18 inches (60 x 45.7 cm)

The success of a formal portrait requires the artist to forgo artistic interpretation and paint the subject as he or she wishes to be seen.

BLOCKING IN THE IMAGE

The initial block-in drawing establishes the scale and placement of the model within the compositional idea and the key relationships of the facial features. Regardless of the method that you use to block in your image, you must take care to remain sensitive to the dynamics of the model. You may decide to draw freehand directly on the canvas, scale up and transfer through a grid, or trace from a study drawing using transfer paper. Each of these block-in methods requires a focus on the drawing process to gain an accurate resemblance to the model.

Drawing on the canvas is best done with thinned paint. (Using graphite or charcoal on a white gesso ground requires that you apply a barrier—such as spray fixative or varnish—on the canvas before you start to paint; this creates a film that lessens the adhesive bonding between the canvas and subsequent layers of paint.) Select a pigment that is only slightly darker or lighter than the toned ground and thin the paint (with OMS solvent and oil) until it is just fluid enough to draw thin lines. The sharp edge of a filbert or pointy tip of a round brush will give precise lines. If you find that you need to make a change, you can easily rub off the undesired marks with a clean paintbrush or a rag moistened with solvent. Although drawing with a brush requires some practice, it guarantees the greatest flexibility in making changes, keeping the block-in drawing transparent (rather than opaque), and building a consistent paint surface.

When working on a toned ground (especially one that is prepared with oily paint) it is *not* an option to draw on the surface with graphite or charcoal. Historically, artists such as Albrecht Dürer transferred their drawings with chalk onto the white priming (before toning the ground) and then traced over the drawing with ink. This approach is not a recommended unless you, like Dürer, are a master draftsman. Although this may seem an easy way to expedite the process of establishing the drawing on the canvas, less experienced artists will relinquish the drawing mode of perception and tend to merely paint within the lines. Directly transferring a (meticulous) study drawing onto the canvas also implies that the final painting is exactly the same scale as the drawing. Special transfer paper is taped between the drawing and the white gesso surface and traced over with a pencil. The simple outline drawing is then inked in with a nonsoluble pen and the toned ground is applied over the drawing. Like drawing in graphite or charcoal, drawing in ink is permanent, which allows very little flexibility for adjustments, and is painted over with more opaque layers of paint.

This student block-in drawing was created with burnt sienna pigment that was thinned with a 50/50 mixture of oil and solvent, which kept the paint both movable and transparent.

ESTABLISHING THE UNDERPAINTING

The purpose of the underpainting is to create the form of the model, using light and shadow that provides the value foundation for a painting. Often, when working from a live model, the block-in and underpainting processes are merged together—as the mode of thinking "in line" blends with describing "in tone." More developed underpaintings include a grisaille approach (achromatic, black plus white) or a monochromatic approach using white and black plus a hue, such as in a green underpainting. When a green monochromatic approach is painted over a neutral ground (black and white plus yellow ocher) the resulting color effects are different from when the same pigments are painted over a toned ground of a complementary earth red (such as the burnt sienna ground shown on page 61).

The wipe-out method is one way to create an underpainting when a movable toned ground is preferred, such as with quick paintings created from a live model, as it allows a wet-on-wet painterly approach. Begin with a white, gessoed surface. Then prepare your paint by thoroughly mixing a small portion of OMS solvent (plus a few drops of oil if the paint is stiff) into the pigment. (As with a dried toned ground, decide which pigment choices will both enhance the quality of the light source and flesh tones.)

Apply the paint with a large brush evenly and thinly across the entire surface. As when toning a ground, the white of the gesso should backlight the color. A soft paper towel or rag can be dragged lightly over the surface to even the color stain and dry the surface for easier applications of pigment. The result should be a midvalue color, which will allow any additional paint to appear darker and any areas that are wiped off to appear lighter in value. The thinned paint should stay movable for 2 to 3 hours, allowing a careful blending between areas. Once dry, the resulting painting will establish a simple monochromatic underpainting that represents the light and dark structure of the face.

When using the wipe-out method, a brush that is moistened in turps will pull away even more paint than a dry rag to create the highlights.

This student work exemplifies a movable value block-in based on a stain of burnt sienna and burnt umber. After a rough drawing was established, the darks and shadows were blended into the wet surface, even as the lights are "wiped" out using a paint rag.

This student value block-in, based on color temperature, utilized the same wipe-out process. However, ultramarine blue and yellow ocher were added to the equation to respectively cool/darken and warm/lighten the value mixtures.

WORKING IN **GRISAILLE**

A grisaille is simply a painting made using various mixture of black and white—or gray, and hence its name. This approach benefits novice painters, as it emphasizes the process of perceiving the value structure (much like a graphite or charcoal drawing). For intermediate painters, making a grisaille painting anticipates glazing pure color over the underpainting.

A grisaille can be approached in one of two ways. On a white surface, the paint can be applied in a direct manner, opaquely building the value range from lights to darks. Alternatively, a dark toned ground can be used, incorporating a negative approach. Instead of painting in the dark values, the initial dark ground is allowed to show through subsequent, thinly scumbled layers. The overall painting progresses from dark to light, scumbling in thin layers over the darks and building denser, more opaque paint for the lightest lights that support the color effect of the final glazes.

Ivory black, flake white, and raw umber are the traditional pigments used in a grisaille. Black plus white generates a cool gray, but the raw umber gives the mixture a certain warmth. A wide range of subtle, nuanced grays can then be created by changing the amount of raw umber in the various gray mixtures. Remember that the same value of gray can appear to advance or recede in space depending on its temperature (warmer or cooler respectively).

The dark toned ground in a grisaille underpainting is not black but burnt umber mixed with a pigment to provide a richer under tone, such as phthalo green, alizarin crimson, or ultramarine blue. The toned ground is opaquely applied and must be completely dry before beginning. The block-in drawing is done with a very low-value gray that is slightly lighter than the ground tone. Changes in the drawing can be simply wiped off or removed with a brush moistened in solvent.

Great care must be focused on slowly building up to the lights, as if the image is emerging from the shadows. The first layer of pigment is lightly scumbled or thinly applied over the dark ground to create the first layer of optical grays. (The value of the pigment mixture can be first "tested" on the margins of the painting.) Once the paint has been opaquely applied, it is difficult to recover the effect of an optical gray or luster. The pigment itself should not be thinned with OMS solvent or with additional oil unless it is too tight to move easily over the surface—too much solvent makes the paint leaner than the toned ground, and too much oil makes the paint fat and slow to dry. It is important to keep the paint surface leaner than the following glaze layers.

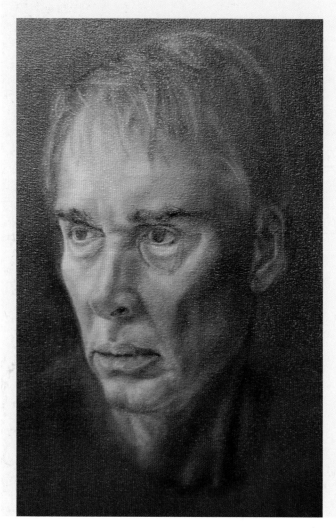

Over a rich, dark ground, this student's example of a grisaille builds up in value so that the thickest layers of paint reside in the lightest values. All the details and subtle transitions are well defined before the final glaze colors are applied.

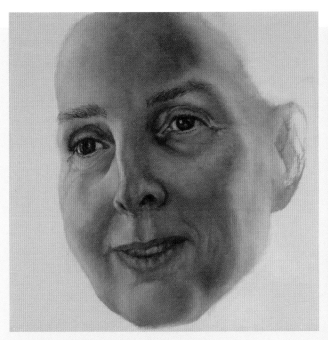

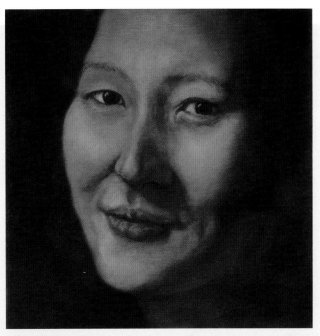

A grisaille study of warm-cool grays over a cool gray ground, using raw umber as a means to vary or warm the gray value mixtures.

A cool gray grisaille over a cherrywood ground, where the gray mixtures of black and white take on a distinct blue tendency due to an optical complementary contrast.

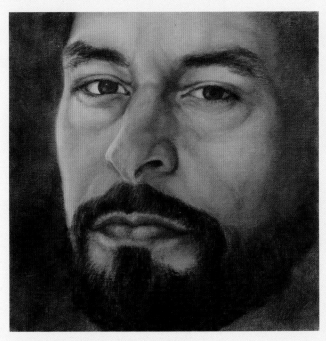

Even a toned ground of transparent terre verte can effect subtle change in the gray mixtures of ivory and noir de pêche (black) with a neutral cool effect.

Over a thinned stain of Venetian red, noir de pêche (black) reveals its slate greenish undertone contrasted to the pink ground.

TRANSFERRING A DRAWING TO YOUR CANVAS **USING A GRID METHOD**

Laying a simple grid over a drawing, photograph, or digital print can help you scale up the proportions for your painting. Determine the ratio between the source image and the final size. For instance, turning a 4 x 6–inch photograph into a 12 x 18–inch painting means you will be enlarging the image three times.

Use a ruler to demarcate 1-inch intervals along the length and width of the original image. (Tracing paper or a plastic sheet of Mylar works well taped over original photographs.) Then, using thinned paint, draw a grid using 3-inch intervals over the canvas. You can now plot out a simplified contour drawing, using the two grids as a means for enlarging the figure.

Once you have indicated the simple line drawing on your canvas, step back and consider the scale and placement of the figure. Is this the painting you want to paint? Are the head and features too small or too large? Does the face feel uncomfortably confined by the edges of the rectangle? Is your composition too symmetrical or static or awkward? If you are not entirely happy, this is the moment to change your mind and wipe off or adjust your drawing. Remember that any method used to create your block-in drawing will require further refinements to establish the key relationships of the features as the painting progresses. See pages 142 to 143 for additional tips on scaling and cropping photographic images.

A digital print of the model is gridded out, allowing for more space on the left side. Adjusting the position of the model on the canvas resulted in a better composition for the final painting.

RIGHT:

Over a cherrywood-like toned ground of burnt sienna and burnt umber, the enlarged grid is lightly drawn in with thinned paint. Placing the block-in drawing is then a matter of transferring a simplified contour line drawing from the original image.

EMPLOYING VARIATIONS ON A **MONOCHROMATIC UNDERPAINTING**

Another approach to underpainting—one that may be thought of as originating with the tradition of an egg tempera painting and continuing in oil mediums with painters such as Vermeer—is to meld a green underpainting with the visual, optical allure of red pigment in the overlying flesh tones. With this method a monochromatic underpainting (of black, white, and green) is applied on a dried neutral ground, such as a midvalue gray or a gray plus a touch of yellow ocher.

A variation of this approach, in the image below, used an earth red ground (which evoked cherrywood) to create a complementary contrast in the underpainting. The green palette for the underpainting was based on a large mixture of terre verte plus flake white. This basic middle-value mixture was divided into four smaller lumps, three of which were modified: one with raw umber to darken it,

another with ultramarine blue to cool it, and the third with yellow ocher plus white to warm and lighten the value.

This contemporary interpretation of the traditional green underpainting imposed color temperature into the value structure to intensify the warm-cool relationship. The goal of the underpainting was not only to define the movement of light to dark but also to define the subtle anatomy of the neck and shoulder girdle in terms of the cool shadows and reflected lights versus the warm of the light source. Several painting sessions were required to achieve the careful blending between values shown below.

Variations upon this monochromatic underpainting strategy can also be viewed in the following demonstration paintings: *Bryson with Kite* (pages 148 to 155), *Sarah* (pages 172 to 179), and *Pigeon* (pages 188 to 195).

The luminescent effect of the toned ground served as a complementary contrast to the green underpainting. Variations of warm and cool pigment mixtures set the stage for the following layers of the flesh tone palette.

PLANNING FOR **TRANSPARENT EFFECTS**

An underpainting need not be restricted to a monochromatic palette; it can also begin as a colorful but transparent underpainting, helpful for developing the most luminous color effects from the toned ground. With this method, the underpainting begins by creating a layer of transparent colorful darks and thinly painted cool, low-middle values. The underpainting in this case does not create a full value range; instead it allows the glow of the ground to appear through the thinly painted layers for optical color mixtures that provides a transition to the middle and light values.

The overall color schema of an image should be determined before you begin the underpainting. Select your pigments with the goal of yielding the greatest range of variations while unifying the overall image. (Refer to chapter two for ideas on how to organize your palette.) The palette, combined with the hue of the toned ground, should be based on the warmth or coolness of the light source and the nature of the model's skin tones. Ask yourself: Is my light source more golden, greenish, or violet? Does the model have peachy, pinkish, swarthy, ruddy, olive, or chocolate skin tones? How will the toned ground influence and support my palette? Of course, you should also be ready to adjust your palette later for specific moments, such as the dull mauve of the lips, the clear blue of the iris, or the metallic gleam of jewelry.

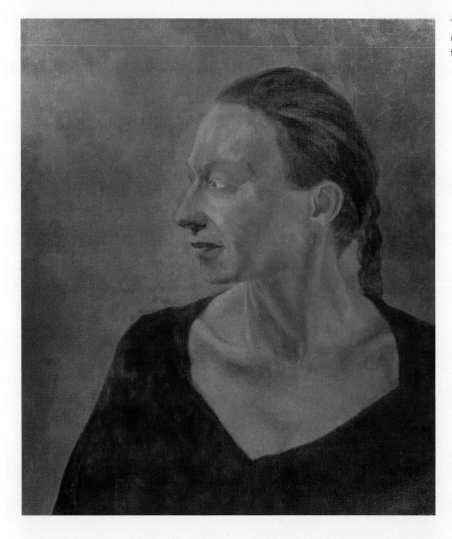

Transparent darks, shown here over a green underpainting, are thinly painted to create the coolness of the shadow areas.

BUILDING THE PAINTING FROM DARK TO LIGHT

The process of building a painting from dark to light has many advantages. The darks and reflected lights can be transparently applied over the toned ground, which creates an optical glow. Layers of warm and cool middle values establish the transitions of the forms with color temperature and provide a smoother transition for the lights. The final application of light values adjusts the overall value range and creates the accent sparks of highlights as the final, thicker layer of paint before glazing.

Shadows appear more credible when they are painted transparently. Adjust the values by varying the thick-to-thin applications of pigment.

ESTABLISHING THE DARKS

This first phase of the painting involves establishing the transparent darks, including both core and cast shadows as well as the reflected lights. Your paint mixtures at this point should be low-key or dark in value, and you should focus on the coolness of the shadows. Even the middle or light areas of the face should be painted now in darker values than what you see. This paint will act as a transition for the buildup of additional paint.

Avoid adding too much white or yellow to any of your mixtures. Instead look for the underlying cool or neutral colors in the flesh tones. These are often found in the small shadows areas—for instance, around the edges of the eye socket, the cheek folds, or on the columns of the lips. These low-key mixtures also provide a transition for the core shadow into the areas that will be the light values, which are painted later.

Paint the dark areas with great care and beauty so that you preserve their transparency. The reflected lights are also more credible when they are painted transparently at this point. Look for the source of the reflected light as a cue to its color and temperature. For instance, is the reflected light an effect of the intense color of the clothing, or is it a light that bounces up from the front of the chest?

Creating a luminous effect in the darks requires putting very little paint on the canvas. Place your paint thinly across the surface by brushwork rather than by thinning the pigment. Avoid adding any oil medium into the paint mixtures unless it is specifically needed for blendability. Pay attention to filling in the texture of the canvas surface, leaving a thin veil of paint over the entire block-in of the face and neck or hands.

Begin at the glabella, checking once again for any small changes in the initial block-in drawing, and proceed outward to the contour edges (the place most likely to change along with the placement of the ears). All the edges should still be soft and well blended, leaving room for changes as the painting progresses from big relationships to small details. The relative values, even in the lights, are still low in value and tend toward coolness in color temperature.

LAYERING FROM TRANSPARENT TO OPAQUE

The middle values serve as the bridge that transitions from the transparent darks to the more opaque lights. These areas of the face are usually filled with subtle changes in color temperature rather than distinct differences in value. Often the same color mixtures used in the darks can now be adjusted with a greater percentage of flake white to raise their value. However, to generate variations in color, make a middle value mixture from the core earth red of the palette and flake white; then slightly cool, warm, or neutralize this mixture with pigments from the limited palette. (See page 54 for an example of creating variations in temperature using one tint mixture.) As a bridge, middle values also include the notion of high-middle values (more white plus yellow or color intensity) or low-middle values (with addition of more blue or burnt umber or black), linking the previously painted darks to the soon-to-be-painted light values.

When the paint is applied more thinly over cool darks or the tone of the ground, the resulting optical color effect is influenced by the underlying pigments. The density of the paint (a thinly applied layer of paint verses a thick layer) will make the same pigment mixture appear different in intensity. This was one technique used by the Old Masters to gain the most from a limited palette of pigments.

Building up the middle values often takes more than one session to complete. It is often easier to build up the middle values after the surface has dried to the touch (overnight or even up to two days). This facilitates having the greatest control in blending new paint over the surface. When you're waiting for paint on the figure to dry is a good time to work on developing the background layers and the model's garment or simply switching to a different painting while the paint film is adhering to the canvas.

The middle values help to define the details of the face. Pay particular attention to clarifying the structure of the eyelids, nostrils, and the area around the lips. You can think of this process as defining the features negatively, such as defining the eyes by first painting the lids. Keep edges soft and well blended. As the form of the face begins to emerge, the need for small changes in the drawing will become more noticeable. Return to the darker mixtures when necessary to restate the drawing or mend the placement of the darker shadows values.

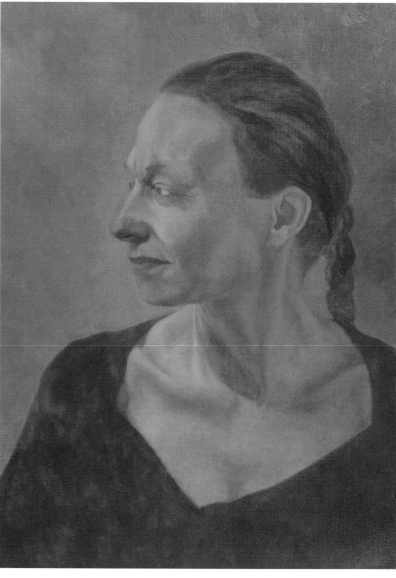

The process of building up the middle values includes using mixtures of pigments that have been warmed, cooled, and neutralized—thinly painting and carefully blending them over the darks.

Avoid working on a canvas where the paint is no longer wet but not quite dry, as it is likely that you will tear off the previous paint that has yet not adhered to the surface.

ADDING THE LIGHTS

Before painting in the lights, check the overall painting for any sinking in of color values. Oiling out the canvas at this point can renew the contrast of darks and lights, restoring the brightness of the color mixtures and revealing the blended transitional edges. (See page 71.) Any abrupt or rough edges between values should be corrected before painting in the lighter values. This can be painted over the oiled surface to help meld the new paint to the old.

This stage of the painting is best done after the background, hair, and clothing details have been addressed. The lightest lights create the greatest contrast, immediately making the darks and low values appear darker. Therefore, they are best judged after the overall context has been established.

The lights are a transition from the brighter middle values into the lightest values—with warmer, intense color mixed with a greater ratio of yellow and white. The stronger the warmth of the light source, the warmer the lights will appear. However, if you are too bold with the yellow, your face will soon resemble a lemon ball. (A final glaze of rose doré can sometimes solve this problem.) By using a similar value of cool pink lights, you can create a visual balance between the warm and cool lighter values and establish optical blending.

Highlights should neither be painted in pure white nor with hard edges. Rather, you want to suggest gleams of intense light. White is a cool color and therefore should be slightly tinted with pigment to suggest the intense warmth of the light source. However, any bright, reflected light along the shadow side of the face should not only appear cooler but should not compete in value with a warm source light. Remember, nothing will corrupt the form more than incorrectly placed value in the reflected light.

Stand back from the easel and review the effects of the lights within the context of the whole image. This is the moment to consider whether glazing should be employed to darken or cool the dark areas or to tweak the color in the light areas. It's also a good time to consider how the background is working in context to the figure. Could it be simplified, perhaps, or pushed further back into space with a glaze? The afterword on pages 204 to 206 offers additional advice about how to bring your painting to completion and problem solving.

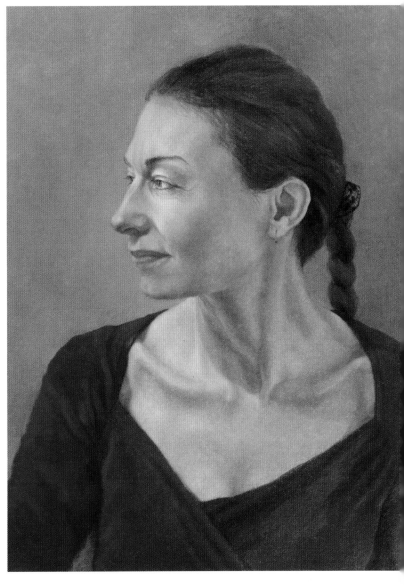

To establish the contrast of values in the flesh tones, the lightest values are carefully blended over the high-middle values.

EXAMINING AN **ALTERNATIVE APPROACH**

The painting process featured on the previous few pages describes an indirect painting approach that builds transparent layers of paint for luminous color effects. However, each artist develops his or her own methods, according to taste, sensibilities, and preferences. This step-by-step demo painting illustrates Robert Armetta's approach to building up the painting on a double-toned ground using a direct painting approach over a transferred drawing. Notice how the artist first applies the shapes of the flesh tones to sculpt the value patterns; then he blends the colors, using a wet-on-wet painting technique. A larger version of the final image can be seen on page 124.

The scale of the finished study drawing determines the scale of the final painting.

Core and cast shadows over the form are painted in as large, dark shapes.

A close-up view reveals the paint handling. The lights are blended into the wet paint surface.

Contiguous areas are then painted. Attention is placed on accurately judging the relative values over the form of the model.

Once the figure is completed, the initial background color is painted to establish the overall value contrast.

Finishing glazes add warmth to the flesh tones and enhance the darkness of the background space.

Robert Liberace, *Robert,*
2002, oil on canvas, 40 x 50 inches (101.6 x 127 cm)

A model who is posed in the studio need not
take on a stiff posture. The personal attire
combined with slouching stance, with hands
in pockets, generates a distinct sense of this
individual.

TRANSFORMING A **PHOTOGRAPH TO A PAINTED IMAGE**

There are pros and cons to painting from photographs. Ideally, art training begins with observational drawing and painting from a model. Novice painters, when beginning to paint from photographs, tend to paint what they literally see: the flatness of the two-dimensional surface. Although photography renders the illusion of reality, it lacks the fullness of dimensional reality. Only after we have a thorough understanding of form can we *translate* the two-dimensional illusion provided by a photograph onto a surface to create a painting that successfully communicates three dimensions.

Potential pitfalls aside, there are numerous possible benefits to working with photographs. They can allow you to record an expression caught at a singular moment—such as surprise, glee, or anger. They can also allow you to paint the people whom you know well, from the present or the past. Ultimately, however, the preference for working from photographic references is entirely a practical one; they allow flexibility to work at one's own pace, whenever one can.

It takes practice to be able to look at a photograph for its three-dimensional clues. This requires the same skills that are employed when you are painting directly from observation—studying and analyzing the model for structural and value information. Ask yourself: Does the core shadow reveal the turning plane of the head? What are the three axes of the head? From this three-dimensional imagining you can begin to interpret the photograph, rather than merely duplicating the flat photographic surface.

Thinking as a painter is melding together what you see (visual perceptions) with what you know (structure of the head). In the end, your sharpened eye paints what it knows about what it is seeing. Above all, when working with photographic references the goal is not to paint literally what you see in the photograph. Study the light and shadow information, decide how you will interpret the color and value, and ultimately compose the photographic image into a painted statement.

Planning Your Painting

Thumbnail sketches, drawn before your subject arrives, can help you decide how you want to compose the model for your painting. These simple graphite drawings, known as croquis, are generated from imagination and represent the essence of an idea. Working on your ideas in sketches allows you to focus not only on the overall gesture of the model but the proportional scale of the final work.

As you plan your painting, it can be helpful to ask questions as you draw: Are you envisioning a square format or an unexpected horizontal composition? Are you interested in the feeling of calm symmetry or a slight sense of tension that could be achieved by moving the figure off-center? What meaning might be implied by the model looking upward rather than at the camera? What would happen if the eye level were dramatically changed or the lighting shifted more to one side? Is the gesture of the hands an important characteristic of your model?

Taking Photographs of Your Model

You have the benefit of setting the stage for a portrait painting—selecting the background, costumes, and lighting—so before the model arrives, decide whether the purpose of your photo session will be to convey the identity of the individual "as is" or costumed for a posed image, whether it will include a symbolic, metaphoric, or allegorical element.

Throughout your photo session, keep your model engaged with you (and not with the camera). This is especially important when photographing non-professional models. Providing a constant stream of conversation (even as you're adjusting settings on the camera) can help distract the model from becoming self-conscious. Take photographs from several viewpoints, adjusting the light direction and bracketing your camera's exposure as needed. It is often helpful to take more shots than you think you need to achieve your photographic goals, from close-ups to long-distance shots. Often the first few minutes or the last moments of a photographic session prove to be the most interesting.

As you work, keep in mind the following tips:

- Avoid having competing light sources. A strong reflected or a secondary light source will only confuse you later in rendering the shadow values effectively.

- Adjust the light source so that the light and shadow information is revealing about the features or

Simplified sketches record your painting ideas—and can supplement your photographs. Marginal notes can remind you of such details as the quality of light, a particular gesture, or a painting idea.

expression but the cast shadows are neither too prominent nor too dark.

- Do not use a flash. A flash deadens the light areas and washes away any details, while making the shadows too dark or flat. Remember that all cameras are designed to register the middle values best.

- Increase the light intensity by using more or brighter spotlights or by incorporating filtered daylight in the same direction as the source light when staging your photo session.

- Consider varying the light source—from warm, artificial light to a more even, cool northern light exposure. This will not only affect the strength of the shadows but will also change the overall temperature of the skin tones.

- Keep the background simple by using a white wall or draped fabric of neutral color when staging models in your studio. This will make it easier to focus on the model's features and gesture rather than the confusion of background details.

- Keep the background soft and merely suggestive of the landscape when staging models in outdoor settings. Avoid shadows from overhanging branches and foliage that will leave confusing shadows on the model's face.

- Move back from the model and include more of the model and atmosphere in the photo than you think might be actually featured in the painting. Upon later consideration, you might want to shift the scale or relocate the model within the composition. It is better to have more, rather than less, information with which to work.

- Make a number of prints. Digital photographs have the benefit of being easily manipulated. Using the same photograph, you can print multiple versions, including one that is underexposed (and that reveals information in the bleached-out lights) and one that is overexposed (and that shows details in the shadows).

COMPOSING THE PAINTING FROM A PHOTOGRAPH

When reviewing the results of your photo session, notice how you have already cropped the photo through the viewfinder of your camera into a vertical or horizontal composition. The camera's frame—a rectangle—begins the process of thinking of a height-to-width ratio for your painting.

Intuitively, we tend to respond to the subject, cropping and placing it within the geometry of the rectangle. If the photograph is well composed, then a simple enlargement, keeping the proportional relationship the same, will suffice. For example, a 4 x 6–inch photograph multiplied by four becomes a 16 x 24–inch canvas. However, a photograph does not always translate well when enlarged onto a canvas that has a different height-to-width ratio. This can lead to stretching or squeezing the figure into the proportions of the canvas and a lack of consideration for the background or negative space. A better approach is to work out the composition on a small scale and then use it to determine the final scale of the canvas. Keep in mind that ready-made canvases come in ratios such as 1:1 (a square of any dimension), 1:2 (e.g., a 12 x 24–inch canvas), or 2:3 (e.g., a 24 x 36–inch canvas). Hand-built canvases allow a painter to work outside of these ratios, creating images that include working off the square (20 x 21 inches) or employing unexpected relationships (15 x 21 inches).

The composition of a painted portrait begins with deciding how much of the photograph you want to include in the painting. (Thinking as a painter, this is the moment when you decide your intention by way of the composition.) Begin by simply placing four strips of white paper along each edge of the photo, in order to bracket the image. (A white picture framing mat can also be used after it is cut into two L-shaped pieces.) You can then easily change the format of the photo—from a rectangle to a square, or from a horizontal to a vertical—by moving the paper strips. Likewise, you can compose the placement of the figure, centering it, moving it to one side, raising or lowering it, as seen in the illustrations below.

Once you have determined the positioning and ratio of the image, tape the paper strips on the photo. You can now simply enlarge the image onto the canvas by drawing freehand. To place a grid over the image, first lay a piece of tracing paper over the photograph or digital print and measure out a grid with a sharp pencil and ruler. This grid serves not only to transfer the composition onto the canvas (as discussed on page 132) but can also organize the picture plane into a more unified or harmonious arrangement.

On an overlay of tracing paper, critical points of intersection begin with finding the center of the canvas by drawing a diagonal line from corner to corner or across the halfway length and width of the image. As the center of any work will have a strong pull, it is best to place this carefully. The division of thirds can also be marked out by drawing a diagonal line from the halfway point along the length to the opposite top and bottom corners

L-brackets laid over a digital print create a horizontal format that emphasizes the mass of the shoulders and background.

A cropped in composition focuses on the face and hands, but loses the dynamic angle of the forearm.

This vertical format captures the gesture of the pose without the face appearing in the center of the composition.

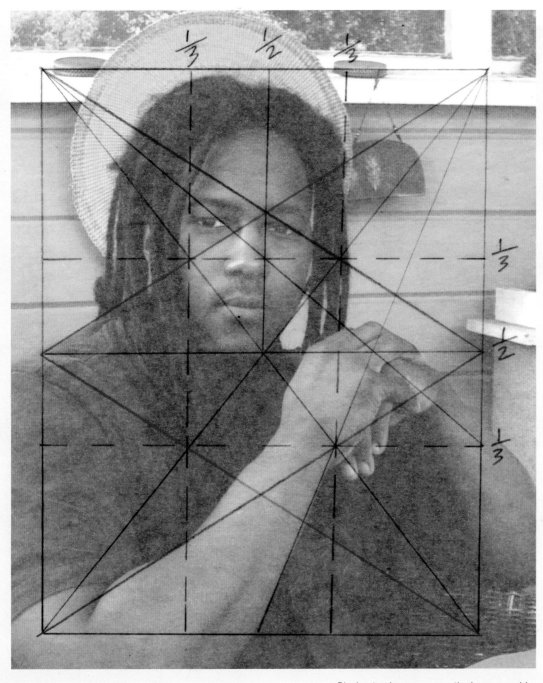

Placing tracing paper over the image, a grid structure determines the center and the division of thirds within the rectangle.

from each side. The illustration above shows how the intersection of these two triangles (red and blue) creates the points where vertical and horizontal lines divide the rectangle into thirds. Pictorial elements that fall along the division of thirds have a unifying, harmonious effect that helps unite the image. Simply shifting the tracing paper over the image is one means for determining the place where converging points will fall to achieve the best composition.

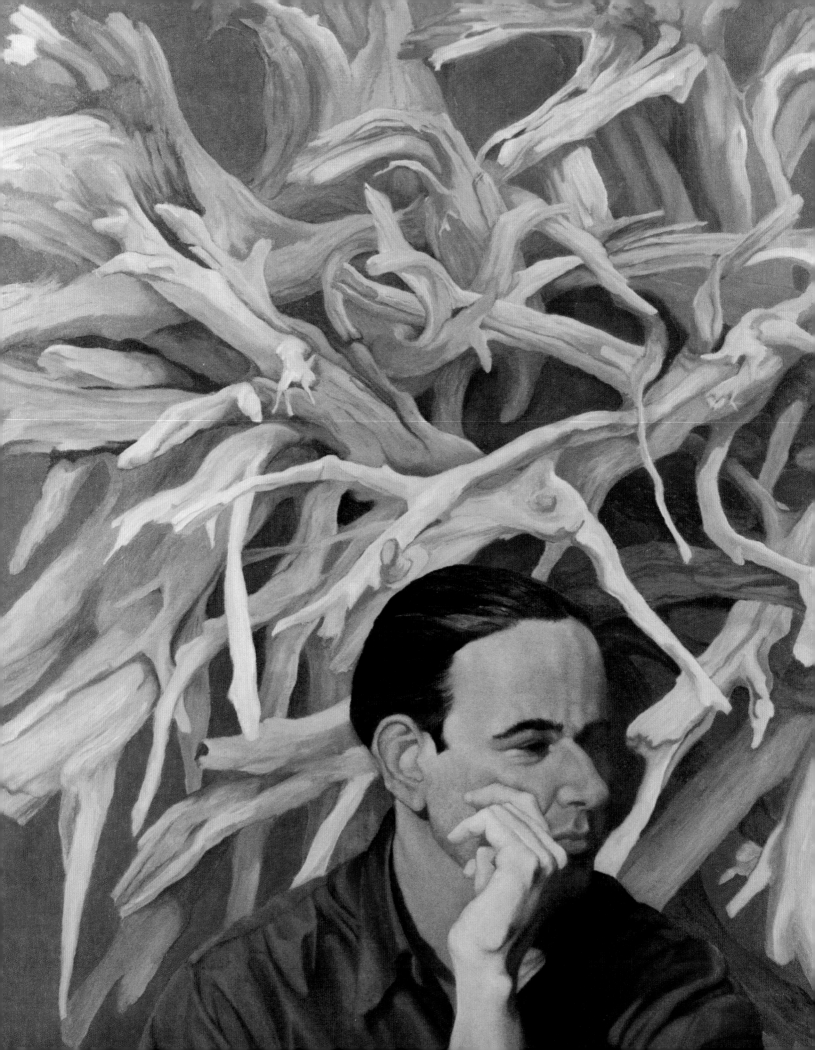

DEMONSTRATION PAINTINGS

CHAPTER SIX

THE DEMONSTRATION PAINTINGS PRESENTED in this chapter have been staged to reveal the step-by-step process. The photographs depict what the canvas looks like at various moments during a seamless process of execution. Except for the last photograph of the final painting, these images are not intended to present complete, fully resolved, separate stages. Painting sessions were irregular in duration; on a good day, I made a lot of progress in an hour, while other times several sessions were needed to complete a specific stage.

The text outlines a sequence to building up the paint layers, with the painting evolving from a focus on the model to the background to the garment to the hair and back again. Although the flow of the painterly process is clearly discussed, specific details—about cleaning the surface, glazing, or color mixing, for instance—are outlined in preceding chapters. (At this point, I'm assuming you've done your homework.) The use of traditional oil mediums in building successive paint layers often requires that a painting dry between painting sessions. To avoid impatience, several paintings were in progress simultaneously at any moment in my studio. A small notebook helped me keep track of how the palette evolved when moving from one painting to another.

Each of these demonstration paintings offers one possible interpretation of working with a toned ground combined with a limited palette. This is not about rigid rules or formulas, as any one pairing of a toned ground and a limited palette offers a number of possible variations. My approach toward the painting process is distinctly within the tradition of Old Master painting, and yet it is driven by a contemporary zest for luminous color. My strategy of combining the toned ground with the palette is a result of trial-and-error experimentation, as over the years I've learned as much from failures as from successes.

OPPOSITE:

Suzanne Brooker, *Portraits of Men, Metaphors of Wood: Doubt,* 2002, oil on canvas, 28 x 32 inches (71.1 x 81.3 cm)

Over a double-toned warm-cool ground, an analogous earth palette is used to paint the model and the background, linking the pondering gesture of the thinking man to the tangled roots of the background.

Each demonstration in this chapter features a list of pigments to serve as a guide; these have been used to create the range of values and color temperatures at various stages. Photographs of the pigment mixtures are also included, showing what the palette looked like for each particular painting. Likewise, a brief description of the toned ground mixtures is included before the overview of the development of the painting itself.

For a painter who has been trained to consider the painting in a direct approach, painting indirectly will take some practice. But take heart, after two or three trial paintings, the idea of layering the paint will eventually make sense. How the paint is applied over the toned ground—from darks to lights, thin to thick—has as much influence on the effect of the color as the pigment mixtures themselves.

KEEPING THE PROCESS IN FOCUS

At the beginning of each painting session, take a moment to evaluate your palette: Are the color mixtures useful? Is the paint the right consistency? Or is another pigment needed for a specific quality of light or additional color contrast? This is the time to analyze your model (both his/her flesh tones and the light) in terms of how the pigments will interact with the toned ground.

The block-in drawing is the crucial first step, the foundation for the entire composition of the painting. Therefore, a bad start in perceiving the foreshortening of the features can rarely be corrected successfully. Unfortunately, it is often easier to see drawing problems after a painting has evolved past the stage when you can fix them without spoiling the transparent paint layers. Constantly review your drawing during the painting process.

Keeping the beauty of a painting alive at every stage begins with painting the toned ground. A successful toned ground is such a pleasure to the eye—both the color note and way it is painted—that it is almost a shame to cover it up. Likewise, no stage of a painting should be left to dry unless you are completely happy with the drawing, palette, and paint handling. It is better to wipe off an area that you suspect will be a problem than to face it the next time you sit down to paint; the result of a painting session should always engender excitement to return to the painting process.

In the same manner, avoid the impulse to rush to paint in details before you have developed the overall, unifying larger areas of a painting. It is not only important to keep building up the paint film at a consistent level, but developing the painting as a whole image allows the critical relationships of color and light/dark contrasts to evolve in tandem. For instance, how will the green of the background affect the reds of the flesh tones—or the dark of the background sharpen the light edge of the model's profile?

Domenic Cretara, *Study for Woman and Baby,*
2004, charcoal pencil on paper, 10 x 10 inches (25.4 x 25.4 cm). Collection of the artist

Every painting requires preparation—from color mixing to oil sketches. This observational drawing of a model studies the focused gaze of the model, which was used in the final painting.

Never let the results of a painting session dry with the intention of coming back later to fix it; paint every moment sincerely.

A great deal of patience is required to build up the transparent layers of pigment, especially when the face appears bizarre—all purple or green with no eyes! Don't panic by throwing on more paint than you can control during any one painting session. Standing back from the painting during a painting session or reviewing the painting's progress as it is drying can help you evaluate the relationship of the parts to the whole. For instance, how are the color effects describing the subtle flesh tones or the values molding the forms of the model? Does the painting still capture your painterly intention?

In the beginning of a painting, the struggle is simply to establish the image, but later you may find that the painting takes on a life of its own, where you, the artist, have distorted or idealized the model in response to his or her character. At this point, thinking as a painter involves not only critical analysis (Is resemblance more important than physiological complexity?) but also an intuitive response toward bringing the work to a resolution. For instance, you may have an impulse to add a bit of red somewhere or change the background dynamics.

Once a painting is ready for the details and lightest values, stand back from the easel to observe the big effect. (The "big effect" can be seen when you stand back from the easel 6 to 10 feet, the distance of the viewer. Notice how small details merge into the overall image.) Does the canvas reveal a variety of paint handling? How dimensionally solid does the model feel in form? Is there enough contrast, with some light places juxtaposed to darker elements? Are the lights too yellow on the skin tones (and therefore will you need a glaze of transparent pink)? These are the kinds of questions that will help you consider the painting as a unified image.

Domenic Cretara, *Woman and Baby,* 2004, oil on canvas, 66 x 48 inches (167.7 x 121.9 cm)

This composition plays on the balance between the color contrast of the woman's red shirt with the earth tones of the overall painting and the value contrast of the baby's pale skin against the woman's dark skirt. This combination of contrasts is often seen in such artists as Camille Corot.

BRYSON WITH KITE

This painting features a pink flesh-tone palette that was painted over a green underpainting and a burnt sienna toned ground.

GROUND:	PALETTE:	
burnt sienna	terre verte	Mars brown
burnt umber	ivory black	green ocher
	flake white	yellow ocher light
	burnt umber	raw umber
	burnt sienna	rose madder
	blue-black	
	rose doré	
	golden barok red	

This photograph of the model, which was taken with a soft, indirect light source, presents a challenge in perceiving the delicate changes of value across the features.

In this demonstration painting, I extracted the figure from an ordinary setting and placed him in an imaginary world that emphasizes the iconic charm and innocence of youth. In the final image the subtle lighting of the figure contrasts with the sky and its animated layers of clouds. Since my intention was to remove Bryson from his contemporary context, I transformed the gesture of his hands—from pulling open the window curtain to holding a kite string. The formal stylization of the hair, the unrealistic suspension of the kite, the sagging folds of the shirt all contribute to a certain timeless quality. To maximize the color contrast I planned to use the orange tendency of burnt sienna to heighten the blue of the sky. At the same time, I also used the transparent glow of the ground in the middle values of his shirt and hair. The green underpainting would provide the means for contrasting the delicate pink palette of his skin tones. In essence, the entire painting uses complementary contrast in one variation or another.

PREPARING THE GROUND

Burnt sienna is a versatile, semitransparent pigment. Considered a part of the earth-red hues, it has a tint of orange that allows it great flexibility on the palette. To check the color tendency of your pigment brand, scrape it thinly over your palette with a palette knife. If your burnt sienna does not have a beautiful red-orange appearance, it may be time to find another brand.

I obtained the beautiful, cherrywood-like hue of this toned ground by mixing a small amount of burnt umber into the burnt sienna. (Another variation is to mix burnt sienna with raw umber or Van Dyke brown.) I then thinned this pigment mixture with a 50/50 mixture of oil and OMS and painted transparently over the white gesso priming.

The underpainting palette featured terre verte, flake white, and ivory black, which I mixed into four distinct values.

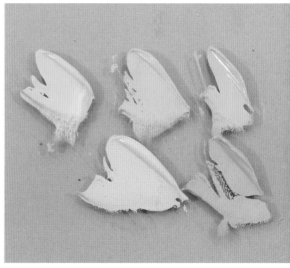

I generated the flesh tone palette of pinks from mixtures of rose madder, rose doré, barok red, yellow ocher light, and green ocher.

LEFT:

I began building up the forms of the features and hands using the green underpainting palette, working in transparent layers.

ESTABLISHING THE BLOCK-IN DRAWING

Using the photo as a reference, I began with a freehand block-in drawing, painting with a thinned and slightly darker mixture of burnt sienna and burnt umber than I had made for the toned ground. This same mixture was then thinly scumbled over the background, keeping the edges soft and flexible for later changes. This process helped to negatively define the shape of the figure. Unlike with other block-in methods, I did not use the red-brown paint mixture to establish any values on the features themselves after the initial block-in drawing. Instead, I wanted to utilize the transparent glow of the ground to animate the subsequent green underpainting.

LAYING DOWN THE UNDERPAINTING

I began the process of underpainting the flesh tones by creating four mixtures of terre verte, flake white, and ivory black, ranging from light to dark in value. My approach was first to establish the shadow patterns and thinly paint in the darks, keeping the transitions into the middle values softly blended. This allowed me to see how the orange glow from the ground might be used to suggest the reflected light in the shadows. As the features and the direction of light began to evolve, it was then easier to apply additional middle to light values to increase their opacity and brightness. I treated the painting of the hands in the same overall way as the face.

Next, I thinly scumbled an oily mixture of ivory black and terre verte to create the folds of the garment over the red ground. I was careful to allow the red ground to glow through the transparent paint layer that represents the middle values; while I more densely applied the dark green-black pigment to create the shadows.

After this painting session, I allowed the shirt to dry before continuing to build up the lights. (During critical junctures such as this one you will need to decide whether working into wet paint will produce the best effect or layering over dry paint will allow better control of the paint density.) Either way, the goal is always to preserve the planned illumination of the toned ground, because once opaque paint has been added, the glow of the ground can never be recovered.

As I developed the form of the hands and face with additional layers of pigment, I continuously evaluated the transitions in value. Specifically, I reworked some areas—the subtle curving edge of the core shadow, the structure of the neck, and the gesture of the hands—to smooth the value changes, emphasizing the lights or reinforcing the darks as needed. While these paint layers were drying, I continued to model the shirt folds, brightening the lights with similar mixtures of terre verte as the underpainting.

Once the figure began to appear solid, I focused my attention on blocking in the imaginary kite with a thinly applied dark gray. (Prior to working on the canvas, I used tracing paper and a digital printout of the photo to prepare a rough sketch to position the kite's shape.) My intention was to evoke a memory reminiscent of a kite, not to render an actual, realistic object, as seen on page 152.

With the kite blocked in and dry, I was now able to add a rough block-in of the hair and curls over the dried areas of the face. This provided the value contrast between the darkest darks (of the hair) and lightest areas (of the face) in the underpainting. I then used a thin layer of flake white to define the white T-shirt at the neckline.

While that paint was drying, I mixed three values of blue-black and flake white for the cloudy sky of the background. Using a reference photo, I first painted the background with an oily scumble of dark gray pigment to transparently cover the burnt sienna of the background. This

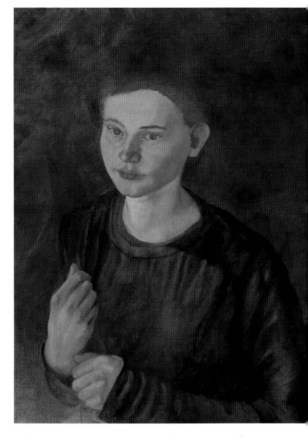

Adding layers of pigment helped refine the placement of features, which gained brightness with the increasing paint density. I scumbled the folds of the shirt with oily dark pigment to retain the luminous glow of the ground.

OPPOSITE:

I further developed the lights on the model and shirt, which helped to clarify the direction of the light source.

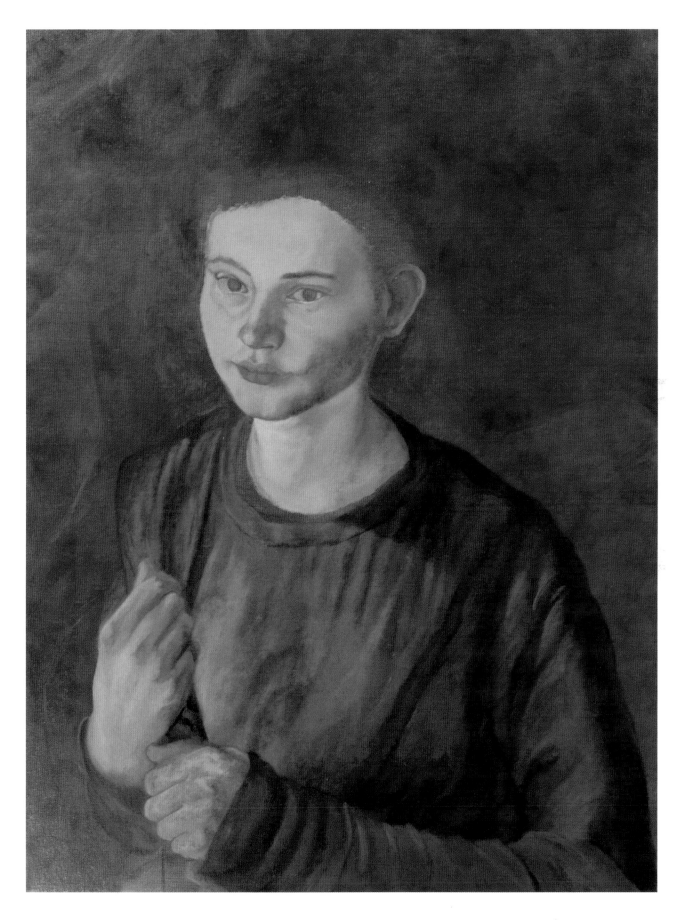

gray appears optically more blue when thinly applied over its complement, yielding a richer, more complex color. Next, I painted the midvalue blue-black grays into the wet paint, using a large, soft brush and building up to the lightest areas of the cloud values. At points, to capture the animation of the fleeting cloud forms, I lightly dragged the lightest values over the wet paint in an irregular fashion.

DEFINING THE MIDDLE VALUES

Although the previous stages defined the relative values of the features, it was not until I applied the first layers of the flesh-toned pigment mixtures that the model came to life. Various combinations of rose doré, golden barok red, Mars brown, green ocher, and yellow ocher light generated the intense pinks, golden pinks, and warm pinks. (To review how additional red pigments can generate subtle different color notes, take a quick look back at the sidebar Developing Strategies for Mixing Flesh Tones on page 52.) While the color of the pinks increases the sensation of the skin tones, they must be carefully layered (with darker and more neutral colors applied before the paler tints) and blended over the green underpainting to reserve the delicate nuances of the small shadows (where the underpainting appears behind the transparent pinks). Remember that the increasing density of the paint layers makes the same color mixture appear brighter without the addition of more white. Likewise, the thinner the paint layer, the more the green underpainting will seem to dull the pink. (This is seen in the hands, which were more thinly painted than the face.)

To complete the background, the form of the kite, and its contrast to the background sky, I applied a thick layer of flake white, which I modulated with the grays of the sky pigments. Then I defined the crossing wooden struts with burnt umber, flake white, and ivory black mixed with Fine Detail Medium (Winsor & Newton).

When the flesh tones of the face were dry, I introduced lighter values of gray mixed with burnt umber into the hair, especially where the curls of the hair overlap the flesh tones. Looking at an overexposed printout of the photograph was helpful, as it revealed details in the dark areas, before I painted the complicated hair pattern.

ADDING THE LIGHT VALUES

Standing back and reviewing the value contrasts is an important step when painting sessions alternate from one area of the painting to another (sky to face to shirt and back to the hair). Evaluating the discrete parts versus the whole of the painting aids in balancing the overall light-to-dark contrasts as well as in establishing the focus of a painting. Although each part is painted separately, the entire image needs to read as a whole. This process can help you determine where final touches of light are needed to balance the composition and where the transitions between values feels ragged or the paint surface appears meager. Never hesitate to

At this point I blocked in the dark of the hair and painted the kite shape with a midvalue gray before painting the cloudy sky.

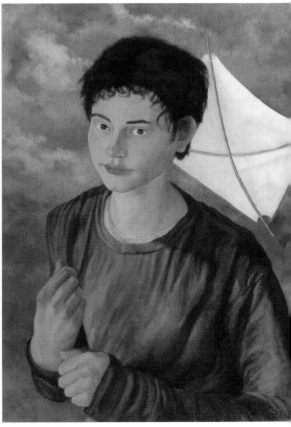

return to the dark or middle values in order to enhance the surface quality of the paint. As the build up of paint continues with the lights, the first thin or transparent layers may seem meager in comparison, revealing too much of the canvas texture. Oily paint carefully blended over these areas can enrich the surface while re-enforcing the darks (however, nothing replaces the surface quality of a well-prepared canvas).

At this stage, I noticed how the drying paint had settled into the canvas, darkening some areas of the high-middle values. Using the same paint mixtures as before (but with a small addition of white pigment), I revisited the lights on the hand and the highlights on curly hair. I also brightened the clouds before painting in the kite string and tail. Once again I waited for the painting to dry and evaluated the relative contrast of the lights and darks. Since I was planning to add a final glaze, the lights had to be sufficiently light enough for the darkening effect of the glazed color.

I first prepared several puddles of glaze pigments for different areas of the painting: rose doré for the flesh tones in the light, raw umber for the shadows, terre verte for the shirt, and blue-black for the hair. Each of these pigments was thoroughly mixed with a portion of linseed and stand oil. For places where no glaze color would be applied, such as the white of the eyes, I used clear medium. After I thinly applied the glaze (using a smaller brush over the skin tones and a larger brush for big areas), I tilted the canvas toward the light to double check that no place had been missed or that no areas of the glaze seemed too thick. I then let the canvas rest horizontally to dry.

Simply oiling up the entire canvas after it has completely dried is one way to restore the zest of the color notes and give an even, reflective quality to the paint surface. Another option is glazing transparent pure color over individual areas of an image (for instance, blue over a sky, green over a shirt, rose or yellow over skin). This cellophane layer of color gives a greater depth to the visual effect of the underlying painting. Semitransparent paint can then be applied onto the oil or glaze, restoring any lights that may have been darkened by the glaze, and the area can later be reglazed.

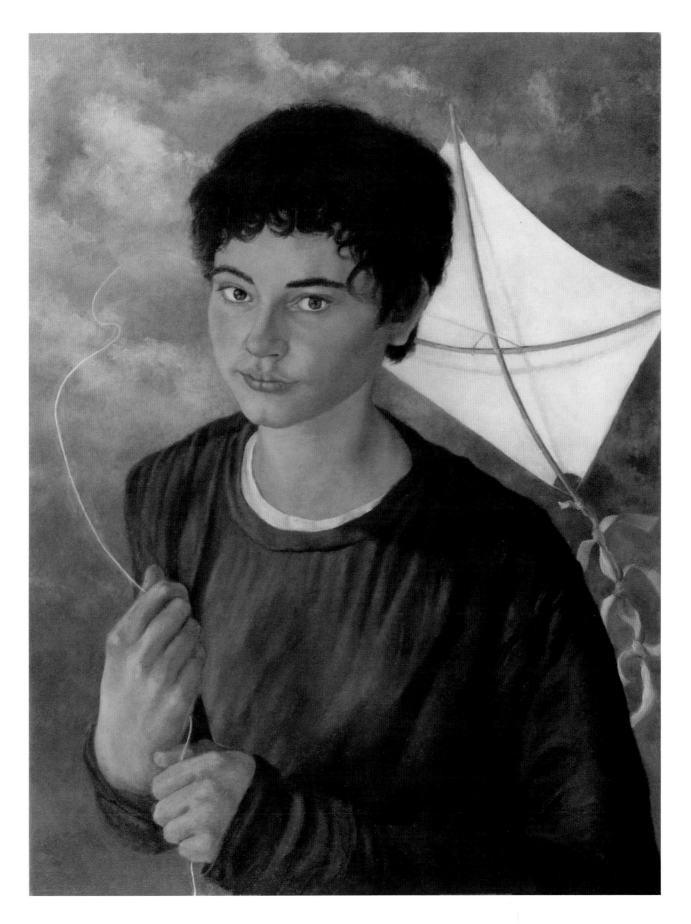

CEDERIC

In this painting, secondary hues were used to generate cool, indirect lighting over a green toned ground.

GROUND:	PALETTE:	
phthalo green	burnt sienna	terre verte
flake white	Mars brown	sap green
	burnt umber	raw sienna
	Mars violet	ivory black
	transparent red	ultramarine blue
	ocher	flake white
	alizarin crimson	transparent white
	raw umber	

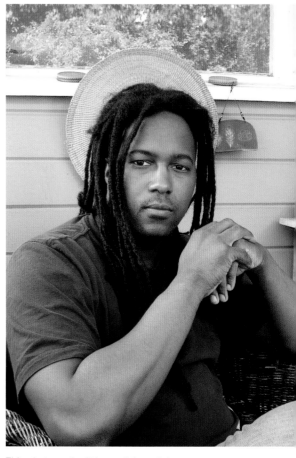

This photograph of the model was taken in a cool, indirect light. His direct gaze is juxtaposed by the contemplative gesture of the hands.

A secondary palette of green, violet, and orange can create subtle color mixtures that express the richness of the skin tones in cool, indirect lighting. From a number of images taken during an informal sitting, I chose this image for the strength of the model's direct gaze in contrast to the contemplative gesture of his hands. The long dreadlocks, which formed a curtainlike shape that was repeated in the arc of the arms and clasped hands, were visually interesting to me as a painter. Careful observation of the image revealed that the hair created distinct cast shadows along the length of the face on the left. Looking at the other side of the face, a subtle core shadow is visible from the brow ridge along the side of the cheek to the jaw line. Because this image lacked sharp value contrasts, I needed to employ changes in color temperature to create a sense of form in this painting.

PREPARING THE GROUND

I prepared the green toned ground using phthalo green and flake white, creating a cool, midvalue tint that I applied in a solid manner over the canvas. This ground serves the same purpose as a green underpainting, emphasizing the complementary contrast of the earth red color notes in the skin tones. Other greens can be used for different effects. For instance, sap green would generate a warm, chromatic ground and terre verte a neutral and transparent ground. Because terre verte can be too transparent to be an effective ground pigment, it is usually mixed with a small amount of yellow ocher, or for a cooler note with raw umber. The temperature and value of the green you choose will depend on how you intend to interpret the skin tones and the quality of the light source.

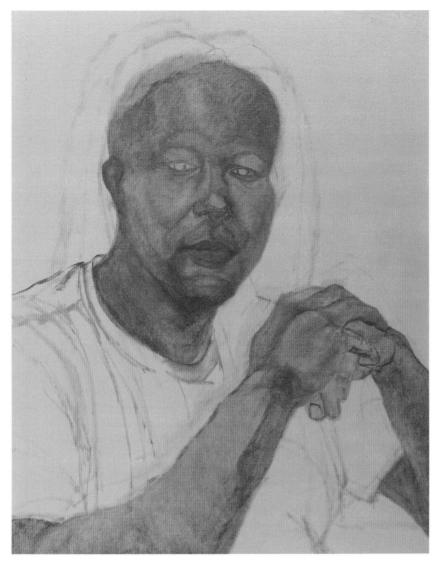

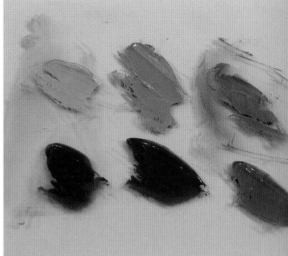

This is the underpainting palette that I used to block in the drawing and create the initial shading of the skin tones.

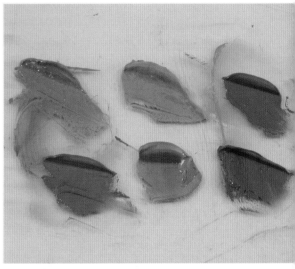

I used this middle-value palette, which balances cool and warm color temperatures, to refine the forms and define the features.

LEFT:

I merged the block-in drawing with a simplified value study of the model to establish light and shadow patterns over the forms.

ESTABLISHING THE BLOCK-IN DRAWING

From the underpainting palette, I selected a mixture of alizarin crimson, raw umber, and burnt umber to block in the model. After drawing in the figure freehand with thinned paint, I thinly scumbled this same color mixture to establish the light to middle to darker values (transparently by a thin application of pigment), allowing the ground to represent the lightest values. My intention at this stage was focused on building the planar forms of the face, neck, arms, and hands. I purposely extended the forehead and side plane of the cheek past the hairline and underneath the hair, as this made it easier to judge the proportions of the face and position the ear. Likewise, I painted the entire form of the neck, even the places where the hair would eventually conceal the skin. Even though I was ignoring the hair itself for the time being, I indicated the cast shadows created by the hair along the side of the face.

LAYING DOWN THE UNDERPAINTING

Continuing with the underpainting palette, I emphasized the underlying plumy quality of Cederic's skin tones by first working with the mixtures of alizarin crimson, raw umber, and burnt umber to reinforce the darks, blending in the cooler low midvalues. The cool temperature of the underpainting not only created a colorful richness for the middle values but indicated what parts of the face were turning away from the light or receding in space. I used a dark mauve (Mars violet and burnt umber) to define the facial features and details in the hands, mixing in discrete brushfuls with other mixtures whenever I needed a darkening agent. For example, I painted a thin scumble of this dark pigment to begin the form shadows (around the mouth and jaw) that would later be followed by a thin scumble of black, articulating his five o'clock shadow. To keep the effect subtle, I planned to paint the middle values of the skin tones over these areas later and allow only a hint of the black to come through.

DEFINING THE MIDDLE VALUES

The palette for the middle values featured the more orange of the earth red pigments (burnt sienna, Mars brown, and transparent red ocher), which generated mixtures for the warmer skin tones. I mixed terre verte and phthalo green in discrete brushfuls to help dull the orange mixtures for the small shadows (such as the folds around the eyes). Whenever needed, I used Mars violet to increase the colorfulness of the shadow areas (such as the inside corners of the eyes and jaw line).

At this stage of the painting, I applied pigment in thin, slightly oily layers, which I blended well to soften the edges. My goal was not to cover the cool underpainting everywhere but to create transitions into the light side. The denser I built up the middle value pigment, the brighter the color appeared.

While this paint layer was drying, I applied (and brushed smooth) a warm stain of pigment for the background, including areas that would eventually fall underneath the hair. The sheer pigment mixture of raw sienna, raw umber, and sap green became optically intensified by the cool hue of the toned ground. Then, using a wash made with ultramarine blue and a touch of phthalo green, I established a block-in for the shirt, focusing on its draping folds over the shoulder and around the neckline.

During the next painting session, I returned to painting the face, which was now dry, and made subtle changes using the same palette as the features became more detailed. I blocked in the eyes using a grayed flake white made with a small amount of burnt umber, and the pupils with a transparent application of ivory black. These placeholders helped me judge the correct angle of the eyelids, but I did not paint any details on the eyeballs themselves until the forms of the eyelids were perfect. I continued to make further refinements on the subtle transitions of the nose and the expression of the mouth.

Then I built up the forms with the underpainting palette of cool darks and low middle values. I extended the hidden side plane of the face and neck so that later I could freely paint the hair overlapping the skin tones.

OPPOSITE:

Painting the background stain and block-in values of the T-shirt created a greater context for the model.

I blocked in the hair after the paint of the background and shirt was dry, which allowed any changes to be easily wiped off.

OPPOSITE:

Adding a scumble of cool green over the warm background created a flicker between color temperatures.

Next, I painted in the shirt more solidly with a mixture made from ultramarine blue, with touches of phthalo green and burnt umber, so that I could paint the drape of the hair more freely once this paint had dried. To keep the edges crisp and clearly establish the spatial relationships, I painted the places where the arms and hands meet the shirt with great care. Because the light on the arm and the dark shadow on the shirt strongly contrasted in value and hue, the contour of the arm needed to be exact.

To draw the pattern of the hair, I thinly applied an oily black over the dried background and shirt, easily wiping off any changes. Next, I mixed three values of gray from ivory black and flake white to create the overlapping forms of the dreadlocks. I painted these wet-on-wet with irregular brush movement to mimic their textural quality.

To create a greater sense of the context for the figure, I focused again on the background. Returning to a mixture of phthalo green and flake white, I roughly scumbled this cool green tint over the background color, allowing the warmer green to flicker through the open brushwork. Then I used a metal ruler and drew with raw umber to establish the straight lines of the wooden slats behind the model.

While the background paint was drying, I further developed the rotating forms of the hands and arms with the same middle value palette used in the face. My intention was not only to more closely match the changes in the skin values and specific color notes but to correct or adjust any foreshortening in the gesture of the overlapping hands. Lastly, I added the detailed weave of the wicker chair behind the arm using an oily black.

ADDING THE LIGHT VALUES

In preparation for adding the lights, I oiled up the completely dry painting to revive the color and value contrasts. This gave me a better idea of

After oiling up the completely dry painting (to resaturate any sunken areas of pigment), I adjusted the value contrast by increasing the lights.

OPPOSITE:

To complete the painting I added the final warm lights and the last details: the garden tool as a metaphor for a sword and a small red bead on his dreadlock.

the relative value scale before painting in the lights. Building up the light values on a darker skin type requires using the intensity and warmth of a pigment rather than increasing the amount of white pigment (which can cause the skin tones to appear chalky and dull). When additional white pigment was needed, however, I substituted flake white with transparent white, as it provided easier blending from the higher middle values to the lightest lights. Increasing the amount of oil medium, mixed into the paint (warmer mixtures of Mars brown and burnt sienna) in discrete brushfuls, both ensured smooth blending and adjusted the pigment's transparency.

As the contrast between the light and darks increased, warm and cool color notes became more clearly defined, allowing details to be seen in comparison to the overall effect. At this point I asked a few final questions: Should the background be reglazed to suggest further distance? Could the texture of the lips be improved, pinkness added to heighten the inside corner of the eyes, or the edges of the fingers softened?

CHERYL

Three low-key primaries were used to build harmonizing variety on a golden toned ground.

The model was caught in a quiet moment, expressed by her clasping hands and thoughtful gaze.

GROUND:	PALETTE:
yellow ocher	yellow ocher
raw umber	flesh ocher
	blue-black
	flake white
	terre verte
	raw umber
	transparent yellow oxide

For this painting I chose a golden toned ground that was directly influenced by the strong warm light on the model, which appears in the skin tones as a greenish-gold hue. Since the shadows were a cool, plum hue, I decided that the overall color contrast for this painting would be based on the complements yellow and violet, even though the palette was made from mixtures of low-key red, yellow, and blue pigments. I tightly cropped the composition to emphasize the pious gesture of the hands, which point inward and contrast with the bold, outward gaze reminiscent of a fifteenth-century portrait. The silky sheen of Cheryl's dress reflects a beautiful gold light onto the under plane of her neck and throat. My intention with this painting was to keep the golden light from the toned ground illuminating a rich variety of color tonalities.

PREPARING THE GROUND

To dull and add a green note to the pigment used to tone the ground I mixed the yellow ocher with a small touch of raw umber. I started with a very small amount of raw umber to test its darkening and dulling effect with yellow ocher before making enough mixture to tone the whole ground. The resulting hue was a rich straw or wheatlike gold. (If the yellow tone had been more intense, it would have been more difficult to judge and control the optical effects of the following paint layers; I resisted adding white to the pigment mixture, as this would just have dulled and flattened the translucent effect of the yellow glow backlit by the white gesso ground.) Then I thinned the pigment with 50/50 mixture of oil and OMS and applied the ground color evenly over the white priming layer.

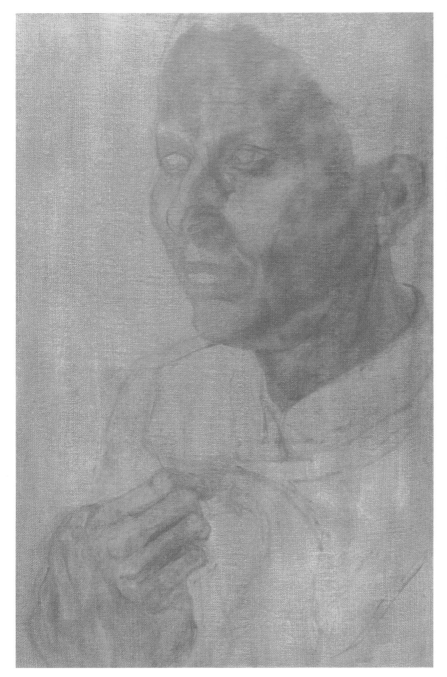

A suite of cool color mixtures that range from light to middle to dark created from a low-key palette of R+Y+B and white.

LEFT:

Using thinly applied paint, I began by establishing the freehand block-in drawing and the first indications of the shadow pattern.

ESTABLISHING THE BLOCK-IN DRAWING

I built up my palette using low-key primaries. Blue-black represented the blue hue that I used to create many subtle cool violet or dark variations when mixed with a low-key red. Using flesh ocher, an intense and opaque earth red, as the red hue helped me maintain the vividness and freshness of my color mixtures and provided the harmonizing link between the different color mixtures in the flesh tones. Yellow ocher served as my yellow hue. I frequently combined it with blue-black to create a dull green used to neutralize the red mixtures.

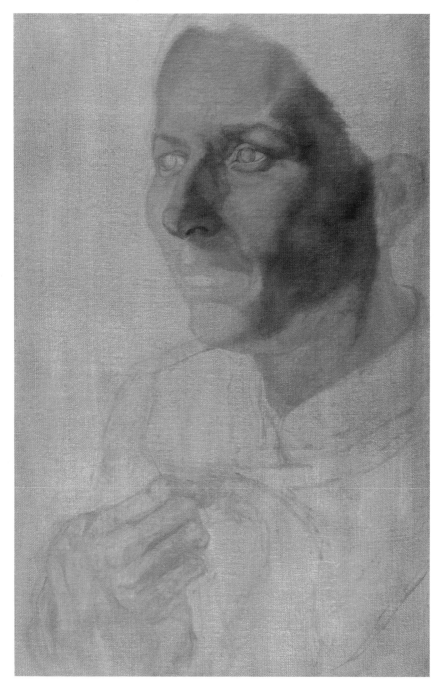

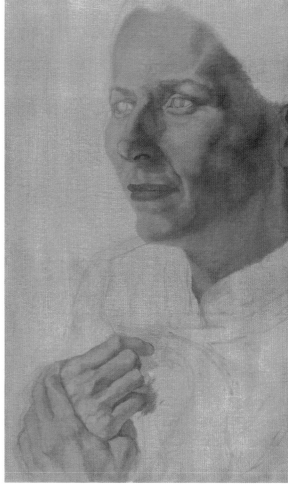

LEFT:

I articulated the core and cast shadows, using a cool dark that I blended well into the low middle values.

ABOVE:

I continued to refine the features and the hands with cool low-middle values.

OPPOSITE:

This close-up view shows the evolving middle values in the flesh tones.

To create the block-in drawing, I used a thinned mixture of flesh ocher, white, and a dot of black. This plumy violet mixture was thinly applied to indicate the initial value structure of the model in the simplified shapes (but not their true values). This provided another way to double-check the accuracy of my block-in drawing. At this point I wanted to create the undulating line of the core shadow seen along the edge of the cheek and nose while blurring their edges. My goal was to reserve the glow of the ground in the lightest areas and create a cool note in the shadows.

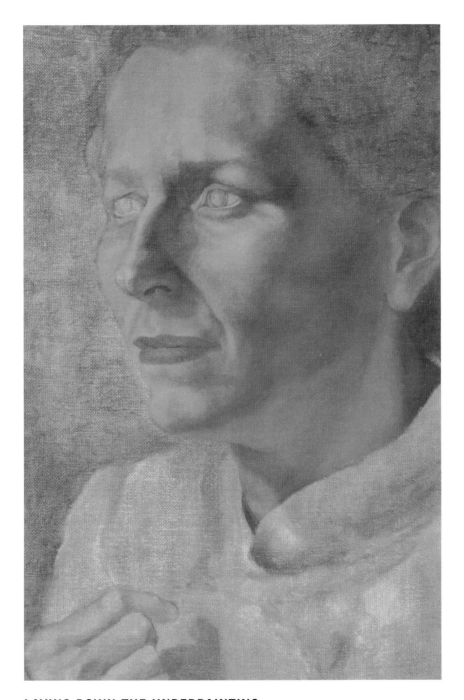

LAYING DOWN THE UNDERPAINTING

After the block-in paint had dried, I began to focus on establishing the transparent darks of the shadows. I thinly applied a cool dark (blue-black plus flesh ocher) at the core shadow—an undulating ribbon of shadow that begins on the forehead and ends below the chin, merging into the cast shadow on the throat. I blended the paint at the edges with particular care, as it described the underlying planar structure of the skull and the forms of the musculature. The core shadow needed to be sufficiently dark enough—not only to separate the light on the face from the shadow side but also to allow a fuller range of low values in the

reflected lights. This was especially important at the transition from the edge of the jaw onto the neck. I also thinly painted the cast shadow from the nose with a dot more flesh ocher mixed into the dark value so that it would remain transparent and capture the glow from the underlying toned ground.

DEFINING THE MIDDLE VALUES

I used the midvalue paint mixtures to begin to define the light side of the face and create the more subtle contours of the face (around the muzzle of the mouth and across the planes of the forehead). The appearance of midvalue pigment is significantly changed by how thinly or thickly it is applied over the warm toned ground as well as subtle additions of green (which neutralizes the intensity of the pink to orange paint mixtures). The middle values also act as a bridge that supports the transitions from the darker values to the lighter values, providing the richest moment of color, neither darkened by black nor dulled by white.

This stage of the painting often requires several painting sessions, as it did with this particular one. In contrast, I painted the hands more directly—using thicker paint that I blended with wet-on-wet brushwork. My goal in changing the paint handling was to exaggerate the difference (using brushwork) and yet create a link (using the same pigment colors) between the gesture of the hands and the expression of the face.

While the face and hands were drying, I added a light scumble of terre verte and raw umber over the background and hair. This began to define the edges of the face and garment. I then created three value mixtures of raw umber, yellow ocher, and flake white to indicate the soft folds and pattern of the dress. I applied this paint in a variety of ways—including a dry-paint scumble (which allowed the golden toned ground to glow through the paint) as well as a fluidly blended wet-on-wet paint (which articulated the animation of the textile designs). I thinly painted the cast shadow from the hands with raw umber and then allowed the image to dry completely before addressing the details and the light values.

ADDING THE LIGHT VALUES

The refinement of features begins at this stage in the painting. Any white added into the midvalue pigments should now be a transparent white, which will ensure transparently blended transitions over the areas of the dried middle values. To increase the warmth of the color temperatures, I added a small dot of a yellow-green to portions of the lightest pinks, reinforcing the link to the underlying tone of the ground color. My goal here was to strike a balance between the light pink and the yellow mixtures in various areas, including around the eye sockets, down the bridge of the nose, and over the muzzle of mouth above the lips.

Once I established the lights over the eyelids, I began painting the details of the eyes. A brownish light gray (raw umber, blue-black, and flake white) created the modulated values for the white of the eyes, while

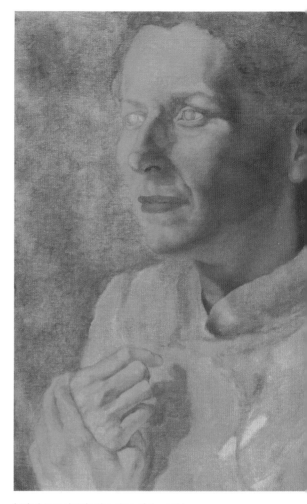

I tried to maintain the glow of the golden ground during my initial block in of the values of the background, hair, and dress.

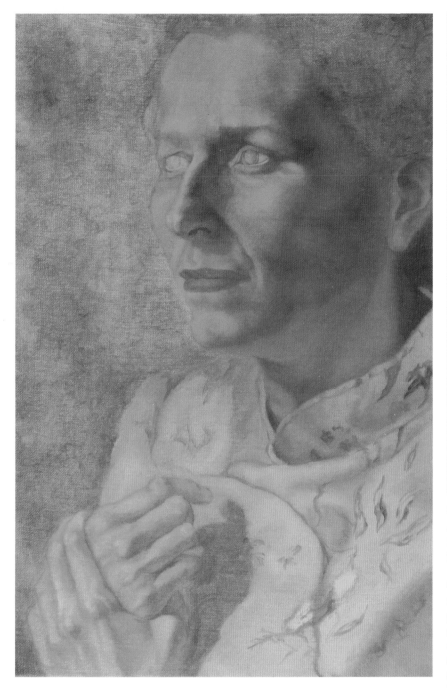

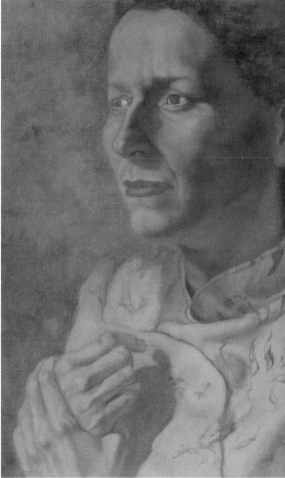

After painting the hands in a direct manner, I built up the lights and textile pattern over the dress.

Next, I built up the contrast of the background and hair, adding scumbled layers of raw umber. Before painting the details of the eyes, I thinly painted placeholders for whites and irises to better judge the angle of the eyelids. A thin veil of dark was also worked into the core shadow, reserving the reflected under the chin.

an oily black indicated the edge of the iris and pupil. I added a dot of burnt sienna, thinned with linseed oil, to the palette to place a more exact matching color note in the iris and blended the area with a very small brush. I then used flake white to paint the highlight gleams on the pupil over the wet paint. (However, I waited until the details of the eyes were dry before adding the eyelashes and eyebrows.) Likewise, at this point I further refined the nose (especially the nostril and the under plane of the nose) and the texture of the lips.

I could not judge the true range of the light-to-dark contrast until I had fully established the dark of the hair and the background, so I cre-

ated an oily mixture of blue-black and raw umber and drew in the hair with a soft brush, following its drape and curl. The soft wisps of hair were easily painted in over the (dry) skin tones of the forehead and ear. At this point I also added an oily scumble of raw umber and terre verte over the background and carefully blended it into the light side of the face. (The contrast between the pink of the face and the green of the background may be strong, but the edge itself is soft.) Where the top of the shoulder moves back into space, I kept the edge softly diffused, meeting the background color with very little value contrast; whereas I strengthened the highlights on the folds of the dress.

APPLYING THE FINISHING GLAZES

Once the painting had dried completely, I cleaned and oiled-up the canvas, noticing areas where the pigment had sunken in. While the oil was wet, I was also able to make a few discreet changes—adding color emphasis in the background, layering a glaze of transparent yellow oxide over the dress, heightening the gleam on the lips, for example. Lastly, I glazed the cast shadow of the hands with blue-black and a touch of flesh ocher, still allowing the golden toned ground to flicker through. (The final details of the hoop earrings and the embroidered toggle of the dress were added after this oil layer had dried.) Even after this oiling up, the dark of the hair had dried matte, and an additional oiling of this part of the canvas was needed.

The painting dried flat in my studio while the paint film settled in. Unconsciously, I reviewed it from time to time as my work progressed on other paintings. Small areas came to my attention. Could the hair have more warm highlights, or the edge of the throat a cool highlight? Could a particular edge be made softer, or another perhaps crisper? Does the posture of the lips really reinforce the gaze of the eyes? These questions provided a means for checking my intentions for the painting against my expression of the paint handling. Did all the parts add up to my desired wholeness of the image? These small discreet changes in a painting bring the work into a final resolved state, marrying the artist's intention with expressive painting handling. The experienced painter arrives at the desired results with the minimum, most efficient paint handling—imagining the final results even as the painting evolves.

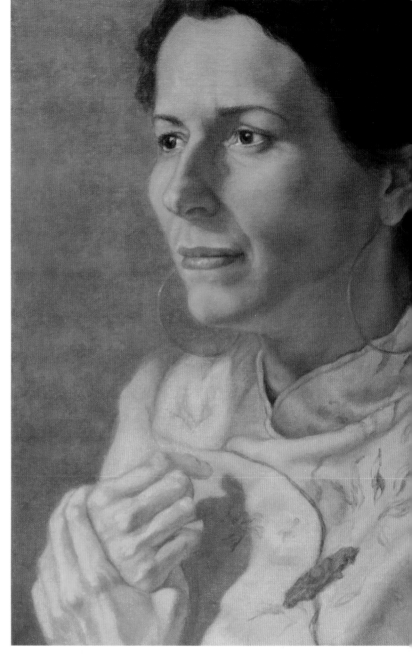

I carefully controlled the edges, even as I added the final details and highlights.

OPPOSITE:

To complete the painting I applied the glazes, adding further contrast to the earrings.

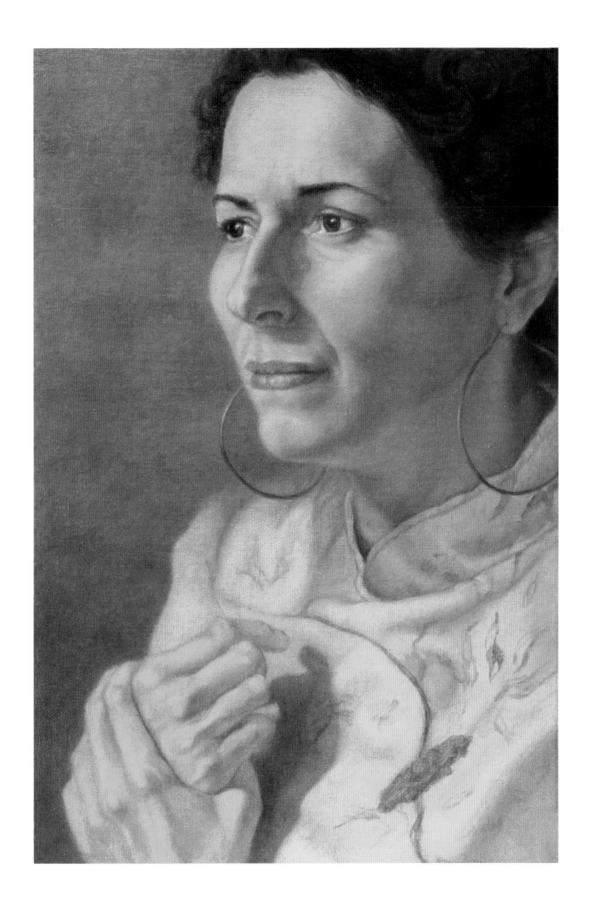

SARAH

This warm and cool palette shows how a cool gray ground can make a subtle complementary contrast for a painting.

GROUND:	PALETTE:	
flake white	burnt umber	rose doré
ivory black	raw umber	flesh ocher
	blue-black	Mars brown
	yellow ocher	cobalt blue
	flake white	
	vermillion	
	burnt sienna	
	ultramarine violet	

The angle of the light and the model's pose combined to create a flow of light and shadows.

One advantage of working with a professional model is her experience in knowing what inspires a painting—such things as having a sensitive response to the light or striking a certain gesture in the pose. This combination provokes an aesthetic response; the beautiful outweighs the personal identity. This portrait does not capture the character of an individual but rather a lively interaction of light to shadow, shape to form, and gesture revealed through anatomy. (The photograph looks like Sarah, but this is not "Sarah.")

Using a cool midvalue gray ground with sheer layers of warm pigment allowed me to provoke a warm-cool flutter of color temperature reminiscent of the work of Peter Paul Rubens. Once mastered, this approach can be the most effective way to create the richest optical effect without the dulling of any color note by the addition of black.

PREPARING THE GROUND

I started by mixing ivory black and flake white to create a midvalue gray and then evenly and opaquely applied the mixture over the gesso ground. My intention was to have the cool temperature of the toned ground contrast with the transparent warm browns of the underpainting. However, I could have created either a warmer gray (by adding a small amount of yellow ocher) or a cooler gray (by adding ultramarine violet). Making this choice depends on how the ground color will be used to render the transitions from the light into the shadows. In this painting, I planned to use the cool gray for the halflights of the shadows and reflected light.

The limited palette featured dark to light values, as I anticipated that the toned ground would act as the cooling agent in the transitions of the middle shadows into the lights.

LEFT:

I transferred the image onto my canvas, using an enlarged grid to establish the block-in drawing and then refining the features to create an accurate rendering.

ESTABLISHING THE BLOCK-IN DRAWING

Following the technique discussed on page 132, I laid out a 2-inch grid on tracing paper over a digital print. This aided in transferring the image of the model onto the canvas, allowing for a subtle shifting of the model from the original photograph onto the proportions of the canvas. Then I drew an enlarged 4-inch grid on the canvas with thinned burnt umber. These guidelines allowed me to easily establish a simple contour drawing, enlarging the information from the photograph's smaller square and plotting it onto the canvas's larger format. Since this process only produces a rough drawing, however, a closer rendering of the features was needed. Before the paint had dried, I refined my drawing, taking time to measure and adjust the key relationships of the features. I was able to easily wipe off any areas of thin paint to make corrections with a clean brush moistened in solvent.

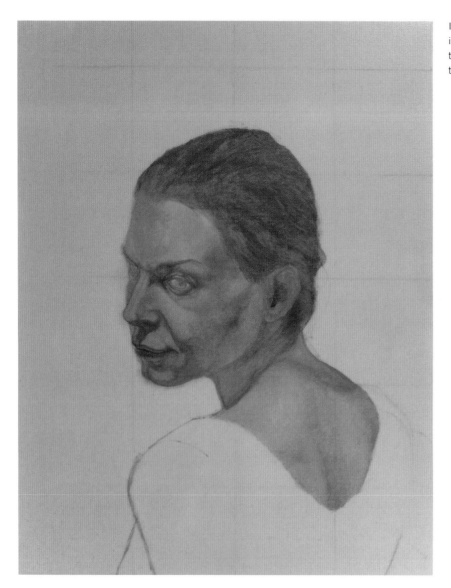

I first applied the underpainting thinly, allowing the glow of the cool ground to create a temperature contrast, and gradually built up the density of the paint.

LAYING DOWN THE UNDERPAINTING

Using burnt umber, raw umber, yellow ocher, blue-black, and flake white, I created mixtures of greenish brown, yellowish gray, and dark brown for a temperature-modulated underpainting. I applied the pigments thinly at this point to maximize the warm-cool glow created as the transparent warm veneer covered the cool ground. Since the toned ground established the middle values, the thinly applied warm pigments changed the temperature (not the value). I carefully blended the transitions along the core shadow, allowing the cast shadows to remain transparent. The lighter values were blended into the middle values, increasing in paint density at the lightest lights. If I had applied the paint too heavily at this point, I would have lost the glow from the toned ground, resulting in a Band-Aid–colored underpainting.

I continued the underpainting onto the shirt, beginning with the underlying drawing of the folds and then scumbling the paint thinly

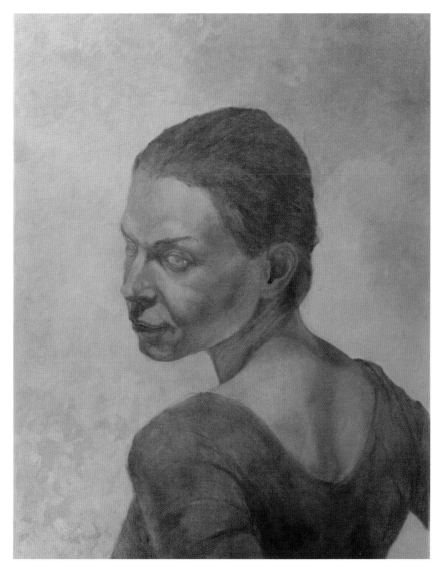

I blocked in the garment and further cooled the background with mixtures of ultramarine violet.

As I began to apply the first layer of the flesh tones, the optical contrast between the complements made it difficult to perceive the color mixtures.

over the canvas to build the range of shadow values. While this stage was drying, I painted the background with three close values of a midvalue violet, using ultramarine violet, flake white, and raw umber. My rough, scumbled brush marks broke up the flat tone of the ground and introduced a cooler color contrast to the background.

DEFINING THE MIDDLE VALUES

To begin painting the flesh tones, I generated several mixtures of peachy pinks from combinations of vermillion, burnt sienna, raw umber, and yellow ocher plus flake white. On the shadow side, I mixed ultramarine violet and burnt umber for the cooler darks.

I started at the glabella to again check the accuracy of the features. My first layer of thinly applied paint appeared intensely orange, a complementary contrast to the cool underpainting. I knew this optical effect would diminish as I continued to cover the entire face with a thin veil of color. Nevertheless, I carefully evaluated the color intensity and value of

the pigment mixtures before continuing. (Adding more burnt umber or raw umber would have darkened the values, while a touch of ultramarine violet would have cooled or neutralized the intensity.)

This approach to building the paint layers anticipates the preservation of the glow of the underpainting—where it will act as a transition into the shadow values. I took great care to apply my paint thinly so as not to lose the effect of the cool ground. While building up the density of the paint on the light side of the face and shoulder, I decided to modify my flesh tone palette mixtures with the addition of rose doré (a transparent cool pink) and flesh ocher (an intense color note). I was able to achieve careful blending between values and over the forms of the features by adding discrete brushfuls of oil medium into the color mixtures. This increased the blendable consistency of the paint and its transparency while I built the values toward the lightest lights.

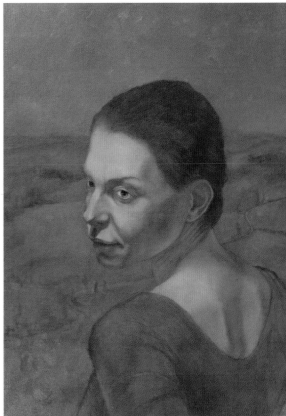

LEFT:

As the density of the paint layers increased the light values, I further defined the features.

ABOVE:

Blocking in the background with a thin scumble of Mars brown elicited the same warm-cool effect as used in the model.

ADDING THE LIGHT VALUES

Once the form of the entire head was firmly established, I then painted and refined the details of the features. I knew at this stage that the relationship of the value contrast on the model could not be fully evaluated until the background was painted. Therefore, I used a thin scumble of Mars brown to create a block-in of the background landscape. As when I blocked in the model, the warm-over-cool pigments created an optical glow. Once this paint was dry, I added a thin application of cobalt blue, scumbling from thick to thin across the sky. This introduced a distinct color note that I knew I would repeat when coloring the shirt.

The shape of the garment, the plunge of the neckline, was as important as describing the underlying form of the outthrust arm. Using rich, saturated mixtures of cobalt blue and burnt umber and a wet-on-wet application, I painted directly over the block-in drawing. The flow of the brush over the cross-contours of the folds of the shirt described the

action of the arm and the angled turn of the model's back as it receded into space. I carefully related the highlights on the garment to the highlights on the shoulder structure of the scapula.

Returning to the background, I used a resource photo to paint in a diffused suggestion of a countryside view, taking care to adjust the cast shadows so that they were parallel to the light on the model. Keeping to the limited palette, I resisted the temptation to add green into the landscape.

I added final lights and glazes once the entire painting was dry, including dark notes and highlights in the hair, a thin glaze of blue over the sky, and a denser blue glaze over the shirt.

LEFT:

I adjusted the relationship between the figure and ground, first by wiping away the brighter version of the skyscape and then further defining the landscape.

ABOVE:

Using a wet-on-wet application of cobalt and burnt umber, I painted the garment.

OPPOSITE:

To complete the painting I added the finishing details and glazing.

MARION

The golden toned ground created a luminous backdrop for a palette of raw umber and three primary pigments.

GROUND:	PALETTE:	
yellow ocher	raw umber	flake white
raw umber	yellow ocher	transparent white
	blue-black	transparent yellow oxide
	rosso Veneto	
	Naples yellow (reddish)	
	ultramarine blue	

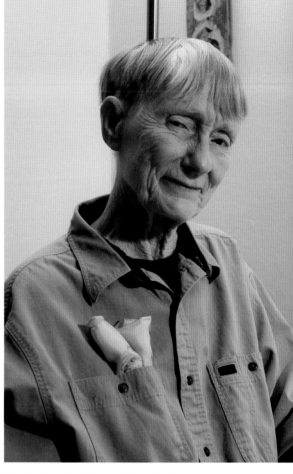

The photograph of the model reveals her character and sense of wry humor.

It is said that the older one grows, the more one owns one's face, so the challenge for a portrait painter is not only to convey the accumulating wisdom of age but also its frailty. My focus for this demonstration painting was centered on the shrewd gaze of the model, emphasized by the tilting thrust of her head. A delicately embroidered hanky, tucked into the pocket of a man's work-a-day shirt, suggests the subject's sense of humor or whimsy in making the practical pretty. I had used this golden toned ground for my painting of Cheryl (see pages 164 to 171), but I selected it again because it supported the overall coloring of the shirt, the golden-white of the model's hair, and the warm light on her the face. Yellow ocher and raw umber, which I also used in my limited palette, became the unifying pigments that created a link throughout the painting.

PREPARING THE GROUND

I began by applying a thinned mixture of yellow ocher and raw umber over the white gesso priming in a rough, scumbled manner (rather than as a smooth, even coat). This provided a mottled surface for the shirt and background. I chose raw umber, a brownish-green, because it darkened and enhanced the dull green undertones of the yellow ocher. As always, I painted the toned ground not only for its anticipated usefulness in the final image but also so that it would be a beautiful surface in itself. If I had applied the pigment mixture so thinly that it had appeared either meager (leaving the textural surface of the canvas too predominant) or scrappy (meaning that the toned ground was applied in a slapdash manner), it would have become a handicap for me as I developed the painting.

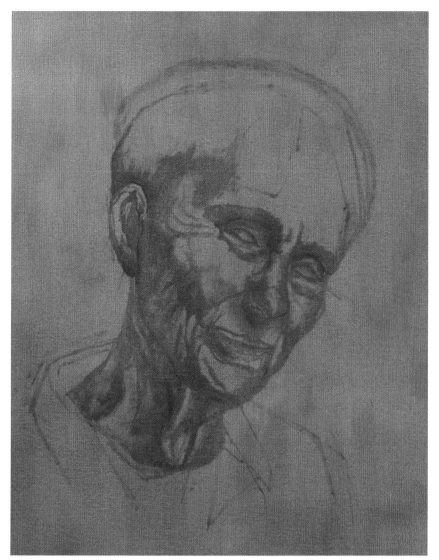

This palette served to block in the dark to low-middle values.

This palette expressed the cooler middle values.

This palette was useful for the warm lights and middles values.

LEFT:
Carefully observing the tilting axes of the head helped me to establish the relationships among the features.

ESTABLISHING THE BLOCK-IN DRAWING

I started this portrait painting by creating a lightly rendered freehand drawing of the figure, using thinned mixtures of yellow ocher, blue-black, and raw umber. To achieve an accurate likeness of my model during the initial block-in drawing, I carefully observed the tilting axis of the head, securing the landmarks of the features. Then I thinly scumbled areas of the shadow shapes as a way to check the accuracy of my drawing, keeping the paint thinly applied and the edges blended. Stepping away from the canvas and comparing the photograph to my block-in drawing, I could easily see where changes were needed in the angle of the eyes and the shape of the head. These changes were easy to adjust before continuing on with the underpainting.

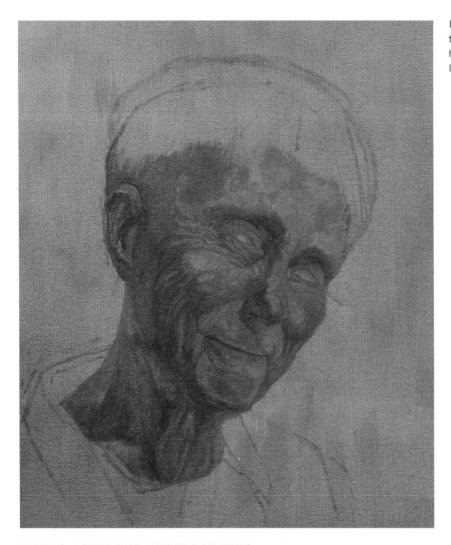

I made this monochromatic block-in of the values with thinly applied paint, which helped retain the golden tone in the areas of light.

LAYING DOWN THE UNDERPAINTING

The drawing stage of the block-in often moves seamlessly into a monochromatic underpainting, as it did with this image. This process involves creating a balance between the density of the areas with more heavily applied paint (which appear darker) and the sheer transparent layers (which appear lighter). In this way, the tone of the ground naturally becomes the lightest lights within the underpainting. I used the same paint mixture for the initial drawing, which made a smooth transition from line drawing to tonal shading.

I carefully placed the wrinkles of the skin folds, around the eye sockets and along the cheek folds, with thinly applied darks, knowing that I would eventually soften them with additional layers of pigment. Deep creases of the skin are better painted at this stage, so that they are implied rather than explicit and never appear as lines floating above the skin. As always, I kept the edges soft, anticipating further refinement and adjustments as the painting advanced.

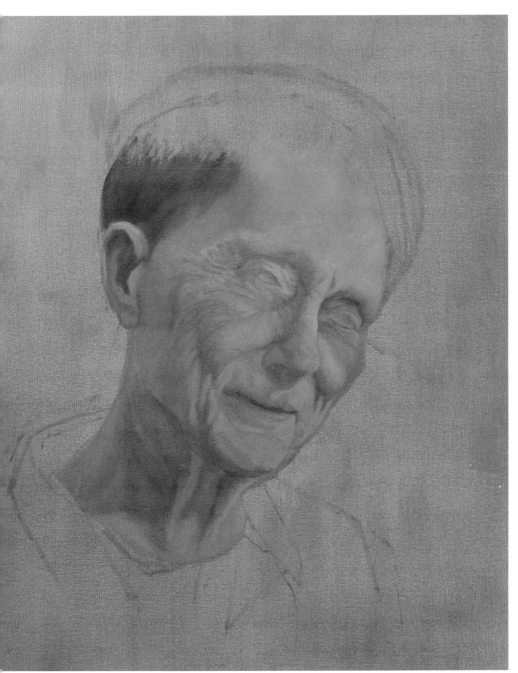

LEFT:

Cool low- and middle-value plumy pinks were applied over the dried underpainting, allowing the golden toned ground to show through in the light areas.

ABOVE:

Additional layers of the middle value began to separate the cool shadows from the brighter side of the face. The deep folds along the sides of the cheeks began to soften as I blended transparent layers over the initial dark pigment.

DEFINING THE MIDDLE VALUES

In order to generate middle-value mixtures of pink to plum, I added rosso Veneto (an earth red different from its cousin Venetian red) and transparent white to my palette. This palette divided the plumy low values of the cool, shadow side of the face from the brighter, more intense pinks of the light. Subtle changes in the features of the model (folds on the eyelids, creases over the cheeks, and so forth) meant that I needed to continually adjust how densely I applied the paint in response to where the light revealed the curving planes of the form. Wherever I applied the paint transparently, the yellow-green of the toned ground dulled the

pink mixtures; however, when I employed a more opaque application I created a brighter color note.

This stage of the painting often takes several sessions to modulate and blend transitions as the details of the features evolve. I painted the flesh tones of the forehead beyond the overlapping of hair so that I could later freely paint the bangs. Likewise, I kept the subtle contour of the face softly blended where it met the background.

As the features of the face dried, I blocked in the shirt with three value mixtures of yellow ocher, raw umber, and flake white. I used the darkest paint mixture to thinly draw in the details of the pockets and collar and then scumbled over the canvas with a larger brush to indicate the shadow of the shirt folds. The tone of the ground became part of the warm middle values, with very little or no paint over the surface. I scumbled the lighter tint loosely to indicate the brighter light on the folds and then blended the edges where they met the middle or dark values.

To create the color of the background, I laid in Naples yellow (reddish), which I had thinned with a small amount of linseed oil to a creamy consistency. I rubbed this paint into the surface with a large brush, leaving an irregular pattern of thick-to-thin paint that reserved the dulling

LEFT:

While the face was drying, I scumbled in the values that helped define the shirt using the same paint mixtures I had for blocking in the face values.

ABOVE:

Next, I applied the first layer of paint over the background, considering the softer edges along the hair line and crisper edges against the clothing. This helped to separate the figure from the ground/negative space and shift the value range before moving into the lights and details.

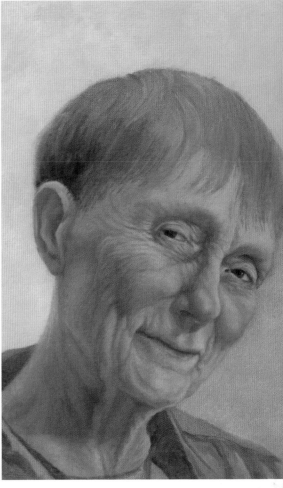

LEFT:

I defined the features while building up the transparent warm lights that blended over the high middle values.

ABOVE:

Once the forehead and side planes of the face were dry, I began painting the hair and shaggy bangs by first using low values with long pulls of a fine brush. Middle-value yellow mixtures were then drawn over the wet paint using the same brush strokes.

effect of the toned ground. Notice how the tone ground changed roles at this point in the process—illuminating the shirt and dulling the more chromatic pigment of the background.

ADDING THE LIGHT VALUES

Now that I had established the relative values of the overall painting, I focused my attention on refining the individual features. I used similar pigment mixtures as I had with the middle values, increasing the value by adding transparent white and a little yellow ocher. It is not the addition of more white (with its tendency to dull or cool color) that increases the brightness of a color but the density of the pigment layer.

Placing a few drops of linseed oil on my palette allowed me to adjust the transparency of the light values in discrete brushfuls. Using a soft filbert brush (which feathers out the oily pigment in a sheer layer), I carefully blended between the middle and lighter values. To increase

the intensity of the light value, I applied the paint in a slightly thicker manner and then blended into the oilier, transparent layer. I emphasized the lightest pink values in preparation for a transparent yellow glaze, knowing that what appeared now as light pink would be warmed to a golden orangey tone but also slightly darkened.

To further brighten the background around the model's head I added another layer of Naples yellow, now mixed with flake white and a peppercrumb of rosso Veneto. I also scumbled a thin glaze of raw umber over the lower bottom of the background behind the sleeve of the shirt, being careful to retain the atmospheric effect by not allowing the paint to build up a flattening opacity.

Once the paint on the background and face had dried, I established the hair using similar mixtures to those I had used earlier to paint in the shirt. I planned to glaze the hair, like the face, in transparent yellow, with the final gleams in the hair painted over the glaze. The fine, soft texture of Marion's hair lay close to her skull, making the changes in value important in describing this underlying form. To mimic the long strands of hair that crisscross and bend over the forehead, I used a round brush with a sharp point to draw thin lines, including thin wisps of hair that overlapped the background.

Standing back from the painting, it was easy for me to see where the finishing details were needed—for instance, the color choice for the triangle of her T-shirt and more details on the hanky.

APPLYING THE FINISHING GLAZE

Once the canvas was completely dry I prepared it for glazing by gently cleaning it with diluted ammonia. As a glazing medium, I used a combination of linseed and stand oil, which I thoroughly mixed with transparent yellow oxide. I tested my glaze for its color strength on an inconspicuous area before thinly applying it over the face and hair. I added further glaze applications (transparent yellow oxide to the shirt and Naples yellow reddish and transparent yellow oxide to the background). To complete the painting I added small final touches (such as the white highlight gleams on the hair using a transparent white drawn over the glaze). Looking at the finished painting, I asked myself: Was the empty background space working? Adding even a small element, such a butterfly, on her sleeve could change the meaning, just as a bouquet of fading flowers in the background would suggest something else. Often a painting will hang in the studio, finished but not yet complete until the solution feels obvious.

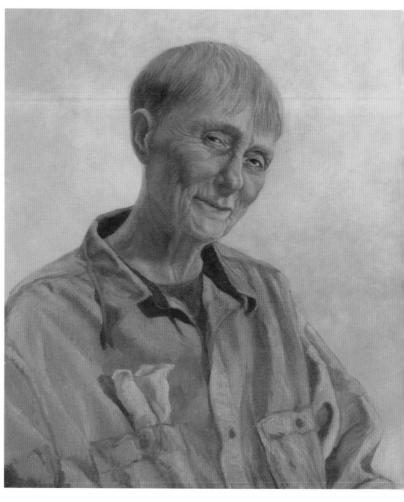

ABOVE:

Increasing the amount of light in the hair, shirt, and background helped establish the overall contrasts of the image.

OPPOSITE:

To complete the painting I added the highlights, finishing details, and glazing.

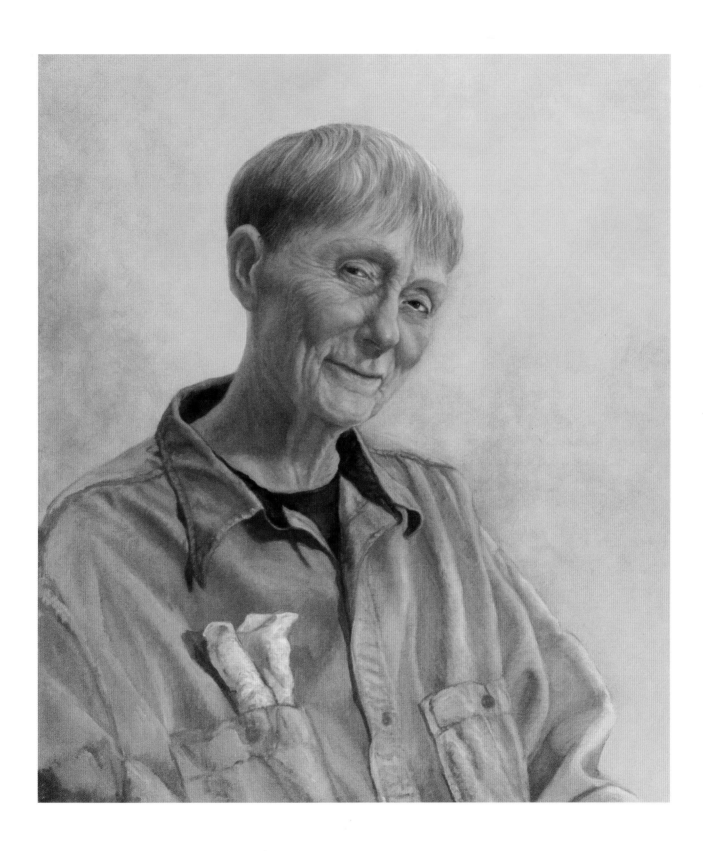

PIGEON

A warm yellow glaze transforms the neutralizing effect of the cool complements on a double-toned red-green ground.

The model was placed in a soft, natural light that created no harsh shadows over her features. Consequently, the core shadow appears as a subtle transition between the light and shadow sides.

GROUND:	PALETTE:
phthalo green	phthalo green
red ocher	raw umber
	terre rosa
	flake white
	red ocher
	blue-black
	terre verte
	transparent yellow oxide

The drama of the light provided the focus for this demonstration painting. In addition, the cantered slant of the hat created a subtle contrast to the angled tilt of the shoulders and the direction of the model's face. By placing the figure to the right side of the canvas, my intention was to use the angles created by the shoulder line and tilt of the hat to lead the viewer's eye from the left side toward the model's expression. I chose a limited palette of earth reds and raw umber to provide unifying elements throughout the painting. However, I purposely varied my paint handling to create diversity in distinguishing the various textures.

PREPARING THE GROUND

Many variations of a red toned ground utilize earth red pigments: Venetian red will generate a cooler dark plum; Indian red, a bricklike red; and red ocher, a dark maroon. Each of these pigments is dense and opaque, so that very little pigment is needed to create the ground pigment mixture. Often the density of earth red pigments is more useful as a ground when modified with the addition of green pigments, which can either be mixed into the red or applied as a thin veneer over the red, as in a double-toned ground.

For this painting I employed red ocher to paint the first ground, applying it in an even layer over the white priming and allowing it to dry. For the second tone I used phthalo green, mixing it with linseed oil so that it was very transparent, neutralizing the intensity of the red. Placing green pigment over red creates a subtle visual opposition between complements. However, if I had mixed alizarin crimson and raw umber together, they would have created a balanced (not red, not green) complementary mixture, resulting in a beautiful toned ground that would have worked well with this limited palette.

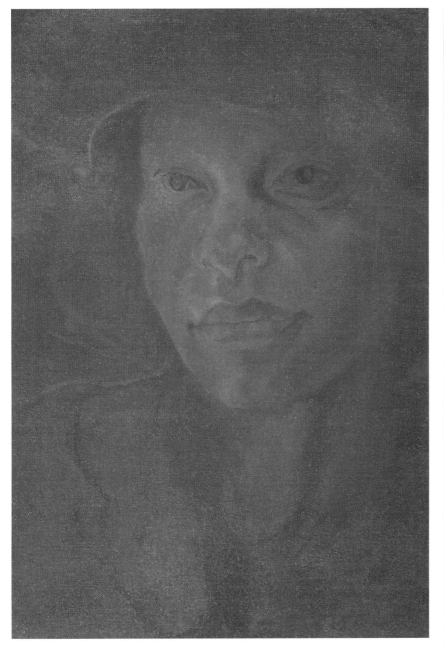

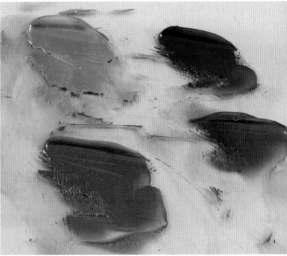

This block-in palette began with variations of raw umber and terre rosa, mixtures that helped establish both a dark- and a middle-value pink, which acted as a placeholder to represent the areas of light.

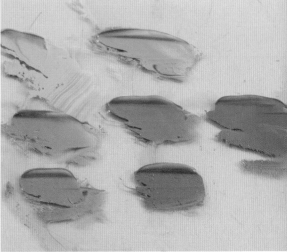

I created this middle-value palette from mixtures of red and green pigments, with the lightest values featuring only red plus white. The final transparent glaze transformed the pinkest light areas to a golden bronze.

LEFT:

I first established the model with a freehand line drawing, using pigment that was closest in value to the toned ground. Then I used low-key mixtures of the block-in palette to develop the forms of the face.

ESTABLISHING THE BLOCK-IN DRAWING

Since the palette that I used for this painting was based on very few pigments, it was important for the raw umber to be transparent and have a distinct greenish tendency. For instances such as this I prefer Old Holland's raw umber over other brands of paint.

First I mixed the red ocher and raw umber pigment plus a small amount of flake white to a value slightly lighter than the toned ground to establish the initial block-in drawing. I used similar low-key value mixtures to block in the value patterns (as placeholders) of light and shadow on the face, using their shapes to further define the placement of the features. The thinly applied paint allowed the red/green of the toned

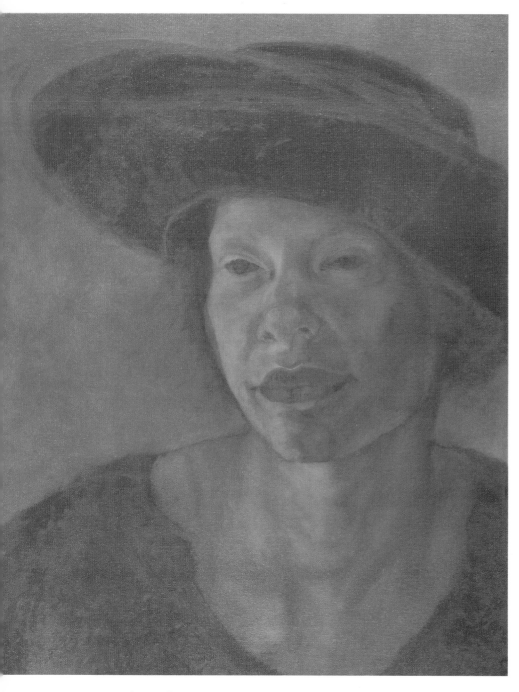

The model became more clearly defined as the underpainting evolved from the thinly painted darks to the denser layers of pigments. I used a scumble of midvalue raw umber and flake white in the background to further articulate the figure from the background.

ground to influence the shadows and reflected lights. This approach is similar to the one I employed for the demonstration painting of Michael on pages 196 to 203, where the dark value of the ground played a key role in keeping the dark areas transparent.

Next, I loosely defined the shape of the hat and garment by scumbling in a mixture of raw umber and flake white over the background, articulating the forms negatively. I also placed the background pigment behind the soft edges of the hair, anticipating the translucent quality of the hair's texture.

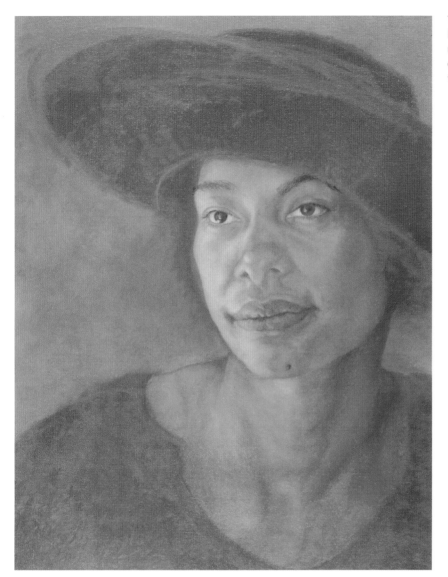

The process of adding details to the features began with the eyes. I achieved a closer resemblance to the model by accurately establishing the relationships among the features.

LAYING DOWN THE UNDERPAINTING

With this portrait my strategy was the same as it would be for any monochromatic underpainting: I used values to create the forms. However, at this stage I added temperature and color intensity, defining the shadows with cool green mixtures made with raw umber and using more intense pinks (made with red ocher) to represent the lights. I worked from dark to light, applying layers of pigment to accumulate opacity, so that the dark of the ground remained the most transparent and thinnest layer of paint. If I applied the paint too opaquely, the possibility of linking the lighter pinks values or creating a complimentary contrast to the toned ground would be lost.

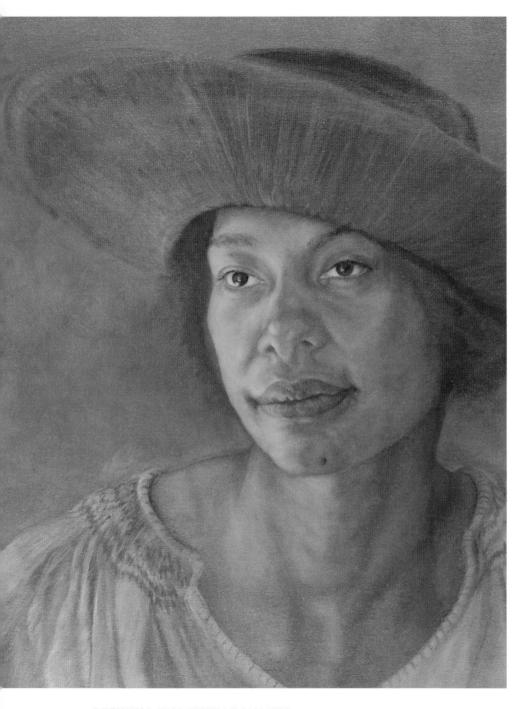

I painted the garment with a dry-brush scumble of neutralized pinks, developing both the folds of the shirt as it draped over the shoulder and around the neckline. Moving from dark to light, I added layers of pigment to create the texture and details of the shirt.

DEFINING THE MIDDLE VALUES

I used the same value mixtures for a number of painting sessions, without adding more white pigment; rather, I increased the brightness by applying denser layers of pigment. Since I needed to keep the contrast between the lights and shadows in balance, I built up the values using an overall approach—one that not only included the face but also defined the neck and shoulder girdle. I kept the edges soft and the transitions between values well blended by using discrete brushfuls of oil medium mixed with the pigments as needed.

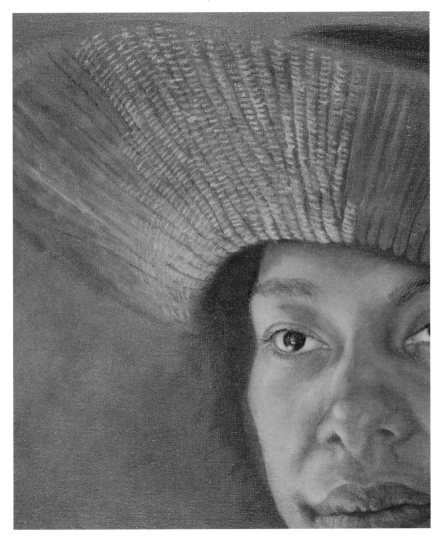

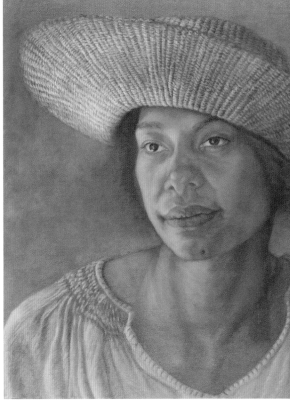

Standing back from the canvas, I noticed that the play of light over the model was beginning to imply the gesture of the head (gaze) expressed through the anatomy: the angle of the head juxtaposed with the thrust of the neck in relation to the shoulders. I knew that I must gently imply the overlapping of these forms (especially at the jawline on the shadow side and in front of the throat), allowing them to be neither too vague nor too detailed. Only after I had well established these larger forms was I able to paint the delicate details of the eyes, nose, and lips.

While the flesh tones were drying, I blocked in the shirt, using the same approach of building up the values from dark to light that I employed earlier. I used three value mixtures of terre rosa and flake white, with raw umber for the shadows and details. I applied the paint using loose, open brushwork that suggested the texture of the cloth as well as described the underlying form of the shoulder girdle. This scumbled brush handling allowed the toned ground to show through the brushwork. Once the paint had dried, I used lighter values to define the light on the folds, again using chunky pulls of the brush to suggest the fabric texture. (I saved the additional color for the embroidery until after I had applied the yellow glaze.)

ADDING THE LIGHT VALUES

In order to evaluate the relative value contrast of the features, I first had to complete the painting of the hat. I indicated the volume of the hat first, before articulating the rich textural surface, by scumbling paint (a mixture of terre rosa and raw umber plus flake white) in the direction of the light along the curving form. On this wet surface, I used the drawn stroke of the paintbrush to reinforce the cross-contours of the hat's form, moving from the brow to the brim and likewise circling around the head, plotting out the pattern of the hat with oily raw umber. I then created mid- to light-value mixtures of raw umber and flake white and used these to place in small, curving, rice-shaped marks to establish the texture of the straw weave. (I knew that once I applied the final yellow glaze, the areas of the painted texture that were now the lightest in value would appear the strongest golden color.)

After adding another scumbled layer (this time a mixture of terre verte and white) over the background, and allowing it to dry, I was now ready to paint the hair. For the hair color I mixed raw umber with a peppercrumb of blue-black and enough oil to draw the paint with a pointy filbert brush in overlapping spirals to mimic the tight curls of the hair. In some places I allowed the background to peek through, which kept the hair from becoming a solid flat mass. I made sure to keep the edges soft where the contours of the face and the hair met.

APPLYING THE FINISHING GLAZES

After the painting had dried completely I cleaned it in preparation for the application of glaze. At this point the overall values in the skin tones were balanced but they lacked the warm influence of the light. Using transparent yellow oxide, I mixed two puddles of glaze mediums on my palette—one that was stronger in pigment for the light side of the face and the hat and another that was very faint in color for the shadow side of the model and the shirt. After testing it in a nonconspicuous place, I carefully brushed on the glaze in a very thin layer, blending at the edges. I did not glaze the whites of the eyes, the background, and the hair with color but rather with clear medium. Holding the canvas tilted toward the light helped me to locate any places that I had missed or areas where the oil was too heavy, which I wiped off.

The areas that were bright pink or a neutral pink suddenly took on a golden sheen in the skin tones, and the hat, which had been a greenish-white, was now distinctly yellow and straw colored. The greatest influence of the glaze was on the lightest pink values. (Because the glaze itself darkens the overall range of values, I could have repainted semi-opaque color mixtures on the wet glaze or after it had dried to restore the lightest values. This paint layer could then have been glazed as well, if needed, to blend it seamlessly into the values of the skin tones.)

I added a glaze of transparent yellow oxide and linseed oil. What was previously a cool and neutral painting was now filled with warm light. To complete the work I painted the dark hair onto the oiled surface with blue-black and raw umber.

MICHAEL

This image features a grisaille underpainting over a burnt umber ground, enhanced by glazing techniques.

GROUND:	PALETTE:
burnt umber	raw umber
alizarin crimson	ivory black
	flake white
	transparent yellow oxide
	rose doré
	transparent red ocher
	lapis lazuli
	magnesium blue

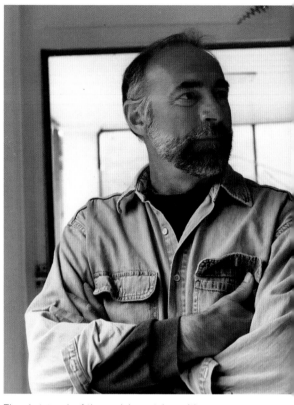

The photograph of the model was taken with a digital camera, allowing me to increase the light exposure and see details in the shadow areas.

In this demonstration painting, the noble stance of the model, with his upward-turning gaze, plays off the humble nature of his well-worn, chambray work shirt. Soft, indirect light from the left reveals the trails of wrinkles and texture of the face, especially around the eyes and cheeks. My intention for this painting was to create a strong triangle shape by placing the model's crossed arms along the bottom of the almost-square canvas. The folds and drape of the shirt would help give a strong dynamic to his gesture and keep the pose from looking static. Working with a palette of ivory black, raw umber, and flake white, I created a grisaille underpainting on a dark (rather than a mid-value neutral) ground, which provided the value structure and details for the image before I glazed it in color.

PREPARING THE GROUND

To start I mixed together burnt umber with a small amount of alizarin crimson to make a deep brownish maroon. A dark ground can be created a number of ways: Van Dyke brown, sepia brown, or raw umber plus ivory black can also be used to achieve this effect. Burnt umber pigment alone tends to have a dull, heavy feel, especially when a less expensive pigment is used. Adding a green, violet, or red hue to either Van Dyke brown or burnt umber can create a sense of depth or undertone within the dark value of the ground. (Even though the ground is dark in value, it is still rich in color.) Because I wanted this ground to provide the darkest dark of the painting and was not concerned with creating translucently with the ground, I covered the white of the gesso with a solid layer of color. The ground color was allowed to dry completely before beginning the underpainting.

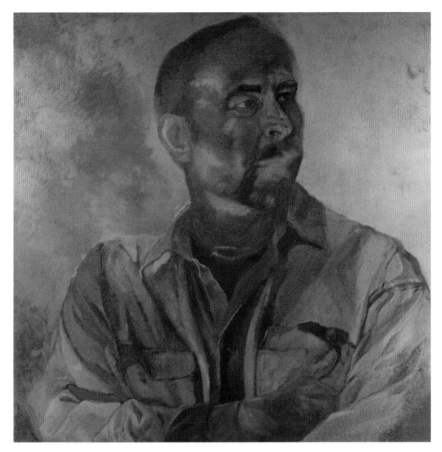

ESTABLISHING THE BLOCK-IN DRAWING

To optimize the rich tone of the ground, I first scumbled in thinned pigment mixtures of ivory black, raw umber, and flake white, which I mixed to a slightly lighter value than that of the toned ground. I used these paint mixtures to create a freehand block-in drawing that established the scale and placement of the figure in the composition. The thinned pigment was easily wiped off for any adjustments as the drawing developed. Rather than beginning with a precise, detailed drawing, my approach for this painting emphasized a loose painterly application of low-middle values that developed the form through the shapes of the lights and darks. At this point I was mainly concerned with establishing the proportions between the big masses and shapes of the figure while reserving the optical effects of the lighter pigments thinly scumbled over the darker ground. It was important to plan where to reserve the dark value of the ground, such as the deep folds of the shirt, the turtleneck, and the areas of the hair and beard. As the thinly applied began to cover the ground, its rich undertone of maroon became more apparent.

I created this grisaille palette of warm and cool grays with ivory black, raw umber, and flake white.

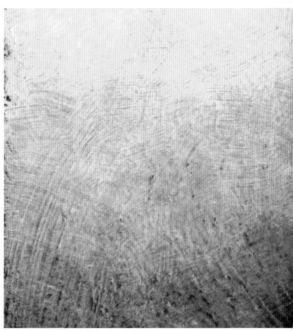

White pigment (or high-value gray mixtures), thinly painted or scumbled over dark areas of a toned canvas, was considered by the Old Masters to be delightful to the eye, as it created an optical gray known as "luster."

LEFT:

I developed the underpainting quickly, loosely painting the larger shapes of light and dark. The thin application of pigment allowed the ground to influence the value, while I reserved the ground as the darkest darks.

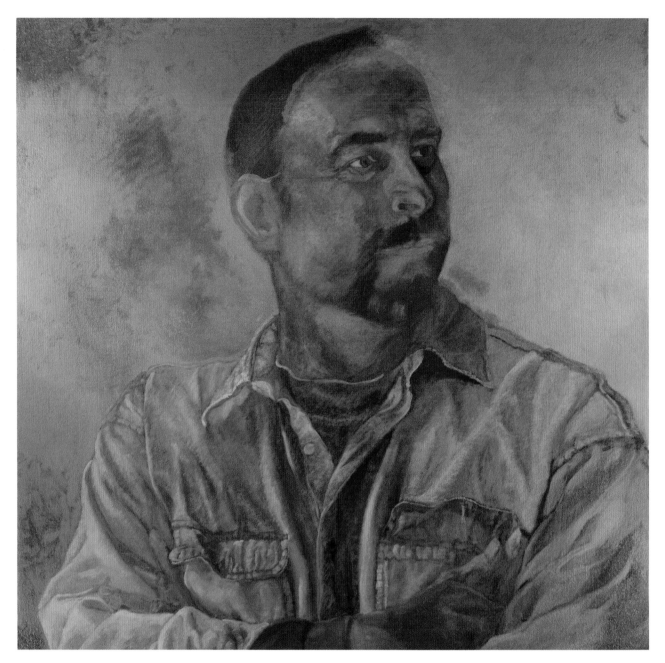

Refinements in the drawing emerged as the nuances in value became clearer.

LAYING DOWN THE UNDERPAINTING

I began with a palette of warm and cool grays, which I created by mixing ivory black, raw umber, and flake white in various values. I added a dot of oil medium to make a creamy consistency, allowing me to move the paint easily over the ground. I defined the figure by first scumbling paint over the background area in a thin-to-thick application of pigment. This allowed me to better judge the value structure within the figure itself. I knew that I would make refinements in the drawing as the shapes of light and shadow became more nuanced.

I reserved the darkest darks by applying little or no paint in those areas. Rather, I scumbled in a transparent veil of gray to articulate the

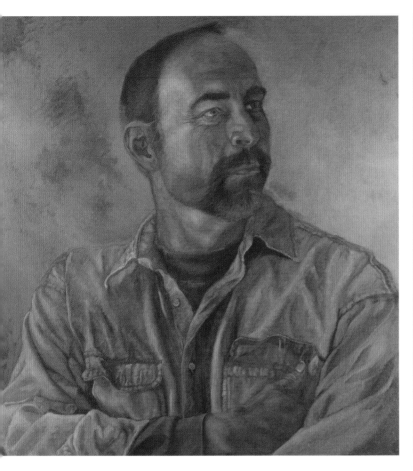

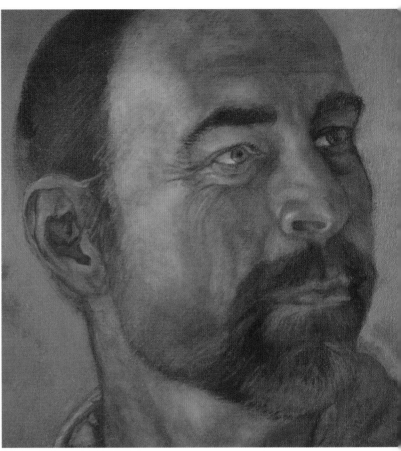

next darkest values, the low-middle values, allowing the maroon ground to optically tint the gray. The key at this point was to allow the toned ground to serve for the darks by incrementally layering transparent (thinly applied) layers of pigment to create an optical effect.

Allowing the paint to dry between layers was crucial for varying my paint handling. For instance, over an area of dried, thinly applied paint, I could now coarsely scumble thicker paint, which allowed flickers of the previous layer to speckle through. Thinking as a painter entails judging when working paint in a wet-on-wet verses blending over a dry surface is to your advantage.

DEFINING THE MIDDLE VALUES

Introducing raw umber in the gray mixtures had a warming effect, compared to the coldness of black and white grays, even though I consider it a cool, neutral green. This allowed me to use temperature as a means of shading the subtle forms of the face by using the cooler grays in the shadows and warmer paint mixtures in the lights.

As the painting progressed, I focused more attention on building up the details of the features and the texture of the shirt. During one painting session, for instance, I more clearly defined the details of the features, such as the creases around the eyes, the structure of the ear, and the set of the mouth. Over the next two or three sessions I slowly

LEFT:

Additional paint does not opaquely cover the lower values; rather, they maintain the optical glow of the ground.

ABOVE:

Refinements in the features evolved as I added finely blended layers of paint using warm and cool grays.

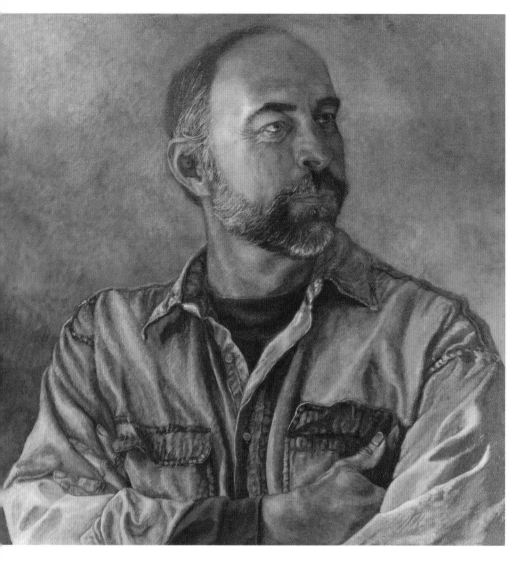

To increase the value contrast I moved into the lightest gray values.

OPPOSITE:

I added the final lights and finished the details of the features before glazing.

modulated in value the transitions of the forehead and the column of the neck until the turning forms read correctly.

While these paint layers were drying, I painted additional information on the textural folds of the shirt, using a "dryer" thick paint, which I lightly scumbled over the lower-middle values. The hands, tucked into the folds of the shirt, became more defined with softer, blended edges, while the background was treated to more layers of modulated warm-cool values of gray dappled over the space behind the figure.

ADDING THE LIGHT VALUES

At this point the figure was starting to take a strong sense of form. It was time to add the accentuated light values, which would provide the basis for the color glaze layers to come. In building up the light values, I tried to keep the whole value scale in check—the darks could not jump away from the middle values, nor could the middle values create strong areas of contrast from the lights. All the details had to be exactly painted at this point before the glazes could be applied.

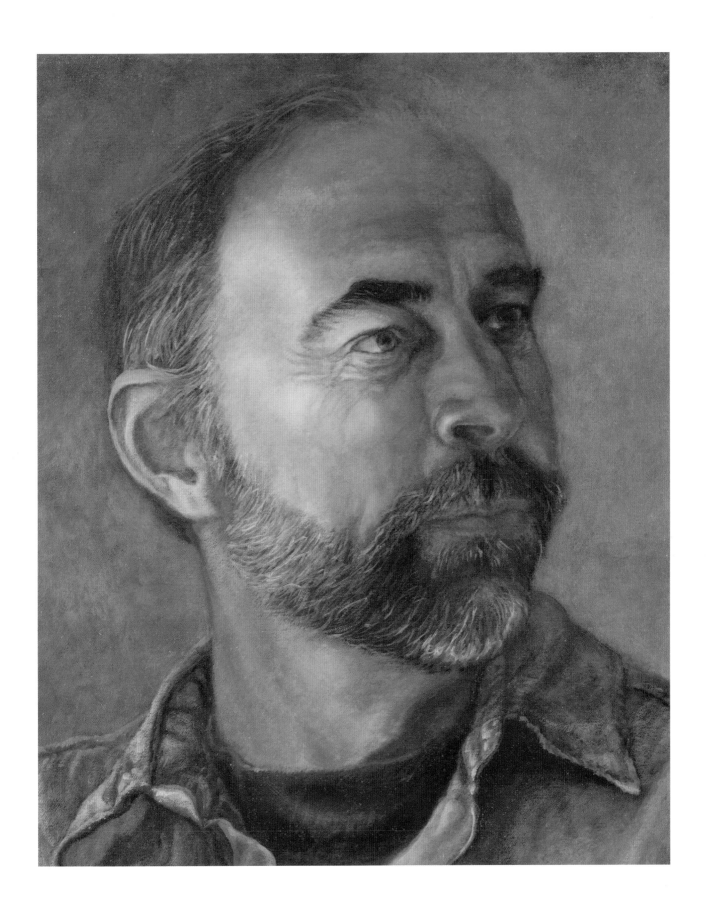

This is often the moment when oiling up the canvas can restore the sunken areas of the darks and refresh the color contrasts before the lighter pigment values are applied. The lighter values of gray can then be painted onto the wet, oily surface for easier blending (or applied onto a dry surface for more control). Any areas that seem rough or jumpy in value should be adjusted by returning to a darker gray value and then blended into the lights.

As I added my lightest values, I kept in mind that they needed to be strong enough in value so that the color of the transparent glaze would be backlit by the palest grays and the darkening effect of the glaze color would not muddy the overall value scale. (To anticipate the color effect over varying tones of gray, refer to the glazing chart on page 72.)

APPLYING THE FINISHING GLAZE

After I had cleaned the surface of the canvas, the painting was ready for the glaze application. On a clean area of my palette, I added several drops each of cold-pressed linseed oil and stand oil and then mixed them together with a palette knife. (As alternative, faster-drying glazing mediums, I could also have used Artist's Painting Medium [Winsor & Newton] or Galkyd Lite [Gamblin] at this point.)

I then used my palette knife to mix small amounts of transparent pigments with the combined oils to create discrete color variations. For instance, I planned to use transparent yellow oxide to warm the light side of the features; transparent yellow oxide mixed with a touch of rose doré to create a more peachy tone for the shadow side; transparent red ocher for color intensity in the cheeks; lapis lazuli and magnesium blue for the blue of the shirt; and a dot of raw umber to further warm in the background. I reserved a puddle of clear oil for those areas where no color would be added (the beard hair, for example) but where an additional layer of oil was needed to keep the paint film even throughout.

The glaze layer is always a thinly applied sheer veneer of oil; the strength of the pigment is adjusted as needed. I applied the glaze colors with a soft brush, blending as needed from the light to the shadow side of the figure. I paid close attention to the glaze at the contour edges of the form, being careful not to let a thick ridge of oil accumulate at the edges. Once the glaze had completely dried, I reviewed the image to judge whether any of the light values had been lost or if the color strength of the glaze could be reinforced with a second glaze application.

OPPOSITE:

To complete the work, I applied glaze colors over the dry and cleaned grisaille underpainting, providing transparent color notes. Notice how the original dark maroon brown of the toned ground appears to unify the overall darks of the painting.

AFTERWORD

TROUBLESHOOTING COMMON PROBLEMS

As contemporary painters, our appreciation of a portrait is based on the successful merging of the image and the artist's use of the oil medium. Therefore, the idea of the completion or finish of a painting can be thought of in two ways: A painting can be considered *complete* when the image obtains the big effect as an artistic statement, even if many areas remain sketchy and minimally painted. A *finished* painting is one in which the paint has been handled in such a way as to achieve a successful (beautiful) surface. Taken together, these two characteristics ensure that the painting will provide a satisfying viewing experience—from the dynamics of the composition to the smallest surface detail. Thinking as a painter requires a focus on the interaction among the brush, the paint, and the support. Each of these elements plays a crucial role in the final outcome of your painting.

Bringing a painting to completion often involves a certain amount of problem solving. The following are a few general problems that most painters experience when first using an indirect approach to painting using transparent layers of pigment.

The Primed Support

Rushing to get started, you did not take the time to prime the surface beautifully with gesso. Consequently you began with a slick/slippery surface. This made the first layers of paint difficult to control. Next time take more care when preparing the surface, from sanding the gesso layers to applying the toned ground.

You have a lovely transparent painting but the fake texture of the canvas is obvious. Choose your support carefully; the more you keep the paint transparent or thinly painted, the greater care you will need to dedicate when preparing the surface.

You stretched your own canvas and primed it carefully, but now that you have begun painting, the canvas has lost its tautness. This problem can sometimes be fixed by moistening the backside of the canvas with clean water (applied with a spray mister or wet cloth) to shrink the canvas from the reverse side. This cannot be done after many layers or thick paint have been applied, however, without risking cracking the paint film. (This same fix can be used in desperation when one canvas leaned against another and left a small dimple.)

The Toned Ground

When you made the color mixture for toning the ground, it was too opaque and resulted in a dead, flat surface that took forever to dry. Scumbling or rubbing in a lighter value over the dry surface or adding a second veneer of color can help restore a more luminous surface before the painting begins. However, next time remember to thin your pigment with a proportion of OMS and linseed oil so that when it is applied to the surface, the white of the gesso still backlights the color.

Your mixture was good but you painted the toned ground poorly, resulting in too meager or splotchy a surface that became more of a hindrance than an inspiration during the painting process. Don't worry, this experience will give you the patience to tone the next time with more care.

The color that you chose for the toned ground was too intense. (For example, in trying to achieve a golden ground, you actually made a really bright yellow.) Consequently, every color mixture you tried looked ugly or bizarre because your eyes were optically overpowered by the color intensity. Painting a second, thinned layer of color over the original toned ground (such as raw umber over the yellow) would quiet and dull the color contrast.

Somewhere in the painting process you lost the luminous effect of the toned ground. This was

because you had trouble planning where the toned ground was going to be most effective in the painting process and applied the paint too thickly. If you were taught to paint more directly, it may be that you also need to practice applying the paint thinly. Reinserting the pigment of the ground color into the palette mixtures is one way to reconnect the ground back in the painting if it hasn't been covered opaquely everywhere. Finish the painting and try again.

The color of the ground lifted off when you made corrections to your block-in drawing with a brush moistened in OMS. This is either because even though the surface felt dry to the touch, it wasn't completely dry or because there was not enough oil in the toned ground mixture to help the pigment bond to the surface. Remember it is the oil that acts to glue the pigment onto the surface. Over splotchy white areas, an application of the ground pigment thinly painted over the completely dry canvas can sometimes restore the toned ground before you continue with the painting.

Color Mixtures

You may have skimmed over the chapter on color mixing, but making the charts seemed like too much work, and now that you've read the text for the demonstration paintings, it doesn't make any sense. Nothing replaces the sound foundation of working through the felt experience of mixing color pigments. Go back to chapter two and study this section more carefully and complete the exercises.

You had trouble making enough variations in your color mixtures, or none of the mixtures was ever just right. Remember that you are not trying to exactly match the skin tones but to make useful blends that create a relationship of value and color temperature that describes both the model and the quality of the light. Perhaps you are being a little too heavy-handed when mixing two pigments together. Adding just a peppercrumb at a time will allow you to see the slight changes in the mixture, especially when you are using a high-staining pigment.

The lightest values look dull and chalky when placed on the richer colors of the middle values. Are you using titanium white? If so, consider flake white, flake white hue, or zinc white. Remember that it is

Robin Frey, *Accra,*
2007, oil on canvas, 14 x 18 inches (35.6 x 45.7 cm)

The dynamics of this portrait rest on the successful merging of paint handling and artistic intention to create the final effect.

the density of the paint application that makes the lightest lights appear bright and more opaque.

Your color mixtures looked great on the palette, but once you started painting, they all seemed wrong: too light in value, too intense, or too dull. Take the time to hold your palette knife with a touch of each mixture against the canvas and the model/photograph to judge each color in context. Make a mental note of where this mixture is going to be useful instead of making random piles of pretty colors. A test swatch with the same toned ground as your canvas is the best way to try out your palette before beginning to paint.

Your color mixtures are great, but the paint is too sticky, goopy, or otherwise unworkable. Could it be that you are working with student-grade pigments? If your paint is too stiff, then add a dot or two of linseed oil to the pigment before mixing the color. Check what kind of oil is milled with your paint brand; alkali-refined linseed oil is often more gel-like, sometimes giving the paint a sticky consistency. Try a different brand of the same color.

Your terre verte seems more like the color of pea soup than a clear, delicate celery hue. Again, try a different brand. There can be a big difference in color between brands. The core colors of your palette are the ones you'll come to rely on the most, and so they should excite your eye.

The hardest part is often giving up bad habits. If you lay out the palette in a careless way, is it just sloppiness or a bad habit that is not serving you well in mixing colors? Often it is the painters who place their pigments indiscriminately around the palette who have the poorest sense of color mixing. If you've been mixing pigments by stabbing your brush into lumps of pigments and then hoping for the best as you swish them together, are you really arriving at the exact color note you want or muddy Band-Aids? Useful, premixed lumps of pigment mixtures can aid in creating more subtle color transitions when blending neutrals or moving from warm to cool color notes. (Review the mixing chart on page 52.)

Mediums

You are going back into the paint to blend, but every pull of the brush is taking off the first layer. If you are using a quick-drying medium, remember that the open time for blending will be relatively short. Working back into these areas often creates blotches where the new paint tears off the half-dry layer of paint underneath. You must wait for the paint to dry before applying any new paint layers.

Returning to a painting (for which you used a quick-drying medium during the initial block-in drawing or underpainting), you found the surface was slippery to work on. Often a simple wash of diluted ammonia water will kill the shine, which allows the next layer of paint to adhere to the surface. However, make sure the paint is completely dry or you could remove all your hard work.

You finished the painting, but then a week later you came back to find that the color looked dead. Yikes, what happened? As the paint dries, the oil sinks downward through the paint layers. Hold the painting against the light and check to see how matte the surface looks, especially in the dark areas. Oil up the canvas using a medium that contains stand oil and let it dry again horizontally. This should refresh the color contrast.

You got too wild with adding mediums into the paint, and now the surface is showing signs of wrinkling, cracking, or even peeling off from the surface. This is the result of not keeping the fat-over-lean rule as you were building the paint film. If you are curious to try out different products, do it on a test canvas board first, not on your painting.

You glazed your painting and forgot to let it dry flat, and now there are drip marks of hardened oil. No fix really works for this problem. If you catch the problem before the oil sets, scraping the drips with a palette knife will take off the worst bumps, and then using a brush moistened in solvent can remove the rest. Your glaze or oiling-up layer may have been too thick to start with, leaving the surface with a gooey layer rather than a thin veneer of oil.

The Painting Process

You are trying your best, but everything feels awkward and the painting is a disaster. Integrating the action of the brush and the consistency of the paint onto the surface of the canvas takes practice. It takes at least a dozen paintings to discover all the problems and then a few dozen more to work them all out. Try to identify the problem areas: Are you working with a brush that is the wrong size or softness? Is the paint too oily? Is the surface too slick? In the beginning, your goal should be to never let the materials get in the way of your progress.

Once you find your problem, great, now you can fix it. If your block-in drawing is wobbly, then your problem is an easy one: You need more drawing experience. If you have trouble painting the lips, you might need a better range of red pigment, more practice color mixing, or a closer look at their form and structure. Your job in thinking as a painter is to identify the problem and find which solution can fix it.

The whole approach to indirect painting feels unnatural; you want to gain more technical proficiency, but you are losing patience in the process. This may not be an approach that suits your temperament as a painter. Looking over the numerous examples of contemporary portrait painters in this book, however, you have probably noticed the diversity of interpretation that melds contemporary sensibility toward color and painting handling with Old Master techniques. The practice of painting requires not only passion on your part but patience and persistence to master the craft. Individual style is a responsive expression of painterly ideas that makes thinking as a painter an important part of the process.

WAR CRIMES IN VIETNAM

Bertrand Russell was among the first in the West to raise his voice against the war in Vietnam. Here he relates his growing involvement in the struggle and illustrates the development of his thought as the war escalated. The author guides the reader through a land of napalm and 'lazy dogs', gas and chemicals, corruption and concentration camps, charting an independent but highly committed position. The catalogue of atrocities is one of the best-documented to appear in the West, but this book is far more than a compilation of horrors; it is an examination of the whole Cold War setting in which the conflict occurs, with the author never failing to urge what must be done to save the Vietnamese people from further agony.

Bertrand Russell is not only as controversial as ever, but presents his arguments with a passion that forces re-examination of the issues. This profoundly shocking and moving book develops a substantial argument, culminating in the broadcast by Lord Russell over the radio of the National Liberation Front of South Vietnam, announcing the establishment of his international War Crimes Tribunal. Any book written in an author's ninety-fifth year is a rarity; Bertrand Russell on Vietnam is a remarkable defence of a small people suffering systematic destruction.

17.1

by BERTRAND RUSSELL

BERTRAND RUSSELL

WAR CRIMES IN VIETNAM

London
GEORGE ALLEN & UNWIN LTD
RUSKIN HOUSE MUSEUM STREET

FIRST PUBLISHED IN 1967

PRINTED IN GREAT BRITAIN
in 10 point Plantin type
BY C. TINLING AND CO. LTD.
LIVERPOOL, LONDON AND PRESCOT

CONTENTS

ACKNOWLEDGEMENTS

I am indebted to Christopher Farley, Ralph Schoenman and Russell Stetler Jr. for assistance in the preparation of this book. They not only undertook considerable research at newspaper offices and libraries and prepared material when some of the chapters were originally written, but also made valuable suggestions on the selection of essays for this volume. I am particularly grateful to Mr Schoenman for his report from North Vietnam, which appears as an appendix.

I wish to record my thanks also to two US magazines, *Liberation* and *The Minority of One*, in which some of these chapters first appeared.

B.R.

ACKNOWLEDGMENTS

INTRODUCTION

The racism of the West, especially that of the United States, has created an atmosphere in which it is extremely difficult to make clear the responsibility of America for problems which are held to be 'internal' to the underdeveloped countries. The war in Vietnam is looked upon as the inevitable and tragic product of backwardness, poverty and savagery—supposedly indigenous to South East Asia. The roots of the current conflict are sought in the dark past: ancient conflicts between north and south are dredged up. The American intervention is, on this view, fortuitous. The Vietnamese people are thought to be pitiable creatures, into whose affairs the Americans have reluctantly and unfortunately been invited.

Racism not only confuses the historical origins of the Vietnam war; it also provokes a barbarous, chauvinist outcry when American pilots who have bombed hospitals, schools, dykes and civilian centres are accused of committing war crimes. It is only the racist underpinning of the American world-view which allows the U.S. press, the Senate and many public figures to remain absolutely silent when 'Vietcong' prisoners are summarily shot; yet at the same time these bodies demand the levelling of North Vietnamese cities if the pilots are brought to trial for their crimes. American violations of the 1949 Geneva Conventions on the treatment of prisoners of war have long been a matter of public record. It was reported, for example, in the *New York Times* of December 1, 1965, that 'the International Committee of the Red Cross in Geneva . . . complained again that the United States was violating an international accord on the treatment of prisoners. . .' The indifference shown to this clear indictment—not to mention the indifference to daily bombardments of civilian populations with napalm and white phosphorus—is appalling.

The fundamental fact which I wish to establish here is that the

Vietnam war is the responsibility of the United States. This elementary truth is central to any understanding of this cruel war. To understand the war, we must understand America, though this is not to ignore the history of the Vietnamese people. Vietnamese culture is rich and dates from antiquity. Oral legends continue heroic traditions, particularly those which tell of the ancient repulsion of feudal China. But history's movement, ever faster, is such that the Vietnam of today is less connected to her ancient heritage than to her present world. The past hundred years of Vietnam's national life have brought her on to the world stage. To understand Vietnam and the agony of her struggle, we must see Vietnam amidst the constellation of anti-colonial forces which are transforming the Third World and, less dramatically, the West itself. Vietnam will not be understood, no matter how deeply we probe her past, unless we cease to isolate her meaning. It is America that has given Vietnam an international significance.

While the beginnings of the American role in Vietnam precede the notorious involvement with Ngo Dinh Diem, it must be noted that France deserves the credit for nearly obliterating the Vietnamese cultural heritage. Before the Second World War, France managed her own colonial affairs with arrogant self-reliance. A rival to Britain, she probed Vietnam in the nineteenth century while seeking new access to China. On the pretext of protecting French missionaries from the reprisals of the savages they sought to Christianize, French naval vessels sailed into South Vietnam in the 1840s. The colonial conquest was begun in earnest. Within a matter of decades, not only the whole of Vietnam, but also Laos and Cambodia had been brought under French colonial rule. Although each region of the vast amalgam, 'Indo-China,' had a different *de jure* status and governmental structure, everywhere the French were ruthless in securing the submission of the native population. Their rule was not to be disputed, and it was their arbitrary right to determine the laws and regulations of every part of the colony. Sporadic, disorganized guerrilla resistance opposed the French and continued into the twentieth century.

It is the totalitarian process of colonization which destroyed Vietnamese society and severed the ties between a people and its past. The skills, habits and beliefs of the colonized people come to be judged by a kind of warped utilitarianism: that is useful and good which benefits the colonizer. Under the Mandarin system which remained in Vietnam long after the expulsion of the Chinese in 937 A.D., there were roughly 20,000 private schools, each with a single teacher, at the village level, in addition to state-supported provincial and district-level classes. In an effort to produce a 'cultural carbon copy' of France, the colonizers utterly abolished these schools, romanized the Vietnamese language to produce a new 'official' language (the 'quoc ngu'), and established only 14 secondary schools and one university in all of Vietnam. With such an inadequate number of institutions, few could pass the new 'literacy' test. Economic changes produced by the requirements of the colonizers were equally profound. Industrial raw materials, not consumption crops, were the prize most coveted. The advent of the motor car created a demand for rubber which turned thousands of Vietnamese peasants into plantation coolies. The establishment of a money economy was swiftly accomplished. As peasants increasingly needed money for buying goods and paying taxes, they were forced to mortgage and to sell their land. No aspect of Vietnamese life was untouched in this process.

White, European supremacy was invariably associated with the unchallengeable rule of the colonizing power. Traditional nobility and Mandarins lost all prestige and respect as French *fonctionnaires* occupied every post of authority throughout the countryside. In the atmosphere of suspicion and distrust which prevailed, the colonizer looked for emblems of subservience. The converted Christian, consciously bowing to the authority of the white man's faith, was feared least and, therefore, rewarded. These conditioned feelings of inferiority were widely established. In such a situation, Japan's victory over Czarist Russia in 1905 was given symbolic importance by many Vietnamese. This was surely proof that an Asian power was capable of inflicting defeat and humiliation upon the West. Knowledge of this event was

possible, ironically, because of the settlers' insistence that the educated Vietnamese learn French. The new language allowed a small number of Vietnamese intellectuals to study events outside their own borders. Around this same time there were strong efforts made by Vietnamese nationalists to obtain reforms within the colonial systems. They campaigned, for example, for free schools, through which their culture could be restored. It was in these schools that the most ardent nationalists were later to be trained.

Another factor which influenced the development of nationalist aspirations was the first world war. Knowledge of this war was by no means limited to those who had studied in the French-administered schools. Heavy casualties at the front seriously affected the mount of manpower available to do the factory work which was equally vital to the French war effort. To meet this labour shortage, the French imported large numbers of coolies from mainland China and southern Asia. The Vietnamese who came to France entered a strange and new world. They came into direct contact with the ideology of home France—with its professions of liberty, equality and fraternity—which was unknown, even proscribed, in the colonies. The tradition of the French Revolution was one aspect of French culture which was not exported and imposed on the Vietnamese by the settlers. The Vietnamese in Paris were intoxicated with the ideas and ideals of the liberal and socialist traditions of Western political thought.

It was also claimed that the great war was being fought to 'make the world safe for democracy'. The war brought forth the most impassioned and idealistic rhetoric to inspire those least anxious to end their lives in futile slaughter. A group of Vietnamese nationalists in Paris conceived the idea of taking the allies at their word. They appeared at Versailles in hired formal dress to request that the allies affirm the principle of self-determination for Indo-China. Among these nationalists was Ho Chi Minh; this tragi-comic meeting was his first attempt to negotiate his country's independence. Needless to say, the pleas of the would-be diplomats fell upon deaf ears. Decolonization was not to come so easily.

By that time the United States had emerged as a world power. Throughout the world the U.S. sought to break up the absolute control of trade and commercial rights by the old empires, most notably in the Open Door policy in the East. There were vast riches to exploit, and the United States wanted a share. At this stage, there was no need to disturb many of the existing power relationships and to destroy competing powers. There was enough for all. In 1923, for example, ex-Naval Secretary Franklin D. Roosevelt expressed the following view in a speech entitled 'Shall We Trust Japan?':

'It is true that we shall continue to overlap and perhaps to clash in the development of the commerce of the Pacific, but when we consider the potential trade of the vast territories and huge populations bordering the North Pacific and South Pacific oceans, there would seem to be enough commercial room and to spare for both Japan and us well into the indefinite future....' (Published in *Far Eastern Review*, XIX, August 1923, pp. 505-8).

In any case, it is clear that something other than principle guided the formulation of American policy in the East.

During the decades between the two world wars, discontent and alienation were reflected in a variety of developments in Vietnam. Nationalist thought was germinating. In the ranks of the educated middle classes there was mixed reaction to the results of the First World War. Some accepted the hypocrisy of the 'democracies' which professed self-determination and practised the most brutal colonialism. These more contented Vietnamese sought token reforms within the colonial system. Reforms were not forthcoming, but many of these advocates of mild improvements found rewards for themselves within the French apparatus, as civil servants and lesser functionaries. Those who were not so easily satisfied began the long task of adapting Western political concepts to the social problems of colonized Asia. It was some years before genuinely original political doctrine was formulated. In the meantime, imitation and crude adaptation of alien political practice were commonplace. Most of the earliest political

parties were models of foreign parties, included one styled after the Kuomintang of Chiang Kai Shek.

France was in full command of the situation throughout this period. On February 9, 1930, the Viet Nam Quoc Dan Dang (VNQDD) led an abortive revolt. The French garrisons were so efficient in dealing with this uprising that this nationalist party was thoroughly crushed, not to appear again for 15 years. The Russian Revolution impressed many Vietnamese intellectuals. Three small groupings joined forces in 1930 to form the Indo-Chinese Communist Party, which increased its numbers steadily, though slowly, in the face of great hardships. In these difficult years the Communists organized some strikes and, for a time, established Soviets at Ha Tinh and Nghe An, but there was no organized national movement. Occasional strikes in the Mekong delta region and in the cities could not threaten seriously the French administrative apparatus. All attempts to build a nation-wide movement were dealt with swiftly and ruthlessly by French mercenaries. Scores of French prisons and labour camps housed more than 10,000 political prisoners by 1932. The Vietnamese have many martyrs from these years; more numerous are the unknown dead, whose graves are marked only 'coolie'. Many others were driven into exile, which was not without certain advantages. Exile made of Ho Chi Minh and others true internationalists, fully conscious of the dimensions of their struggle.

The hardships of long-term political struggle convinced certain of the discontented elements of Vietnamese society that salvation was rather to be found spiritually. Religious revival took strange new forms, and spread throughout the countryside. Foremost among the new sects were the Hoa Hao and the Cao Dai, the latter being the more bizarre of the two. (Cao Daiism combined elements of Buddhism, Christianity and Hinduism, and included Victor Hugo among its saints). These sects developed wide followings, and were consequently feared and distrusted by the French. Persecution of the sects caused them to build their own armed communities; there was no avoiding the worldly struggle. As the wheel has come full circle, they have played

increasingly important political roles, being integrated into the main organizations of political conflict.

In these same decades, Japan moved steadily towards absolute hegemony in Asia. She had occupied Korea in 1910, and in the early 1930s she moved to assert her sovereignty in Manchuria. In 1937 she invaded north China. For reasons mentioned earlier, these actions did not at first alarm the United States. Trade and co-operation with Japan were of great interest to American businessmen, for Japan provided indirect access to the rest of Asia. The largest portion of American investment in the East was directly or indirectly tied to Japan. It took, therefore, many years for the United States to come to regard Japan as an enemy. Before America finally endorsed Chiang Kai Shek, Japanese domination of China seemed preferable to an independent republic in the eyes of many American policy-makers.

When France fell to the Nazis, Japan saw her opportunity in Indo-China. America felt the increasing threat of Japanese competition, and made clear her determination to allow Japan no more than secondary status in Asia. Roosevelt did not hesitate to warn the Vichy Government that France would lose Indo-China after the war if she yielded it to Japan. The French then callously appealed to Hitler to maintain white (Franco-German) supremacy over the colony; this explicitly racist proposal was rejected by the Axis. The Vichy Government soon capitulated to the demands of the Japanese. The occupation of Indo-China, together with Thailand's decision to join the Axis, gave Japan strong positions for her invasions of the rest of Southern Asia. In Indo-China the French colonial apparatus was left intact; it merely served new masters. Elsewhere, such as in Burma and Java, the Japanese found Asian collaborators by skilfully exploiting the nationalist and anti-Western sentiments with their slogan 'Asia for the Asians'. Both the use of French collaborators in Indo-China and the promotion of 'nationalist' collaborators in other parts of Asia reflected a pragmatic attempt on the part of the Japanese to use the resources of the regions without disturbing the existing social structures.

The interests of Japan and the USA were irreconcilable. Over

many years, US leaders had proposed to the Japanese an unequal partnership. The Washington Naval Conference had explicitly prescribed a militarily inferior position for the Japanese. Japan decided that co-operation with the United States was a difficult matter, and the course on which she finally embarked was an open challenge to Washington. It always carried with it the risk of war. Provocative acts did not begin with Pearl Harbour. The attack on the US gunboat *Panay* was symbolic both of Japan's determination and of America's ever-present naval threat. Protection of American interests in China had long dictated the presence of American warships in the Orient. The final rupture between the United States and Japan was no accident. The bombing of Pearl Harbour on December 6, 1941, was only the *coup de grace*.

American war aims in the Pacific were somewhat complicated. Most obviously, the United States sought to defeat Japan militarily. Towards this end, America recruited an eclectic combination of allies, including communist-led nationalist movements. But the political objectives of the war were not so simple. Even before entering the war, President Roosevelt contemplated the prospective post-war gains. The breaking-up of the British Empire would be of singular importance to American business interests. On January 12, 1940, the President addressed a group of publishers and editors of business magazines as follows:

'As you know, the British need money in this war. They own lots of things all over the world . . . such as tramways and electric light companies. Well, in carrying on this war, the British may have to part with that control and we, perhaps, can step in or arrange—make the financial arrangements for eventual local ownership. It is a terribly interesting thing and one of the most important things for our future trade is to study it in that light.'

(Press Conference 614-A.)

Thus, throughout the war, Roosevelt was not particularly interested in upholding Churchill's plans for the restoration of the Empire. He specifically endorsed independence for British India.

At an early point in the war, it was vaguely decided that a 'strong' China, under Chiang Kai Shek, would be the basis of the post-war Asia policy. That is to say, co-operation with a China which would be 'strong' in comparison with the rest of Asia and weak by comparison with the United States was the American plan for stabilizing the East. The Americans correctly noted two features of traditional Western imperialism which were inimical to the interests of American capitalism. First, American access to the colonies of the British Empire was strictly limited by the policies of the rival power. There was no equality, no 'open door', so far as trade with imperial colonies was concerned. This was an important ingredient in the spirit of anti-colonialism which was nurtured in the U.S.A. even in the period of industrial expansion. Secondly, brutal rule was seen to be self-defeating, by causing unrest and social revolution. The Americans had seen in the case of Mexico that even non-communist national revolutions could result in the expropriation of American property. Prudent decision-makers, therefore, favoured a policy of staunch lip-service to anti-colonialism and national independence, combined with aid to traditional native ruling élites which would not be likely to implement programmes of far-reaching social change. A partnership with local ruling groups and business interests seemed preferable to the risk of complete colonization. China provided one model for this policy. In the Philippines, fear of communist-led nationalist guerrillas prompted immediate plans for post-war independence along the same lines.

The Vietnam problem was more difficult. Unlike China and the Philippines, Indo-China was a region which had not been penetrated by American capital and in which there was almost no American influence. The French had taken no steps to cultivate local rulers. No understanding had been reached with corrupt 'nationalists' to provide nominal independence. A critical situation had developed quite rapidly. The French were collaborating with the Japanese. Taking advantage of the confusion, which was inevitable, given the mutual distrust of the Japanese and the French, many exiled Vietnamese nationalists began to slip across the border from Southern China and set

about organizing a resistance movement. The chief initiative in this enterprise was taken by the communists. A coalition known as the Viet Nam Doc Lap Dong Minh (or simply Viet Minh) was formed, under the leadership of Ho Chi Minh. The breadth of participation in this coalition was most impressive. The Viet Minh built its resistance movement throughout the countryside, waging a campaign of guerrilla warfare against the Japanese and their collaborators. The US and its allies accepted the support of the Viet Minh and dropped some supplies to the guerrillas from the air. The communist leadership of the Viet Minh was, of course, no secret. As the war drew to a close, the United States was faced with the problem of how best to 'stabilize' Vietnam and how best to make it accessible to 'American interests'.

As I have already mentioned, the United States threatened the Vichy Government with the loss of Indo-China following the war. In the course of the war the Free French were likewise excluded from big-power conferences at which the fate of Indo-China was discussed. The United States preferred Chiang Kai Shek's China as the fourth power to consider such questions. As late as 1944 President Roosevelt spoke vaguely of a trusteeship system as the best solution to the Indo-China question. Such proposals were discussed in the light of the United Nations organization, which was soon to be established. But trusteeships involved gradual steps towards independence and local self-government. The Viet Minh was ahead of schedule.

On March 9, 1945 the Japanese staged a *coup*, thereby taking full and direct control of Indo-China. They feared that the French collaborators would be unreliable elements as the Allied forces moved nearer to total victory. Might they not opportunistically switch sides? The Japanese immediately incarcerated large numbers of Frenchmen. Many of these were also forced to suffer public humiliation. The Japanese had a sufficient garrison to handle the French, but their forces were wholly inadequate to deal with the Viet Minh. They attempted to woo some of the nationalists, and managed to coax a certain Bao Dai to accept the position of 'Emperor' under their tutelage. Their attempts to form youth corps and Vietnamese military units to fight on their

side failed for the most part: they merely provided the opportunity for many Vietnamese to learn military skills and to acquire weapons for the Viet Minh forces. In the spring of 1945 the gains of the Viet Minh were enormous: large areas, especially in the north, were consolidated. By the summer, they were in a position to claim *de facto* state power.

These various events created an atmosphere of crisis for American decision-makers in 1945. The power of communist forces emerging in liberated Europe had caused many policy planners to re-evaluate wartime strategy. Moreover, at the 1944 convention of the Democratic Party in the USA, conservative elements asserted themselves forcefully. Vice-President Henry Wallace was replaced by Harry S. Truman. Subsequently, important changes took place in the State Department: Secretary Edward R. Stettinius appointed men like Dean Rusk and Nelson Rockefeller as his assistants in charting a somewhat different foreign policy. Roosevelt's death and the consequent further reorganization of personnel made the shift decisive. Secretary of State Byrnes was unequivocal in his anti-communism. The main concern of this new team was not the military defeat of Japan. In effect, that was already assured: in every important respect the Japanese Navy and Air Force had been rendered inoperative by the spring of 1945. Early in the spring, the Japanese communicated with Soviet leaders about possible surrender terms, and the Russians in turn passed this information on to the United States. But by this time, the Americans were preoccupied with more subtle political matters.

The United States wanted undisputed hegemony in the post-war world. The Russians were no real threat. Devastated by war, they could not match the military and industrial might of the USA. Moreover, Stalin's ideological influence was hardly a direct threat to America. Indeed, Stalin had already shown his willingness to counsel against revolutionary seizures of power in order to keep alive the 'united front'. In the case of France, for example, the communist-led underground movement (FFI) was on the verge of taking power when Maurice Thorez returned from his prolonged stay in Moscow. Thorez convinced his party that the

overall interests of the international communist movement
dictated that all power be yielded to the Paris government of
de Gaulle. In Asia, however, there was a somewhat different
situation. Enormous anti-colonial movements had grown up
during the war. Hundreds of millions of Asians—Chinese,
Indonesian, Vietnamese, Filipino—were part of a struggle which
was transforming their lives irrevocably. Here was a profound
social force with which the United States would have to deal.

The Americans sought first to minimize Soviet influence in
Asia. They wanted to avert any activity by the Russians in Asia,
fearing anything which would encourage the emergence of
socialist nations in the regions fighting for independence. The
terms of the Yalta Agreements had provided for Russia's entrance
into the Asian theatre in the summer of 1945. This factor, plus the
power of the nationalist movements, was held firmly in mind
when the decision was made to incinerate Hiroshima and
Nagasaki. The full reasons for this decision are, of course, com-
plicated. The use of two different kinds of atomic bombs on the
two cities, however, suggests a calculated experimentation, at
the cost of thousands of lives. Throughout the development of
the atomic bomb, leading policy-makers doubtless contemplated
its usefulness for intimidating the Soviet leadership. But the
awesome power of the nuclear devices could have been as easily
demonstrated by using them on uninhabited areas. The decision
to use them on Asian cities can be seen, therefore, to have had
two motives. First, there was the psychological motive. Using
the A-bombs on the Japanese established a myth namely, that
the bombing of the cities was decisively effective in obtaining the
surrender of the Japanese. For reasons which are obvious, the
Soviet leaders could not have been expected to believe this myth.
But for ordinary people in the West—as well as Asian nationalist
leaders who were not privy to the information that the Japanese
had sued for peace six months earlier—the myth was readily
accepted. Westerners *wanted* to believe that there was some
technological alternative to ground warfare. Secondly, the bombs
were dropped in order to make clear that American power
could—and would—be used to annihilate masses of Asians in a

single stroke. The incineration of the two Japanese cities could hardly have been expected to gain popularity for America in Asia (particularly in view of the often ambiguous attitude of Asian nationalists towards the Japanese). This horrific act could only have been contemplated to terrorize Asian nationalists.

The Viet Minh were not to be intimidated. Throughout August 1945 they moved to consolidate their power. On August 19 a government was set up in Hanoi, and Bao Dai, the former puppet Emperor under the French and Japanese, was persuaded to abdicate. On August 25 a large demonstration was called in Saigon to declare support for the new government. On September 2, 1945 Ho Chi Minh issued a declaration of independence, based, ironically enough, on the American declaration of July 4, 1776. The bold action of the Viet Minh forced the United States to come to a decision on the question of Indo-China. Turning their backs on Ho Chi Minh, the Allies chose to have the Japanese surrender taken by more 'reliable' elements. Rather than allow the Viet Minh to disarm the Japanese and thus to equip themselves for the defence of their independence, the Allies designated to the Kuomintang and to the British responsibility for accepting the Japanese surrender in Indo-China. British colonial troops from Burma and India were to move into the south of Vietnam, and Chiang Kai Shek's troops were to act in the North. In fact, neither set of forces carried out the stated mission properly. In the south, the British-administered troops, under Major-General Douglas Gracey, were more concerned with restoring French control than with disarming and repatriating the Japanese. They immediately secured the release of those Frenchmen who had been belatedly interned by the Japanese, and they rearmed nearly five thousand French troops. The British acted openly to depose the Viet Minh, and on September 23 the French staged a *coup* which was fully supported by the British. The French were anxious to avenge the humiliation they had suffered at the hands of Asians. They correctly sensed that their hegemony was threatened by the Viet Minh, which was in the process of setting up a full governmental apparatus. With the aid of the British, the French undertook mopping-up operations against the Viet

Minh. On more than one occasion, the French and British
employed Japanese troops to assist in these. It is worth recalling
that the British originally attacked the Viet Minh on the pretence
that they were agents of the Japanese.

Meanwhile, in the north, the Kuomintang displayed its
characteristic avoidance of danger and fighting. As usual, these
corrupt forces were willing to serve the highest or nearest bidder.
As a result, they intervened very little, while the Viet Minh
effectively took the surrender of the Japanese. Additionally,
many of the Kuomintang regulars sold their valuable American
weaponry to the Viet Minh. Despite the difficulties in the south,
therefore, the Viet Minh was able to take great steps towards
consolidating its position in the north during the first months of
peace.

The early post-war period appears to have been most con-
fusing to the Viet Minh. They failed to see the United States as
an enemy. Of course, the attitude of the United States towards
them was ambiguous. The *New York Times*, for example, stated
in its editorial of September 21, 1946:

'Ho Chi Minh . . . is Viet Nam. That strange little figure,
meek in appearance yet so determined in purpose, emboldened
the spirit, the aspirations and probably the future of the new
state. He moulded it, he put it through the fire, and he will guide
it.'

Likewise, the Viet Minh placed a certain trust in the socialist-
communist coalition government in France. Between 1945 and
1947 the Viet Minh attempted to negotiate independence from
France, in the most moderate of terms. Viet Minh literature of
this period reflects the confident view that the preservation of
French colonialism in Indo-China would be supported only by a
small clique of French capitalists—and not by the French people,
or the American people, or even the American capitalists. But
before the end of 1945 the French had moved some fifty thousand
troops into southern Vietnam. Negotiations continued; general
elections in January of 1946 confirmed the legitimacy of the Viet
Minh government. President Ho Chi Minh signed an agreement

with the French in March 1946 which explicitly declared: 'The Government of France recognizes the Republic of Vietnam as a free state having its own government and its parliament, its army and its finances, forming part of the Indo-Chinese federation of the French Union.' The French ignored every promise made to the Viet Minh, and instead rapidly restored their power, moving in tens of thousands of troops. The presence of Foreign Legion troops provoked immediate hostilities in the cities. Massacres were commonplace. French respect for the *modus vivendi* was a farce; as a final show of power, they bombed Haiphong on November 23, 1946. Thousands of innocent civilians were killed. No peaceful settlement was possible.

Had it not been for the Marshall Plan, France would have been in no position to finance the costly, protracted war which ensued. American aid not only made possible the war, but it had a considerable influence on the manner in which the war was conducted. Without commenting on the effect of American aid on the character of the coalition governments in France, we can see that the United States attempted to create a new 'image' for the Indo-Chinese war, increasingly bore the brunt of financing it and soon contemplated direct intervention as it became clear that the French could not win. Initially the United States favoured the restoration of French colonial hegemony in Indo-China, not out of great sympathy for French colonial interests but because France seemed more likely to be co-operative with American investors and more receptive to American aid than a socialist Vietnam. Given France's client relationship to the United States, one would hardly have expected any difficulties for the Americans from the superficially dominant position of France in Indo-China. But the French had to put down an indigenous insurrection, and the United States had to find the least embarrassing means of supporting someone else's brutal colonial war.

The United States made clear to the French that American aid would cease if the war were portrayed blatantly as a colonial conquest. Instead, the Americans argued, it should have the appearance of an anti-communist crusade, a war against sub-

versives, bandits, and rebels, a war to stop the aggressive designs of 'Soviet imperialism'. On the positive side, the war should be fought by a 'more genuine' nationalist force in Vietnam, generously aided by France and her Free World Allies—not by a colonial power. One obvious difficulty, of course, was that the war was already going on, with no pretence of French support of a nationalist government. Indeed, France had acknowledged the legitimacy of the duly elected Ho Chi Minh government in 1946. In the midst of the fighting, the United States proposed to conceal the identity of the side it supported. The policy was difficult enough, but the actual task of finding a 'nationalist' who would subscribe to this absurd scheme was nearly impossible.

This was an American scheme from the very start, largely inspired by the American plans for Chinese and Philippine 'independence'. It was the Americans who eventually selected the appropriate 'nationalist'. President Harry Truman instructed his emissary, William C. Bullitt, to conduct the search. The man Bullitt found was hardly an imaginative choice; it was none other than Bao Dai, earlier distinguished for his collaboration with the Japanese. Bao Dai, moreover, had formally abdicated in favour of the Viet Minh and had received an honorary post as Political Counsellor to Ho Chi Minh. His interest in the Viet Minh government had proved short-lived, and he quickly disappeared into the anonymity of Hong Kong night life. From Hong Kong he moved to the French Riviera, where Bullitt finally encountered him. It took a good deal of convincing to persuade Bao Dai to return to 'politics', but after nearly two years of discussions he agreed to disavow his former abdication and accept the restored title of Emperor. It was not until the summer of 1949 that the French colonial war was officially transformed into a defence of the 'legitimate' government of Bao Dai.

The awkwardness and tardiness of the metamorphosis of the Indo-Chinese War were a source of great irritation to American policy-makers. The notoriety of Bao Dai, moreover, was reminiscent of the stigma attached to the corrupt clique around Chiang Kai Shek; the failure in China was a dangerous omen. All these factors, along with the military failings of the French, soon

convinced American intelligence agents that some other alternative was required. (The clandestine activity of US personnel in this period is the subject of Graham Greene's novel *The Quiet American*.) As the battered French forces continued to wage their futile war, energetic and often naive CIA operatives, sometimes posing as university personnel, began quietly searching out and screening potential replacements for Bao Dai. Their ultimate choice is well known: Ngo Dinh Diem, discovered by Professor Wesley Fishel in Tokyo in 1950.

The war went badly for the French. Since it was conducted by the Ministry of Colonies, rather than by the Ministry of Defence, it was impossible under the regulations of the French Constitution to send conscripts to fight in Indo-China. Thus, French officers directed a motley crew of foreign legionnaires, mercenaries, and the colonial armies against the Viet Minh resistance. Black troops from Africa and the West Indies drew powerful lessons from the experience. They quickly grasped the elementary fact that they were being used as cannon fodder in a racist war of conquest. Moreover, the withdrawal of large numbers of colonial troops from the African garrisons weakened French defences in the northern African colonies. The combination of weakened garrisons, military experience for Africans, and the direct inspiration of the Viet Minh's struggle accounted for the growth of militant resistance movements in Tunisia (1952), Morocco (1953), and Algeria (1954). Such was the international importance of the Vietnamese revolution.

By 1954, France had poured more than 400,000 men into Indo-China. According to Jules Moch, French delegate to the United Nations (quoted in the *New York Times*, July 22, 1954), there were 92,000 fatalities and 114,000 wounded on the French side. The cost of the war was some seven billion dollars. French officers were annihilated in Vietnam as quickly as they could graduate from the French military academy at Saint Cyr. The French became less and less willing to conduct the war. The stage was set for direct American intervention. The *New York Times* of July 4, 1954 reported: 'In the current year the United States is paying 78 per cent of the French Union costs in the

Indo-Chinese war.' As the siege of Dien Bien Phu began early in 1954 the question of American intervention was only one of means. There are indications that John Foster Dulles offered Bidault the use of nuclear weapons at Dien Bien Phu. Vice-President Nixon released 'trial balloons' in April 1954, attempting to discover public reaction to the possible employment of American ground forces in Vietnam. At the time, a number of factors stood in the way of such immediate military commitments.

In the course of the Senate debate during the battle of Dien Bien Phu such influential politicians as John F. Kennedy opposed US intervention on the side of the French. The memory of Korea remained; the American people were not anxious to send their sons to die in another Asian war. Powerful elements in the US Government had already begun to view this as an opportunity to make a fresh start in Vietnam. The CIA had long desired to get rid of Bao Dai and to discard fully the unattractive image of a colonial war. All parties turned their attention to Geneva.

The negotiations lasted many months. Dien Bien Phu fell on May 8, and the French made clear their intention to leave Vietnam. The British and the Americans utilized a simple strategy: promise them anything. The letter of the Geneva agreements could hardly be construed as contrary to the interests of the Viet Minh. The agreements provided for withdrawal of all foreign military personnel, national unity under a freely elected government, and prohibitions on the introduction of new foreign troops. Behind the scenes, however, the Americans were working hard. On July 7 Bao Dai was persuaded to appoint as premier the American placeman, Ngo Dinh Diem. In addition, the Americans had already begun to introduce their 'advisers' and other civilian personnel secretly into South Vietnam.

The story since 1954 is well known. The responsibility of the Americans is clear. The need now is cogently expressed by the playwright Peter Weiss:[1]

[1] Peter Weiss is intimately involved in the international War Crimes Tribunal (see below), including its work of investigation.

'The tenancy of the rich nations is infected with the stench of carrion. The progress that politicians in these countries speak about with voices drowned in tears looks more and more like progress in the elimination of human life. America, that country that shelters many true democrats, appears to the people that strive for freedom and independence as the inheritor of Guernica, Lidice and Maidenek. The neutral look on, give expression time after time to their protests, but still look for conciliatory aspects and do not want to become at cross purposes with the big commercial partner. The workers in countries in the West with their gigantic union organizations are silent. While they are occupied with taking over middle class values, they shut their eyes to the fact that the proletariat of Africa and Latin America still lives in the most shameful conditions and that they are being massacred by the hundred thousands in South-east Asia. They remain silent, although they are the only ones that could, through a common proclamation, prevent the blood bath. Appeals by students, scientists, artists, and writers have until now been of limited effect. But if millions of workers at last rose to speak and emphatically with all the means at their command demanded that the American acts of war immediately be discontinued, it would be difficult for Johnson and his government to continue the murdering.'

The Press and Vietnam
March–July, 1963

The role of the Western press in the Vietnam controversy has been important and revealing. It is from Western newspapers that I derived my earliest understandings of the involvement of the United States, and it is from these same reports that I first became aware of the barbarous character of the war.

On October 21, 1962, for example, the *New York Times* reported: 'Americans and Vietnamese march together, fight together, and die together, and it is hard to get much more involved than that.' Earlier, Mr Homer Bigart, a leading correspondent of the *New York Times*, had spoken of the 'senseless brutality' of the war. In an article which appeared on July 25, 1962, Mr Bigart stated: 'American advisers have seen Viet Cong prisoners summarily shot. They have encountered charred bodies of women and children in villages destroyed by napalm bombs.' Indeed, the use of chemicals in the Vietnam war had been reported in the *New York Times* as early as January 1, 1962. On January 26, 1962, the *New York Times* went so far as to refer to the use of chemicals as a 'crop-killing programme', in the manioc and rice fields of South Vietnam.

Although many of these highly revealing articles were buried in inside pages of the newspapers, a careful reading of the Western press every day made it possible to assess the character of the war from evidence and documentation which could not be easily dismissed. My method in accepting this material was the familiar procedure of 'evidence against interest'. I assumed that when the *New York Times* stood to gain nothing from the publication of an article, it was likely to have no other motive than a desire to print

a truthful account. Rarely does anyone fabricate reports and evidence which are inimical to his interest.

I was soon to discover, however, that although some newspapers were prepared to publish isolated pieces of horrifying information, they had no intention of forming a coherent picture of the war from these reports and every intention of preventing others from doing so. The informed press knew that there was something seriously wrong about the war, but restricted themselves to pedestrian comments and peripheral criticisms. This course preserved their 'responsible' stance but prepared the ground for a later *volte face* when their earlier attitude was widely discredited. (Anyone who thinks this a far-fetched description of how the fourth estate goes about its business would do well to recall the press' attitude to dissenters in other fields—for example, to early critics of the Warren Commission report.)

Repeatedly the press gets away with such disgraceful behaviour through the helplessness of the public. Most people have no access to facts in matters about which their suspicions are aroused, nor the resources to gather information independently. Even if they can remove these formidable obstacles, they still have no means of communicating their findings to the public. I have tried to overcome these difficulties in three ways: first, through a thorough study of the war as reported in Western, Vietnamese and other publications; secondly, by sending observers regularly through the Bertrand Russell Peace Foundation to travel widely in Indo-China and return with first-hand reports;[1] and thirdly, by raising my voice whenever possible.

Meanwhile, I have learned certain rules that must be observed in reading the newspapers.

1. Read between the lines.
2. Never underestimate the evil of which men of power are capable.
3. Know the jargon of 'terrorists' versus 'police actions', and translate wherever necessary.

Experienced newspaper readers may care to compile their own glossaries of terms used for 'our' side and 'their' side.

[1] One such report appears at the end of this book.

As the war in Vietnam escalated, slowly and steadily, the *New York Times* came under increasing pressure not to print articles which exposed the lies and distortions of the American Government. An important suppression of vital information occurred as early as March 1962, for example, when the *New York Times* (as well as every other major American daily newspaper) declined to publish an article sent over the wires of the Associated Press by Mr Malcolm Browne, later a recipient of the Pulitzer Prize in journalism for his reporting from Vietnam. Mr Browne described in some detail the first national congress of the National Liberation Front of South Vietnam, held from February 16 to March 2, 1962. That such information should be denied to the American public is criminal. The article spoke for itself, and people in the West must have access to such information.

The reaction of the editors of the *New York Times* to my own efforts to make these facts known is shameful, but not unique. I choose it from many examples to illustrate these points because it proudly proclaims that it publishes 'all the news that's fit to print'. The following exchanges on Vietnam and journalistic standards were in the spring of 1963.

On March 28 I addressed the following letter to the Editor of the *New York Times*:

Sir,

The United States Government is conducting a war of annihilation in Vietnam. The sole purpose of this war is to retain a brutal and feudal regime in the South and to exterminate all those who resist the dictatorship of the South. A further purpose is an invasion of the North, which is in Communist hands.

The real concern which brings the United States to pursue the brutal policy abandoned by France in Indo-China is the protection of economic interests and the prevention of far reaching social reforms in that part of the world.

I raise my voice, however, not only because I am in profound disagreement with American objections to social change in Indo-China, but because the war which is being conducted is an atrocity. Napalm jelly gasoline is being used against whole

villages, without warning. Chemical warfare is employed for the purpose of destroying crops and livestock and to starve the population.

The American Government has suppressed the truth about the conduct of this war, the fact that it violates the Geneva agreements concerning Indo-China, that it involves large numbers of American troops, and that it is being conducted in a manner reminiscent of warfare as practised by the Germans in Eastern Europe and the Japanese in South-East Asia. How long will Americans lend themselves to this sort of barbarism?

Yours faithfully,

Bertrand Russell

This appeared on April 8 (April 10 in the International Edition) along with the following editorial:

Bertrand Russell's letter on this page reflects an unfortunate and—despite his eminence as a philosopher—an unthinking receptivity to the most transparent Communist propaganda. It stems from the delusion that communism is no longer a menace and the real threat to world peace comes from the West's efforts to check Communist aggression.

This newspaper has repeatedly made it clear that it does not mirror the Kennedy Administration's viewpoint about American policies in Vietnam. We have criticized its too rigid support of the autocratic Diem regime, which has insufficient popular backing, and we have urged greater freedom for the individual and more rapid social and economic reforms. We have been deeply concerned, as most thinking Americans have, about the increasing military commitment in South Vietnam, and we have not shared Washington's excessive optimism about American successes.

But Lord Russell's letter represents something far beyond reasoned criticism. It represents distortions or half-truths from the first to the last sentences.

The United States Government is not supporting a 'war of annihilation' in Vietnam. There are some 12,000 uniformed Americans there as advisers and trainers, whose bearing, moderation and judgment have done a great deal of good. Their purpose

is not to 'retain a brutal and feudal regime in the South and to exterminate all those who resist', but to prevent an armed take-over of the country by Communist guerrillas, encouraged, and in part supplied, trained, led and organized from North Vietnam or Communist China or both. In the never-never land in which Mr Russell lives, he twists the Communist infiltration of South Vietnam into an imagined US programme to invade the North.

Napalm has been used by the South Vietnamese air force against real or imagined havens of Vietcong guerrillas. Its use has certainly killed innocent people—as other weapons have done in all wars. American advisers have opposed its employment, on both moral and practical grounds, against all except clearly identified military targets. Defoliation chemicals (common weed killers) have been employed largely in attempts, so far with limited success, to strip leaves from heavy jungle growth near lines of communication and base areas.

Lord Russell's statement that the 'real concern' of the United States is 'prevention of far-reaching social reforms' is arrant nonsense, as even he in his heart must know. There are many questions to be raised about the extent and the wisdom of the American commitment in South Vietnam, and about the need for reform of the government that the United States is supporting there; but to call the United States the aggressor and to say nothing about the Communist push for domination against the will of the inhabitants in Vietnam is to make a travesty of justice and a mockery of history.

My reply of April 12 appeared in the *Times* on May 4, but the section which I have bracketed here was omitted:

Sir,
 Your editorial of April 8th calls for a reply from me on various counts.
 You accuse me of an 'unthinking receptivity to the most transparent communist propaganda'. In fact, I base my remarks about the war in South Vietnam upon careful scrutiny of reports in Western newspapers and in publications of the British and

C

American Vietnam Committees. My belief, derived from this study, is that US support of Diem is driving more and more of the inhabitants of South Vietnam into the arms of the Communists— a result to be deplored.

You accuse me of distorting the truth or of speaking only half truths, but this is a charge which may be turned against you. I agree with the point of view that you express in your second paragraph. But, in my letter, I give reasons for my point of view: it is, I suppose, these reasons to which you take exception. They are: (1) that the purpose of the war is to retain 'a brutal and feudal regime in South Vietnam and (2) to exterminate all who resist Diem's dictatorship'; (3) that the US is pursuing a brutal policy (abandoned by France in Indo-China) in order to protect economic interests and to prevent far-reaching social reforms in South Vietnam; and (4) that the war is an atrocity. It is an atrocity because such things as napalm bombs are being used—bombs which do not simply kill, but which burn and torture—and that chemical warfare is employed to destroy crops and livestock and so to starve the people of South Vietnam. I did not mention innumerable appalling atrocities carried out by Diem's Government because for these America has only the indirect responsibility involved in the continued support of Diem.

You say in your fifth paragraph that napalm bombs have been used, but only against 'real or imagined havens of Vietcong guerrillas' and have 'certainly killed innocent people'. You say, however, that 'American advisers' have opposed the use of these bombs. This may be true, but it is less than a half truth. You have said in your fourth paragraph that Americans are in Vietnam only as advisers and trainers. This is not true, and invalidates your explanation concerning the napalm bombs. I suggest that you read the report of Richard Hughes on conditions in Vietnam in the (London) *Sunday Times*, January 13, 1963—a journal by no means pro-Communist, anti-American or even very liberal—in the course of which he speaks of 'the Washington fiction that no United States troops are involved in combat and that United States officers and "trainers" are on the scene merely to "advise, observe, support and assist".' He says, also: 'The Americans are

now operating more than 200 helicopters and scores of reconnaissance and troop transport planes in the combat areas. Probably half of all bombing and strafing missions by the South Vietnam air force are undertaken by Americans serving as pilots and co-pilots.'

[In your fifth paragraph you also endeavour to minimize the effect of 'defoliation chemicals' by calling them 'common weedkillers'. If sprayed, as they must be to achieve the end for which you say they are intended, certain common weedkillers would destroy many crops and animals. But, in fact, chemicals other than common weedkillers have been used (some of these were once used as 'common weedkillers', but were found to be too dangerous). The US Government has been charged by the South Vietnam Liberation Red Cross, after a year's study by them of the chemicals sprayed in South Vietnam and their effect upon the health of human beings, animals and crops, with using weed killers which, in the large doses used, are harmful; with using white arsenic, various kinds of arsenite sodium and arsenite calcium, lead manganese arsenates, DNP and DNC (which inflame and eat into human flesh) and calcic cyanamide (which has 'caused leaves, flowers and fruit to fall, killed big cattle like buffaloes and cows, and seriously affected thousands' of the inhabitants of South Vietnam); with having spread these poisonous chemicals on large and densely populated areas of South Vietnam. Admittedly, the South Vietnam Liberation Red Cross is, as its name suggests, allied with those opposing the US-supported Diem regime, but its published findings cannot be ignored since it has urged international investigation of the situation. The use of these weapons, napalm bombs and chemicals, constitutes and results in atrocities and points to the fact that this is 'a war of annihilation'.]

I criticize 'atrocities' where I find them. I was considered too anti-Communist by the liberals of the US in Stalin's day for objecting to the atrocities that occurred in Russia at that time. I have recently been carrying on a correspondence concerning the hardships suffered by Jews in Communist countries. I see no reason to suppose that atrocities are to be condoned when committed by Western Governments. It is not I, but you, who, in

attempting to whitewash US action in South Vietnam, are speaking half-truths and are thereby doing the very thing of which you accuse me: ignoring the Communist push for domination. Moreover, the emulation of what the West says it considers most dastardly in Communist behaviour is unlikely to win support for what the West says it stands for anywhere in the world. It makes a mockery of the phrase so beloved by the West—'The Free World'.

Two other accusations you make against me: you say that 'to call the US the aggressor and to say nothing about the Communist push for domination against the will of the inhabitants in Vietnam is to make a travesty of justice and a mockery of history'. The latter is a fine peroration. But I would call to your attention the fact that you yourself had already said (paragraph 2) that you have criticized the US Government's 'support of the autocratic Diem regime which has insufficient popular backing'. I would also call your attention to the following bit of history: the Geneva Conference of 1954 proposed compromise concerning Vietnam which was admirable and which would have solved the problems of that country if it had been observed. The signatories were Molotov and Selwyn Lloyd who signed as co-Chairman representing East and West respectively. The agreement reached by this Conference was, with the backing of the US, not observed by South Vietnam. A new regime was established in South Vietnam under a dictator named Diem of whom *Time* says (November 21, 1960): 'Diem has ruled with rigged elections, a muzzled Press, and political re-education camps that now hold thirty thousand.'

I can only deduce that, in your failure to face the facts, and to publicize them, concerning the war in South Vietnam you are, to use your own phraseology, indulging in 'arrant nonsense as even you in your heart must know.'

Yours faithfully,
Bertrand Russell

Noting that the crucial evidence supporting my defence against the editorial of April 8 had been omitted in the *Times*' version of my letter, I wrote in protest:

Sir,

I am profoundly shocked by the journalistic standards of the *New York Times*. I have been engaged in a public controversy with the *New York Times* concerning a matter of international importance, namely, the atrocities presently being carried out by the Government of the United States in Vietnam. You attacked me in an editorial, accusing me of arrant nonsense and of stating things without evidence to substantiate them. In my reply to that attack, I presented the evidence in the course of a long letter. You published my letter, omitting my evidence and without even an indication by means of dots to suggest that the letter had been cut or shortened. I have had correspondence and controversy in the pages of *Izvestia* and *Pravda* and I wish to point out to you that never have I been so shabbily treated, never have *Izvestia* and *Pravda* behaved in a manner comparably dishonest.

I am writing to request you to publish the evidence which you omitted from my last letter . . . [Here followed the text which appeared in brackets above.]

<div align="right">Yours faithfully,
Bertrand Russell</div>

None of the remainder of my correspondence with the *New York Times* on this matter was published in the *Times*. It is published here without further comment since it speaks for itself:

<div align="right">May 17, 1963</div>

My dear Lord Russell:

The *New York Times'* journalistic standards, which you denounce, need no defence from me. The fact is that the *Times* has given you more than ample space in which to air your views.

Your second letter (published May 4) was longer than the maximum we allow. We will not permit even you to monopolize our letters columns. In accordance with our long standing procedure, we reserve the right to cut without notice—and in this instance we did find it necessary to cut an overly long letter of yours to bring it down to the required length. The excision was made solely on account of excess length of the original and for no

other reason, nor did it in any way alter the sense of your letter.

We exercised our own judgment in selecting the paragraph to cut. The one selected contained detailed allegations relating to the general charge of chemical warfare. I haven't the slightest doubt that you would have objected equally as vociferously no matter which paragraph, sentence or phrases had been cut. In respect to the dots you mention, we never use them in our letters column.

Permit me to remind you that in our editorial of April 8, replying to your first letter (which was also published that day), we fully acknowledged that chemicals—specifically napalm—had been used in South Vietnam by the Government forces. This is not and never was the point at issue. The phrase 'arrant nonsense' was specifically applied to your (and the Communist) allegation that the United States' 'real concern' is to prevent social reforms in South Vietnam. That charge still stands as the arrant nonsense we said it was.

Sincerely yours,
John B. Oakes
Editor of the Editorial Page

June 5, 1963

Dear Mr Oakes,

Thank you for your letter of May 17th. I note that you now maintain that what you denied emphatically in an editorial in your newspaper was entirely known to you. I suggest therefore, that it is not the journalistic standards of the *New York Times* which need denouncing, but the integrity of its Editor.

You say that you have not the slightest doubt that I should have objected equally no matter which paragraph or sentence or phrases had been cut. That is not so. The reason it is not so is that you took such care to omit precisely those sentences which specify the chemicals used and the absence of which provoked an attack upon me by the *New York Times* previously. The further point that these chemicals were not merely weedkillers, but destroyed livestock, crops, and killed human beings, was never admitted by the *New York Times*.

I further point out that the *New York Times* of January 19,

1962, states that of 2,600 villages in Vietnam, nearly 1,400 have been destroyed because of military action by the United States and the Diem Government, in which both chemicals and napalm were used. You take exception to my designation of this conduct as 'a war of atrocity'. You attack me publicly for making such charges without substantiation. You omit the evidence in my reply to your attack when publishing it, and you write me a letter in which you say that you allow me ample space in which to air my views. You say, further, that you need make no defence of the journalistic standards of the *New York Times*. I am impressed by your confidence and, therefore, request permission to publish this correspondence forthwith.

<div style="text-align: right">Yours faithfully,
Bertrand Russell</div>

<div style="text-align: right">July 3, 1963</div>

Dear Lord Russell:

Your letter of June 5th is again full of the kind of 'distortions or half-truths' which we correctly ascribed to you in our editorial of April 8th. For example, we did not deny in our editorial that napalm was used; we specifically admitted it. We did not deny that defoliation chemicals were used; we specifically admitted it. We did not challenge you to specify the other chemicals, if any, that were used; yet you insist that this is the question that 'provoked' our editorial attack on you.

What 'provoked' our editorial was your own letter of March 28th, sent to the *Times* for publication, and published on April 8th, in which you accused the United States of 'conducting a war of annihilation' in Vietnam, the 'sole purpose' of which was 'to retain a brutal and futile[1] regime in the south', to protect economic interests and to prevent 'far-reaching social reforms in that part of the world.' As I have already informed you in my letter of May 17th, this is the kind of language that we described in our editorial of April 8th as 'arrant nonsense'; and arrant nonsense, I repeat, it is.

[1] [*sic*] I wrote *feudal*, not futile.

Apropos of your comment about *Pravda* and *Izvestia*, do you honestly believe that they would have published a letter attacking the USSR, written in terms comparable to those you used about the United States in your letter of March 28th?

If you publish this correspondence, I trust you will also publish with it your letter to us of March 28th and our editorial reply of April 8th, as well as this letter.

Sincerely yours,
John B. Oakes
Editor of the Editorial Page

July 27, 1963

Dear Mr Oakes,

Let us consider where the 'half-truths' lie. You did not deny that napalm was used but you did deny that Americans were involved in its use. In your editorial of April 10, you state: 'American advisers have opposed its employment, on both moral and practical grounds, against all except clearly identified military targets'. This is not true. Your own reports of January 19, 1962, refer to the destruction of nearly 1,400 villages. Napalm and chemicals were used in the course of this devastation.

You state that chemicals employed were common weedkillers and were intended solely to strip leaves from jungle growth. This is untrue. The evidence in my letter which you suppressed establishes its untruth which is, of course, why you disallow it.

Considering that my charge of atrocity is based upon the ruthless use of chemicals and jelly-gasoline, the wholesale devastation of civilian populations in their villages and the use of concentration camps, it would appear that these are the facts to which you object when you refer to my statement as 'arrant nonsense, distortion and half-truth from the first to the last sentence'. Clearly, 'the first to the last sentences' is at least inclusive of my remarks on chemicals and napalm. You chose to cut my paragraphs on the specific chemicals used because these paragraphs served to show that the chemicals affected human beings and animals and were not merely weedkillers. You are not honest when you contend that this information was already acknow-

ledged by the *New York Times*. It is precisely the distinction between chemicals which are weedkillers and chemicals which rot human flesh and kill those who come in contact with them that I have sought to make in the course of making clear to the American public the nature of the barbarous war conducted by their Government in South Vietnam.

That Diem's regime is 'futile' and serves American economic interests, I should be willing to stand by before any impartial mind.

I agree that *Pravda* and *Izvestia* might well suppress a letter attacking the USSR as forthrightly as my letter on Vietnam attacks the United States. This, however, was not the point I was making, as you well know. Never have *Izvestia* or *Pravda* purported to publish a letter of mine while omitting surreptitiously the very evidence in dispute in the course of an exchange. This form of dishonesty is, to my mind, more perfidious than the absence of publication of a letter. It is conscious fraud.

Yours faithfully,
Bertrand Russell.

War and Atrocity in Vietnam
March 13, 1964

The war in Vietnam is eighteen years old.[1] It began as a broad movement of resistance to the French under the leadership of Ho Chi Minh, a Communist. The French fought with ferocity against an unarmed peasantry. Using guerrilla tactics, the Vietnamese drove the French out of the North of Vietnam and finally defeated them in the battle of Dien Bien Phu. The negotiations at Geneva led to the establishment of an international Commission, intended to stabilize peace and watch over any attempt at foreign intervention.

Before developing what I wish to say about this subject, I should like to make clear that the facts in this article are taken from daily papers and similar sources. Many are taken from bulletins of committees concerned with Vietnam. Some are from reports of the South Vietnam Liberation Red Cross and others from a very interesting book by Wilfred G. Burchett called *The Furtive War*. Many of the facts have passed unscathed through the crucible of American denial. Many of them have been accepted even by the American authorities. All of them, I have good reason to believe, are incontrovertible.

It is important to realize that, since the French were defeated finally at Dien Bien Phu in 1954, the war has been conducted surreptitiously under American direction. A substantial number of American forces began to be committed there after the French withdrawal and the Geneva talks. One of the most important aspects of this war has been that the United States pretended for many years that no such war was taking place and that the war

[1] This essay was written in March 1964.

which was not taking place was not being conducted by Americans. I have experienced some frustration in attempting to bring to light the fact that the war has been taking place and that Americans have been deeply involved in its conduct. At first, Western newspapers and even persons connected with the peace movement in the West held that there was no evidence of American direction of this war. The *New York Times* stated this several times. Finally, in the course of controversy, it was allowed that American participation was solely in an advisory capacity.

When it was alleged that chemicals were being employed by the United States forces in Vietnam, it was first denied and then alleged that the chemicals employed were used against American advice and wishes. It was then admitted that they were used under the direction of the United States, but it was said that chemicals were harmless to human beings and were intended solely for the purpose of clearing vegetation and foliage. I brought to public attention impressive and documented evidence concerning the use of additional chemicals and asked for international investigation of these allegations and the evidence adduced to support them. I was informed by various Western newspapers that no observers had found harmful results through the use of these chemicals and that no condemnatory comment had been made by the International Control Commission.

It is odd that this is advanced on behalf of that Commission. The function of the Commission was to regulate and prevent intervention from the outside. The failure of this International Commission to make known its observation of American participation was in violation of its mandate and does not inspire confidence in its ability to detect chemicals where it failed adequately to detect armed forces, aircraft, military supplies and a full-scale war. I shall wish to return to these more contemporary aspects of the war in Vietnam. It is sufficient here to note that the extraordinary war which has been raging in Vietnam managed to elude the juridical commitments of the Geneva agreements. It encompassed repression and extermination without great hindrance on the part of the Control Commissions set up at Geneva, escaped for some time the notice of the Western press

and enjoyed restrained consideration by those nominally committed to opposition to Cold War, small wars and wars of annihilation.

The history of French and Vietnamese relations, particularly in the North, is much the same as that of the United States and South Vietnam. At the time of the conclusion of the Second World War, a movement of rebellion began, acquired new strength and culminated in the Geneva decisions. Vietnam was to be partitioned for an interim period, with the North under the control of the forces of Ho Chi Minh, and the South under the control of pre-Western groups. It was agreed that there would be a general election throughout Vietnam, out of which unification and neutralization were expected to come. The Geneva Conferences of 1954 were designed to bring neutralization to all of Indo-China. The United States, though not a signatory to these agreements accepted them in name and professed them to be the basis of American policy in Indo-China.

In fact, the United States quickly decided that it was impossible to permit a general election, in view of what it considered to be 'the disturbed state of the country'. The United States began to intervene actively with arms, money and men and established in power a ruling oligarchy subservient to American interests. This direct foreign intervention destroyed the purpose of the Geneva agreements and was a test for the International Control Commission. Its failure to resist this violation steadfastly prepared the way for violence, the intrusion of the Cold War and the present threat to the peace of the world in South East Asia.

John Foster Dulles had urged the use of nuclear weapons at Dien Bien Phu. His desire to encompass the area in the Cold War led to the formation of the South East Asia Treaty Organization. The purpose of this body was to forestall neutrality and to forge a military alliance of anti-communists. The United States favoured Ngo Dinh Diem, a rich refugee from North Vietnam. He and his family, together with the Nhu family, represented a group of landowners and the Catholic hierarchy in Vietnam—a small, closely-knit circle. The Diem family installed officers and relatives in various provinces, who administered them virtually

as private estates. Various religious sects and cults in Vietnam were subdued because they failed to prove sufficiently loyal to the Diem regime. The Diem and Nhu families were dependent upon American backing for their power. American policy aimed at keeping South Vietnam in the anti-Communist camp and at opposing all groups not subservient to that purpose. The 'Vietcong'[1] were to be eradicated, despite the fact that they were neutralist. Diem's regime was one of terror and persecution. Ghastly tortures were inflicted upon the peasants. It is instructive that it has been possible for 350,000 people to be placed in camps as political prisoners and for the greater part of the rural population to be uprooted and put in camps without vigorous protest taking place. Part of the responsibility for this default lies with the suppression of facts which, until the last two years, characterized Western reports about Vietnam. Part of the fault lies with the silence of peace groups, frightened to appear to be seen supporting 'the Communist side' of things.

One case is related in *The Furtive War*. It is that of a young girl:

'One day', she says, 'I came home and there were two security agents waiting for me. I was taken to the town of Faifo and for months on end I was tortured very badly . . . Once I recovered

[1] 'Vietcong'. The United States has sought to slur the guerrilla movement by naming it the 'Vietcong'. 'Vietcong' means 'Vietnamese Commies'. No group in South Vietnam refers to itself by that abbreviated name. Those who chose that name for the guerrillas ignored something very important. They relied on the fact that in the USA the term 'Communist' is enough to alarm the public and to smear any movement, and never realized until too late what favourable connotations 'Communist' has elsewhere. The US has, by its own intended slander, reinforced the good image Communists have had in South-East Asia through associating Communism with movements for national liberation, and movements of the people for independence and social justice. It is ironic that when the US realized its grave blunder, it sought to rectify the situation by renaming the liberators. As reported in the *New York Times* on June 5, 1962, the United States Information Agency sponsored a contest 'for a new name for the Vietcong guerrillas', admitting that it didn't think 'communist is the type of a name to inspire hatred among the country's illiterate masses'. It offered a cash prize for a 'colloquial peasant term implying disgust or ridicule.' In South Vietnam, the only names which meet that test are 'French' and 'American'.

consciousness and found I was stark naked, blood oozing from wounds all over my body. There were others in the cell. I heard a woman moaning, and in the half dark saw a woman in a pool of blood. She had been beaten into having a miscarriage. Then I made out an old man. An eye had been gouged out and he was dying. Alongside him was a thirteen- or fourteen-year-old boy, also dead; a little further away, another dead youth with his head split open. They had thrown me there, hoping the sight of this would break me down.'

Finally, she was covertly conveyed to North Vietnam. This story was subsequently confirmed by neutral enquirers. It is typical of many among the 350,000 political prisoners.

The vast majority of peasants support the guerrillas. It is estimated that 160,000 have died and as many as 700,000 have been maimed. In order to combat the support of the population, Diem and the Americans instituted what were called 'strategic hamlets', into which the inhabitants of rural areas and existing villages were, in cruel circumstances, moved at a moment's notice. 'Strategic hamlets' were, in reality, prisons. Those who had been forcibly brought into them were unable to get out. These 'hamlets' were surrounded by spikes, moats and barbed wire and were patrolled by guards with dogs. They have all the character of concentration camps. The *Observer* estimated that sixty-five per cent of the rural population, or over seven million people, were inside these 'hamlets' by mid-1963. Their establishment was the result of a decision on the part of the United States, publicly set out by W. W. Rostow, an adviser of the State Department. He suggested that Vietnam should be used as an experimental area for the development of anti-guerrilla techniques and weapons by American forces.

The rural population was stuffed into the 'strategic hamlets' so that they would be shut off from the guerrilla forces, who depended for their food and manpower upon them. I wrote letters to the *Washington Post* and the *New York Times* in 1963 in which I sought to set out the full nature of this war, which I designated as a war of annihilation and atrocity. The *New*

York Times vigorously denounced me for making such a charge.[1]

The State Department denied that chemicals were used in Vietnam and the *New York Times* admitted editorially that weed-killers were used, but stated that napalm was not used by Americans but only by Vietnamese governmental forces. Madame Nhu stated: 'If they don't like our chemicals, why don't they get out of our jungles?' The *New York Times* failed to remember its own reports of June 19, 1962, which refer to the destruction of nearly 1,400 villages by governmental forces. Napalm and chemicals were used in the course of this devastation. My charge of atrocity was based upon the ruthless use of chemicals and jelly-gasoline, the devastation of civilian populations, and the use of concentration camps.

In addition to uprooting the population and establishing the hamlets, the United States sent special helicopters which could fire small rockets and ammunition in excess of that used by any aircraft during the Second World War. The Americans, as mentioned earlier, professed that their soldiers and airmen in Vietnam were only there in an advisory capacity and were not responsible for Diem's doings. At the same time, they took great pains to conceal from the world the sort of things that were being done. The *New York Times*, in its editorial comments, illustrates this attempt.

In the course of controversy in the pages of the *Observer*, I sought to bring to the attention of people facts which I had before me in the form of photographs and documents which gave particulars of villages, dates, individuals and specific chemicals, and the use of toxic chemicals in Vietnam by American forces. I have evidence that over 1,000 people were caused severe illness, characterized by vomiting, bleeding, paralysis and loss of sight and consciousness. Other evidence concerned the destruction of fruit trees, vegetables, cattle and domestic animals. Further evidence specified the use of toxic gas on densely populated areas. This evidence was provided in part by the South Vietnam

[1] See Chapter I for full texts of the exchange with the *New York Times*.

Liberation Red Cross and in part by the Foreign Minister of North Vietnam. It has been offered to any international agency for impartial consideration. The replies to my setting out of this evidence were indicative of Western attitudes towards this war. Dennis Bloodworth, the Far Eastern Correspondent of the *Observer*, blandly stated that I was 'apparently referring to the defoliation campaign known as "Operation Ranchhand" ' and said that the weedkillers were popularly known in America and had been used widely without causing harm to animals or to humans. He contended that a propaganda campaign was being employed in which it was falsely said that these chemicals had ill effects and suggested that I was assisting in a Communist propaganda campaign.

Let us now consider some of the statements which have appeared in the American and British press over the past two years. These statements will help to indicate the nature of the war and the validity of the editorial protests which have peppered my appeals about the situation in Vietnam. With respect to the contention that Americans served only as advisers, it is worth looking at the *New York Times* of March 17, 1962. It was stated that, after two Vietnamese pilots pulled out of formation and launched a full attack on Diem's palace, Americans were designated to accompany every Vietnamese pilot on a mission. The *Saturday Evening Post* of March 23, 1963, published a long report in which it contradicted the *New York Times'* statement that uniformed Americans were 'solely advisers and trainers'. The *Post's* report said: 'Virtually all the fighting is done by US troops.'

Richard Hughes in the *Sunday Times* of January 13, 1963, speaks of the 'Washington fiction that no United States troops are involved in combat and that United States officers and trainers are on the scene merely to "advise, support and assist". The Americans are now operating more than 200 helicopters and scores of reconnaissance and troop transport planes in the combat areas. Probably half of all bombing and strafing missions of the South Vietnam Air Force are undertaken by Americans serving as pilots and co-pilots'. It is illustrative, as well, of the nature of this war to quote the *New York Times* and other American papers for

the period 1962 to 1963. On July 7, 1962, the *New York Times* stated:

'Tactical air support is used extensively. It is difficult to ascertain whether the people who are being killed by napalm and fragmentation bombs are guerrillas or merely farmers.'

On June 16, 1962, the *New York Times* had stated:

'Though the Government makes some attempt to re-educate the captured guerrillas, many are shot.'

The *New York Times* had stated on June 5, 1962:

'Seven leprosy clinics were wiped out by mistake in bombing raids last fall.'

The *Chicago Daily News* is more direct in its statement of January 18, 1963:

'The Government regards Vietcong hospitals as fair targets for ground or air attack. If Vietnamese commanders order an air-strike on a medical centre, the planes bomb and strafe it, even when Americans are along as advisers or instructors. When asked if Americans officially condone these attacks, a US military spokesman said: "There has not been a definite policy ruling for Vietnam". Planes of the Vietnamese Air Force are frequently piloted by Americans.'

The *New York Times* which, editorially, overlooks its news reports (as when it reported the razing of sixty per cent of the villages of the country) might have been advised to listen to the Voice of America on January 6, 1963. It was stated that during the year 1962 the *American* Air Force carried out 50,000 attacks on villages and upon virtually all of the peasant population outside of the strategic hamlets. This report was confirmed by the United States Defence Department. Senator Michael Mansfield of Montana stated that there were American troops in every fighting action in Vietnam. Senator Mansfield referred to the action as 'America's secret war'. Areas in which heavy guerrilla activity was

D

reported were denuded of population and then virtually obliterated.

The *New York Times* managed to say on October 21, 1962:

'Americans and Vietnamese march together, fight together and die together, and it is hard to get much more involved than that.'

The *New York Herald Tribune* of November 23, 1962, stated:

'The United States is deeply involved in the biggest secret war in its history. Never have so many US military men been involved in a combat area without any formal programme to inform the public about what is happening. It is a war fought without official public reports or with reports on the number of troops involved or the amount of money and equipment being poured in.'

This war in which seven million people have been placed in internment camps, 160,000 killed, 700,000 tortured, 350,000 imprisoned—requiring 16,000 camps—was described by *The Nation* of 19 January, 1963:

'It is dirty, cruel war. As dirty and as cruel as the war waged by the French forces in Algeria, which so shocked the American conscience.'

The Nation continued:

'The truth is that the United States Army, some 10,000 miles from home, is fighting to bolster up an open and brutal dictatorship in an undeclared war that has never received the constitutional sanction of the United States Congress.'

The concealment to which I have referred has included the effects of what were euphemistically called 'weedkillers'. Dennis Bloodworth described how in April, 1963, South Vietnamese officials 'rubbed defoliation on their hands and arms in the presence of foreign correspondents who had selected the canisters from which it should be drawn—and in one case drank some of it' (*Observer*, 9 February, 1964).

It is interesting to examine these weedkillers and their effects. The *Times* of 16 May, 1963, disclosed the death by pesticide of birds of fifty-eight species and described fifty pesticides in widespread use as responsible for 'acute poisoning' of animals and human beings. President Kennedy found it necessary to halt their use and to begin a formal investigation. It was stated in the United States that chemicals used there for purposes of defoliation and the killing of weeds resulted in California in 1,100 cases of serious illness and 150 deaths (*Reuter*, May 16, 1963). Dr Jerome Weisner, the Chief Science Advisor to President Kennedy, designated unregulated use of these weedkillers as potentially 'more dangerous than radioactive fallout'. The actual use of those weedkillers has killed and caused serious illness in Britain, the United States and Scandinavia.

Napalm is a chemical which burns unremittingly and cannot be extinguished. The victims suppurate before terrified observers. The object of this weapon is to create hysteria and panic, as well as to annihilate. This weapon has been used on over 1,400 villages. The United States has spent one million dollars daily on the war. The *Observer* of 8 September, 1963, estimates that there has been an average number of 4,000 casualties monthly. The Central Intelligence Agency has spent an estimated sum monthly of 250,000 dollars on private armies, espionage and intrigue, according to *The Times* of September 10, 1963.

This war was largely conducted under the nominal rule of Diem. Diem grew more and more reckless and was at last murdered in a coup which most agreed was engineered by the United States, after a number of eminent Buddhist priests had burned themselves to death. It is noteworthy that the military oligarchy which succeeded Diem complained that he was secretly attempting to negotiate with the North, but not, noticeably, that his tyranny was unpalatable to the population. The death of Diem brought no amelioration. He had been, in fact, only the tool of the Americans and the sole change brought by his death was that the Americans had open responsibility for whatever they had formerly blamed on Diem and for what was done under his regime.

The National Liberation Front was formed on December 20,

1960, unifying the various elements of revolt against American domination.[1] By 1961, 10,000 Diem troops had deserted and joined the guerrillas with their arms. Let us consider again the treatment accorded to this popular revolt. Homer Bigart described in the *New York Times* of January 30, March 27, March 29, April 1, April 4, April 20, May 10, June 24 and July 25, all in 1962, the following programme:

'The rounding up of the entire rural population in strategic hamlets, the burning of all abandoned villages with the grain and possessions of the inhabitants and the "locking" of strategic villages behind barbed wire.'

It is clear that the majority of the inhabitants wish their country to be neutral. This the American Government cannot tolerate. The euphemisms used for the military operations which have belatedly been acknowledged to be the full responsibility of the United States are instructive. 'Operation Sunrise', 'Pacification of the West' and 'Morning Star' resulted, in the area attacked, in the destruction of all villages, fields and crops. In 1962 alone, according to General Paul D. Harkins, 30,000 peasants were killed. The *Christian Science Monitor* described this process on March 8, 1963:

'Since the army finds sullen villagers and does not know which are pro-Communist and which are merely dissatisfied with Saigon, and since the army must do its job, it shoots anyone seen running or looking dangerous. It often shoots the wrong peasants.

[1] National Liberation Front. In this common front, all those forces combined who had suffered and decided on armed self-defence. It constitutes an organization of many segments of the population. Communists and non-Communists alike were victims of Diem's regime; they united in self-defence. Much of the leadership comes from the intellectuals, who felt the lack of freedom most severely; doctors, lawyers, and university professors play prominent roles in the committees of the National Liberation Front. Many religious leaders were instrumental in the organizing of the Front. They represent the majority (Buddhists) and the minorities (some Roman Catholics and many ethnic minorities whose unique ways of life were intolerable to the bigot, Ngo Dinh Diem) of South Vietnam's worshippers. Small businessmen and even progressive landlords joined peasant farmers, fishermen, and workers to help form the Front against the common enemy and oppressor.

They are in the records of battle listed as Communists. Anyone killed is automatically a Vietcong.'

On January 25, 1963, *Life* had photos of napalm bombings with the following caption:

'Swooping low across enemy infested land, US pilot instructors watch Vietnamese napalm strike. The object of the fire bombing is to sear all foliage and to flush the enemy into the open.'

'The *New York Times* also reported that US advisers made a tally of guerrilla corpses after each battle to make sure that Diem's troops were using American equipment to maximum advantage, so that they could display a good "bag".' (*Militant*, April 15, 1963).

In the light of all this evidence, it is strange to find the *New York Times* saying on April 8, 1963:

'Napalm has been used by the South Vietnam Air Force and has certainly killed innocent people, as other weapons have done in all wars. *American* [my emphasis] advisers have opposed its employment on both moral and practical grounds against all except clearly identified military targets.'

This definition appears to include sixty per cent of the villages, hospitals and clinics and all peasants who run or look dangerous. This editorial reply contradicts the *New York Times*' own news reports about American use and insistence upon the use of napalm and other weapons on non-military areas.

Many people in the Pentagon are urging that the war should be extended to an invasion of North Vietnam. President Johnson has announced that those countries which are directing and supplying the (so-called) Communist guerrillas in South Vietnam are playing a deeply dangerous game. A map in the *New York Times* of April 1, 1962, shows the forces of the Liberation Front in the far South around Saigon, and nowhere near the borders of Laos or North Vietnam. Both British and American reporters have stated that primitive guerrilla weapons have been used by the 'Vietcong', in addition to those plentiful supplies captured from the forces of

the nominal government of South Vietnam. The London *Times* of February 24 has stated that it is now considered doubtful whether the Government of South Vietnam has any will to win the war. The *Observer* of March 1, 1964, quoted an American official as stating that the trouble lay in the fact that, while the United States wished to extend the war, the Vietnamese only wanted to end the war.

The situation which faces those who have conducted this war is grave. Should the United States retire and allow victory to the NLF? Should America engage in a naked war of conquest, which will be clearly seen as such, and attempt to establish again a Government dependent entirely upon alien armed force? This 'enemy' controls nearly seventy per cent of South Vietnam. The majority of the NLF was described as non-Communist by former Premier Tran Van Huu in Paris, as reported in the *Observer*. The 'Vietcong' official policy asks for a neutral and disengaged South Vietnam. Despite all the attempts on the part of the Western press to describe this war as one in which a helpless democratic people is under ruthless attack from an aggressive Communist neighbour, it is evident that the NLF is a popular front which has fought an appalling tyranny in South Vietnam and has been opposed by the United States at an incalculable cost to the population. Why is this non-Communist, neutralist, popular front so ruthlessly opposed? Even the Communist North has declared, through Ho Chi Minh, that it wishes to be unified with the South on terms of neutrality in the Cold War and independence of Russia, China and the West (*The Times*, 5 November, 1963).

The policy of the United States which has led to the prospect of an American invasion of North Vietnam will likely bring on Chinese involvement, with war with China as the result. The Soviet Union would then be drawn in. There are few parallels with the war in Vietnam. It has lasted nearly two decades; two Western industrial powers of overwhelming might have fought peasant guerrillas in a manner reminiscent of the Japanese during the Second World War. Everything short of nuclear weapons has been employed. Atrocity has characterized the conduct of the

war throughout its history. The Western press has hesitatingly discovered some of the facts about this war during the last two years. The Western peace movement has been conspicuously silent or restrained in its setting out of the truth about the war. The war has had no purpose. Its extension will bring direct conflict between the Cold War powers, with the possible destruction of mankind as the culmination of this folly. The tragedy in Vietnam indicates the extent to which it is possible to hide or disguise terrible crimes and it is time that people in the West raised their voices for an end to the bloodshed.

CHAPTER 3

Free World Barbarism
December, 1964

A distressing aspect of world politics is the extent to which liberals and even socialists have accepted the basic assumptions of the large and powerful forces behind the Cold War. The role of the United States as a perpetual intruder in the international affairs of other nations is taken as sacred. The right of the United States to interfere in countries, if the social and political policies of those countries are incompatible with private economic power, is happily accepted.

Instead of questioning how private, corporate capitalism and its overseas commitments have become identified with American national interests, liberals and many socialists accept this sinister sleight of hand. It is this sleight of hand which has successfully eliminated the Left in American politics. The investments in the Congo are sacred. If they are threatened, then 'freedom' is proclaimed to be in danger, and the US government and its military arm are brought to bear. If a national uprising takes place in Vietnam, American intervention is called 'response to external aggression'—as if America had the right to treat a country on the borders of China as a part of her national territory.

Dissent calls itself a quarterly of socialist opinion. In the summer 1964 issue there are several statements in its editorial, 'Last Chance in Vietnam', which are odd:

'Even US military men no longer say the war in South Vietnam can be won. The question now is how to minimize losses. . . . But if continuing the present policy means a hopeless attrition of the Vietnamese people, it must be stressed that simply for the US to

pull out of the country would mean something quite as inhumane. For it would then be a matter of months, at most, before the country was completely under Communist control and there would almost certainly follow a slaughter in the South of all those . . . who have fought against the Communists. To abandon these people now, after years of bitter civil war, would be an act of callousness.'

This statement sums up the ignorance and confusion of many well-meaning Americans who choose not to know the true role of the United States in world affairs or the true facts about conflicts such as that in Vietnam.

I am certain that until Americans on the Left challenge the right of the United States to suppress national revolts, to overthrow governments and to equate sordid economic exploitation with national interest or the 'defence of freedom', Goldwater and his fellows will reign, in effect if not in name. If, for example, it is thought legitimate to wage full-scale war against Vietnamese guerrillas, then it is, indeed, half-hearted to stop at the seventeenth parallel—or the Chinese border.

It is not the tactic of a world army for counter-revolution which should be disputed by the American Left; it is the policy itself which should be challenged. If the usurpation of power in America by the military and the large industrialists is credited with national or democratic aims, then both American democracy and world peace are sacrificed by default.

Dissent is tragically wrong about Vietnam. I know of few wars fought more cruelly or more destructively, or with a greater display of naked cynicism, than the war waged by the United States against the peasant population of South Vietnam. It is a war which epitomizes the indifference to individual freedom, national sovereignty and popular well-being—which is so characteristic of the world-policy of the military and industrial groups controlling the United States.

My files contain material on the war in Vietnam which tells of horrible inhumanities. It is important to set it before Americans. An examination of the facts exposes several myths: (1) the

National Liberation Front is a Communist organization; (2) the United States is defending the freedom and well-being of the populace; (3) the National Liberation Front is controlled from outside the country; (4) the United States is merely advising and assisting an indigenous government which is responsive to the people of South Vietnam; (5) the United States' calculated attacks on North Vietnam had been provoked by that country.

The Central Intelligence Agency acts as if it were an independent government and on many occassions it has called the tune in South Vietnam. There is not very much to choose between the Central Intelligence Agency and the more polished diplomats who proclaim their love of freedom in Washington and at the United Nations. I have in mind President Johnson and Ambassador Stevenson. These people are responsible for the tragedy in Vietnam.

Much of my data comes from a publication, *Sword of Free Vietnam*, which is the official organ of the Democratic Party of Vietnam, a virulently anti-Communist group composed of former officials and sympathizers of the South Vietnamese governments prior to that of the late Diem. The motto of this party (which I shall refer to as hereafter as DPV) is: 'For the defeat of Communism in the interests of Free Men EVERYWHERE!' Much of the data is incomplete as it was compiled up to late 1963. The scope of the tragedies is broader than partial figures can suggest. The accounts of brutality and suffering are conservative.

Sword of Free Vietnam quoted General Paul D. Harkins, Chief of US military operations in Vietnam, as stating that in 1962 alone 40,000 Vietnamese were killed. A White Paper of the DPV, for 1963, put the number of dead by late 1962 at 100,000.

By mid-1962 over 5,000,000 people had been put in camps designated by the DPV White Paper as 'concentration camps' and so described in the report quoting the White Paper in the *Los Angeles Times* of October 19, 1962. The Student Peace Union Bulletin for April 1963 stated that by late 1962 as many as 45,000 students alone were kept in South Vietnam's concentration camps. The number of people interned by 1963 on Paulo-Condore Island was 300,000. The DPV White Paper placed the number of

anti-Communist nationalists held in internment camps at 100,000. Paulo-Condore Island and other camps for anti-Communist prisoners indicate the vast extent of oppression in South Vietnam.

The leader of Buddhists in the National Liberation Front is the Venerable Thich Thien Hao. His estimates concerning the results of the war are: 160,000 dead by mid-1963; 700,000 tortured and maimed; 400,000 imprisoned; 31,000 raped; 3,000 disembowelled with livers cut out while alive; 4,000 burned alive; 1,000 temples destroyed; 46 villages attacked with poisonous chemicals; 16,000 camps existing or under construction.

By mid-1962 over half of South Vietnam's rural population was held in these 'strategic hamlets' and by mid-1963 their number had risen to over seven million. These camps are distinguished by spikes, moats, machine gun turrets, patrols and forced labour. The appelation 'concentration camp' given by the DPV White Paper seems just. The DPV report for September 1963 has a particularly sobering fact: forty per cent of 'enemy casualties' claimed by the government are those of guerrillas and sixty per cent are those of peasants not involved in the military struggle.

It is revealing that by mid-1963 the secret police numbered 300,000. So huge an army of oppressors suggests the suffering which has been inflicted and if the excesses of each agent on each individual occasion were collated, we should have an adequate idea of the kind of 'freedom' upheld by the United States in Vietnam.

The US Government embarked on the programme of 'strategic villages' under the Staley-Taylor plan. The declared intention was to separate guerrillas from the peasantry, depriving them of food, shelter and recruits. The DPV report for September 1963 also gave an account of life in the 'strategic hamlets':

'Strategic hamlets mean forced labour under 300,000 secret police. The programme is planned for fifteen million people. It is the only conflict on record in which every means is employed to destroy one's own people. [It is] . . . more severe and brutal than all of the French colonial period. [It includes] . . . series of

barbaric attacks on unarmed peasant villages with American arms and assistance. . . . Three hundred thousand secret police committed numerous atrocities. . . . Farm land and food sources [are] destroyed.'

Time magazine of May 17, 1963, was quoted in *Sword of Vietnam* for July 1963:

'Already 8,000,000 villagers—fifty-nine per cent of South Vietnam's population—are living in the 6,000 hamlets so far completed. The basic elements of the government's battle plan is to resettle almost the entire rural population in 12,000 "strategic hamlets" with bamboo fences, barbed wire and armed militiamen.'

A DPV report was quoted in a letter to the *Dallas Morning News* of January 1, 1963, in an appalling account of 'resettlement':

'Supposedly the purpose of the fortified villages is to keep the Vietcong out. But barbed wire denies entrance and exit. Vietnamese farmers are forced at gunpoint into these virtual concentration camps. Their homes, possessions and crops are burned. . . . In the province of Kien-Tuong, seven villagers were led to the town square. Their stomachs were slashed, their livers extracted and put on display. These victims were women and children. In another village, a dozen mothers were decapitated before the eyes of compatriots. In still another village, expectant mothers were invited to the square by Government forces to be honoured. Their stomachs were ripped and unborn babies removed. . . .'

On October 18, 1962 DPV submitted a report to the International Control Commission. It specified among its complaints 'decapitations, eviscerations and the public display of murdered women and children. . . . 685,000 people have been maimed by firearms or torture.'

These accounts and these data convey what Tran Van Tung, the leader of the DPV, felt when he stated during an interview on CBS, reported in the DPV Bulletin for September 1963:

'It is certainly an ironic way to protect the peasant masses from

Communism—to herd them behind wire walls under police control, to subject them to intensive indoctrination, to burn their villages. Poor as the Vietnamese are, they are not domestic animals.'

The Federation of American Scientists quoted Defence Department sources on the subject of chemical and biological warfare. It concluded that chemical poisons are used by the United States in South Vietnam and that South Vietnam has been used as a proving ground for chemical and biological warfare.

The United States Government admits that defoliants and other chemicals have been used extensively and that they have caused the destruction of fruit trees, vegetables, cattle and domestic animals. The South Vietnam Liberation Red Cross has offered evidence to any international investigatory body showing that over 1,000 people were caused severe illness accompanied by vomiting, bleeding, paralysis and loss of sight and consciousness.

Other more deadly chemicals cited by the Liberation Red Cross are: white arsenic, arsenite sodium and arsenite calcium, lead manganese arsenates, DNP and DNC (which inflame and eat into human flesh), and calcic cyanamide (which caused leaves, flowers and fruit to fall, killed big cattle and seriously affected thousands of people). These chemicals were sprayed over densely populated areas of considerable size.

Ma Thi Chu, representing the Vietnam Women's Union and the National Liberation Front, told last year's World Congress of Women:

'During the period from January to March [1963], when chemicals were used against 46 villages, 20,000 people were affected, many of them women, children and old people. I have been on the spot. I have seen children with swollen faces and bodies covered with burns. I have met women blinded or suffering from sanguinolent diarrhoea. Many of them died afterwards. I have seen the luxuriant vegetation of the Mekong Delta devastated by chemicals. Our enemies have thus attacked all life, human, animal and vegetable.'

The Baltimore Sun of March 21, 1964 carried an Associated Press dispatch from Saigon reporting calmly:

'We supply a phosphorous explosive fired from artillery and from fighter bombers which erupts in a white cloud, burning everything it touches.'

I am reminded of the argument of an eminent Nazi that he did not kill a single Jew; he provided the lorries. On March 22, 1964, the *Washington Star* carried an Associated Press report which said, 'The spectacle of children half-alive with napalm burns across their bodies was revolting to both Vietnamese and Americans.'

When US journals brag of military exploits in Vietnam, it defies human imagination to visualize the horror involved. When, for example, the Voice of America transmitted a US Defence Department report (January 6, 1963) declaring that in 1962 alone the US Air Force carried out 50,000 attacks on virtually the entire rural population outside of strategic hamlets, how much suffering, destruction and brutality corresponded to these familiar words of war?

When the *Saturday Evening Post* declaims 'virtually all of the fighting is done by US troops,' it becomes clear who bears responsibility for the indiscriminate murder, arson and destruction inflicted on this devastated country. The *New York Times* unwittingly reports, on occasion, what it is at pains editorially to deny:

'Many of the "enemy" dead reported by the government to have been shot were ordinary peasants shot down because they fled from villages as troops entered. It is possible that some were Vietcong sympathizers, but others were running away because they did not want to be rounded up for military conscription or forced labour.' (July 25, 1962).

Nguyen Thai Binh, an anti-Communist leader of DPV, cried out like Job:

'The people cannot follow the strange logic which decrees that they should be shot or imprisoned in the name of freedom. Offered the very finest facilities for forced labour, they rebel; installed in the newest of concentration camps, they protest. Showered with napalm bombs, they are so ungrateful as to think

in terms of a new government. The charred bodies of innocent women, children and peasants, lying in their fields; the bullet-riddled corpses of Buddhist demonstrators . . . this is the South Vietnam of today.'

In spite of the slaughter of their children, the peasants, incredible as it may seem, still dislike the Americans. . . .

These almost unbelievable atrocities have been committed by troops under American authority, an authority chosen by more than half of the voters of America. Those who voted otherwise were, for the most part, demanding even harsher measures. In the name of freedom pregnant women were ripped open, and the electorate did not rebel. Every American who voted Republican or Democratic shares the guilt of these sanguinary deeds. America, the self-proclaimed champion of freedom to torture and kill women and children for the crime of wishing to go on living in their homes. It is surprising that American proclamations are looked on coldly?

It is sometimes stated by US authorities that the war in Vietnam is used as an opportunity to test weapons, men and anti-guerrilla methods. The American Federation of Scientists' report shows this.

The US military did not hesitate to admit this. They often express their enthusiasm to the press. Reports appeared in *Look* magazine of December 23, 1963 and circulated throughout the American press:

'The Army tested small-calibre ammunition as long ago as the 1920s, but it was not until the recent combat experience in Vietnam that it really sat up and took notice. About 1,000 AR-15s were sent out by the hush-hush Advanced Research Projects Agency in the Defence Department. A report has been issued marked Secret because of the gory pictures in it. The story of what happens to Vietcong guerrillas who get hit with the AR-15 is being kept under heavy wraps. But, aware that the enemy already knows what the AR-15 does, you can find an occasional returnee who will tell you what he saw:

"When I left out there it was *the* rifle. The effect is fantastic.

I saw one guy hit in the arm. It spun him around and blew the arm right off. One got hit in the back and it blew his heart literally out of his body. . . .

"A man hit in the buttocks lived for five minutes. All others died instantly. His wound would have been superficial with other bullets. The fellow had his head blown clean off—only the stump of the neck left".'

The article is accompanied by a photograph of a five year old child with his arm shattered and in tatters. What words are appropriate for such barbarism of which the military are proud ?

The National Liberation Front was founded in December, 1960. It has a thirty-one member Central Committee headed by a non-Communist lawyer. Represented on the Central Committee are leading Buddhist priests, Catholic priests, Protestant clergy, small businessmen, professional groups and three anti-government parties.

Few will challenge the estimate made in a report of the DPV in July 1963 that 'seventy-five per cent of the people, in varying degrees, support the rebels who dominate ninety per cent of the land.' Many sources, including American sources, claim a higher proportion of rebel support.

It is clear that the rebels of South Vietnam speak for the people of that country. Any other view is insupportable. Even General Paul D. Harkins stated, 'The guerrillas are not being reinforced or supplied systematically from North Vietnam, China or any place else. They depend for weapons primarily on whatever they can capture.' (*Washington Post*, March 6, 1963 and *Free World Colossus* by David Horowitz.)

On December 10, 1962 *Newsweek* quoted a US captain as saying:

'All the Communists [in South Vietnam] have is their dedication. If I was [*sic*] in their shoes, I'd be pretty sore at Hanoi for letting me down.'

David Halberstam reported in the *New York Times* of March 6, 1964:

'No capture of North Vietnamese in the South has come to light.'

These statements refute the official US posture and also indicate the odds against which the rebels have fought.

In assessing the information about this atrocious war it is instructive to note the coincidence of reports from the National Liberation Front and the Democratic Party of Vietnam, despite the political opposition between them. The reports in Western newspapers have appeared, it would seem, in spite of US efforts to hide the true nature of the war. The Associated Press issued a dispatch from Washington on May 5, 1963:

'A potentially explosive document in the hands of a House sub-Committee is reported to lay down administration guidance for restricting movement of correspondents covering the warfare in South Vietnam: (1) Keep reporters away from areas where fighting is being done entirely or almost entirely by US troops. (2) Keep reporters away from any area which will show the failure to attract full allegiance of South Vietnamese people.' (Quoted in DPV report for June 1963.)

When slogans about freedom are put aside some of the more basic purposes for this war emerge. The DPV report, for September, 1963 reveals:

'A tremendous dope smuggling racket has seen the light of day. One of the key figures is Mme . . ., wife of a prominent general.'

It was also reported in the *New York Herald Tribune* of February 3, 1964 that:

'General Khanh boasted he had ten million dollars and could flee to lead a life of ease if he wanted to.'

The most revealing article, however, was carried in *Aviation Week* for April 6, 1964:

E

'An air cargo company, Air America, incorporated in Delaware is currently the principal instrument for the extension of the war in Laos, Cambodia and North Vietnam. This company has some two hundred aircraft . . . used under charter . . . It is airlifting South Vietnamese Special Troops to various places . . . the return trip [carries] a load of opium for further transport to markets in the US in a big Boeing aircraft. These aircraft are under the command of US Army General Paul D. Harkins and the pilots are former US military pilots.'

A further consideration of this remarkable article can be found in the Asian affairs monthly *Eastern World* by Edgar P. Young, Commander, Royal Navy, rtd.

I should wish at this point to consider the actual programme of the National Liberation Front, if only in the hope that readers of *Dissent* will take note:

'. . . To carry out without delay, real and broad democracy in which freedom of thought, expression, the press, organization, assembly demonstrations, trade-unions and freedom to set up parties political, social and professional organizations; freedom of movement, trade, religion, worship, corporal liberties which are to be guaranteed by law for the entire people without any discrimination. . . .

'[We shall] stop persecution, arrest, detention and harassment of patriots and of opposition, of individuals and parties. We shall cancel the barbarous prison regime, especially torture, penitence brain-washing and ill treatment of prisoners.

'[We shall] refrain from setting up in South Vietnam any form of dictatorial regime, either nepotic and militarist or set up by a group or party, and refrain from carrying out a mono-party or mono-religious policy, a policy of dictatorship in ideology politics, religions and economy. . . .

'[We wish] free general elections to elect organs and to form a national coalition government composed of representatives of all forces, parties, tendencies and strata of the South Vietnamese people . . . a policy of neutrality [through which we] will no

adhere to any military bloc, nor let any foreign country station troops or establish bases in South Vietnam. We will accept aid from all countries, regardless of political regimes and establish friendly relations on an equal footing with all countries. We respect the sovereignty of all countries and form together with Cambodia and Laos what must be a neutral zone on the Indo-Chinese peninsula. Reunification will be realized step by step on a voluntary basis with due consideration for the characteristics of each zone, with equality and without annexation of one zone by the other.'

Why do American journals pontificate about the 'Vietcong' when they are so ignorant of the programme set about above? Are they aware that Ho Chi Minh of North Vietnam declared his desire for 'Neutrality for both North and South Vietnam and independence of Russia, China and America . . .'? (*The Times*, November 5, 1963.) The US Government, however, is in gross violation of its own official declaration at the conclusion of the Geneva Conference of July 21, 1954:

'We take note of the agreements and of paragraphs one to twelve inclusive of the final declaration. . . . The US will refrain from threat or use of force to disturb them . . . and would view any renewal of aggression with grave concern [and as] a threat to international peace and security.'

This declaration by W. Bedell Smith established American support for the Geneva Conference Report providing for neutrality, elections and non-interference. But US troops are the only foreign troops in Vietnam today.

W. W. Rostow, director of the State Department's Policy Planning Board, advanced a plan known as "Plan Six" providing for a naval blockade and air raids against North Vietnam. Representative Melvin Laird stated in a committee of the US House of Representatives that 'the US administration is preparing plans for a strike into North Vietnam.' The Associated Press reported a

combat force of fifty jet bombers training in the Philippines in preparation for bombing of targets in North Vietnam. The bombers are said to be furnished with intelligence data obtained by U-2 reconnaissance planes. During the Honolulu Conference of June 1964, attended by Secretaries Rusk and McNamara, it appears plans for air raids and sabotage against North Vietnam were discussed. I take these references from a letter which I received from the Foreign Minister of North Vietnam. They have been amply supported by independent sources, as well as American sources.

Substantiation for the contention that the United States has been deliberately provoking North Vietnam can be found in *Aviation Week* for April 6, 1964:

'War against the Communists has already erupted over the borders of South Vietnam with raids and infiltration moves as far north as China. . . . With US backing in aircraft, weapons and money, an estimated fifty thousand elite South Vietnamese troops are being trained to take the offensive in over-the-border strikes at Communist supply centres and communication routes. Despite Defence Secretary McNamara's implication in Washington (March 26) that the decision has not yet been made to extend the war, it is known here that guerrilla strikes against the Communists have been increasing since last summer.'

Despite this disclosure of plans and preparations, when the aggression actually occurred, US officials had no qualms about feigning utter surprise. *Aviation Week* goes on to discuss the specific preparations:

'Key factor in the current raids is the airlift provided by Air America, a US cargo company [which] camouflages its US Governmental sponsorship. US military advisers here are optimistic that extending the war beyond the borders, plus a stable government in Saigon, will force the Communist insurgency to collapse in a year. . . .

'Special forces—now one-tenth of the half-million South

Vietnamese under arms—are not connected with the formal military organization. They rely on Air America using numerous secret airstrips in South Vietnam and Thailand.

'. . . Last fall, when US officials decided it was impossible to win the war by confining it inside South Vietnamese borders, they began an expanded programme of training special forces at secret bases, emphasizing techniques of operation beyond national borders.'

To his credit, Senator Wayne Morse delivered a speech in the US Senate on April 14, 1964. He said:

'We have already aided and abetted the extension of the war beyond the borders of South Vietnam. I am fearful that as the proof of that becomes clearly established—as I believe it can be— we may wake up some morning to find charges levelled against us in the United Nations. . . .'

There were many more disclosures of raids into North Vietnam which had already occurred and more reports of plans for more ambitious military ventures.

James Cameron wrote in the London *Daily Herald* of March 4, 1964:

'W. W. Rostow's Plan Six provides initially for a naval blockade of Haiphong, the port of Hanoi. If Hanoi still refuses to call off support, the Northern ports should be bombarded from the sea, and finally US strategic bombers should attack Hanoi itself, if necessary flying the South Vietnam flag.'

In the vernacular of the State Department, whenever Hanoi is urged to call off its 'support of the South Vietnamese insurgency,' what is really meant is that Hanoi should apply pressure and sanctions to force the rebels to submit to the United States.

On April 10, 1964, the *New York Times* reported that 'Secretary of State Dean Rusk told SEATO nations the US [was] absolutely committed to remain in South Vietnam and reiterated that the war may be brought to North Vietnam soon.' On April 13, 1964, the *Wall Street Journal* reported that 'US planned South Viet-

namese bombing attacks on the North may commence as soon as late May or early June.'

After all these announcements, when the US finally attacked, the American press, which for days and weeks had carried the announcements, pretended shock and amazement as if the United States had been an innocent victim of surprise attack.

Senator Wayne Morse has been more honest and stated after a secret briefing by Dean Rusk:

'An expanded war in Asia could only be won if we used nuclear weapons.'

The report of James Cameron bears this out:

'The grim thing about Plan Six is that it has no end. If Hanoi must be bombed. . . . Shanghai must be bombed to stop Chinese help to North Vietnam. . . .'

American and British warnings are reflected in the memorandum sent to me and others by the Chinese Charge d'Affaires in London:

'On July 30, US warships intruded into the Northern territorial waters of the Democratic Republic of Vietnam and shelled Hon Me and Hon Ngu islands. On August 1 and 2, US airplanes bombed a border post and village of the Democratic Republic of Vietnam. The bombing of coastal towns of the Democratic Republic of Vietnam on August 5 was a premeditated move by US imperialism to extend the war step by step. . . . (Mr Hsiung Hsiang-hui, August 6, 1964).

The *Manchester Guardian* editorial of August 11, 1964 confirmed that the movement of the Seventh Fleet into the Gulf of Tonkin was calculated and directly related to naval attacks by the 'South Vietnamese' Navy:

'A new account is now emerging in Washington. . . . The North Vietnamese islands of Hon Me and Hon Ngu had indeed been attacked from the sea, as Hanoi had alleged, before the crisis blew up; this is now admitted in Washington. The attackers were

South Vietnamese ships, not the Seventh Fleet; but that distinction may not seem so significant in Hanoi as in Saigon and . . . at that point the US destroyer *Maddox* sailed into the Gulf of Tonkin. . . .'

Nonetheless, as far as the US press is concerned, all the warnings and admissions, the leakage of Plan Six, the formerly acknowledged preparations for extending the war by the US Government, are ignored in descriptions of the attacks on North Vietnam. The knowledge of editors and of reporters is not brought to bear on the situation; the editors and reporters instead bear false witness.

American dissenters, liberals and socialists who identify with the official presentation of the events in Vietnam and who accept the interpretation of national interest set out by the military and the industrialists, may be asked if they consider the facts discussed in this article to comprise a model of the Free World? Can national interest be allowed to mask such barbarism, however interpreted? Is it not time for 'national interest,' the 'Free World' and the professed principles of American dissenters to be scrutinized more closely? The time for protest is overdue. We may hope it is not too late and that this war of atrocity may be ended.

Danger in South-East Asia
March, 1965

The Americans have at last succeeded—too late, alas—in shocking the conscience of mankind. They have been engaged for years in various kinds of atrocity in endeavouring to subdue 'inferior' races at home and abroad, but these acts have been excused as occasional excursions of a too energetic population. The British Labour Government has applauded them and has made itself an accomplice in unspeakable cruelties. But, in the endeavour to exterminate the inhabitants of South Vietnam in the sacred name of freedom, they have now adopted the use of what we are told is 'non-lethal' gas. For some reason, which I do not quite understand, people who thought nothing of the murder of babies and the torture of women and children are shocked by this new method of warfare. It is not their present shock that is astonishing, but their previous indifference. The present cries of horror are amply justified. What our Press tell us about these American 'non-lethal' gases is that, when employed against an enemy, they induce a state of nausea or in some way render the victims incapable of action for a period. During this period, however, it is clear that the possessor of the gas can murder his enemy, or imprison him, or capture his citadels so that he is killed or, when he comes to, finds the battle has been lost.

This is bad enough, but the recent history of Americans in Vietnam makes one doubt whether it is really the whole truth. Are the gases really non-lethal? One remembers the 'defoliants' which were said to poison only vegetation, but, in fact, also poisoned animals and human beings. We have been told that they were harmless weedkillers and that to deprive the population of

its crops is no grave matter. We learnt, slowly and with difficulty, that what were called 'weedkillers' were, in fact, poisons of which, after observation of their effects, the use in the United States has been forbidden. I cannot remember what excuse was given for the use of Napalm bombs which burn people alive in unspeakable and prolonged agony. The American authorities have, in fact, indulged in a vast career of concerted lying. A Government official, the Assistant Secretary of Defence, Mr Arthur Sylvester, stated publicly in December, 1962, that lying is a proper weapon for a Government to use. One cannot, therefore, escape the suspicion that the 'non-lethal' gases are, in fact, lethal and that the purpose of their employment is the depopulation of Vietnam, both North and South.

We have been told on high American authority that the next step America will take will be the destruction of China. When China has been destroyed, Americans will turn to giving assistance to their henchmen in the British Labour Party in their struggles in Malaysia. She will then 'liberate' various other, hitherto happy, countries in Asia and Africa. When these tasks have been accomplished, America will rule the world. No one will dare to resist, since resistance will be useless. A population rendered cruel by wholesale slaughter will feel no restraint in practising cruelties, by this time become habitual, in any part of the world.

Is there anything that can be done to prevent this universal empire of evil? Certainly the first step is to help the people of Vietnam in their efforts to win and preserve their freedom. As for the further steps, if mankind is to be preserved from the threat of a nuclear war, there is only one hope for the world, which is that the better elements in the American population will refuse to follow collective mass murderers on their fatal course and will restore to mankind permission to remain alive.

This is a work in which individuals as well as nations and parties can take part. It may be that if the greater part of mankind expresses, forcibly, a horror of such a prospect and the almost universal hatred of America which its success would entail, the more ferocious elements in America would be res-

trained by those who have some feeling for human welfare. These are, I am convinced, the great majority of Americans— eighty-one per cent, according to a Gallup Poll. There is no reason why we should sit down and be overridden passively by organized murderers. It should still be possible, though it is getting daily more difficult, to induce Americans to choose a Government not composed of savage exterminators, a Government with some respect for human rights and happiness. The British people, despite the attitude of the leaders of the two great parties, can help to bring this about. The action of the ninety-four Labour MPs and of important trade unions in protesting against the American aggression, is a step in the right direction.

White men, generally, have been accustomed to some centuries of supremacy, but the day has come when men of other colours demand equality, possibly in combination with the better elements in the white nations. It may prove possible for more radical views to prevail. But it is necessary for these radical views to be publicized, to be strong and clear statements based on trustworthy information. This is a slender hope, but it is all that the present world can justify.

CHAPTER 5

The Cold War: A New Phase?
February, 1965

Man is a quarrelsome and power-loving animal. Life without power and without quarrels would seem to him a tame and tedious affair. From the combination of quarrels and love of power most of history proceeds, and, more particularly, wars and empires. The possible size of empires increases with the advance of technology. Cyrus, whose empire was the first of any magnitude in Western history, depended for the stability of his empire upon a great road from Sousa to Sardis. To travel on a horse from one of these places to the other took a month for an emissary of state, but three months for a private traveller.

Roads dominated history from the time of Cyrus until empires began to depend upon sea power. Next came railways, and, then, air power. Many of the most important events in history were determined by roads—for example, Constantine adopted Christianity in York and immediately marched on Rome, arriving at its gates before his change of policy had become known within the city. That is why most of the West is Christian.

For thousands of years no stable empire could be as large as the world and, therefore, men's quarrelsome instincts remained satisfied. A new thing that has happened in our day is that a stable empire can be as large as the world. This is the result of nuclear weapons, and has caused perplexity to all who live by slaughter. The result of the invention of nuclear weapons is that war may exterminate our species and may, therefore, fail to satisfy any of the desires which have inspired the wars of earlier periods. In this situation, statesmen remain perplexed. All the satisfying wars of earlier times have become impossible. The

only probable alternatives that remain are peace or extermination. In this situation, traditional statecraft collapses. The old phrases become hollow, and the old aims of policy become unattainable. This fact has begun to be understood even by politicians and is necessitating new forms of the Cold War.

Until very recently, the traditional love of war and hope for victory fitted the developed powers of the world into two camps, East and West. The final conflict was imagined as one lasting for an hour or two and ending with six Americans and five Russians, or *vice versa*, thus giving final and absolute victory to the six. But, gradually, this picture lost its attractiveness. Warlike ferocity could not be sustained at a level involving the destruction of everything and everybody that had been loved or had been a cause of delight. It has come to be felt that a global nuclear war must be avoided. This requires new policies and an abandonment of the simple bi-polar organization that has satisfied statesmen since nuclear weapons were invented.

America, faced by this new situation, has developed a new policy, the aim of which is to transfer to America as much as possible of what used to belong to West European Powers. Wherever Britain or France or Italy were involved in a difficult colonial war, America would come to the assistance of the Power concerned and, by financial and military superiority, would gradually oust the former imperialist masters, thus replacing the former colonial empires with a puppet state of its own.

This process proceeded somewhat differently in different continents. In Latin America, large trading companies have been created, dominated by Americans and controlling completely the internal as well as the external policies of the various South American countries. The only exception to this policy has been Cuba. In Asia, the policy has been considerably frustrated owing to the fact that Russia, Pakistan, India and China owned much of the greater part of both the territory and the population of that continent. Where the policy has been possible, as in Southeast Asia and Central Africa, it has proceeded by finding a small percentage of the population which was friendly to the West, recognizing it as the sole legitimate source of political power, and

keeping the government in its hands by means of American troops and American money.

American activity in these spheres is possible only because of American superiority to Russia in arms. The Soviet Government realized at the time of the Cuban Crisis in 1962 that, in a war between Russia and America, Russia, certainly, and America probably, would be ruined. This enabled the American Government to do things that were objectionable to the Russians—as, for instance, the war in South Vietnam. Not only America, but the whole non-Communist West, could play a perpetual game of brinkmanship in which Russia had always to retreat.

There were, it has proved, certain difficulties. Most of the smaller countries in which America was seeking power wished to be neutral and could only be subdued by abominable cruelties. The process of overcoming popular sentiments in the countries concerned caused the general population to become more and more anti-Western in their feelings. Americans hope that, in the course of time, the hostility of these countries may diminish, but former British experience in India makes this seem highly improbable.

Another difficulty that faces Western powers in Asia and Africa is that many parts of these two continents have achieved complete independence in the course of the struggle. Almost the whole of Africa is now completely independent, while the Congo remains doubtful. With some exceptions, the old colonial empires have passed under the political or financial domination of the United States.

But great questions remain: Can the new empire succeed and can it last? Can the American policy succeed? America has already encountered great difficulties of which, at the present moment, the most important are in South Vietnam and in the Congo. South Vietnam was part of the French region of Indo-China, but rebelled during the Second World War. The French were finally defeated at Dien Bien Phu in 1954. An international conference took place at Geneva and decided that the whole region of Cochin China was to be divided into several separate states, one of which was Vietnam. Vietnam itself was divided

into North and South, but this division was to be temporary and within two years the two were to be re-united and a neutral parliamentary regime was to be established over the whole.

This proposed settlement, however, broke down almost immediately. North Vietnam decided to be Communist, while a large majority in South Vietnam wished to be neutral. The small minority which adhered to the West appealed for American support. America responded by a campaign whose object, it soon became clear, was to turn South Vietnam into an American colony. The Vietnamese supporters of America were those who had previously supported the French. They were headed by the Diem family which was Christian, while most of the population was Buddhist.

The Diem family proceeded to various atrocities. A number of eminent Buddhist dignitaries anointed themselves with inflammable oils and burnt themselves to death. This was too much for the Americans, who threw over the Diem family. The Americans, however, continued their opposition to the peasants, most of whom joined the roving bands of 'Vietcong,' a loosely organized band of guerrillas. The 'Vietcong' would descend upon a village and acquire the support of its inhabitants. To stop this, the Vietnam Government, with the support of the Americans, organized the rural population in 'strategic villages'. The post-Diem regime, with the support of the Americans, continued to do so. Those villages were virtual prisons. Previously existing villages were forcibly evacuated. In the new ones inhabitants were closed in and guarded. Meanwhile, the pro-American armed forces had established a reign of terror. The secret police grew into hundreds of thousands, and their behaviour was unbelievably cruel. The leader of the Buddhist hierarchy, the Venerable Thich Thien Hao, reported, in 1963, that a hundred and sixty thousand had died as a result of the regime. Seven hundred thousand had been tortured and maimed. Four hundred thousand had been in prison; thirty-one thousand raped; three thousand, disembowelled and their livers cut out while alive; and four thousand, burnt alive. Similar figures can be quoted from other reliable sources. The Americans learned with astonishment that, in spite of this treatment, they

were not loved by the population. Now, they are contemplating an attack on North Vietnam, which the Chinese have undertaken to defend. It is not unlikely that the Russians will do likewise, as indeed, they have announced they intend to do. If America persists, world war becomes an imminent threat.

How can it come about that ordinary, decent people in America support this war? How can they, by their votes, encourage the use of defoliants, nominally against trees, but, in fact, for the purpose of killing the population, including children? How can they favour a government which disembowells pregnant women and exhibits their unborn children to the public? How can they contemplate, as they are doing at this moment, the extension of the war to North Vietnam with the risk of its further extension, first, to China and, then, to Russia, which would in all likelihood entail the destruction of the human species? All this is rendered possible by a vast campaign of lies, partly governmental, partly journalistic. The purpose of the lies is to keep alive belief in the wickedness of Communists, which is represented as so appalling that, in order to put an end to it, the death of all human beings would not be too great a price. There is still hope that America may abstain from this last step, but the hope is diminishing daily.

The situation in the Congo is very similar, except in two respects. The first of these is that China and Russia are more distant from the Congo than from Vietnam. The other is that many of the states of Western Europe are equally concerned in the slaughter.

Ever since the bomb was dropped on Hiroshima, it has been obvious to all thinking people that nuclear disarmament was the only solution to the world's troubles. In the countries that already possessed nuclear arms, it was loudly proclaimed that every additional country which acquired them increased the danger of nuclear war. But, in spite of this, new countries have become members of the 'nuclear club'. Britain and Russia quickly followed the example of America. These three finally concluded the partial nuclear test ban treaty, by which they hoped to prevent the further spread of nuclear arms. But France refused to sign the treaty and has developed her own nuclear bomb.

Since the conclusion of the treaty, China has become a nuclear power. India and Brazil are likely soon to become nuclear powers; the Middle Eastern countries, Scandinavia, Belgium and others do not wish to be left behind. Many in the West are urging that Germany be given nuclear weapons. Whenever disarmament is proposed, each side argues that the other side asks too much, is too heavily armed, and is so deceitful that it cannot be trusted to fulfil its promises. All these are forces tending to make nuclear war more likely.

What is there to put on the other side?

There are some powerful and growing movements for the avoidance of war, but whether they will grow fast enough to overcome the interests of the armament industry and the passion of national vanity is doubtful, since they cannot become decisive without a great change in public sentiment. There will have to be a much smaller belief in the wickedness of the 'enemy' and a much greater realization of the disastrousness of nuclear war. There will have to be a general spread of good sense in spite of the governmental pressure in the direction of disaster. There will have to be a realization that mass murder is not the most important duty of man, and that the only road to general welfare lies in co-operation. Whether this can be achieved before war breaks out is the great question of our time. It is better for nations to live together in happiness or to perish in agony? It would seem that governments prefer the latter—or, at any rate, policies leading towards it. It is difficult for public opinion to reverse the policies of governments, but I do not believe that it is impossible. To attempt it is the supreme duty of every man who is either or both, sane and humane.

What are the steps in this direction that must be taken in 1965?

The first and easiest move that must be taken is to include China in the United Nations. The war in Vietnam must be brought to an end in a manner pleasing to the inhabitants of that country—North and South should be united and neutralized, as was intended by the Geneva accords of 1954. The civil war in the Congo must be terminated otherwise than by an extension of Western imperialism. The United States' influence in Latin

America must cease to take the form of upholding capitalist governments which prolong the poverty of the great masses of the population. The mutual hatred of Arabs and Jews must be mitigated. Some solution of the German problem must be found. But, above all, a beginning must be made of nuclear disarmament. Most of these should be done in 1965; all of them must be begun with a serious promise of their being soon accomplished. If all these things are done, there will be new hope for the world. If they are not, the drift towards disaster will continue, and with increasing rapidity.

Human beings will have proved themselves indistinguishable from either lemmings or gadarene swine.

CHAPTER 6

The Selection of Targets in China
April 29, 1965

The selection of targets in China for bombing by the United
States is very grave news. It follows a pattern of escalation of the
war in Vietnam which has been developed for at least eighteen
months. When it was seen that the United States had lost the war
in South Vietnam, W. W. Rostow, the Director of the State
Department's Policy Planning Board, advanced a plan known as
the 'Rostow Plan 6' which has, in fact, proved to be the basis of
the policy. It provided for the bombing of North Vietnam and
naval blockade. Targets in North Vietnam were selected and
combat forces of jet bombers were trained in the Philippines.
Ground troops were also trained for strikes in North Vietnam.
All were to be used unless Hanoi applied pressure and sanctions
to force the National Liberation Front to submit to the United
States. In August 1964, following repeated incursions into North
Vietnam by aircraft, frogmen and assorted CIA agents and
provocations by the US Seventh Fleet along the coast of North
Vietnam and China, the aerial destruction of the North began in
earnest. At first, it was necessary for the United States to claim
that this was retaliation against acts by North Vietnamese
torpedo boats or by the National Liberation Front, but even these
pretences were soon abandoned. The bombing was extended
further North. It was falsely claimed that only military targets
were attacked. In fact, there has been a large number of civilian
casualties and churches and villages have been destroyed.

Plan 6 has no end. If North Vietnam must be bombed for its
encouragement of resistance to the United States in the South, so
must China be bombed to prevent it sending help to North

Vietnam. The emphasis that McNamara now places upon a few weapons allegedly of Chinese manufacture found in South Vietnam comes ominously at the time of the announcement of the selection of targets in China. Escalation is to continue, evidently, as it has over the past year.

War with China means world war. If, as is likely, Russia comes to the support of China, nuclear weapons will be used, the war will be short and most of the inhabitants of China, the Soviet Union, the United States and elsewhere will be annihilated. I ask people everywhere whether this is the price they wish to pay for American refusal of peaceful independence and neutrality to South Vietnam.

The Labour Party's Foreign Policy
October 14, 1965

(A speech to the Youth Campaign for Nuclear Disarmament, London)

As some of you may possibly remember, I made a speech at the London School of Economics on February 15 in which I, first, recalled the election Manifesto of the Labour Party before last year's General Election and, then, compared it with what the Labour Government had been doing. It appeared that the Labour Government's record had completely failed to make even a beginning of carrying out its electoral promises. Today, I wish to consider the actions of the Labour Government since that time and to inquire, in view of their record, how anybody can continue to support them.

The Labour Government, as I shall try to persuade you, has acted in complete subservience to the Government of the United States. Those who had hoped for any improvement in international policies, have suffered a double misfortune: there were elections both in America and in Britain. In both elections, the more ferocious party was defeated. After those elections, the Governments which had been elected adopted the policy of their defeated opponents. The result has been a growth of atrocious cruelty in various parts of the world. Attempts have been made to conceal these acts. I wish to join those who try to defeat such attempts.

In my speech of February 15 I came to the conclusion that the only promise concerning foreign policy made by the Labour

Party in its electoral Manifesto which the Labour Government had carried out in its early months of office was to appoint a Minister for Disarmament in the Foreign Office. After a year, this remains the sum of the Government's achievement in carrying out its promises.

But I propose now to consider what the Government *has* done.

The sins of the present British Government in foreign policy are of two sorts: there are minor sins which consist of desperate efforts to hang on to some shreds of the decaying British Empire, and there are other, much worse, sins which consist of supporting America in unspeakable atrocities. Of the former sort, one might mention Aden, where Britain is carrying out her old Imperialist policies in support of her continuing imperialism in the Far East. One may mention, also, North Borneo where we have a large army at war with Indonesia. British Guiana has a constitution forced upon it by the Tories and so jerrymandered as to be totally unacceptable to the majority of the inhabitants. This constitution, our present 'Labour' Government continues to support. In all these cases its policy is merely a continuation of the bad policy of previous Governments.

In Rhodesia, the situation is in doubt. Though up to this time the Labour Government has continued Tory policy, it now appears to be making some effort to support majority rule there. It remains to be seen if it will act strongly, or merely talk.

To come nearer home, the Government has issued a White Paper concerned with the problem of immigration. It has attacked none of the problems which make the present immigration difficult—problems such as housing and education of immigrants —but it merely proposes to limit the numbers of immigrants. Even there, it misses the point; its proposals would limit the unskilled immigrants who are necessary to the British economy as it is now geared, but leaves loopholes whereby the number of skilled workers remains high while our own skilled workers, themselves, emigrate.

But what is much more serious is our Government's support of America no matter what America may do. The holders of

power in America have invented a myth by which they profess
to justify cruelties equalling those of Hitler. This myth has two
sides: on the one hand, it holds that all Communists are wicked;
on the other hand, it holds that all movements of reform, every-
where, are inspired or captured by Communists and are, there-
fore, to be combated from their inception. This myth is held to
justify the upholding of corrupt governments wherever the
United States has the power to do so. It is pretended that popula-
tions cannot possibly like the sort of governments that Com-
munists inspire, or dislike the kind of tyranny which Americans
describe as 'The Free World'.

Throughout South America there are political contests between
democratic parties and parties supported by America. The latter
represents capitalism in its crudest form. But everywhere,
excepting Cuba, American hostility has prevented the democratic
parties from achieving power. The recent troubles in San
Domingo are a case very much in point.

The worst aspects of American dominion, however, are being
displayed in South Vietnam—again supported by Britain.
America has no vestige or shred of right to take any part in the
affairs of Vietnam. When the French were finally expelled from
Indo-China, of which Vietnam was a part, an international con-
gress at Geneva decided that Vietnam, North and South, should
be independent and should if they wished be unified after free
elections. Britain and Russia jointly were the initiators of this
policy. The Americans, however, though they agreed to support
it, did not like it. They sent 'Observers' to South Vietnam who
reported that the country was too disturbed for elections. The
Americans proceeded to make friends with the small faction
that had previously supported the French. Their 'Observers'
became more and more numerous and more and more in the
habit, as 'Advisers', of giving orders to the puppet Government
which they installed. The population rebelled and the peasants
were moved into 'Strategic Hamlets'—'for their protection' it
was said, but the Hamlets were, in fact, concentration camps.
They refused to submit and inaugurated guerrilla warfare. The
guerrilla armies were nicknamed the 'Vietcong', and the civilian

authority which they acknowledged was called the National Liberation Front. A long, long war began. So far, there is no prospect of an end to it. The Chairman of the US Senate Committee on Preparedness stated recently: 'We still have a long, hard, bloody road ahead. We may have to keep our troops in Vietnam for fifteen years or longer.' (*Herald Tribune*, September 27, 1965).

Gradually, we have been allowed to become aware that American troops in South Vietnam behave in a manner in which, one would have thought, no civilized troops would behave. They use napalm which adheres to the skin and causes unspeakable agony. They use gas to smoke out suspected 'Vietcong' hiding places. They attack civilians from the air. When they capture civilians, they torture them. According to the *New York Times* of October 3, 1965, there have been up to the beginning of October, 170,000 civilians killed; 800,000 maimed by torture; 5,000 burnt alive, disembowelled or beheaded; 100,000 killed or maimed by chemical poisons; 400,000 detained and tortured savagely. One method of torture used by the American troops is partial electrocution or 'frying' as one United States Adviser called it—by attaching live wires to male genital organs or to the breasts of 'Vietcong' women prisoners. Other techniques which are designed to force on-looking prisoners to talk, involve their watching the cutting off of the fingers, ears, fingernails or sexual organs of other prisoners. A string of ears decorates the wall of a Government installation. These details were reported by the *New York Herald Tribune* (not a subversive journal) on July 21, 1965.

On July 18 of this year, the US Associated Press reported: 'The wailing of women and the stench of burnt bodies greeted the troops as they marched in Bagia' (a province of South Vietnam). 'A United States Air Force officer said, "When we are in a bind we unload on the whole area. We kill more women and children than we do Vietcong, but the Government troops just aren't available, so this is the only answer".' I could continue indefinitely with such quotations. The stomachs of pregnant women have been ripped open and their unborn children publicly

exhibited. But the tale is sickening. I cannot bear to tell the whole of it—nor could you bear to listen.

Meantime, of course—and again with our concurrence—the Americans have carried the war into North Vietnam where they have deliberately bombed schools, hospitals and orphanages— more civilians than armed forces. They even proposed for a time to bomb the great dams which would have caused such flooding and devastation and loss of life that the rest of the world cried out against it and it has been ostensibly given up and the US has denied that it ever had such an intention.

There are other matters such as the problem of the refugees, who are suffering exposure and starvation, and the public execution of prisoners. But there is not time for me to go into all the horrors even if I would.

Apropos of the public execution of prisoners, however, I should like to bring up another problem:

These public executions were first indulged in by the United States Forces and the South Vietnamese Government. They have been answered by reprisals in kind, though so far, I believe, fewer in number, by the 'Vietcong'. There is an acceleration in savagery which is to be expected and which is one of the worst aspects of guerrilla war—indeed, any war. But this is the responsibility of the invader.

I should like to call your attention to an article concerning the Congo which appeared in the *Observer* of August 29 entitled 'Mercenary exposes Horror' which was answered in the following week's *Observer* by a letter 'Congo Mercenaries'. This letter points up what I am trying to say about the inevitable and limitless hardening of cruelty under the stress of war. The policies at present condoned by the Labour Government involve, inevitably, the condoning of the methods of carrying them out.

In the Congo, as well as in Vietnam, our Labour Government has supported the United States.

Concurrently with the savageries and unbridled cruelty of the war in Vietnam the United States has initiated a programme of sweetness and light: The US Forces there are given small cards urging a display of strength, understanding and generosity upon

them and nine rules of conduct for their guidance. These were printed in the *Daily Worker*, September 22, 1965, and are as follows:

'1. Remember we are guests here. We make no demands and seek no special treatment;

2. Join with the people, understand their life, use phrases from their language and honour their customs and laws;

3. Treat women with politeness and respect.

4. Make personal friends among the soldiers and common people;

5. Always give the Vietnamese right of way;

6. Be alert to security and ready to react with your military skill;

7. Don't attract attention by loud, rude or unusual behaviour;

8. Avoid separating yourself from the people by a display of wealth or privilege;

9. Above all else you are members of the US military forces on a difficult mission, responsible for all your official and personal actions.'

These cards of exhortations end: 'Reflect honour upon yourself and the United States of America.'

I ask you to contrast these precepts with the actions of the armed forces of the US in Vietnam to a few of which I called your attention a short time ago.

For anyone interested in hypocrisy these exhortations make an absorbing study. For anyone interested in humanity this gilding of a very rotten and stinking lily is nauseating.

But this propaganda campaign has been carried further than mere precepts. On September 11 our papers, most, if not all of them, carried reports of one of its most egregious actions:

On September 10, the day of a children's festival in North Vietnam, American aircraft showered on five North Vietnamese cities 10,000 packages of toys, school supplies and soap labelled 'From the children of South Vietnam to the children of North Vietnam'.

'The United States and South Vietnamese psychological war-

fare experts', reports *The Times* on September 11, 'devised the packages for which the Vietnamese Government paid. The five cities are all in an area from 30 miles north of the border to 70 miles north of Hanoi.' The report ends: 'In South Vietnam American and Vietnamese marines pressed on with a search and destroy operation which has so far killed 167 guerrillas.' The day before, the US aircraft had been employed in destroying bridges in North Vietnam.

It is to be noted that the area over which the packages were rained upon the inhabitants had been bombed by the US forces. As the *Daily Worker* remarked (11.9.65) the precious parcels fell upon children, some of whom had no eyes to see them and no hands to grasp them, because of previous raids of the US Air Force with their high explosives, napalm and Lazy Dogs.

The extreme cynicism of these propaganda actions has rarely, if ever, been equalled. Yet there has been little notice taken of them in our press—save in the *Daily Worker*—and very little outcry against them amongst the general public.

We, through our Government, are condoning such actions.

If further evidence of the hypocrisy that we support is needed, there is plenty of it: On September 23, the US Ambassador to the United Nations said: 'We seek only to ensure the independence of South Vietnam . . . and opportunity for its people to determine their own future . . . by the principles of self-determination.' On September 23 he also said, in arguing against the admission of Communist China: 'The Members of the United Nations, under the Charter, share a common responsibility to demonstrate to those who use violence that violence does not pay.' It will be difficult for the Pope's plea for peace to move very deeply those who subscribe to such double talk—and our Government is among such subscribers. Mr Stewart's 'handbook for nations' will hardly help.

We must remember that this sort of thing is supported by a Government for which we voted and which promised in its election Manifesto things far different from these. It may be that the Government finds it easier than many laymen to accept the cynical opposition of fair words and savage cruelty since it has

apparently accepted and defended the opposition of its actions to its own promises of little more than a year ago.

When I compare the horrors of the Vietnam war with the election Manifesto of the Labour Government, I find myself confronted with the most shameful betrayal of modern times in this country. Hitler, at least, seldom professed humanity, but these men who now pollute the chairs of office professed, before election, the most noble and lofty ideals of human brotherhood.

The British Government has, it is true, made some apparent efforts to bring to an end the Vietnam war. It has refused to send troops to South Vietnam—but that, one suspects, was due to the fact that all the troops that we could spare were needed in Malaysia. Our Government, supported by the majority of the Commonwealth countries, has suggested terms of peace, but these always have been such as would leave American forces on the soil of Vietnam and were plainly and blatantly illusory.

Concurrently with these unreal efforts for peace, the British Government has iterated and reiterated, again and again, its support of United States policy in Vietnam. It has done everything in its power, moreover, to prevent a knowledge of the atrocities which are taking place there—let alone a knowledge of the reasons for the Government's complacence in face of them.

Representatives of the National Liberation Front applied for visas to be allowed to state their case in Britain. Visas were refused by the Home Secretary, supported by the Prime Minister, without explanation.

It will be remembered that at Oxford Mr Stewart stated the importance of all points of view being heard by the British public on Vietnam. It will also be remembered that the Labour Party Manifesto states that the Labour Government would welcome criticism and discussion with all in the Party.

When the visas—for which the Bertrand Russell Peace Foundation had applied on behalf of the three members of the National Liberation Front—had been refused, Field Marshal Auchinleck, Archbishop Roberts, The Bishop of Southwark, Lord Silkin (the Leader in the Lords), Kingsley Martin, and Professors from

several universities, joined twenty-five Members of Parliament in requesting the visas on the ground of free speech and the right of the British people to hear the spokesman on Foreign Affairs of the NLF. But the Home Secretary refused to receive a delegation of these people to discuss the matter as 'no useful purpose would be served'.

At the Labour Party Conference the Executive refused to allow the emergency resolution of Nottingham City Labour Party calling for the granting of visas to be put on the agenda. When the President of the Nottingham Labour Party tried to give a speech on the subject, the microphones were cut off by the Chairman.

And yet France has granted visas to them and they toured France. Sweden has officially invited them and Canada has granted them visas. Only Britain under the Labour Government refuses.

The Prime Minister, speaking at Blackpool, said that were the members of the NLF coming for the purpose of serious negotiation they would come to the Government. But since they were coming to speak to the British public, it was evident that they were coming for purposes of propaganda and that could not be permitted. One wonders why Mr Cabot Lodge was given a visa to come to speak at the teach-in at Oxford.

It is to be noted that visas which the CND tried to obtain for representatives of North Vietnam have also been refused.

The immediate situation is dark. The Labour Government has not only not carried out its electoral promises, but has reversed them. In carrying out Tory policies and in its subservience to America, it is helping to bring the world to complete disaster. One must hope that opposition to this policy will grow stronger before long. Especially, it must be hoped that the young, who have not shared in the atrocities of Hiroshima and Nagasaki or in the shameful dishonesty of so-called 'disarmament' conferences, will retain their indignation as they grow older and will, at last, prevail upon mankind to permit the creation of that happier world which was once the aspiration of the Labour Party.

For my part, I feel that I can no longer remain a member of this so-called 'Labour' Party, and I am resigning after 51 years.

It is time that a new movement leading to a new Party more nearly like the movement for which Keir Hardie struggled, be formed to carry out the aspirations of those who have hitherto upheld the present Party.[1]

[1] At the end of this speech I tore up my Labour Party membership card.

CHAPTER 8

Peace Through Resistance to US Imperialism
January, 1966

Throughout the world today increasing numbers of people con-
cerned with peace and with social justice are describing US
imperialism as the common destroyer of peace and justice. To
some, the expression 'US imperialism' appears as a cliche because
it is not part of their own experience. We in the West are the
beneficiaries of imperialism. The spoils of exploitation are the
means of our corruption. Because imperialism is not part of our
experience we do not recognize the aptness of the description for
the economic and political policies of what President Eisenhower
termed 'the military industrial complex'. Let us consider briefly
the nature of US power.

3,300 military bases and vast mobile fleets, bearing missiles and
nuclear bombers, are spread over our planet to protect the owner-
ship and control by US capitalism of sixty per cent of the world's
resources. Sixty per cent of the world's resources are owned by the
rulers of six per cent of the world's population. The aggressive-
ness of this empire imposes on mankind an expenditure of 140,000
million dollars annually or 16 million dollars each hour. The
current arms expenditure exceeds the entire national income of
all developing countries. It exceeds the world's annual exports of
all commodities. It exceeds the national income of Africa, Asia
and Latin America. The US military budget is nearly 60,000
million dollars per year. One Atlas missile costs thirty million
dollars, or the equivalent of the total investment for a nitrogen
fertilizer plant with capacity of 70,000 tons per annum.

Consider this in terms of the United Kingdom only, to take the
example of a prosperous country: one obsolete missile equals four

universities, one TSR 2 equals five modern hospitals, one ground-to-air missile equals 100,000 tractors.

During the past fourteen years the US spent 4,000 million dollars to purchase farm surpluses. Millions of tons of wheat, oats, barley, maize, butter and cheese have been stored and poisoned to keep prices up in the world markets. Blue dye is poured into great mountains of butter and cheese to render them unusable. By 1960, 125 million tons of bread grain had been stored in the United States to rot—enough food for every citizen of India for one year. Unimaginably vast quantities of foodstuffs are calculatedly destroyed by the rulers of US capitalism, for no other purpose than the continuation of their profits and the retention of their power. Like vultures the handful of the rich batten on the poor, the exploited, the oppressed. A drop of five per cent in the world price of staple exports of any country would, according to Dag Hammarskjold, wipe out all investments of the World Bank, of the United Nations and all bilateral and other investments.

These were the fears of Hammarskjold. What are the facts? In recent years prices have operated against poor countries not merely at five per cent but at forty per cent. The industrial production of Western capitalism is consciously employed not only to perpetuate the hunger which exists in the world, but to increase it vastly for profit.

In South Africa, 10,000 children die annually from gastro-enteritis. The smallpox which haunts many countries could be eliminated at a cost of 500,000 dollars. Hundreds of millions who suffer from yaws could be cured by a fivepenny shot of penicillin. Five hundred million people have trachoma. Sixty per cent of the children of Africa suffer from protein deficiency diseases such as kwashiokor, beri-beri or pellagra. When US capitalists hoard food and poison it they not only deprive the starving, but force the developing countries to buy food at high costs. The riches of the earth are destroyed, wasted, stolen by the few and used to murder the millions. 3,300 military bases are spread across the planet to prevent the peoples from destroying this evil system.

Let us examine the role of the war industry in the United

States. The United States Defence Department owns property valued in 1954 at 160 billion dollars.

This value has almost doubled. The US Defence Department is the world's largest organization. The Pentagon owns millions of acres of land, including thirty-two million in the United States and over three million acres of land outright in foreign countries. The Pentagon building is so large that the Capitol, which contains the United States Government, could be swallowed in any one of the five main segments of the Pentagon. The 1962 budget involved fifty-three billion dollars for arms, exclusive of the military space programme.

Thus, by 1962, sixty-three cents out of every dollar were spent on appropriations for arms and space. A further six cents were for army services, and more than eighty per cent of interest payments were for military debts. Seventy-seven cents out of every hundred are spent on past wars, the Cold War and preparations for future war. The billions of dollars placed in the pockets of the US military give the Pentagon economic power affecting every aspect of American life, and of the lives of mankind.

Military assets in the US are three times as great as the combined assets of the great monopolies, greater than the assets of US Steel, Metropolitan Life Insurance, American Telephone and Telegraph, General Motors and Standard Oil. The Defence Department employs three times the number of all these great world corporations.

This immense world concentration of power and wealth is directly linked to large scale capitalism in America. The billions of dollars in contracts are awarded by the Pentagon and filled by large industry.

In 1960, 21 billion dollars were spent on military goods. Ten capitalist corporations received 7½ billion dollars, three received one billion each and two others 900 million dollars. In these corporations there are more than 1,400 retired officers of the army above the rank of major. This includes 261 Generals and flag rank officers.[1]

[1] See the report of the Herbert Investigating Commitee of the House of Representatives in the US *Congressional Quarterly*.

The largest company, General Dynamics, has 187 retired officers, 27 generals and admirals and the former Secretary of the Army on its payroll. American policy and the military bases serve a vast power complex inter-connected and interested in the perpetuation of the arms race for its own sake. This concentration of power spreads throughout the economy of the United States. Sub-contracts awarded by war contractors involve every city of any size. The jobs at stake involve millions of people.

Four million people work for the US Defence Department alone. The payroll of twelve billion dollars is twice that of the US automobile industry. A further four million people are employed directly in arms industries. Thus eight million people depend for their jobs on the military adventures of the US rulers. Eight million jobs mean twenty-five million people in total.

Missile production accounts for eighty-two per cent of all manufacturing jobs in San Diego, California, seventy-two per cent in Wichita, Kansas. Military contracts alone account for thirty per cent of all manufacturing jobs in six States, including California. In Los Angeles nearly sixty per cent of jobs are directly or indirectly dependent on the arms race. Thus the United States as a whole devotes over fifty per cent of all its public expenditure to military spending.

This colossal investment is in exploiting and domination. Every food store and every petrol station in America requires, under capitalism, the perpetuation of war production.

This is the world system of imperialism. And the system also has a silent army: the Central Intelligence Agency. The CIA has a budget fifteen times the size of all diplomatic activity of the US. This vast agency purchases members of the army and police in countries all over the world. It draws up lists of popular leaders to be assassinated. It plots to start wars. It invades countries.

In Latin America, a band of reactionary generals, at the instigation of the Central Intelligence Agency and the US Ambassador in Brazil, Mr Lincoln Gordon, crushed the democratic government of Joao Goulart. In Argentina, American tanks smashed the civilian government of Arturo Frondisi, solely because this conservative spokesman for middle-class interests was insufficiently

subservient to US capitalism. Brutal military putsches have been imposed upon Ecuador, Bolivia, Guatemala and Honduras. For decades, the United States armed and supported one of the most barbaric and savage rulers in modern times, namely, Trujillo. When Trujillo no longer served their interests, they allowed him to suffer the fate of Ngo Dinh Diem, but the United States remained the enemy of the people of the Dominican Republic, as can be seen by the arrogant military intervention to crush the brave revolution of April, 1965.

The fact that this naked aggression is condoned by the United Nations, and the ability of the United States to escape expulsion from the United Nations for its gross violation of the Charter, demonstrates that the United Nations has become a tool of American aggression of the kind displayed in the Dominican Republic. All my sympathy lies with the struggle of the people of the Dominican Republic, which continues at this very moment.

In the Congo, mercenary troops, acting for Belgian and American interests and shamelessly supported by the British Government, have killed indiscriminately every living villager in the path of the advancing mercenary armies. The dregs of American militarism have been used for this purpose: the mercenary soldiery of South Africa and of the Cuban counter-revolution.

In the Middle East, United States' and European oil interests force poverty and tyranny on the people. British imperialism, relying on the military and financial power of the United States, is showering the people of Aden with napalm and high explosives in an attempt to suppress the popular movement.

In Southern Africa, incalculable riches are taken out of the Copper Belt of Rhodesia and of South Africa and the fascist states of Salazar and Verwoerd survive through NATO arms. In South-East Asia, 50,000 troops prop up the puppet state of Malaysia, and right-wing generals, with United States' money, have taken control of Indonesia. Throughout the South China seas, every patriotic and radical force is gaoled and persecuted by the imperialist powers. The United States boasts of its intrigues in the Maghreb. It brazenly publishes its plans to subvert all nationalist governments.

This is a predatory imperialism and nowhere has it been more cruel and reckless than in Vietnam. Chemicals and gas, bacteriological weapons and phosphorus, napalm and razor bombs, disembowelment, dismemberment, forced labour, concentration camps, beheadings, elaborate torture—every species of cruelty—have been employed by American imperialism in Vietnam. Clinics, sanatoria, hospitals, schools, villages have been relentlessly saturated with fire bombs: and still the people of Vietnam resist, after twenty-five years of struggle against three great industrial powers.

The people of Vietnam are heroic, and their struggle is epic: a stirring and permanent reminder of the incredible spirit of which men are capable when they are dedicated to a noble ideal. Let us salute the people of Vietnam.

In the course of history there have been many cruel and rapacious empires and systems of imperialist exploitation, but none before have had the power at the disposal of United States' imperialists. This constitutes a world system of oppression, and represents the true threat to peace and the true source of the danger of world nuclear war.

I have supported peaceful coexistence, out of the conviction that conflict in a nuclear age can only be disastrous. This conviction was based on the hope that the United States could be persuaded to come to an agreement with the socialist and communist countries. It is now painfully clear that US imperialism cannot be persuaded to end its aggression, its exploitation and its cruelty. In every part of the world the source of war and of suffering lies at the door of US imperialism. Wherever there is hunger, wherever there is exploitative tyranny, wherever people are tortured and the masses left to rot under the weight of disease and starvation, the force which holds down the people stems from Washington.

Peaceful coexistence, therefore, cannot be achieved by requesting US imperialism to behave better. Peace cannot be realized by placing hopes on the goodwill of those whose power depends on the continuation of such exploitation and on the ever-increasing scale of military production. The system which oppresses the people of the world is international, co-ordinated and powerful:

but it is hateful and oppressive and in various ways resisted by the people of the world.

A united and co-ordinated resistance to this exploitation and domination must be forged. The popular struggle of oppressed people will remove the resources from the control of US imperialism and, in so doing, strengthen the people of the United States itself, who are striving first to understand and second to overcome the cruel rulers who have usurped their revolution and their government. This, in my view, is the way to create a secure peace, rather than a tenuous and immoral acquiescence in US domination, which can neither work nor be tolerated by humane men.

If the Soviet Union, in its desire for peace, which is commendable, seeks to gain favour with the United States by minimizing, or even opposing, the struggle for national liberation and socialism, neither peace nor justice will be achieved. US imperialism has provided us with all the evidence to which we are entitled as to its nature and its practice. The peoples of the world bear witness to it.

War and oppression have a long history in human affairs. They cannot be overcome except through struggle. A world free of exploitation and foreign domination, a world of wellbeing for the masses of people of all continents, a world of peace and of fraternity, has to be fought for. This is the lesson US imperialism teaches us. It is not a palatable lesson, but nothing will be accomplished by ignoring it.

The danger of nuclear war will not be averted through fear of United States' power. On the contrary, the more isolated the wielders of power in the United States become, in the face of world rejection of their values and resistance to their acts, the more likely we are to succeed in avoiding a nuclear holocaust. It is the illusion on the part of US imperialism that it can accomplish an aim and defeat people by the use of such weapons that constitutes today the main source of nuclear danger. But when the people of Peru, Guatemala, Venezuela, Columbia, Vietnam, Thailand, the Congo, the Cameroons, the United States, Britain —all the people—demonstrate and struggle and resist, nuclear power is of no avail. Its possession will destroy its user. Let us join together to resist US imperialism.

CHAPTER 9

The Only Honourable Policy
April 27, 1966

The United States must be compelled to get out of Vietnam immediately and without conditions. There are at least four important reasons why such a policy must be enforced. First, the United States is committing war crimes in Vietnam. These have been documented so frequently by Western observers that they need no further cataloguing here. Suffice it to say that repeated newspaper reports of chemical and gas warfare, concentration camps and indiscriminate destruction of civilians, torture and atrocities are so commonplace that we are in danger of over-looking their essential character: these are war crimes perpetrated in our names, on our behalf, with our money and our acquiescence.

Secondly, the United States has no right to be in Vietnam. The 'Government' in Saigon which, we are told, invited US troops is no more legal than it is representative. The ambitious Vietnamese generals who nominally rule a fraction of South Vietnam on behalf of the United States are nothing more than the linear descendants of the former French puppet 'ruler'. The United States has simply continued the French policy of selecting a safe nominee and imposing him on as much of the country as it can subdue by force of arms and foreign money.

Thirdly, Washington's talk of 'halting aggression' is shameless Orwellian doublethink. The United States wrecked the Geneva Agreements, prevented free elections and the promised reunification with North Vietnam, took South Vietnam into its sphere of control, pretended that the seventeenth parallel was a national boundary and North Vietnam a foreign country and repeatedly

failed to produce evidence for its allegations of massive Communist infiltration from the North. Only quite recently, after the South Vietnamese were being slaughtered at the rate of well over 1,000 a week, was there any evidence of substantial military support for the National Liberation Front from the North. And this, of course, is not 'foreign invasion'. It is support for their fellow countrymen who have been artificially and illegally separated from them by a Power from thousands of miles away. It is the United States that is guilty of foreign aggression.

Fourthly, if the Vietnamese are to lose, even partially, their independence, the United States will be encouraged to think that aggression pays and to act accordingly in three continents. I oppose United States aggression today as firmly as I opposed Nazi aggression in 1939—and for the same reason: appeasement of those who commit war crimes and blatant aggression does not pay. It serves only to increase their appetite for aggression. They must be isolated.

It is indeed instructive to recall the Nazi era if we are to understand what is happening in Vietnam today. The National Liberation Front of South Vietnam and the North Vietnamese Government, we are told by Washington, are not interested in negotiating a conclusion to the war. Therefore, the argument continues, responsibility for the war rests with them. Their belligerence, says the US Government, has two possible causes. The first is the 'false assumption' that victory is at hand. Of this they must be 'disabused'—by every means the United States finds necessary. The second 'cause' is that behind the Vietnamese lurks China, which desires the defeat of the United States and which could be asked to provide military assistance for its neighbour.

At first sight, one must admit, this interpretation contains the minimum number of half-truths necessary for a public already browbeaten with the myths of the Cold War. It can not, however, stand up to inspection. How would citizens of the United States respond if, say, China had an army of occupation seeking to dominate everywhere south of San Francisco, Denver, St Louis and Washington, and was systematically destroying everywhere to the north by aerial bombardment? How would Americans then

respond to Chinese invitations to 'negotiate' a reasonable conclu-
sion to such a war? It is at this point worth recalling the response
which Hitler encountered in his reckless pursuit of empire. In
1940 Britain's survival as a nation was at stake. In asking the
House of Commons for a vote of confidence in his new Admini-
stration, Churchill used language which, shorn of its rhetoric,
could be that of Ho Chi Minh today:

'I have nothing to offer but blood, toil, tears and sweat.... You
ask, What is our policy? I will say: it is to wage war, by sea, land
and air, with all our might and with all the strength that God can
give us: to wage war against a monstrous tyranny, never sur-
passed in the dark, lamentable catalogue of human crime. That is
our policy. You ask, What is our aim? I can answer in one word:
Victory—victory at all costs, victory in spite of all terror; victory,
however long and hard the road may be; for without victory there
is no survival. Let that be realized: no survival.... I feel sure that
our cause will not be suffered to fail among men. At this time I
feel entitled to claim the aid of all....'[1]

A month later, as the danger to Britain increased, Churchill
went further in calling publicly for the support of a foreign
Power:

'... we shall defend our Island, whatever the cost may be. We
shall fight on the beaches, we shall fight on the landing-grounds,
we shall fight in the fields and in the streets, we shall fight in the
hills, we shall never surrender; and even if, which I do not for a
moment believe, this Island or a large part of it were subjugated
and starving, then our Empire ... would carry on the struggle,
until, in God's good time, the New World, with all its power and
might, steps forth to the rescue and the liberation of the Old.'[2]

When we are the imperialist power, wars of liberation are at
best placed in inverted commas, or more usually termed Com-
munist aggression. In 1940 nobody in the West questioned the
determination of Britain to be free, or its right to call for foreign

[1] May 13, 1940. The motion was carried unanimously.
[2] House of Commons, June 4.

assistance, or called Britain pig-headed for standing alone. Churchill's first message, on becoming Prime Minister, to President Roosevelt, stated categorically:

'We expect to be attacked here ourselves, both from the air and by parachute and airborne troops, in the near future, and are getting ready for them. If necessary, we shall continue the war alone, and we are not afraid of that.'[1]

One of the more absurd statements of Lyndon Johnson when he was vice-president, which history will certainly record against him, was to describe Diem as the Churchill of Vietnam. There is no doubt that the real national hero there is Ho Chi Minh, who led the successful expulsion of the French colonialists and has refused to surrender to the United States. If Ho Chi Minh today sounds like the Churchill of 1940, the following statement also has a familiar ring:

'In this hour I feel it to be my duty before my own conscience to appeal once more to reason and common sense (among the enemy) as much as elsewhere. I consider myself in a position to make this appeal, since I am not a vanquished foe begging favours, but the victor, speaking in the name of reason. I can see no reason why this war need go on. I am grieved to think of the sacrifices it must claim. . . . Possibly (the enemy) will brush aside this statement of mine by saying it is merely born of fear and doubt of final victory. In that case I shall have relieved my conscience in regard to the things to come.'

This is not President Johnson addressing Hanoi. It is Hitler in the Reichstag, after the Nazis had overrun France, making what he called his 'Peace Offer' to Britain.[2] This gesture was followed by great Nazi diplomatic activity, but nobody was fooled. Three days later, in a broadcast, the British Foreign Secretary brushed aside Hitler's 'summons to capitulate to his will' and announced that 'we shall not stop fighting until freedom is secure'. Churchill's own comment is instructive:

[1] May 15, 1940.
[2] July 19, 1940.

'Naturally Hitler would be very glad, after having subjugated Europe to his will, to bring the war to an end by procuring British acceptance of what he had done. It was in fact an offer not of peace but of readiness to accept the surrender by Britain of all she had entered the war to maintain.'[1]

In reply to the King of Sweden's enquiry, the British Government formally rejected Hitler's 'offer' by cataloguing Nazi war crimes against bordering states, especially Belgium and Holland, 'in spite of all the assurances given to them by the German Government that their neutrality would be respected.' These 'horrible events', including vast massacres, darkened the pages of history with an 'indelible stain'. The British Government's intention to prosecute the war 'by every means in their power until Hitlerism is finally broken' had been so strengthened that 'they would rather all perish in the common ruin than fail or falter in their duty'.

Here the analogy ends, for the peace terms of Churchill and Ho Chi Minh are very different. Churchill demanded of the Nazis 'unconditional surrender', and was not satisfied until, following the saturation bombing of open German cities, the enemy capital was finally occupied. Ho Chi Minh, however, demands nothing more than that the Americans go away. The Vietnamese are not threatening a single American city; they plan no subjugation of the USA. If Britain's response in 1940 was reasonable, how much more so is that of Vietnam today. If we are to have one standard for the West and another for the Vietnamese, we deserve every accusation of racism.

Does all this mean that we are not to seek an end to the war in Vietnam? Must the slaughter continue? The Vietnamese know that President Johnson's suggestion of 'negotiations' is as unacceptable as was Hitler's to Britain. They have every right to their own country, to which the United States has none. If the Vietnamese were to suffer US invasion and destruction of their country, and then sit down and 'negotiate' with the invaders how much of it America should retain or control, then aggression would be legalized and encouraged. The Vietnamese have already

[1] *The Second World War*, Vol. III, Chapter 13.

tried negotiations at the conference table in 1946 and again in 1954. First the French and then the Americans took advantage of their desire for peace by utterly ignoring the terms of the agreements. A long-suffering and heroic people will this time, I earnestly hope, gain their independence. It is the duty of all in the West who value justice to help reduce the price they have to pay. I appeal to Americans, who have never in their lifetimes known a foreign army of occupation on their soil, and never suffered the systematic destruction of their country from the air, to try to understand imaginatively what is happening in Vietnam. The Government of the United States has fallen into the hands of war criminals who must be halted whilst there is yet time. World opinion can still help bring the only honourable solution: the United States must be compelled to get out of Vietnam immediately and without conditions.

CHAPTER 10

Broadcast on National Liberation Front radio
to American Soldiers
May 24, 1966

This is Bertrand Russell speaking to you on the radio of the forces of the National Liberation Front of South Vietnam. I am speaking to you American soldiers in order to explain how your Government has abused your rights in sending you to occupy a country whose people are united in their hatred of the United States as a foreign aggressor. It is not difficult to understand why it is that the Vietnamese hate Americans. The people of Vietnam have been fighting for twenty-five years to secure their independence. They first fought against the Japanese, who were very cruel, and later against the French, who had set up guillotines in villages throughout Vietnam and who beheaded those suspected of being opposed to foreign occupation. Not many of you may know that the United States Government financed more than eighty per cent of the cost of the French war and supplied France with all modern weapons, in order to assist France in her evil task of killing and subduing the people of Vietnam.

When the United States first began to intervene militarily in South Vietnam, the pretence was made that the United States was merely helping a Government in Saigon put down subversion from outside. But you American soldiers have seen for yourselves what kind of governments have existed in Saigon. They are brutal, corrupt, dictatorial and completely despised by the people. Why is it that these governments have been able to continue, one after another, in Saigon, despite the fact that the students, the women, the villagers, everyone risks life itself to overthrow them? The sole answer is that the United States is using its enormous

military force to impose on the people of Vietnam puppet governments which do not represent them.

Let us now consider together why the US Government does this. The excuse that they are protecting the Vietnamese against the 'Vietcong' or the North Vietnamese can be seen by all of you to be the disgusting lie it is. Vietnam is one country. Even the Geneva Agreements acknowledge that it is one country. The North Vietnamese and the South Vietnamese are not merely the same people, but the wives and children of men living in the North are in the South and many of those who live in the South were born in the North.

You may not know that between 1954 and 1960 more Vietnamese died than since 1960. Think hard about that. The 'Vietcong' had not taken up arms until 1960, and yet more Vietnamese died in the six years before that time than since the National Liberation Front began to struggle. The reason is simple. The Government of Ngo Dinh Diem killed, tortured, imprisoned and mutilated hundreds of thousands of Vietnamese and was able to do this solely because of the military support and direction of the United States. Can any of you forget the brutality of Ngo Dinh Diem, which moved Buddhist priests to burn themselves in protest?

It ought to be clear that the National Liberation Front, which you know as the Vietcong, took up arms to defend their people against a tyranny more brutal than the Japanese occupation itself, for more died under Diem than under the Japanese. This is the responsibility of the United States Government.

The reason why you American soldiers are in Vietnam is to suppress the people of Vietnam, who are trying to free themselves from economic strangulation and foreign military rule. You are sent to protect the riches of a few men in the United States.

Do you know that the United States controls sixty per cent of the resources of the world, but has only six per cent of the world's population, and yet one out of three Americans live in poverty? Do you know that the United States has over 3,300 military bases in the world, almost all of which are used against the population of the country in which the bases exist? The US rulers have built

an economic empire which is being resisted from the Dominican Republic to the Congo, and especially in Vietnam.

Could you imagine yourselves voting for Cao Ky? If a foreign power occupied the United States to steal American resources for itself and if a traitor government were established by force, would you feel it was your government? Worse than this, because the Vietnamese people are so determined and show such fantastic heroism that the greatest military power on earth has found it impossible to conquer them, you American soldiers are trained to use every modern weapon of war.

Your Air Force is flying 650 sorties a week in the North and the tonnages used in the South are higher than those used during the Second World War or the Korean War. You are using napalm, which burns everything it touches. You are using phosphorus, which eats like an acid into those who are in its path. You are using fragmentation bombs and 'lazy dogs', which cut up in pieces and lacerate women and children in the villages hit without discrimination. You are using poison chemicals which cause blindness, affect the nervous system and paralyse. You are using poison gases which are listed in army manuals of World War II as poisons, and other gases which are so deadly that even soldiers with gas masks have been killed by their own gas.

When you return from battle, ask yourselves who are these people you are killing? How many women and children died at your hands today? What would you feel if these things were happening in the United States to your wives, parents and children? How can you bear the thought of what is taking place around you, day after day and week after week? I ask these questions of you because you bear the responsibility and within your hands lies the choice of whether this criminal war is to continue.

When Britain occupied North America in the eighteenth century, American farmers fought with pitchforks in their bare hands, although they were hungry and in rags. They fought for eight years and they defeated the British Empire in their own country. Do you know that in the United States today, 66 million people are living in poverty? Do you know that in the United

States today the unemployed equal the population of thirty-five individual states?

You are being used to enrich the few industrialists whose profits depend on taking the natural resources from other countries, and this is why the world is rising against this brutal war waged by the United States Government. You know that the Geneva Convention outlaws gas, chemicals, torture and mutilation and you also know that American special forces are trained in techniques used at Auschwitz and the other concentration camps.

Master-Sergeant Don Duncan has revealed the truth about the films showing Nazi tortures which were used for instruction of American servicemen. And you yourselves know from your daily experience what happens to villagers who are suspected of being 'Vietcong' and who are captured. You know also that the strategic hamlets are little more than concentration camps, where forced labour, torture and starvation occur. These things were the reason for the hatred the world had for the Nazis. These things led to the trials at Nuremberg, in which the Nazi leaders were hanged as war criminals. I know that most of you came to Vietnam not because you wished to but because you were sent. I know that most of you have been told that you were defending helpless people against a stronger neighbour. But you have been lied to and no one knows it better than yourselves.

You must not think that you are alone, for throughout the United States people are opposing this war. When 100 thousand people meet in New York City alone, and tens of thousands meet in other cities across the United States, it should be clear that the American people have seen through this war and want it ended. Why else has the Government been unable even to make a declaration of war?

Have you been present when an officer has attached electrodes to the genitals of a woman or a child? Have you been one of those who, out of fear or nervousness, pulled the trigger on an automatic rifle, releasing so many hundreds of bullets in an instant that, before you knew what had happened, women and children lay dead before you?

Along with world famous figures, Nobel prizewinners, novelists, philosophers, mathematicians, I am forming a War Crimes Tribunal in order to pass judgment, in most solemn terms and with the most respected international figures, upon the crimes being committed by the United States Government against the people of Vietnam. I appeal to you to end your participation in this barbarous and criminal war of conquest. I appeal to you to inform the War Crimes Tribunal of the truth about this war and to place before it the evidence of your own eyes. I appeal to you 'as a human being to human beings. Remember your humanity and forget the rest. If you can do this, you will perform a courageous service to mankind. If you cannot, you will allow your rulers to continue to degrade your country and cause its name to be hated by decent people the world over.

Join us, Americans, Englishmen, West Europeans, Latin Americans, Asians, Africans, people from every walk of life, in our determination to defeat those in the United States responsible for the suffering and horror which you American soldiers have seen and for which you have responsibility. Refuse to fight any longer in this unjust war. Demand to be transferred anywhere but Vietnam. Make known that you will make public your opposition to this war and the way in which it is fought. There are too many people ready to support you for reprisals to take place. It is no use postponing your decision. The moment of trial is always. Now is the appointed time.

Speech to the National Conference of Solidarity
London, June 4, 1966

I welcome you to this National Conference of Solidarity, which has been convened solemnly to create a national movement in Britain of active support for the people of Vietnam. Where is there a parallel for the heroism with which the Vietnamese have struggled to be free from foreign occupation and every species of brutality? When, since the reign of Nazism, have such barbarous tortures been applied to helpless people? It should never be forgotten by us that more Vietnamese died during Diem's reign, from 1954 to 1960, than in the post-1960 period, when the people of Vietnam took up arms under the leadership of the National Liberation Front. Nor can it be forgotten that the Vietnamese have known the horror of foreign occupation since the last century and have been struggling against it virtually since the Japanese occupation of 1940. The Japanese, the French and the Americans have attempted to subdue this people. They have all failed. But neither the Japanese nor the French equalled the United States in barbarism.

The United States today is a force for suffering, reaction and counter-revolution the world over. Wherever people are hungry and exploited, wherever they are oppressed and humiliated, the agency of this evil exists with the support and approval of the United States. Whether it is Mobutu of the Congo or Blanco of Brazil, whether it is Pak of South Korea, Thanom of Thailand, Ngo Dinh Diem or Cao Ky, the arms which kill the people bear an American stamp of origin.

When considering what horror has been perpetrated in Vietnam itself, it is more than I can bear than to describe it for

you. Eight million people were placed in concentration camps under forced labour. People have been subjected to experimental weapons such as poison gas which blinds them, paralyses them, asphixiates them and causes convulsions. Chemicals which affect the nervous system and mental balance have been used over wide areas. Napalm and phosphorus, which burn and burn until only a cinder remains, have been dropped on the most densely populated areas. Weapons of sheer evil, such as the Lazy Dog, have been used throughout the country. In one province of North Vietnam alone—Thanh Hoa—100 million slivers of steel were rained on the population during the last year. 650 sorties per week, with vast tonnages exceeding those used in World War II and the Korean War, have taken place relentlessly, week after week, month after month.

And yet, despite all this, despite the fact that the United States is the most powerful military force the world has known, despite the fact that her Air Force is not challenged and her sea power is not hampered, despite the fact that the automatic weapons in the hands of her soldiers fire several hundred rounds of bullets per minute, despite the fact that the Vietnamese are an agrarian people with little industry, these people, like the Greeks at Salamis, have defeated a great and cruel colossus.

When I think back to 1940, during the Blitz, and recall the mood of Englishmen at that time, I know clearly and without hesitation what our responsibility is to the Vietnamese. Do you remember our feelings when the Nazis were bombing our cities. Do you recall the determination which swept Britain, never to surrender and never to accept a Nazi occupation of our country. Did we suffer gas and chemicals at that time? Was our country cut in half? Were our people in concentration camps? Was our countryside razed with gas, chemicals, jelly-gasoline and fragmentation bombs? No, none of this occurred. And yet Churchill spoke for all of us when he declared that we would fight on the beaches, but we would never surrender.

The purpose of this Conference is to declare our fervent hope for the victory of the people of Vietnam, total, unequivocal and swift. The purpose of this Conference is to build a movement in

Britain worthy of the heroism of the people of Vietnam themselves; a movement which will not equivocate or pander to the economic power of the United States. We wish to build a movement capable of exposing the sordid squalor of our Prime Minister's subservience and greed.

We wish to create a movement which will evolve concrete forms of action, such as a War Crimes Tribunal, which will call before it victims and witnesses of the great panoply of horror which is the war of aggression waged by America in Vietnam.

Our movement will be broadly based. It will seek its support amongst the working people of this country, from the trade unions, from the teachers, from the students and from all those who see in the struggle of the people of Vietnam that decency and dedication which calls forth the best responses in human beings. For let us have no doubt that we do the Vietnamese no favour by declaring our solidarity. Their struggle against economic domination is a guide to the road we ourselves must travel.

Britian has been made into a bully's lackey, and a brutal and heartless bully at that. If, today, we are not hungry because the peoples of Africa, Asia and Latin America die daily to keep us fed, we are degraded and corrupted by that unworthy plenty. Squalor serving plenty has always defiled the beneficiaries of misery, from the days of Egyptian slavery and from the times of early Christianity to our own.

So it is that the struggle in Vietnam is a struggle for human decency and our very own emancipation. The people of Vietnam will not be in our debt. They deserve no pity. They display heroism, not passivity, and they are overcoming and not turning to private disillusion and despair.

No one who enjoys a high standard of living in the West, which is inexorably derived from brutality and exploitation, has the right to ask people who struggle against our exploitation to abandon that struggle on terms we lay down. This is why it is unseemly for peace movements and movements of the Left to ask the Vietnamese to treat with Johnson, while he continues his criminal aggression against them. There can be no peace of any value or of any duration which is a slaves' peace, nor can we

obtain peace of mind by requesting the hungry and oppressed to die in silence. They will not listen to such pathetic advice. They must not. Nor must we give it.

Our Campaign for Solidarity, our War Crimes Tribunal, our films, our books, our meetings and our material help must have one aim: the victory of the Vietnamese over their tormentors. And I express the wish that this victory may herald similar victories of the oppressed everywhere until the day when our own people reclaim their government and transform it into an instrument of good.

SPEECH TO NATIONAL CONGRESS IN SOLIDARITY 115

obtain peace of mind by requesting the country and oppressed to die in silence. They will listen to no partisan advice. They cannot and, Nor must we give it.

Our Congress must act to safeguard the peace. It must demand our people's own peace. Our greatest gift at this special hour must have none save the victory of the Vietnamese over their tormentors. And I express the wish that this victory may herald similar victories of the oppressed world-wide until the day when our own people rebuild their government and transform it into an instrument of good.

CHAPTER 12

Appeal to the American Conscience
June 18, 1966

I appeal to you, citizens of America, as a person concerned with liberty and social justice. Many of you will feel that your country has served these ideals and, indeed, the United States possesses a revolutionary tradition which, in its origins, was true to the struggle for human liberty and for social equality. It is this tradition which has been traduced by the few who rule the United States today. Many of you may not be fully aware of the extent to which your country is controlled by industrialists who depend for their power partly upon great economic holdings in all parts of the world. The United States today controls over sixty per cent of the world's natural resources, although it contains only six per cent of the world's population. The minerals and produce of vast areas of the planet are possessed by a handful of men. I ask you to consider the words of your own leaders, who sometimes reveal the exploitation they have practised. The *New York Times* of February 12, 1950 said:

'Indo-China is a prize worth a large gamble. In the North are exportable tin, tungsten, manganese, coal, lumber and rice; rubber, tea, pepper and hides. Even before World War II Indo-China yielded dividends estimated at 300 million dollars per year.'

One year later, an adviser to the United States State Department said the following:

'We have only partially exploited South-East Asia's resources. Nevertheless, South-East Asia supplied ninety per cent of the world's crude rubber, sixty per cent of its tin and eighty per cent

of its copra and coconut oil. It has sizeable quantities of sugar, tea, coffee, tobacco, sisal, fruits, spices, natural resins and gums, petroleum, iron ore and bauxite.'

And in 1953, while the French were still in Vietnam fighting with American backing, President Eisenhower stated:

'Now let us assume we lost Indo-China. If Indo-China goes, the tin and tungsten we so greatly value would cease coming. We are after the cheapest way to prevent the occurrence of something terrible—the loss of our ability to get what we want from the riches of the Indo-Chinese territory and from South-East Asia.'

This makes clear that the war in Vietnam is a war like that waged by the Germans in Eastern Europe. It is a war designed to protect the continued control over the wealth of the region by American capitalists. When we consider that the fantastic sums of money spent on armament are awarded in contracts to the industries on whose boards of directors sit the generals who demand the weapons, we can see that the military and large industry have formed an interlocking alliance for their own profit.

The truth is that the Vietnamese popular resistance is just like the American revolutionary resistance to the British, who controlled the economic and political life of the American colonies in the eighteenth century. Vietnamese resistance is like the resistance of the French Maquis, the Yugoslav partisans and the guerrillas of Norway and Denmark to the Nazi occupation. That is why a small peasant people is able to hold down a vast army of the most powerful industrial nation on earth.

I appeal to you to consider what has been done to the people of Vietnam by the United States' Government. Can you, in your hearts, justify the use of poison chemicals and gas, the saturation bombing of the entire country with jelly-gasoline and phosphorus? Although the American Press lies about this, the documentary evidence concerning the nature of these gases and chemicals is overwhelming. They are poisonous and they are fatal. Napalm and phosphorus burn until the victim is reduced to a

bubbling mass. The United States has also used weapons like the 'lazy dog', which is a bomb containing ten thousand slivers of razor-sharp steel. These razor darts slice to ribbons the villagers upon whom these weapons of sheer evil are constantly used. In one province of North Vietnam, the most densely populated, one hundred million slivers of razor-sharp steel have fallen in a period of thirteen months.

It is even more revealing and terrible that more Vietnamese died during the reign of Diem, from 1954 to 1960, than since 1960, when the Vietnamese partisans took up armed resistance to the American occupation in the South. What the papers have called the 'Vietcong' is, in fact, a broad alliance, like the popular fronts of Europe, including all political views ranging from Catholics to Communists. The National Liberation Front has the most ardent support of the people and only the wilfully blind will fail to see this.

Do you know that eight million Vietnamese were placed in internment camps under conditions of forced labour, with barbed wire and armed patrols? Do you know that this was done on the direction of the United States Government and that torture and brutal murder were a continuous feature of life in these camps? Are you aware that the gases and chemicals which have been used for five years in Vietnam blind, paralyse, asphixiate, cause convulsions and result in unbearable death?

Try to imagine what it would mean if an enemy were bombing the United States and occupied it for twelve years. How would you feel if a foreign power had saturated New York, Chicago, Los Angeles, St Louis, San Francisco and Miami with jelly-gasoline, phosphorus and lazy dogs? What would you do if an occupying army used these toxic gases and chemicals in every town and hamlet they entered? Can you really think that the American people would welcome so savage an aggressor? The fact is that everywhere in the world people have come to see the men who control the United States Government as brutal bullies, acting in their own economic interests and exterminating any people foolhardy enough to struggle against this naked exploitation and aggression.

When the United States began its war against the Vietnamese, after having paid for nearly all of the French war against the same people, the US Defence Department owned property valued at 160 billion dollars. This value has since doubled. The US Defence Department is the world's largest organization, owning thirty-two million acres in the United States and millions more in foreign countries. By now, more than seventy-five cents out of every hundred are spent on present wars and preparation for future war. Billions of dollars are placed in the pockets of the US military, thereby giving the Pentagon economic power affecting every facet of American life. Military assets in the United States are three times as great as the combined assets of US Steel, Metropolitan Life Insurance, American Telephone and Telegraph, General Motors and Standard Oil. The Defence Department employs three times the number of people working in all these great world corporations. The billions of dollars in military contracts are provided by the Pentagon and fulfilled by large industry. By 1960, 21 billion dollars were spent on military goods. Of this colossal sum, $7\frac{1}{2}$ billion were divided amongst ten corporations and five corporations received nearly one billion dollars each. I ask you to consider carefully that in the executive offices of these corporations there are more than 1,400 retired army officers, including 261 generals and officers of flag rank. General Dynamics has 187 retired officers, 27 generals and admirals and the former Secretary of the Army on its payroll. This is a ruling caste, which stays in power no matter who is elected to nominal public office, and every President finds himself obliged to serve the interests of this all-powerful group. Thus, American democracy has been emptied of life and meaning because the people cannot remove the real men who rule them.

It is this concentration of power which makes it necessary for the Pentagon and big industry to continue the arms race for its own sake. The sub-contracts they award to smaller industries and war contractors involve every American city and, thus, affect the jobs of millions of people. Four million work for the Defence Department. Its payroll is twelve billion dollars, twice that of the US automobile industry. A further four million work directly in

arms industries. In many cities military production accounts for as much as eighty per cent of all manufacturing jobs. Over fifty per cent of the gross national product of the United States is devoted to military spending. This vast military system covers the world with over 3,000 military bases, for the simple purpose of protecting the same empire which was described so clearly in the statements of President Eisenhower, the State Department adviser and the *New York Times* which I mentioned earlier to you. From Vietnam to the Dominican Republic, from the Middle East to the Congo, the economic interests of a few big corporations linked to the arms industry and the military itself determine what happens to American lives. It is on their orders that the United States invades and oppresses starving and helpless people.

Yet, despite the immense wealth of the United States, despite the fact that with only six per cent of the world's people, approaching two-thirds of the world's resources are in its possession, despite the control over the world's oil, cobalt, tungsten, iron ore, rubber and other vital resources, despite the vast billions of profits that are gained by a few American corporations at the cost of mass starvation amongst the peoples of the world, despite all this, sixty-six million Americans live at poverty level. The cities of America are covered in slums. The poor carry the burden of taxation and the fighting of colonial and aggressive wars. I am asking all of you to make an intellectual connection between events which occur daily around you, to try to see clearly the system which has taken control of the United States and perverted its institutional life into a grotesque arsenal for a world empire. It is the vast military machine, the great industrial combines and their intelligence agencies which are regarded by the people of three whole continents as their main enemy in life and the source of their misery and hunger. If we examine the governments which depend for their existence upon American military force, we shall always find regimes which support the rich, the landlords and the big capitalists. This is true in Brazil, in Peru, in Venezuela, in Thailand, in South Korea, in Japan. It is true the world over.

The result of this is that in order to suppress a national revolution, such as the great historic uprising of the Vietnamese people, the United States is obliged to behave as the Japanese behaved in South-East Asia and the Nazis behaved in Eastern Europe. This is literally true. The concentration camps to which I have referred, and which held nearly sixty per cent of the rural population of South Vietnam, were scenes of torture, massacre and mass burial. The special experimental weapons, like the gas and chemicals and jelly-gasoline, are as horrible as anything used by the Nazis during the Second World War. It is true that the Nazis systematically exterminated the Jews and the United States has not yet done anything comparable in Vietnam. With the exception of the extermination of the Jews, however, everything that the Germans did in Eastern Europe has been repeated by the United States in Vietnam on a scale which is larger and with an efficiency which is more terrible and more complete.

In violation of solemn international agreements signed by American Presidents and ratified by the American Congress, this Johnson Government has committed war crimes, crimes against humanity and crimes against the peace. It has committed these crimes because the Johnson Government exists to preserve the economic exploitation and the military domination of subject peoples by US industrial magnates and their military arm. The Central Intelligence Agency, which has a budget fifteen times larger than all the diplomatic activity of the United States, is involved in the assassination of heads of state, and plots against independent governments. This sinister activity is designed to destroy the leadership and the organization of peoples who are struggling to free themselves from the stranglehold of American economic and political domination. United States' militarism is inseparable from that same predatory capitalism which reduced the American people themselves to poverty within the living memory of this generation. The same essential motives have led to barbarous and atrocious crimes on a great scale in Vietnam.

I have called on intellectuals and eminent independent men and women from all parts of the world to join in an international War Crimes Tribunal which will hear evidence concerning the

crimes of the US Government in Vietnam. You will remember that Germans were considered guilty if they acquiesced in and accepted the crimes of their government. Nobody considered it a sufficient excuse for Germans to say that they knew about the gas chambers and the concentration camps, the torture and the mutilation, but were unable to stop it. I appeal to you as a human being to human beings. Remember your humanity and your own self-respect. The war against the people of Vietnam is barbaric. It is an aggressive war of conquest.

During the American War of Independence, no one had to tell Americans the purpose of their struggle or conscript them against their will. Nor was it necessary for American soldiers to go ten thousand miles to another country. In the American revolutionary war against foreign troops Americans fought in fields and forests although they were in rags and the occupying army was the strongest of the day. Americans fought the occupier, although they were hungry and poor, and they fought them house by house. In that war of liberation, the American revolutionaries were called terrorists and the colonial power was the one labelling them rebels and rabble. American national heroes responded with words such as Nathan Hale's and Patrick Henry's. The sentiment, 'Give me liberty or give me death', inspired their struggle, just as it inspires the Vietnamese resistance to United States' aggression and occupation.

The Nathan Hales and Patrick Henrys of Vietnam are not the United States army. Those who display heroism, love of country and that deep belief in freedom and justice which inspired the American people in 1776 are today the people of Vietnam, fighting under the revolutionary leadership of their National Liberation Front. And so the American people are to be used as cannon-fodder by those who exploit not only the Vietnamese but the people of the United States themselves. It is Americans who have been killing Vietnamese, attacking villages, occupying cities, using gas and chemicals, bombing their schools and hospitals—all this to protect the profits of American capitalism. The men who conscript the soldiers are the same men who sign the military contracts in their own benefit. They are the same men

who send American soldiers to Vietnam as company cops, protecting stolen property.

So it is that the real struggle for freedom and democracy is inside the United States itself, against the usurpers of American society. I have no doubt that the American people would respond just as the Vietnamese have responded if the United States were invaded and subjected to the atrocities and tortures which the United States army and Government have inflicted on the Vietnamese. The American protest movement, which has inspired people all over the world, is the only true spokesman for American concern for individual liberty and social justice. The battle-front for freedom is in Washington, in the struggle against the war criminals—Johnson, Rusk and McNamara—who have degraded the United States and its citizens. Indeed, they have stolen the United States from its people and made the name of a great country stink in the nostrils of people the world over. This is the harsh truth, and it is a truth which is affecting the daily lives of Americans irrevocably and increasingly. There is no looking the other way. There is no pretending that the war crimes are not occurring, that the gas and chemicals do not exist, that the torture and napalm have not been used, that the Vietnamese have not been slaughtered by American soldiers and American bombs. There is no dignity without the courage to examine this evil and oppose it. There is no solution for the American crisis short of the emancipation of the American people themselves from these barbarous men who speak in their name and defile a great people by doing so. The American people, however, are becoming alert and are showing the same determination and courage which the Vietnamese have so movingly displayed. The Negro struggle in Harlem, Watts and the American South, the resistance of the American students, the increasing distaste for this war shown by the American people at large, give hope to all mankind that the day when greedy and brutal men can deceive and abuse the American nation is drawing to a close.

My appeal to Americans is made with full awareness that the rulers of the United States have spared no device in propaganda to hide from the American people the ugly face of their rulers

and the truth about their behaviour. Abraham Lincoln gave expression to the hope that a people, once aroused, can be deceived no longer. All Americans who know from their own experience and from that of their closest relatives what has been done in Vietnam should come forward now. Speak the truth and take your stand alongside your brothers throughout the world. Struggle for an America free of murderous production, free of war criminals, free of exploitation and free of the hatred of subject peoples. These peoples look to the ordinary people of the United States to understand their plight and to answer their struggle with an American resistance capable of making the United States again a citadel of individual liberty and social justice. The international War Crimes Tribunal is itself an appeal to the conscience of the American people, our allies in a common cause.

The War Crimes Tribunal is under urgent preparation now. I am approaching eminent jurists, literary figures and men of public affairs in Africa, Asia, Latin America and the United States itself. Vietnamese victims of this war will give evidence. Full scientific data concerning the chemicals used, their properties and their effects will be documented. Eye-witnesses will describe what they have seen and scientists will be invited to examine the exhibits in the possession of the Tribunal. The proceedings will be tape-recorded and the full evidence will be published. There will be documentary film material concerning the witnesses and their evidence. We aim to provide the most exhaustive portrayal of what has happened to the people of Vietnam. We intend that the peoples of the world shall be aroused as never before, the better to prevent the repetition of this tragedy elsewhere. Just as in the case of Spain, Vietnam is a barbarous rehearsal. It is our intention that neither the bona fides nor the authenticity of this Tribunal will be susceptible to challenge from those who have so much to hide. President Johnson, Dean Rusk, Robert Mc-Namara, Henry Cabot Lodge, General Westmoreland and their fellow criminals will be brought before a wider justice than they recognize and a more profound condemnation than they are equipped to understand.

POSTSCRIPT
The International War Crimes Tribunal

This book went to press in the autumn of 1966, as I was preparing the international War Crimes Tribunal mentioned in it. At the Nuremburg war crimes trials, Chief Prosecutor Justice Jackson of the United States Supreme Court declared:

'If certain acts and violations of treaties are crimes, they are crimes whether the United States does them or whether Germany does them. We are not prepared to lay down a rule of criminal conduct against others which we would not be willing to have invoked against us.'

There was, however, a moral ambivalence rooted in the nature of the Nuremburg trials and in the role of Justice Jackson. Nuremburg was a trial conducted by the victorious party over the defeated. Nuremburg was carried by a real-politik alliance of powers and yet, through the legalisms of *force majeure*, crept the voice of humanity, a voice crying out against the unconscionable criminality of the Nazi terror.

I have called for an international War Crimes Tribunal to be held in 1967 because, once again, crimes of great magnitude have been taking place. Our tribunal, it must be noted, commands no State power. It rests on no victorious army. It claims no other than a moral authority.

Over a period of years, an industrial colossus has attacked a small peasant nation. The Vietnamese revolution is part of an historical development through which exploited and hungry peoples are establishing their claim to the basic necessities of human life. The United States has shown itself determined to overwhelm with brute force this struggle for life. We have, on American authority, the fact that three million pounds of bombs have been falling daily on North Vietnam, involving an average

of 650 sorties per week and tonnages in excess of those used during World War II and the Korean war. Beyond this, the armies of the United States have been using experimental weapons such as chemicals, gas, napalm, phosphorous, 'lazy dog' fragmentation weapons and bacteriological devices.

Who, in the West, is unaware of these facts, as they have been presented on film, on television and almost daily in our newspapers? Who among us has not seen the photographs, or read the statistics? Who among us can deny the David-and-Goliath character of this incredible Vietnamese struggle for national autonomy and social transformation?

It is this awareness which provides the proper background to my call for a War Crimes Tribunal. I do not maintain that those who have been invited to serve as members of the Tribunal are without opinions about the war. On the contrary, it is precisely because of their passionate conviction that terrible crimes have been occurring that they feel the moral obligation to form themselves into a Tribunal of conscience, for the purpose of assessing exhaustively and definitively the actions of the United States in Vietnam. I have not confused an open mind with an empty one. I have not believed that to be just one must be without conviction. The authority of the Tribunal and its reputation for fairness follows from the character of its membership and the correctness of its procedures.

The Tribunal was convened in London on November 13, 1966, and was expected to announce its structure, statement of aims and time-table. It was anticipated that commissions would be appointed by the Tribunal to prepare evidence in roughly five areas:

1. the crime of aggression, involving violation of international treaties.
2. the use of experimental weapons, such as gas and chemicals.
3. the bombing of hospitals, sanatoria, schools, dykes and other civilian areas.
4. the torture and mutilation of prisoners.
5. the pursuit of genocidal policies, such as forced labour

camps, mass burials and other techniques of extermination in the South.

The Tribunal members will function as a commission of enquiry, and the commissions under its direction will prepare the evidence, subjecting documentary data to thorough and verifiable scrutiny. Defence witnesses can not be compelled to appear, but the US Government and President Johnson have been formally requested to provide representation for their policies before the Tribunal.

The prima facie evidence of crimes sufficient to warrant the calling of such a Tribunal involves the assumption that the crimes of the apparent aggressor are unique, and that no equation can be made between the oppression of the aggressor and the resistance of the victim. Only those who can not distinguish the rising of the Warsaw Ghetto from the violence of the Gestapo, or the struggle for survival of the partisans of Yugoslavia, the resistance of Norway, the underground in Denmark and the Maquis in France from the invading Nazi armies could fail to recognize the merit of examining the actions of the United States in a manner morally and qualitatively different from the actions of the Vietnamese resistance.

The hearings are planned to last approximately twelve weeks and to take place in Paris from March, 1967. The secretariat of the Bertrand Russell Peace Foundation has been established in Paris at 58 bis rue de la Chaussée d'Antin, Paris IX. A team of very eminent French lawyers has been preparing a plan of procedure for the attention of the Tribunal. Preparatory sessions will be heard in London. Documentary film will be taken from the testimony of the witnesses, the proceedings of the Tribunal and the evidence. Tape recordings will be made of the hearings and pressed into gramophone records for wide distribution. All data, testimony and evidence will be published.

Those who have accepted my invitation to join the Tribunal, at the time of writing, are:

Gunther Anders, German writer and philosopher. He left Germany as a refugee from the Nazi regime in 1933, and now lives in Vienna. His book, *Burning Conscience*, has made known

the story of Claude Etherly, one of the pilots involved in the bombing of Hiroshima.

Mehmet Ali Aybar, Turkish intellectual and Member of Parliament for Istanbul. He is president of the Turkish Workers' Party and a former professor of International Law at Istanbul University. In 1948 and 1949 he was convicted of the crime of public criticism of the President and Government of Turkey.

Lelio Basso, Italian lawyer and parliamentarian. He has been a Deputy in the Italian Parliament since 1946 and a member of the Commission on Foreign Affairs. A former general secretary of the Italian Socialist Party, he is now chairman of the Proletarian Socialist Unity Party. He is Professor of Sociology at Rome University, editor of the *International Socialist Journal*, an expert in international law and a lawyer at the Court of Milan.

Mme Simone de Beauvoir, French social historian and novelist. She is the authoress of *The Mandarins* (which received the Prix Goncourt), *The Second Sex* and other widely-acclaimed works.

Stokely Carmichael, American Negro leader. He is the chairman of the Student Non-violent Co-ordinating Committee (SNCC).

Lazaro Cardenas, former President of Mexico. He was Commander-in-Chief and a general of the Mexican army and was awarded the State Peace Prize in 1955.

Lawrence Daly, British trade union leader. He is general secretary of the Scottish National Union of Mineworkers and a writer and lecturer on trade union affairs. He has also spoken widely in Britain on the war in Vietnam.

Vladimir Dedijer, Yugoslav writer. A former professor of Modern History at the University of Belgrade, he has also held university posts at Manchester, Oxford, Harvard and Cornell. He is a Doctor of Jurisprudence and was Yugoslav delegate to the UN General Assembly, 1945-52. During the Nazi occupation he was a Lieutenant-Colonel in the Partisan army. He was wounded three times, awarded the Order of Liberation of Yugoslavia and published his *Partisan Diary*.

David Dellinger, American writer. A leader of the US anti-war movement, he is editor of *Liberation* magazine (New York) and

chief organiser of the Fifth Avenue Peace Parade Committee.

Isaac Deutscher, Polish-born political historian and essayist. He is the biographer of Trotsky and Stalin and a leading Marxist theorist. Since 1939 he has lived in Britain and has established himself as a prolific writer on Soviet affairs.

Amado V. Hernandez, Philippino poet laureate and labour leader. As President of the Philippine Congress of Labour Organisations, he was sentenced in 1951 to life imprisonment. After six years he was released and totally vindicated in 1964 by the unanimous decision of the Supreme Court. He is chairman of the Philippine Democratic Labour Party and co-founder of the Philippines Newspaper Guild. He has received the Republic Cultural Heritage Award and the Manila Cultural Award for Literature.

Mahmud Ali Kasuri, Pakistani lawyer and politician. A barrister at law and Senior Advocate of the Supreme Court of Pakistan, he is also general secretary of the West Pakistan National Awami Party, the leading opposition party in Pakistan.

Floyd McKissick, American civil rights leader. He is the secretary general of the Congress of Racial Equality (CORE).

Kinju Morikawa, Japanese civil liberties leader. He is an attorney at law and vice-chairman of the Japan Civil Liberties Union. He is also secretary-general of the Japanese committee for the investigation of US war crimes in Vietnam and was president of the investigating committee into the Tonkin Bay incident (August 1964).

Shoichi Sakata, Japanese scientist. He is a Professor of Physics and a leading member of the Japan Civil Liberties Union.

Jean-Paul Sartre, French writer and philosopher. In addition to his philosophical writings, he is a notable literary critic, playwright and novelist. He was offered, but declined, the Nobel Prize for Literature. He is founder-director in Paris of *Les Temps Modernes*. During the Nazi occupation he was active in the resistance movement.

Laurent Schwartz, French mathematician. He is Professor of Mathematics at the University of Paris and has received the Fields Medal of the International Congress of Mathematicians

and the Grand Prix de Mathematiques of the Paris Academy of Sciences. He is also a member of the French National Vietnam Committee and of the central committee of the League of the Rights of Man.

The Tribunal received from the beginning very considerable public support, not least from very many citizens of the United States. National committees of support were soon established in Britain, France, Scandinavia, the United States and Japan. This support included mass meetings, an international signature campaign, the preparation of evidence, the creation of photographic exhibitions, the distribution of literature and the donation of substantial sums of money to help meet the vast expenses incurred.

If readers of this book would like to assist in any of these ways, or in the distribution of reports after the Tribunal, I should be grateful if they would write to the Bertrand Russell Peace Foundation, 3 & 4 Shavers Place, Haymarket, London, S.W.1.

APPENDIX

Report from North Vietnam
(by Ralph Schoenman, April 11, 1966)

Over many years, Bertrand Russell has sought to alert people in the West to the nature of the war waged by the United States in Vietnam. He has established international committees of support for the people of Vietnam and is, at the moment, preparing a War Crimes Tribunal in which eminent people have been asked to participate. One American among many who have taken up resistance to the war in Vietnam is David Mitchell, who is on trial for his refusal to participate in the US Army in Vietnam. Mitchell is neither a pacifist nor a conscientious objector. His contention is that the United States is guilty of crimes against peace and crimes against humanity, in the precise sense laid down at Nuremburg, and he cites as evidence the Geneva Convention, the Geneva Accords of 1954, the Kellogg-Briand Treaty, the London Agreements of Nuremburg and the United Nations Charter. Nearly all of these agreements were formally ratified by the United States Senate and signed by American Presidents. As such, they are fully binding within the terms of the American Constitution upon all officials of the US Government and upon citizens of the United States. Thus, says Mitchell, the use by the United States of poison gas, poison chemicals, napalm, experimental fragmentation bombs, nerve gases and the vast bombardment of hospitals, schools, tuberculosis sanatoria and leprosaria are not merely in violation of legally binding treaties, but are war crimes for which Germans were hanged. Indeed, ordinary citizens of Germany who failed to refuse orders by the government of the day were executed at Nuremburg for complicity in crimes against humanity and crimes against the peace. American Supreme Court Justice Robert Jackson stated at Nuremburg that

the justification for the War Crimes Tribunal lay in the fact that it mattered not whether the perpetrators of war crimes were Germans or Americans. He stated that if the day should come when the United States Government were guilty of such crimes, it would be the duty of its citizens both to refuse to carry them out and to oppose those who issued such orders. David Mitchell is on trial for insisting that that day has arrived.

Bertrand Russell sent me to Vietnam to gather first-hand evidence concerning such war crimes, evidence which was to be used not only in defence of David Mitchell, but in the international War Crimes Tribunal which Lord Russell was in the process of establishing. I arrived in Hanoi on February 21, 1966, and travelled in five provinces under heavy bombardment. South of Thanh Hoa, in Ha Tay, Nam Ha, Ninh Binh and the surrounds of Hanoi I saw the result of 650 sorties per week, bombs of 1,000 pounds, napalm, phosphorous and a fiendish weapon known as the 'lazy dog'.

Seven o'clock on the morning after my arrival in Hanoi, I was received by Prime Minister Pham Van Dong and President Ho Chi Minh. Ho Chi Minh moves with agility and dresses in simple baggy trousers, a long, open shirt and open sandals. His manner is direct, and his humour immediate. The warmth and the comradeship which were shown me moved me. I retained the terrible feeling that I was an American, moving amongst the victims of the crimes of my Government and obliging them to repeat for me their everyday experience, so I might write it down. Although an American citizen, I have lived in England for eight years. I return frequently to the United States, and went there immediately after my trip to North Vietnam to give evidence in the trial of David Mitchell in Hartford, Connecticut.

Ho Chi Minh and Pham Van Dong know the West well, our culture and our history. Ho Chi Minh is familiar with the streets of London, Paris, and New York. They are lifelong revolutionary leaders, internationalists, literally men of the world. Both recall clearly and personally the Nazi invasion of Europe. They discussed the requests made to them so frequently by westerners to accept negotiations with the United States. How, they had been asked,

could they expect the war to end unless there were negotiations? The Vietnamese leaders are reminded of England in 1940, when the Luftwaffe was bombing London, Coventry, Bristol, Manchester, and Glasgow. To the English, this was their finest hour, because, after a few months of bombing of a few cities the expectation on the part of others that the great power of Germany would intimidate the British was not fulfilled. The English were proud, and indignant at the thought that they would yield. What is it that makes such resistance and such sentiments permissible for Englishmen after a few months of bombing, but impermissible for an agrarian people withstanding the invasion and atrocity of the United States of America? The people and leaders of Vietnam view this very simply: racism. I feel it passionately since my return to the West: the racism of imperialism, which is in the air we breathe, the same racism displayed by Johnson when he said, 'Unless the United States has unchallengeable air power, we shall be hostage to every yellow dwarf with a pocket knife.'

Just as a peace mission from Mussolini would have been absurd to any Englishman in 1940, and just as negotiations with Hitler while the bombs fell on London and Coventry would have been treated as an insult to the self-respect and intelligence of every Englishman, so to the Vietnamese the suggestion that they must negotiate with the United States, while American troops are in occupation of their country, is but another expression of Western arrogance and racism. It does not matter whether the Communist Party USA, the Soviet Union or President Johnson request them to betray their struggle, the response will be much the same. They have negotiated once in 1954 when they abandoned half of their country, having liberated it, for the sake of international considerations which proved to be illusory-considerations which led to twelve years of horror. When Ho Chi Minh says: 'We will go on another five, ten, fifteen or twenty years, if necessary,' he is not indulging in rhetoric. The Vietnamese resistance will not be ended. The Vietnamese war will be ended when the resistance within America has made it impossible for it to go on.

We travelled by night, a team of eight, including doctors and

photographers. We were without light and we stopped often during alerts. The road was pitted, though passable, and the extraordinarily beautiful countryside showed the effects of un-relenting bombardment. The radio carried the poems continually recited by Vietnamese in a living oral tradition, applying recitative to the experience of recent days: the poetry of Vietnam and its people.

In village after village I listened to the accounts of the survivors and surveyed the results of napalm. One afternoon, rummaging in the rubble of a school, I picked out stained pages from the lesson book of a twelve-year-old Vietnamese child:

Page 2: *The Little Korean Child*—
 a poem composed by a Vietnamese poet at the time
 of the Korean War:
 'Where is your mother?
 There is nobody around to ask.
 Everywhere there are but fire and smoke.'

Page 9: *Memories*
 'I am losing my father. I am losing my mother.'
 (Excerpts from the story of a young girl).

Page 15: The last days of Huang Van Thu (executed by the
 French in the early forties).

Page 1: Our hands can do everything.

Page 5: *Land Reclamation Song*.

Page 24: How he faced the firing squad.

Page 19: Grammar: subordinate clauses, auxiliary verbs.

Page 10: Human efforts can turn arid soil into rice.

On this village and school were dropped thousand-pound bombs and lazy dogs. At another part of the village I picked up a lazy dog bomb. This was Van Dinh hamlet, Van Hon Village, Thieu Hon district, February 26, 1966. A 'lazy dog' is a grenade-like bomb containing 250 slivers of razor-sharp steel. There are forty such bombs in a cylinder: 10,000 pieces of steel in a sudden storm of hail, lacerating anyone exposed or seeking shelter from the half-ton bombs. The 'lazy dog' has been dropped continuously on the most heavily populated areas of North Vietnam. 10,000

cylinders of lazy dog bombs have fallen on Thanh Hoa province since April, 1965. 1,281 rockets have been used. 37 guided missiles have been launched against villages in Thanh Hoa province. 3,000 bombs alone were dropped on Ham Rong bridge which still stands. Roads, means of communication, schools, hospitals, the tuberculosis clinic, sanatoria and old age rest houses have been bombed in Thanh Hoa province. I visited all. I picked a 'lazy dog' out of the ruins of a school where it had fallen after the thousand-pound bombs had made great craters, destroying the shelters and exposing the inhabitants.

'Usually, my friends go to school every day. We like to sing "Ha Tinh Quang Binh". My friends are Nhung, Ky, Chau, Nguyen. They are thirteen, twelve, fourteen, twelve. They are all girls. I have a friend who is a boy, named Liem. He was thirteen. My friend Ky liked to play. She would say: "You go first. You go quickly, or I will step on your heel." '
(Rhymes in Vietnamese).

'When the bombs fell I saw Ky's bowel and intestine come out of her body. Her head blew away. Her arm and leg blew away. Nhung was buried alive and was dug out dead. Chau's teeth were broken by stones which shattered them. Nguyen was buried alive. Liem was beheaded. My friend Phuong laughs sometimes; cries; speaks without knowing what she says; she screams; she is twelve. I was buried completely. Teacher Minh dug me out. I have pains in my spine. Canh and Khoa had their chests crushed.

'When I become a grown-up I would like to be a teacher. I would like to ask you, uncle, to convey my best wishes of good health to my American small friends.'

Nguyen Thai Mao was recently twelve. She has been strafed frequently on the way to school. She spoke of a bombing attack on her village on February 9 of this year. Her teacher, a young man of twenty-four named Thai Van Nham stated:

'Fragments of clothing, books and furniture flew so high that all in the vicinity knew the school was bombed. Students were blasted. Many were buried in the earth. I was among those

buried alive. I was dug out later and was brought to conscious-
ness. There was nothing left but a bomb crater, fifty-five feet
wide and twenty-one feet deep. Everything was levelled. Parts
of the children were protruding from the earth. We found their
heads twenty yards away. Their bowels and intestines were
scattered everywhere. Two of my children were spattered on a
palm tree and hung from it. Children were pressed to the trench
walls. Blood filled the trenches. Children clutched their books
tightly to their chests. The books were smeared in blood and
ink. Some of them could speak a little when dug out. Then blood
shot from their mouths, due to their crushed organs and they
died. One little girl, Hoang Thai Nha, twelve, could only be
recognized and identified by her rubber shoes. Six of the children
were too mutilated to be recognizable to the parents. One dug
out became conscious and asked how many of her friends died
before haemorrhaging. Little Hung's body was found on top of
unfinished poems he had written, along with a notebook of
paintings. He had aspired to be a poet, painter and composer.
His poems, paintings and songs are all signed: "Composer,
Dinh Hung". He was thirteen.'

The bombing of Huong Phuc school on February 9 is one
event: a daily event for the past fourteen months in Vietnam. For
Vietnam, 650 sorties per week with tonnages in excess of those
used during the Second World War, with napalm and fragmenta-
tion bombs, the targets and the victims are the population at
large. There are no other targets. The population knows that the
United States wishes to impose so ghastly a price in national
suffering that the will to resist will be broken.

The will to resist is like ozone after a bombing storm in Viet-
nam. In every village, production teams work round the clock to
increase food output. Militia units, under the command of
nineteen-year-old girls, mount the most exposed positions to
fire at diving jets with rifles and what amount to little more than
muskets. Old machine guns are mounted on the very bridges
subject to attack. The militia do not take shelter. When American
planes are at the climax of their dive, bullets fly from thousands

of rifles and machine guns and the whole population is in arms. Everyone who can hold a rifle is firing one.

The old-age and invalid home in Thanh Hoa was levelled. It is a scene of vast craters, filled with water, and the shells of buildings. Mosaics litter the ground—lovely pieces of the floor and walls in soft water-colour design. Out of one crater I picked the tattered pages of books which had once been part of the old-age home library. Here, those Vietnamese who had lived through three generations of struggle against the Japanese, the French and the Americans had retired in the ill health of old age to rest. Many of them were feeble through years of brutal labour before the victory of Dien Bien Phu released them from their feudalism. Even in their old age, the fruits of their struggle were denied them and, like the children of the schools, their soft bodies were smashed and splattered. One very famous hero of the resistance to France, recuperating from severe wounds, went insane in this final attack.

The destruction of Than Hoa tuberculosis sanatorium is a study in horror. On Sunday, February 27, the Director gave the following account:

'This is the second most important sanatorium in our country. It was set up by our own efforts. We had no help from abroad. We cherish it all the more because of this. The third floor of the tuberculosis sanatorium had very large Red Cross flags hanging outside. There are large Red Cross crosses on the entrance, clear to any aircraft. At 8.00 a.m., four groups of four aircraft came. Among the sixteen were five F105D jets. The rest were F101 and F102. The planes circled several times and attacked. They dived at the clinic. Five F105D jets dived together. Each dive released ten bombs per plane, totalling fifty. The others dropped two each, totalling twenty-two. Many patients were got to the trenches with difficulty. After the first attack, they circled, and each plane dived repeatedly, strafing everything standing with rockets. There was thirty minutes of uninterrupted bombing, with 1,000 ton bombs, accompanied by rocket strafing of all who ran out of the buildings. Five doctors were hit and killed instantly. Two of

them were women. Physicians and specialists and nurses were killed. Fifty-eight patients were killed almost immediately by strafing. One of the gravely ill tuberculosis victims was a famous Vietnamese resistance hero, who went insane as a result of the bombings. All through the bombing, the shrapnel fragments, lazy dogs and the rockets, doctors and personnel carried patients to trenches. Patients and the sick carried others, while vomiting blood and haemorrhaging. It was only this heroism which kept casualties down.

'If we had been dependent upon only the ability of doctors and nurses to rescue patients, the number of deaths would have been infinitely higher. Some of the patients, though weak and ill, tried to save medical equipment: X-ray machines, medicines, implements, files. Throughout these efforts they were strafed. In the surrounding area, people whose own houses were bombed and burning abandoned them, and also the shelters, to help rescue patients and equipment of the clinic.

'After the first bombing, the personnel tried to evacuate surviving patients from the ruins. Five days later, the survivors were removed to new hospitals and sanatoria. A few days later, two jets came again and bombed the ruins of the sanatorium. They strafed everywhere in the vicinity. They bombed and strafed the clinic and all buildings of the sanatorium for thirty minutes. Two planes were F105 jets. Each dropped ten half-ton bombs at a time. Other planes came and fired rockets. Two planes dispersed and returned again to fire rockets. There were three total bombings and strafings. Thus, of the sanatorium and clinic, nothing is left.'

As the doctor spoke, I moved amidst the rubble, the great craters, the twisted ruins of X-ray machines and the broken glass of medicines and photo-electric lamps. Occasionally, there were bloodstains. It was difficult to imagine the vast sanatorium, with its many operating rooms and quarters for patients. The Director continued:

'All of our people understand now that the sanatorium was a clearly intended target of the attack. There was no error. We were

hit in three separate and prolonged waves from diving planes.
This was a hospital. There were large Red Cross flags flying. Our
patients and doctors were strafed, seeking shelter. We realize
that the enemy will do anything. The US maintains that the
treatment of tuberculosis and leprosy is one of our most urgent
and difficult tasks, so they destroy. It is entirely in keeping with
their bacteriological warfare. The bombing of our sanatorium
has affected us profoundly. Every effort has been made by the
population to assist in the lodging and treatment of the surviving
patients.

'They talk about civilization. It is unimaginable. Our hatred is
great. The more we confront this bombing of our leprosaria,
hospitals, clinics, sanatoria, schools and villages, the more we
struggle.'

The K71 tuberculosis sanatorium covered $2\frac{1}{2}$ hectares. There
were thirty large buildings and 560 resident patients. There were
425 visiting patients per week and 350 doctors and nurses.

The equipment destroyed included X-ray machines, steriliza-
tion equipment, refrigeration facilities, circulatory and respiratory
machines, oxygen equipment, distilling and purification equip-
ment, electronic machinery, modern operation rooms and
facilities, antibiotics and drugs. I inspected the remnants and
ruins of the following stores of drugs: INH (produced in Vietnam);
Streptomycin; Rimifon; Subtilis; Filatov; vitamin compounds;
vitamin oils; cod liver oil; sulphur; iodine and various medicines
and serums. Medical supplies for the surrounding population were
destroyed. Tonics, food supplements, enriching additives for
special regimens and diets were all lost in the bombing. Plasma,
the blood bank, ambulances, first aid units, the medical library,
monographs and notebooks of doctors, microscopes, bacterial
cultures, all operating equipment and chambers, tables, elec-
tronic devices, lamps and infra-red equipment were all devastated.
This was not an isolated event. Wherever I went I saw comparable
destruction.

I returned to Hanoi, after some time, and met with Dr Nguyen,
a young man who had recently arrived in North Vietnam from

liberated areas of the South. The doctor had been blinded by poison chemicals and was under treatment. He was planning to return to the South. I spoke to him from 8.00 in the morning until 11.30 at night. He described to me the nature of the chemicals, their properties, their medical peculiarities, the villages where they had been used and the curious effects they had on human beings. He gave me parts of his medical diary, dating back to 1961:

'I am a victim blinded by toxic chemicals. I have recovered part of the vision of one eye. I have treated countless victims of chemicals. I married after 1954, but the terror of the Saigon Government forced me to leave. Had I stayed, I should have been conscripted by force into the puppet army. Since that time I have devoted myself entirely to the treatment of victims of torture and of chemical and gas warfare. My family is in the same situation as so many others in South Vietnam. The Government forced my wife to divorce me and to marry an officer in the puppet army. I had no children, thank God. I was born in Binh Dinh province. My father was a doctor of herbal medicine. I am 36.

'Because of the vast bombing and terror of the US, I had to keep moving in the jungle and in the mountainous area of South Vietnam. I have always been on the move and have been in other provinces in the South. The general situation was impossible to imagine. The atrocities by US officers and soldiers have never ceased. The crimes of the US army have resulted in vast numbers of cases, in indescribable suffering, which I have encountered daily for almost twelve years. I have cared personally for the victims of US governmental crimes and for the victims of Saigon puppet soldiers, almost all of whom have acted with American advisers or officers present. I know this from my first hand experience. The victims, when surviving, are invalids for life. The most common diseases are those of the nervous system and digestive tract. After this, tuberculosis ensues, induced by the general condition of the victim. I must say to you that the policy I have observed is one of extermination of our people, of exter-

mination and of experimentation. They have used various kinds of poisons which I have analysed. The poisons are chemicals, gases, bombs of phosphorus and napalm bombs. I understand that the US authorities state that these chemicals are intended to clear trees and grass. The truth is that these chemicals combine heavy toxic concentrations, which affect fatally both human and animal life. Among the chemicals I have encountered and analysed are:

1. DNP (Dinitrophenol)
2. DNOC (Dinitricorto)
3. 2;4D (Acid Diclophenocyncetic)
4. 2;4;5T (Acid 2, 4, 5 Triclophenocyacetic).

'These chemicals have been sprayed by various means. Usually, they are employed in a powdered form, or spread as a liquid over vast areas by aeroplane. Areas sprayed are ten or fifteen square miles. These toxic chemicals poison water, food, vegetation and animal and human life. The poisoning of the water and vegetation spreads the chemicals in larger areas. Toxic chemicals are also mixed with rice, which is then sold or distributed to the people. I encountered this in 1962, throughout the provinces of Kon Tum and Gia Lai. These poisons have also been mixed in sugar, which was distributed to people. I examined victims of this and analysed the poisoned sugar in Long My village and in Kan Tho province in 1964. Chemicals have been put into the wells and the springs supplying water in Tra Bong, Ba To and Son Ha districts of Quang Ngai province. In these three districts, there have been 450 buffaloes killed, and I have personally examined 41 people killed, who died as a result of drinking this poisoned water. They died in great pain. I examined eleven children who were critically ill as a result of having swum in a stream which had been poisoned in this way. Three of these children were blinded. This chemical warfare has been carried out continuously. I have been in all provinces and have encountered it everywhere I have been. I have studied and treated its effects everywhere I have gone in the South, since 1961.

'Since June, 1964, I have encountered frequently the following two poison gases:

1. C6H5—CO—CH2—CL (Chloroacetophnemon)
2. C6H5—CU—BR—CH (Bromborzylcyanure).

'Since 1965, these chemicals and poison gases have been employed on a vastly increased scale. The gases I have encountered have been used in different forms. Some have been contained in hand grenades, others in bombs and in bottle-containers. In certain dosage, the Americans have designated these as "tear gases", but this is very misleading, for in any degree of concentration these gases cause perforation of the lungs, asphixiation and beri-beri. They are fatal in any confined area and kill through lack of oxygen, as well. A fatal dosage of the so-called "tear gas" is 0.3 milligrammes per cubic metre—a small dose.

'In the beginning of November, 1964, four skyraiders bombed and strafed the area where I lived in Lam Dong province. Raids and bombing lasted about two hours. Then came one helicopter and two Dakotas. The smell of the chemical was unbearable. It was very sharp and burned the nostrils. It had characteristics of chloroform. After five minutes, leaves of sweet potatoes, rice plants and trees became completely desiccated. Domestic animals would not eat and almost all died. People in the area experienced very severe headache. They then displayed a racking cough. They vomited on the spot.

'I was operating on a bombing victim at the time and had no chance to cover myself with a nylon cloth. I was heavily affected. My first impression was one of suffocation and asphixiation. I felt great, burning heat on my eyes. The suffocation was extreme and I vomited violently, excreting considerable blood.

'Only fifteen minutes later the Dakota planes returned and sprayed chemicals a second time. By now, my nose was infected, and I had no sensation. I could not smell, nor taste anything. But I observed the leaves, which had a shiny coat, like the shimmering of a film of petrol. I was less acute in observing and noting the effects of the second chemical, because I had suffered the first

chemical attack very shortly before the second one. I now experienced however, great cold and even more severe headache. Others around me had the same symptoms.

'When they spray chemicals, our people run to try to save their crops. They try to save the tubercles of the manioc from rotting. The people cut off the leaves and stems of the trees. To prevent us from saving our crops, the attacking US planes used time bombs of chemicals and napalm, which burned everything and completely destroyed the crops.

'No one was able to eat that day, because of the effects. Everyone (including myself) was unable to sleep. The effects on the nervous system were very unusual. I had the sensation of flying in the air. I could not feel my weight. I felt hot, sharp burning in my eyes, which was extremely painful. It was as if my eyes were filled with acid, or chilli pepper. The next day, all our poultry were dead. The fish in streams and lakes were floating on the surface of the water, discoloured. The buffaloes were dead. The grass was poisoned. All crops were without leaves and burned and the unburned vegetation was rotting.

'All the women who were pregnant and all pregnant animals had miscarried on the spot. I felt the symptoms of the first day increase—all of them. I could no longer see clearly. I continued to vomit blood, which weakened me and was painful. Everyone was ailing gravely. Ten days later, a squadron of US aircraft came and spread chemicals a third time, destroying all the crops which the ailing people had planted with great difficulty. This spraying was accompanied by bombing and strafing. I saw nineteen people killed and 600 gravely injured. Three were blinded by the chemicals. My eyes were so affected that my sight was gone. I have remained blind until only very recently, when part of the sight in my left eye returned. All the crops were completely destroyed and burned out. The people were driven to eat contaminated roots and fruit, for they were starving.

'People were unable to work or do anything, for weeks and months. I was unable to move. I vomited all the time. My throat, mouth, stomach and bowels were inflamed. Fifteen days later, I could not read. One month later, I could no longer see. In three

months I could eat only soup. During that entire three months, I was unable to sleep. The effect on my nervous system made it impossible to gain unconsciousness. Throughout the time that I was awake, I had headaches which lasted day and night. My eyes had been burned. I had recurring sensations of flying in the air. My hair fell out.

'After three months, my weight had fallen to 107 pounds. There was great famine. The people had food for the first time three months later, when the sweet potatoes they had planted after the third attack began to sprout tubercles. Many of those plants were infected.

'The care which has been given me by my people has enabled me to begin a recovery. My right eye is permanently blinded and you can observe the crystalline, which is pitted with small holes. I am a physician and I know my right eye is beyond cure. My nervous system is so affected that I can sleep only rarely. My ability to operate has gone, but I shall return, nonetheless, to treat people as best I can.

'As I mentioned, many people were completely blinded and have no hope of cure. After I had moved out of that area, to try to treat other victims, I learned that again the planes came and sprayed new chemicals. Whenever they see green on the soil, they come to kill the crops, to cut off the source of life of the people and to cause famine and epidemic, in addition to the painful disease and death resulting from the chemicals.

'Every time they spray chemicals, they threaten us with loud-speakers, broadcasting from the aeroplanes, telling people to go to areas controlled by Saigon, or they will suffer death. Our people cling to the land, no matter how it is affected. The people of other areas have come to assist them to survive. It is also true that national capitalists have come with rice, which they sell us at exorbitant prices. This is hard. When survivors regain strength, they clear forests in order to have unaffected land. We have organized watches for aircraft.

'I have treated victims now since 1961. Most of the time our people are left to their own cure, for there are not enough medical officers to treat them. After long periods of struggle, our people

have devised masks which they have made to give them some protection, but as the chemicals affect the food and water, it is almost impossible to escape their effects. Our people are victims in their villages and fields continuously and indiscriminately.

'I have always thought that scientific achievement should aim at serving the wellbeing of people and to help their lives. The US rulers are using scientific knowledge to torment and massacre our people. They are doing this throughout South Vietnam. This is the behaviour of the so-called most civilized nation in the free world. This is what is being done to my country. I want to tell you that I personally am moved and deeply impressed by the protests of American intellectuals and students. These protests have made a profound impression on my people. I hope you will convey my sincere thanks. We feel that we are struggling, not for Vietnam alone, but for the people of the world. I hope I can welcome American intellectuals to an independent Vietnam. Please accept my warmest greetings and wishes for the longevity of Bertrand Russell. I wish his activity for mankind every success. I am grateful to you.

'Let me tell you this, as well. Even when our people are so ill, they establish anti-aircraft units to resist the planes. They are determined not to be intimidated or defeated, and that determination sustains them, through everything. I can tell you that these people are not "Vietcong". They are common people, who have escaped from strategic hamlets. All the chemicals I specified have been used in a compound mixture to gain multiple effect on both vegetation and animal life. As far as poison gas is concerned, this is carried in bottles and spread in shelters, where local women and children seek protection. I was present in Phu Lac during a US attack, in which the American troops used poison gas. I examined eighty people killed by the gas. Those affected by what the Americans call "tear gas" could only be saved if treated immediately. The other gases killed and were impossible to remedy. This tear gas is used against people in shelters and it removes oxygen, killing those inside. The effect is the same as that of the more deadly gases. The United States Government and Robert McNamara have declared that poison gas is a 'basic

K

weapon' of their forces in Vietnam, and so in every raid and in every district attacked they use poison gas; from planes, from helicopters and in ground raids. When they see green on the ground they spray toxic chemicals and gas. Thus it is that my life since 1961 has been one steady stream of encountering victims and treating them. Let me show you my medical diary. Some of my notes are in French:

"*3, 4, 5 March, 1965:*
Air spray of chemicals in Long Phung village, Binh Dai district, Ben Tre province. 30 people examined, dead. 200 critically ill. 90 per cent of domestic animals dead. All crops and vegetables destroyed. Famine and epidemic inevitable. Once again, nothing to be done.

"*23 March, 1965:*
Phanh Thoc village. Chemicals dropped in rubber balloons; beri-beri. Boi Loi region: napalm over a vast area, everything burned. Unextinguishable. Whole forest afire. Have to abandon all victims. No hope. Little boy, Ho Van Bot, burned all over, deep burns, napalm eating.
' "Phosphorus: victims of phosphorus rotting after exposure. No hope for Nguyen Van Ba".'

But the Vietnamese have endured more, for they have fought from the forests since 1940, and the Resistance was unable to enter the villages until the French were driven out. The population is locked together with that bond of profound self-esteem and mutual regard which a child of the West has never had, and cannot understand without encountering it. Their self-respect is based upon the dedication they see around them. All struggle, all sacrifice and what we understand by heroism comprise the minutiae of everyday existence.

On February 22 I met with Colonel Ha Van Lau in Hanoi. Among other things he spoke to me about new developments in the military struggle:

'Formerly, the US used puppets as their mainstay. Now they must add the expeditionary corps. Therefore, now a true full-scale

war operation of US aggression against Vietnam and the occupation of South Vietnam have made the South into a US neo-colony.

'The US has not succeeded in using "special war" to achieve its objective. At first they thought that "special war" could accomplish the end, but the defeat (by August, 1964) forced them against their will to use their own troops. They have suffered a complete political defeat. Now the use of US troops exposed to our people the true nature of the aggressive war and this spurs our resistance. This use of more troops by the US has made ALL in the South, even in the puppet administration and army, see the aggressive nature of US imperialism.

'The US rulers want to strengthen the morale of the puppets BUT the more they introduce US troops the more this morale falters. In 1964, apart from defeats, there were 80,000 desertions. By 1965, 100,000 desertions occurred, including over 40,000 regulars. These vast desertions took such proportions that many divisions can no longer fight for lack of men. So, by introducing more troops the US has, against its will, lost the initiative on the military field; and on the political level it exposes its true face to world opinion. At the same time the presence of US troops aggravates contradictions both between the US government and world opinion and also between the US government and its puppets.

'There are also such contradictions between the US government and its allies AND within the US government. This is the fundamental weakness of the policy of introducing more troops into Vietnam. The fighting morale of US troops must become lower and lower. As they meet harsh reality in the South and confront the lies of their own government these will become more and more clear to them. After one year of sending increased numbers of troops to Vietnam, the US government is further than ever from it aims. The Mansfield delegation report confirms this. It says, in effect, that the situation has not changed in a year. The US has lost real initiative. Militarily it has certain strong points, but due to internal contradictions in policy, arising from the intensification of the war and the introduction of more troops, the US cannot make the most of its strength. On the contrary. For example, the US is waging a war but hasn't proclaimed war. It dares not. So how

K*

can it win the support of its people? The US military strength is large, but its impact is enormously diminished by its very introduction into Vietnam.

'Secondly, while US troops and equipment are powerful, this power can not be applied to Vietnam. It is not the same as in Korea. Two hundred thousand troops at the 38th parallel could block it, but 200,000 to cover all South Vietnam are not remotely enough. So they must settle in strong points like Chu Loi and Da Nang. Then those points are encircled by our people like islands. When the US troops engage in "mopping up" operation they must fragment themselves. The First Cavalry Division must break up into company groups; but in Plei Mei each company parachuted separately into the jungle and was immediately decimated, group by group. So the US cannot make the best use of its manpower and artillery. It is limited both tactically and strategically. Even when planes and troop activity are co-ordinated, the men are bombed by their own planes. This is simply because there is no front. Every battle is interrelated and entangled. There are no distinct and separated fronts.

'Moreover, US equipment is very heavy and cumbersome. In jungle battles, its forces fragmented into small groups, the US is quite unable to use its equipment, which then becomes a burden and hindrance rather than an advantage. This makes more certain the troops' confusion and heavy losses. When they are defeated they flee in helicopters, abandoning this heavy equipment to the NLF who use it against US strongpoints. There it is effective! In short, US troops have been organized, educated and equipped for modern warfare. But South Vietnam is a peoples' war, a guerrilla war. Every contact with the National Liberation Front results in defeat. This can be demonstrated for battles throughout 1965.

'The contradiction between the concentration of troops and simultaneous dispersal of troops is basic. By now the NLF controls four-fifths of South Vietnam. If US troops want to occupy South Vietnam, they must disperse; but then *how* can they administer heavy blows to the NLF? This is the plague of all imperialist operations in Vietnam. Thus, with over 200,000

troops, Westmoreland appeals for more. And all US troops sent here are crack troops! On February 19, 1966, the NLF attacked Anh Khe. US sources revealed that only US troops were used in maintaining this base. All these crack troops have been sent here to be used as custodians. The first cavalry, the marines, the para-troops all serve only to occupy the strong points as guards! They can't trust the puppet troops to do this. So, militarily speaking, the US is not making good use of its crack troops. What use is this? The US cannot use its puppet troops at all any more. Even operations by US troops are no longer told to the puppet high command out of fear of leakage—this enormously heightens the conflicts between them. The contradiction between invading troops and the people, tactically and strategically, and between people and government, is very serious.

'Added to this is the great contradiction of their logistics! Warehouses, harbours, ships—all means of transport—are needed for the vast army, and the US press knows this. The US tries to solve this but cannot. If its best attempts to solve logistic pro-blems with 200,000 troops bring no results, how can the US solve it with even more troops? These problems are all the more intensified by the guerrillas' destruction of the means of com-munications. The US has to resort to airplanes even for internal transportation, even for drinking water and rice. And this is true not only for the needs of the army but for the needs of the civilian population in the occupied areas. Even Saigon suffers greatly from the lack of meat, vegetables, rice and other kinds of foodstuffs, as well as coal, in fact all supplies. All communications around Saigon have been cut. But the US troops use houses, electricity, cars, taxis and buy all the things they like, so the very people of Saigon now suffer directly from the presence of US troops in Saigon. The logistical problem is quite insoluble and will be made worse by the sending in of more troops. Recently, reports have appeared about the introduction of more troops—up to 300,000 or 400,000. Insofar as manpower is concerned, this may be possible, but logistically it will be VERY difficult. Even if the US solves the logistical problems, it will have to face political crises.

'North and South, our people have long experience in guerrilla

struggle. We fought from weakness against strength and have built up our strength from nothing. Our struggle is a just one, so with each passing day it draws more support from the peoples in the world including the American people which will more and more support us. We are firmly confident in our final victory. But on the other hand, the US imperialists are die-hards. Before submitting to reason they will still frantically try to create difficulties and calamities. But peoples' warfare is invincible and peoples' struggle is unconquerable. By the peoples' strength we mean the strength of our own people, that of the American people and of the peoples of the world. We are co-operating in our efforts against US imperialism; we are solidarizing with each other in one common effort.'

Pham Van Dong had offered to make all facilities available for the gathering of evidence. Our requests that victims should be able to give evidence at the trial of David Mitchell and during the proceedings of the international War Crimes Tribunal under preparation were willingly accepted by the Prime Minister, and by President Ho Chi Minh. One of the requests made was to meet captured US pilots, in order to learn from them the nature of their targets in Vietnam, and their feelings about what they had been doing. This request was also met, and a meeting was established with the then most recently captured pilot, Lieutenant-Commander Gerald L. Coffee.

When I met Coffee, I introduced myself and told him I was an American. I did not inform him of the purpose of my visit. I had decided beforehand that I should keep this information to myself until after our discussion had concluded, so as not to influence his words with knowledge of what information I was seeking. After our discussion had concluded, I sent him a letter, informing him of all aspects of my mission.

Lieutenant-Commander Coffee is a professional who was based on the US aircraft carrier *Kittyhawk*. He was evidently in sound health, alert and showed no signs whatever of maltreatment. He had been shot down on February 3, thirty miles north of Vinh city. I asked him what happened to him, after that. He said:

'I received a broken arm from the ejection point. I got medical attention quickly. I was down in a remote area and taken to a village, to a hut where I was treated. I got the best attention possible. They made it as comfortable as they could. They bandaged me. Within a couple of hours I was given a meal of hot rice.

'When I had regained consciousness in the water, I found everything necessary had been done for me. My parachute was removed. My flotation gear was inflated. We were about half a mile from the beach. The two small boats which had rescued me were full of people. When the boats arrived, the cover jets came and strafed the boats carrying me. The people in the boats were armed with rifles, pistols and machine guns. The American jets made six strafing passes before I was able to get to the beach.

'No mistreatment occurred at any time. The strafing of our planes had no effect on their attitude to me. I was amazed. I couldn't understand it. I had expected the worst. I stayed at a village until sundown on February 3. There were six windows in the house. People came from the whole vicinity. My belongings were taken from me. I was utterly astonished at the treatment I was getting. It became apparent to me, after a time, that this was their policy. They took me to another village. People were curious and gathered around to see me. I was offered hot tea. The children followed me and tried to touch me. That night, I was taken to another place, where I was also treated well. I was fed; my bandages were changed; they gave me all I could eat. The man in charge said that the people were deeply angry, as the bombings were still going on, and they took me to another area because of the aroused feelings of the people, but I encountered no hostility, anywhere.

'We came to Route 1, which is the main north-south highway. The military car took me toward Vinh. We stopped at the driver's house and spent a long time with his family. I was offered rice in tea leaves, with much meat and fish. It was extremely good. They told me to go into the house. I was told to lie down on the driver's bed. I slept on the bed next to his small son. The next morning, I arrived at the new place, which appeared to be the

centre of provincial administration. I began to realize that this area has been bombed continually and without stop since the beginning. That is over a year. For more than one year, they have known nothing but bombing by us. And yet, they showed no hostility to me. I was disturbed. They questioned me firmly, but always treated me well. I had to admit that my government had not declared war against Vietnam and that legally I had no right to be considered as a prisoner of war. I was told that I was a criminal and that the crimes which I had committed against ordinary villagers were such that would entitle them to try me and shoot me. I was kept in a home with a family. There was an old couple, a young woman and her three-year-old child. They gave me a soft, warm straw bed. Everybody treated me so well; constant hot tea, more food than I could eat, stew, rice. They picked limes off the tree for me, as many as I wanted. I thought I would need the citrus, so I ate as many as I could.

'During the questioning, I came to realize that they could just as well have shot me. They had it non-stop, the bombing, for over a year. Everything was under attack. I wholeheartedly accept their designation of criminal. I was kept at the second place for three days. My wounds were treated. I was fed. Anybody who could speak English or French asked me: "Why are you here? Why have you come to Vietnam?" I couldn't answer them.

'What impressed me more than anything was the overall gentleness of the people to me. Gentleness is the right word. I can hold nothing against them. The civilian casualties they suffer are not ordinary ones. They are, in my opinion, unilateral, criminal aggression. I have to say that I played a definite part in this. The word "criminal" is exact. It is true. I can't deny it. I have observed the gentleness of these people, not only in the way they treated me. While I was in their homes, they talked together. They joked. They took tea. The atmosphere was gentle, in a family way. What I like and prefer. They made me feel at ease. They were simple people, tillers of the soil, farmers, peasants and they treated me kindly. Two things became apparent. One was their real love for Ho Chi Minh. Whenever his name would come up their eyes would light up. They obviously revere him. The second

was this fantastic and unanimous determination of theirs not to be intimidated by the bombing. I could see that each new bombing raid, with its death and destruction, brought more and more hate to their hearts for Americans.

'I was brought north slowly. My interpreter was from Thanh Hoa. We stopped at his home. We visited his family and he took me in to them. I was offered hot tea. We stayed and talked. When we arrived in Hanoi, my arm and dislocated elbow were bad. They were swollen and beginning to be infected. That was February 7. By the 11th, I had seen practically a corps of doctors, who visited me at the prison. They diagnosed me and then they operated on my hand. On the 11th I was taken to a hospital and my arm was X-rayed. They gave me an anaesthetic and returned my elbow to its socket. They put my arm in a cast, which I kept on for two weeks. Throughout this time, I was given medication. They gave me four injections in four days. On February 26, they took more X-rays and they put a new cast on, which I will keep on until the end of March.

'In prison they have questioned me and they have tried to explain their view of the true issues of the Vietnamese war and the feelings of the Vietnamese people. The living conditions are simple, but always adequate. The sanitation is fine. I am given enough clothing and more than sufficient food each day. I am able to wash when I wish. They have given me a toothbrush and tooth-paste, along with soap and towel. I can't get over the fact that the guards are so sympathetic. They help me to dress and do small things for me, ungrudgingly. They button me, because I have trouble with my broken arm.

'Apart from the discussions which I have, they have given me a great amount of literature. I received this with complete scepticism and suspiciousness. It all deals with South Vietnam and the origins of the war and the involvement of the United States. I have to say that I am unable to refute the logic of the whole story. It is unanswerable. I believe now I know, for the first time, who we are really fighting in South Vietnam.

'I know the pretences under which I was willing to fight. The pathetic thing is that you can't call it political indoctrination. I

could have found out the same damn things at home, in the
library, on my own. If I had only taken the time, it would have
been just as easy for me to find this out at home. I was willing
to take part in this war for the usual, rather vague reasons of
protecting our democratic way of life, honouring our agreements
with our allies and resisting communism. I have been here a
short time, but I have seen enough to know that none of this
applies here. My contemporaries and I are all guilty of the same
thing: of not making the effort to really find out what it is all
about. Unfortunately, that is really the way the majority of the
American people are. Right up to February 2, I considered
the anti-war demonstrations intolerable. I couldn't understand
what they were stirred up about. It seemed to me outrageous.
I never thought about what they were doing. I never took the
time to find out. Now I feel very strongly, because of the very
deep love and affection I have for my country. I feel very strongly.
We have no business here. We are involved in a situation in which
we have no right. I think I understand how we became involved.
I have thought a lot.

'When the Vietnamese were fighting their resistance against
the French, we aided the French. We gave them arms and officers
and paid for most of it. Mainly for two reasons. Under the
French, we could still get the tin, rubber and tungsten the
United States wanted from the Indo-Chinese area. They showed
me a statement of Eisenhower's. Also, under the French, we were
assured of a military hold in Indo-China, which we thought
was necessary. But in spite of our aid and our willingness to get
involved, the Vietnamese revolution defeated the French. As far
as I can make out, Ho Chi Minh was able to unite a number of
different revolutionary fronts and, therefore, to lead the defeat of
the French. The Geneva Agreements were convened and stipulate
that there should be no foreign military personnel or military
goods in Vietnam. The Agreements clearly guarantee the territorial
integrity and independence of Vietnam, Cambodia and Laos.

'These are the things I have been reading, and they correspond
to what I remember vaguely, from talks we used to have. The
division of the Seventeenth Parallel was provisional. There was

supposed to be demilitarization and neither Government was supposed to enter into military alliances or permit any foreign military intervention. There was supposed to be an election after two years to reunify the country, but two months after the Agreements we formed SEATO and included Vietnam, Cambodia and Laos as areas under our military protection. It was obvious that we still wanted a military hold on Indo-China. So the French left, and we put Diem in power and made Bao Dai the Emperor. Then he was made Premier, after a referendum which we ran. Then we started putting in massive aid to keep control and built up the army, police and militia. We set up the Military Advisory Aid Group and sent US troops. I can't deny that this violates the Geneva Agreements. Those Agreements were supposed to unify Vietnam.

'The Diem Government was obviously unpopular. He persecuted people and he persecuted non-Catholics and established a dictatorship. He put his family in office. He could never have lasted without our military backing. As the elections approached, he refused offers from North Vietnam for elections and ignored the provisions of the Geneva Conference, and this was done with the insistence of our Government. It is perfectly clear, and even Eisenhower said it, that elections would have put Ho Chi Minh in as President. I tell you, I think rightly so. What is the difference between him and Washington ? He is their revolutionary hero. He brought land reform and economic stability. I could see that myself. That is why we did not let Diem hold elections. These people want reunification. They want to see the labour of their revolution bear fruit. They don't want their victory over the French to be made meaningless and they dream of reunification, and we had shattered that dream. Only a revolution was left to them. The revolution was based on their bitterness at their betrayal. It seems to me that the National Liberation Front was trying to free them and was called "communist" because it tried to defeat our plan to stay. Maybe it has communist inclinations, but it seems to be a national body. We are fighting the people of Vietnam. We are refusing to deal with the people of Vietnam. I thought I was stopping the spread of communism, but I have

seen the life here. They are fed. They are productive. They seem to be happy, despite what we are doing. How can it be worse than the South?

'I know the literature I read was printed in Hanoi and, as I told you, I was completely sceptical. But I remember the reports of what Diem was like, and we always joked about how there was a coup every day, and we were setting up another bunch. At the time, I thought it was the thing to do. I don't know if anyone had the foresight to realize what it meant. We make so much of the supposed aid from North Vietnam to South Vietnam, as if they were a disinterested party, horning in on something none of their business. But what they want is the reunification of their country, and they are the same people. Reunification is part of their national purpose. It's practically in the Constitution. I think, logically, they have every right in the world to assist as best they can. They have the same goal—reunification and independence of the country. If we escalate further, it will result in drawing in other countries, including China. The devastation and the sacrifice of life will be appalling.

'Everything I have read and everything I am telling you is compounded by the fact that our cause simply isn't just. We are sacrificing whatever honour and respect we might have. We could honour these Geneva Agreements, say we were wrong, accept the four-point plan of Ho Chi Minh, because all that is the implementation of the Geneva Agreements. We should leave Vietnam.

'I am thirty-one years old and I am from Modesto, California. My parents are in Hanford, California. I have a wife and three children in Sanford, Florida. My wife is expecting our fourth child and I am really worried about her. She doesn't know whether I am dead or alive. I want to write an open letter to the American people. My feelings are what I have told you. I am neither a journalist, a political scientist or a crusader. But I have a unique point of view because of my experience here and maybe people will listen to me. Don't rely on what I say. Find out for yourself and, when you see, take any step you can to stop this war. I want to write to *Time*, *Newsweek* and the *US News and World Report*. I may be naïve, but maybe they will give me space.

'To attest to my integrity, I want to tell you that I have been a respected naval officer for eight years. I hold the Distinguished Flying Cross. I have taken part in reconnaissance flights over Cuba. I have a personal letter of commendation from the Director of the Marine Corps, General Shoup, for my reconnaissance flights over Cuba during the missile crisis in October, 1962. I have been promoted to the rank of Lieutenant-Commander a year earlier than my peers. By writing these letters I am going to be laying my military career on the line. I have always been loyal to my profession and I love my country deeply. But the time has come when the two are not compatible. I must do what I think is right for my country.

'They will say: "He is a prisoner. It is the way he will get home". There are over 100 pilots captured, but it is not that with me. It will save lives and also our country's honour. Please point out the bit about political indoctrination. With the exception of my contact with the Vietnamese people, everything I have learned and everything I have told you I could have found out at home, if I had taken the time. Believe me. Nothing I have said to you is rehearsed. It reflects the thought I have given the whole thing after what I have seen and experienced. I speak to you and I want to ask you how can I best reach the American people? I want to write to *Time*, *Newsweek* and *US News and World Report*, and I chose them because they seem to me to be the best way to reach the people I want to reach. But I have had no favours here, no special treatment, no offers. I want people to know, I really do. I am laying it on the line.'

Lieutenant-Commander Coffee is a professional. It was apparent to me that he believed what he had been told by his officers and, because he believed this, he was all the more shaken and disturbed by the realities he encountered. The first shock was the disparity between what he had been told about communists and the medical attention he was given by them after his capture. The second fact was the horror of the bombing in which he had so recently participated. These things become clear in the letter to his wife:

'From: Gerald L. Coffee
To: Mrs Gerald L. Coffee,
 306 Tucker Drive,
 Sanford, Florida,
 USA

 1 March, 1966
'My Dearest Family:

'I pray to God this letter reaches you very soon. My desire to let you know that I am alive and well has been almost over-whelming as I have wanted to spare you the grief of thinking the worst and the worry of just not knowing. I had written and sub-mitted an earlier letter but I was very much afraid it wouldn't reach you by mid-April. Last night I had the opportunity to talk with an American visitor to North Vietnam and he assured me he would carry this back to the States and then mail it on from there, so I am confident that this will reach you on time.

'I am in good basic health both physically and mentally and, Darling, I pray this finds you the same way. I do have a problem with my right arm and hand, however, hence the left hand-writing. When I ejected from the aircraft my right forearm was broken and my elbow dislocated. I also received many cuts and burns on both arms and was knocked unconscious. Right after my capture the people who held me did what they could for my wounds and made my arm as comfortable as possible. I was amazed at how gently they treated me in spite of their obvious hate for us for what our bombings have done to their homeland. I was soon to find out, however, that this kind of treatment was the rule and not the exception. After arriving at my present location, I was taken to a hospital where my hand was operated on and my arm X-rayed and set. My elbow is healing well. There is still some offset of the bones in my forearm but I think they may come around some. I have since been back to the hospital for more X-rays and a new cast. This one, palm to shoulder, won't come off until the end of March. You can see that I am very grateful to the people and the doctors of the Democratic Republic of Vietnam (DRV) for all the medical care I am receiving.

'Our immediate future is truly in God's hands now, Darling.

I pray to Him every day to watch over all of you and to take good care of you. I'm sure He's doing a better job of it than I could.

'Kimmie, Steve and Dave, Daddy thinks of your bright little faces every day. I'm sure your all keeping busy in school or in helping Mommie every day in as many ways as you can.

'Kim have you started preparing for your first communion yet? It's a big job and if you do go this time I'm sure you will do very well. I know some Grandma will see that you have the prettiest white dress there. Of course, it's the little girl in the dress that will make it the prettiest. I know you must be getting very anxious for the new baby to arrive and I hope it's a baby sister for you.

'Steve, Daddy has been counting on you to be the Daddy while he's gone. Take good care of your Mommie and your sister and brother. Be sure and pass that football around with Grandpa and also keep hitting those tennis balls over the fence. I'll bet you sure got a lot of Valentines at school on Valentine's day, didn't you.

'Dave my boy, I'm sure you have learned many new tricks on the new swing set by now. Have you been behaving like a good boy in church? Have you been helping Mommie get ready for the new baby? She will sure be needing a good helper like you. Pretty soon you and Tippie won't be the littlest ones in the family any more, will you. Start watching out for the Easter bunny now and don't forget to say your prayers each night at bed time.

'Honey, I have had some time to think of names and I hope my thoughts will be of some help. For a girl I like Chris, Mary and Susan in that order, and specifically, Chris Marie. For a boy, Matt, Tim, or Jay or any combination; possibly Timothy Jay. Don't worry yourself over this at all. I'll be perfectly pleased with whatever you decide, Babe.

'I dearly hope that all has been going smoothly there for you Sweetheart, and that John has been taking good care of you. Just don't ever forget that my thoughts and prayers are with you constantly and will continue to be especially around mid-April. Only by explaining the significance of April to the authorities here have I been allowed to write this letter so soon. Normally I believe I would have had to wait much longer to contact you.

'My experiences with these people this past month have

certainly given me new insight into this war and situation here. You know I could never understand or even tolerate the motives of the anti-Vietnam war demonstrators but, Honey, now I know they are right. It is the bulk of the American people, like us, who think we know why we're involved here but really don't understand the true issues or nature of the war at all. I haven't been brainwashed or politically indoctrinated. I'm still the same man I was when I left home except now I'm a little wiser. This comes from reading which I had started aboard ship and from observing and talking with these people here. I feel I must pass at least some of this on to you so you will understand. Very briefly, it goes like this:

'After WWII the Vietnamese people, under the leadership of the present president of the DRV, Ho Chi Minh, revolted against French colonial rule. Because we, the US, were interested in the natural resources and the militarily strategic foothold in Indo-China, we supported the French with substantial military aid and advisory personnel. In spite of this, the Vietnamese people defeated the French in 1954 at the famous battle of Dien Bien Phu. It had taken nine years but they had won their freedom and independence. The 1954 Geneva Convention, convened for this specific purpose, stipulated that the independence, unity, and territorial integrity of Vietnam be recognized and that participants in the conference shall refrain from internal interference in her affairs. The agreements called for a provisional military demarcation zone or line dividing the country to facilitate its demilitarization and that in two years free, national elections would be held to reunify the entire country. Finally, the agreements prohibited foreign troops or military personnel into either zone nor may either zone enter into any military alliance. So the intent of the agreements is quite clear: to clear all foreign troops from Vietnam as expeditiously as possible and to guarantee the Vietnamese people the rights for which they struggled so hard i.e., self determination in a united country with no foreign intervention whatsoever. Still with our eye now on South Vietnam, President Eisenhower said: "The US has not been party to or bound by the decisions of the Conference." Two months later

the South East Asia Treaty Organization (SEATO) was formed with the US as the major power. In spite of the clear intentions of the Geneva agreements, SEATO included South Vietnam in its "protection area".

'As the French evacuated S. Vietnam, our next step was to ease Ngo Dinh Diem, a western educated and completely US controlled puppet into the government. We supported his regime with massive aid both economic and military. We established the Military Advisory Aid Group to train his troops. His government was never popular with the people and couldn't have lasted without our continued support. In 1956 when it came time for the national elections, he rebuffed all overtures and pleas from the north to arrange the elections. Naturally we backed him up for now we had our foothold in South East Asia.

'The people were furious. They protested but, of course, to no avail. It was well known that had the election taken place Ho Chi Minh would have been elected President of all Vietnam, and rightly so. He was the revolutionary hero of the people, just as Washington was ours. He had made good progress in the north with land reform and economic stabilization. With Diem's refusal to allow reunification, the people were seeing their victory over the French become meaningless. Their only recourse was to revolt against Diem; our man. Because they were revolting against a government which supposedly represents our Democratic way of life and because they were for unification with the now socialist north, they were labelled Viet Cong; Communist. They have since called themselves the National Front for Liberation. So this people's revolution, founded on their bitterness at their betrayal, is the war we are fighting here now. And yet, these are the people we have refused to negotiate with. I don't understand why on either count.

'Worse yet, we have been bombing N. Vietnam because they are supporting the revolution in the south. We have inferred that they are intervening and that this is none of their business. The DRV has every right to support their country-men in the south. They are one and the same people. Reunification of their country is a part of the national purpose of the people of N. Vietnam.

'All this time I have been content to fight for those old standby and often vague reasons such as "to protect our American way of life" or "to honour our commitments and agreements with our allies" or "to stop the spread of communism". Well these things just don't apply here at all. The Saigon Government certainly doesn't represent our way of life and the people have never really known our way of life. All commitments and agreements in this case are strictly self-imposed for our own convenience to have "reasons" to be in South Vietnam. The S. Vietnamese "government" wants us there but the people certainly don't. Why should we now be so anxious to help the people whom we were aiding the French to put down? It is true that if Vietnam were unified she would probably fall under the same socialist government as that of the DRV. However I have observed these people in their homes and in their dealing with one another. The simple and contented lives which these people lead is far better than the lives of war and terror led by their countrymen in the south. I'm not really sure but that a socialist government was the only answer to N. Vietnam's social, economic and agricultural problems at the end of the revolution. Furthermore, we barely lifted our finger to stop the spread of communism 90 miles off our own coast so why this almost fanatical commitment of lives and resources 9,000 miles from home?

'What it all means is this. We just don't belong here. This is not our war. We knowingly undermined the Geneva agreements all along and kept the Vietnamese people from realizing the fruits of their own revolution. Our country loses more honour with each new involvement. We have got to leave Vietnam strictly to the Vietnamese. Our country must live up to its greatness and say "we were wrong". Further escalation will be catastrophic because the N. Vietnamese are prepared and determined to fight forever.

'God knows and you know, Honey, that I love my country dearly and that I am loyal to my profession. These are the very reasons I feel so strongly about it. Aside from my actual contact with the peasants and the authorities here, I could have found all this out at the station or city library if I'd just taken the time.

'People might think: "Sure he's advocating an early end to the

war. That's the only way he'll get home". Of course an end to the war would hasten the repatriation of scores of American pilots and crewmen but it would also save thousands and thousands of lives, millions and millions of dollars in resources, and a measure of honour for our country in initiating an end to the fighting and withdrawing our troops. We are fighting an illegal, dishonourable and unjust war here.

'Please show this letter to our family and friends. They have got to know the truth. Use the letter to its fullest extent to show our people what's going on here. Once our people know the truth, they must make it plain to our legislators that they will tolerate this situation no longer. Yes, this is really me talking, Sweet, and, believe me, I'm speaking right from my heart. But enough of this for now.

'These people have been generous so as to allow me to receive one letter per month. It may contain letters from any of my immediate family and may contain photos. The envelope may not weigh over 20 grams and must be sent by regular air mail. The address must be:

> Gerald L. Coffee,
> Detention Camp for Captured American Pilots,
> Democratic Republic of Vietnam,

and, of course, your regular return address.

'Please give my love to all our dear family and friends whom I know are taking good care of you and the children. Tell each of our precious children how very much their Daddy loves them and give them a kiss for me. You must know that my thoughts of you sustain me from day to day. I'll be right there with you when that time comes in April so just think of me holding your hand. Also, happy birthday, Honey. You can be sure we'll make this one up. My love for you gives me the strength and courage I need each day, Darling, and I dearly hope it works the same way for you.

> 'I love you,
> 'Jerry.'

Coffee is a Catholic and a very religious man. It is plain to

me that his views are prompted by no ideological commitment other than the sentiments induced by the direct contact with the situation and population of Vietnam. When I returned to the United States within a few days of my leaving Vietnam, I telephoned Mrs Coffee to tell her of my meeting with her husband. I said 'Mrs Coffee, I have just come from Vietnam where I have seen your husband and I want to tell you that he is in perfectly good health.' Her reply was rather disturbing: 'Anything you have to say to me you can tell to Captain Fowler of the US Air Force.' I said: 'Mrs Coffee, I have a letter for you from your husband. Would you like me to read it to you? Her reply was: 'What is your name?' I told her: 'That is not important. Do you wish me to tell you of my meeting with your husband?' She said: 'Anything you have to say you should tell to Captain Fowler of the US Air Force.' I posted the letter of her husband to her and retained a photostatic copy, which I released to the Press after she had had time to receive the original. Those who are concerned about brain-washing might consider who it is who is so victimized, Mrs Coffee or the Lieutenant-Commander.

My meeting with the Lieutenant-Commander lasted almost four hours. He spoke with earnestness and listened with great attentiveness to all that I might say. He seemed eager to be reassured that his new-found thoughts and sentiments were worthy. I resisted the strong temptation to tell him precisely what I felt, but conveyed these feelings in my letter to him subsequently. When I asked him if there was anything I could do for him, he asked me if I would make known as widely as possible what he had told me and if he could give me a letter to his wife, and would I make known to the American people the feelings he expressed in this letter about the war?

My thoughts during the time I was with the Lieutenant-Commander turned again and again to my experience of the previous week, to the moments when the blood pounded my head as I fought down cries and sought to retain composure in my conversations with children and parents, doctors, teachers, poor peasants, militia girls. Faces flashed before me. I think of Le Van Lac, whose eight-year-old daughter was killed on

September 15, all of whose neighbours were killed, including a mother and four children, a wife and husband and two children. Le Van Lac's eye, ear, shoulder and right arm were lacerated. He had been rendered deaf and impotent—unable any longer to work. As we spoke to one another, I tried to convey something of my feelings. I told him of my determination to translate his suffering into effective action against my Government and, as we said 'Good-bye', he suddenly embraced me, yelling very loudly in Vietnamese: 'I am very painful. Please recognize my pain.'

A poor peasant, wizened and old at forty-one, told me of the simple heroism of her thirteen-year-old son, Ngoc:

'It was Sunday, April 4, 1965. Ngoc was at home. Suddenly, the jets came and bombed. There is nothing in my village but huts, no buildings. I do not know why they attacked us. Ngoc was writing a lesson for his little brother, Hoa, who is seven. We tried to get to a shelter, but the children of the neighbours, who were having their meal, were injured and could not reach the shelter. One of them had been killed immediately. Ngoc leaped from the shelter and, although the bombs were exploding, he was able to bring back one of the injured children. The second child he brought back had a broken leg, with the bone protruding. Blood was everywhere. The third time he was hit by a lazy dog. His left side was sliced open and, although he was so wounded, he crawled into the shelter with the small child. He told me: "I may die, Mummy, but don't cry. You and Daddy must work to have enough food for my brothers and sisters. If I die, I have done as best I could."

'That was eight in the morning. He remained in that shelter with me until eleven. He was taken to a provincial hospital to be operated on. They tried to remove the slivers of steel, but the tiny darts had pierced his liver and pancreas. I followed him to the hospital, but he asked me to go back to his younger brothers and sisters, who were so small. He said: "Don't worry. I shall come back to help you with the farming." So I stayed in the house and the next day I learned he had died at 7.0 a.m.

L

'I have no place to house my children. On that day, four of Ngoc's friends in the fifth grade were killed. The first air raids made me afraid. But now I am used to the bombing. We produce and farm and that is our resistance. I am utterly defiant. I will never forget that Ngoc sacrificed his life. I will revenge him. I will work to produce rice, so we can defeat the people who bomb us. Everyone loves their children. I love my children. So you can know my pain. I believe if the US pilots saw their children die like I saw Ngoc die, I believe they would not drop these steel bombs on my village.

'I have learned that you are an American. I want to tell you I have not done anything harmful to the Americans. Neither did my boy. US bombs killed him. I bear deep anger and hatred in my heart. I wish you American boys could help stop these bloody killers who are killing our children.

'Before the revolution I was a servant with a landlord. I cannot read or write. I cannot speak well or use nice words. I just tell you about what has happened in my village and to my family and to my son. I hope you will bring the truth to your people. My boy died and so I have this opportunity to tell you of his sacrifice. I am more determined than ever to do anything I can to defeat the attackers. I request you to make them know this.'

But, above all, the woman who is fixed in my mind, whose small figure, round, brown, sober face and quiet, patient eyes haunt me is Madame Nguyen Ti Tho, with whom I spoke for fifteen hours one day, from early morning to late at night. It was Thursday, February 24, and she came in wearing a shawl and a light brown dress. She had a solemnity which was communicative, and I sensed that she had lived through something that could not be formulated easily or completely.

'I am a woman living in the province of Thu Dan Mot, north of Saigon, near the rubber plantations on the east coast of South Vietnam. I am forty years old. I live by farming. I work gardens and the rice fields. My husband is dead and I live with my mother and have one son, who is fourteen. I should like to tell you something of my experience.

'I was arrested in a bus when I spoke to passengers. In 1956 people were held under the point of gun everywhere in the South. To terrorize people in my province, Saigon opened the Truong Tan Buu, or mopping-up operation. Regiments of troops came against the people. The elections of 1956 were not to take place. When I was put in gaol, I found it full of people. They arrested as many as 700 in a raid. There were members of all groups and organizations—social organizations, women's organizations. Many were arrested because they had tried to spread the Vietnamese script, others for teaching people to read and write. There were many religious believers and there were intellectuals. Terrorism was carried out everywhere against the people. Anyone who had been in the former resistance was hunted. Even people who spoke about an election were arrested. People who tried to meet the International Control Commission to tell them about violations were immediately arrested. Tens of thousands of people were being gaoled. Prisoners did not have enough room to sit down or lie down. They had to stand through the night. The "anti-communist" campaign was started, and the wives of anyone who had been regrouped to the North, under the Geneva Agreements, were made to divorce their husbands. People were gaoled for six years without trial. I was gaoled for many years, without ever being brought to trial.

'Sometimes, the Press published the release of a person like Mrs Nguyen Thi Tu, who was supposed to have been released after years of imprisonment, because she had committed no crime, but, in fact, she was never released and had been sent to a new prison in Paulo-Condore island.

'Poisonous snakes were put in the vaginas of the women. Women died agonizingly. The authorities used broken bottles, which they forced into the vaginas of the women. The women fell unconscious and usually died. The guards used iron nails, which they drove under the finger nails of all fingers of the prisoners. They, then, bandaged the fingers, soaked them in gasoline and set them alight. They pumped water into our mouths and noses. The water was mixed with fish sauce, which was extremely spicy. It burned the membrane. They also used soap.

They used "Crezil", which is a very powerful sewer disinfectant, used in lavatories and toilets to kill germs.

'How can I tell you? There are so many people to mention. They failed to arrest Mr Kiem, so they arrested his wife and small daughter. She was tortured for long hours, but did not reveal anything about her husband's whereabouts. They brought a petrol drum, full of water. They put her small daughter, whose name was Nga and who was five years old, into the drum. She was completely immersed. They then beat the outside of the drum. The pressure of water caused the child's eyes, ears, nose and mouth to issue blood. I saw this with my own eyes. Madame Thi was forced to witness it.

'There were 150 women in the same room. The room was 12 feet by 21 feet. We had no toilet. They put a container in the room. The stench was overwhelming in that small place. Almost all those who survived and were eventually released are now invalids, incapable of walking. They suffer from nervous diseases and from periodic loss of consciousness.

'On the first day I was called to the security officer. I was not asked anything. I was simply beaten continuously for eight hours. One would beat me and then others would take their turn to beat me. They used various kinds of torture. At first, I was beaten with rectangular sticks with four, sharp, angled edges. I was beaten on the breasts and on the back. After some time, I lost consciousness and collapsed. After recovering consciousness, I was tied up. They used sliced strips of cane, which were very strong and sharp. They had tied my two feet together and suspended me from a hook in the ceiling, upside down. Each blow made me think my limbs would be torn from my body. The pain and the nervous reaction caused sharp and severe pangs in my heart. The first session lasted over an hour. When I regained consciousness, they began to beat me again. When I was finally lowered down, I could not stand. They stripped off all my clothes and tied me, naked, to a table. They covered my mouth and nose with a piece of thin cloth. They forced a rubber pipe into my mouth and nose and poured water into my mouth and nose. I could not breathe and was forced to swallow. My stomach was

extended larger and larger. First, it was only water. Then they mixed fish sauce, then soap, then very powerful disinfectant, which burned. They tortured me like this for forty minutes. Then I felt a black screen fall over my face. I lost consciousness. When I recovered consciousness, they were pressing my belly and shaking my head, violently. Water came out of my mouth and nose. It spread over the floor of the room. There was a period when I felt as if I were immersed in the water coming out of me. I heard, very faintly, the voices of the security agents. One was saying: "Look at you, a security agent for years and you still don't know how to tie them. She can move her head."

'They tied me, naked, to the table. My head was fixed tightly. Then began drops of icy water on the centre of my forehead. It went on, hour after hour. I felt as if my whole face and head were being constantly attacked. At first, it had seemed nothing. After some time it was unbearable. Drop after drop. I endured it, at first, for four hours. Then my brain became numb and paralyzed.'

(There was a doctor in the room, who broke in: 'The cold contracted the arteries and veins, preventing blood from feeding the brain. This method of torture is very dangerous, because the brain is under constant excitement and must resist. Full recovery from this torture is very difficult.')

'When I was about to lose consciousness, I heard them saying to me: "We will make you a lifelong invalid." In fact, since my release, and to this moment, I have heart ailments, attacks and a disease of the nervous system which affects my brain periodically. After attacks, I suffer from bleeding of the rectum, which is one effect of the torture I endured.

'In the gaol they put my mouth in a lock made of wood and shaped like a bit. It was forced into my mouth and it was impossible for me to close my mouth, which was kept open all through the night in this way. The lock was fixed round my head. Breathing was extremely difficult.

'I had been arrested together with a man. I was tied up with him for one month. One night, we were taken to a small room from the early evening until 2.0 a.m. They listened to us from outside.

They wanted us to have sexual intercourse. They wanted to humil-
iate us. At last, they removed us and we were told: "You know
what we want you to do." I replied: "You, who are odious and
barbarous, are of such character. We will never lose our dignity."

'After endless torture, I was put in the Gia Dinh gaol. This
gaol was the most densely populated, as it is the gaol from which
they despatch prisoners to the others. It is the central gaol.
During the daytime, people can only sit by being on top of each
other. At night, people slept on each other. If one wished to turn,
let alone move, all had to turn. We had to sleep on our sides.
The gaol was so hot that every prisoner tried to fan himself. Each
night, there would be twenty or more people who would become
unconscious because of the lack of oxygen. They were removed.

'After one month in these conditions, everyone had rashes,
pimples, blisters and swellings.'

(The doctor commented: 'Each person had a space of less than
one foot—thirty centimetres—and had one cubic metre of air.')

'During the first month of gaol in Gia Dinh, I watched seven
men die from asphixiation. I could not understand how the women
survived or endured it. The ration of food was so poor that in
every meal one person received a tiny cup of rice with almost no
vegetables or sauce. I lived there seven weeks and was sent finally
to Paulo-Condore Island prison. In Paulo-Condore gaol every
possible device for killing people slowly was employed. People died
before our eyes every day. The means used ensured very slow but
certain death. I was detained one year in Paulo-Condore Island.
Out of twelve months, I was kept in a cell for ten months. The
cell was a small shelter on the surface of the ground. It was three
feet by six feet in area. The walls were made of stone, eighteen
inches thick. The ceiling was made of concrete. The walls were
painted black. The ceiling was under six feet in height.

'The bed was made of stone. It was a cell for one prisoner, but
I was kept in this cell, six feet by three feet, with four people. One
slept on the "bed". One slept in each corner. There was a can
of excrement, changed once a week. It held four gallons. The
room connected with the sewers and a sewer hole was open inside

the cell, causing a constant stench. The door was made of petrified wood, eighteen inches thick. This wood is harder than steel and nails cannot be driven into it. It is known in Vietnam as "iron-wood". The window of the room was eight inches by six inches and covered with an iron net of bars. We were without any clothing in the cells, as the heat was so unbearable that we removed our clothing. Through the window, a ray of light collected our drops of sweat and showed them evaporating from our bodies and condensing again on the walls and ceiling. After only one day in the cell we all cut off our hair. It was too unbearable to have hair, such was the stifling heat.

'In twenty-four hours we received a small cup of water, each about three mouthfuls. We were sweating constantly. In over four months we had no water with which to wash. During our monthly periods, blood dropped on ourselves and on the floor. We tried to clean the floor with our rags of clothing and with our hands. We slept on the floor. We were so thirsty that the noise of rain drove us to frenzy. We yearned for a drop to come into the cell to touch our parched faces or soothe our raw throats. We were starved for air to such an extent that we looked at the opening of the door as a famished child looks at her mother's breast.

'The rice was mixed with paddy husks. The flies were inside the rice and covered it like a black veil. The flies clustered everywhere. Due to the sewer-hole and the can of excrement in the cell, it was perpetually filled with odours so powerful that it was a torment to breathe. They often put eight and even twelve people in this cell, six feet by three feet! When we were four, it was possible to sleep lying down. When we were eight, it was possible to sit; when we were twelve, we stood. When there were twelve people, if there was no help from a few of the guards, we should have died in forty-eight hours. Some guards would secretly open the door for ten minutes every six hours. This enabled us to survive. This form of detention is an ingenious method of slow death, slow murder; we died of shortage of water, of air, of food, of disease and of exhaustion.

'As the guards helped us in their meagre way, we barely survived. But in the cells in which the men were kept, they died constantly

from vitamin and protein deficiency—slow, torturous death.'

(The doctor broke in, once more: 'Vitamin deficiency caused flesh-dehydration.')

'When we saw a prisoner with toes and feet black, we knew that the process of slow, painful death had begun. The body would die before the eyes of the victim. We needed only four vitamin pills, but we got nothing. The guards used Oreomycin and Theramycin to prevent disease of their chickens. All of us suffered from dysentery and worms—all the prisoners.

'After ten months of detention, I was reduced to a skeleton. Just bones. Very few people could walk. If we could survive, it was because we tried to appeal to the humanity of some of the puppet-soldiers. Some few who observed our suffering helped us a little, enough to enable some of us to survive. The men, alone, in Paulo-Condore died 300 at a time from atrocities in the prison. They were left dead for days in the cells. Thousands upon thousands were attacked by disease in epidemics. There were mass burials. In the midst of this death and suffering, the Chief of the Island, Bach Van Bon, clapped his hands and laughed at us on inspections.

'On Christmas Eve, the Catholic prisoners could not go to church. So they organized a Mass, in gaol. They were beaten for this from midnight, Christmas Eve, until 1.0 p.m. the following Christmas Day. Although the prisoners surviving were weak from disease, we were compelled to do forced labour.

'One strong man can produce one cubic metre of firewood per day. We were forced to produce three cubic metres per day from the jungle. At the end of each day we were beaten and bled profusely because of insufficient amounts of firewood. There was a time when we went on hunger strike to protest the meagre ration of rice. We were forced to be exposed to the boiling sun all day. Hundreds died. I was in Paulo-Condore during one year when there was a strong protest movement in Saigon demanding the release of women from Paulo-Condore. The strength of the movement against detention of women in Paulo-Condore, which took place in Saigon, led to our removal to another gaol on the mainland.

'We were too weak and almost unable to walk to the ship going to the mainland. We had to assist each other. Nineteen hours on board ship was terrible. We were all vomiting. On arrival in Saigon, we could not walk off it. The ship did not actually pick us up at Paulo-Condore. They used small boats to bring us to the main ship. When we were on board, forty-one fell unconscious from exhaustion. This ship, called *Phu-Ong Khanh*, was a cargo ship. There was no air. We were crowded in the hold. It was utterly exhausting. After we had been suffocating in the hold, the sailors who observed this argued and protested fiercely with the security men. They knew we would die in the hold and demanded that we should be allowed on the deck. The sailors helped us much. They intervened with the ship's captain for medicine to give us strength to survive until we reached the mainland.

'From the ship we were led to Phu Loi concentration camp. It was vast, holding 8,000 people. At Phu Loi camp, they forced us to salute their colonel and to shout slogans of support for the Diem regime. We refused to do so. We were beaten and sent to another prison, called Thu-Duc gaol.

'After we left Phu Loi, they carried out an enormous massacre in the camp. They effected a mass poisoning, which killed over 1,000 and made 6,000 gravely ill. When I was in Thu Duc I met a friend who told me, first-hand, of the mass poisoning in the Phu Loi concentration camp: "The Phu Loi concentration camp was situated in the midst of a plain; it was intolerably hot and exposed. There was almost no water in the camp. The concentration camp was built by forced labour. The labourers had to work in broiling sun to build the barbed-wire fences, shelters and huts. The prisoner had to perform brutal work, but only received a tiny portion of rice. Any resistance or disaffection led to our being placed in cells underground, without air and which were broiling hot. Many became unconscious. Because of the solidarity of the prisoners, the authorities were forced to make certain provisions. Then, they began systematic reprisals. One day, they gave us a good meal of beef, other meat and bread. People were starved and ate eagerly. After the meal, there was

violent pain, bloody vomiting and bloody evacuation. Then death. Furious, survivors captured the loudspeakers and broadcast the crimes and appealed for first aid. Troops and police came and slaughtered us in the course of repression. Many more were beaten to death."

'There was a woman named Phung who was beaten and then tortured, as follows: The security agent used his baton and rubber truncheon to penetrate deeply and with brutal force into her vagina. To this day, she bleeds when she feels weak or sick. She was a nurse who had saved many people in the camp. She still lives in a Saigon-occupied area of South Vietnam. After some time, I was returned to Phu Loi concentration camp. Blood was visible on all the walls.

'The second time I was there, they started all the same torture again. Everything I endured in Paulo-Condore and before was repeated. I was hung from the ceiling for hours; they beat me endlessly; they forced water with soap into my lungs and stomach, causing lesions and perforation. It went on for periods of two to two and a half months at one time, for one entire year. I was almost insane. The first session lasted two and a half months. I was with an eighteen-year-old girl who was stripped, hung from the ceiling and tortured. In winter it was bitterly cold. All the women were subjected to the same, without exception. After torture, we had to lie, naked, on the floor. Cold water was flooded upon us. The torture was started all over again.

'Each campaign of torture lasted, without stop, for two months. I was treated this way continuously, until six days before my release. Until that moment, I was tortured almost constantly. If I am still alive, it is thanks to the care given me afterwards by my fellow countrymen. I consider my life a great victory. I live. Tens of thousands, when set free, have become both invalids and sterile.

'I was released in 1960. In 1962, I was again arrested and herded into a strategic hamlet. Let me tell you how they organized the strategic hamlet and what it meant. First, they sent aeroplanes to bomb the villages. Then troops to attack the villages. Finally, bulldozers to destroy completely all the people's houses. The homeless were then forced into these strategic hamlets, built

through their own forced labour. In my province there were 200,000 people. All 200,000 were herded into strategic hamlets. The herding of people directly violated the whole fabric of life of the people. The people resisted in any way they could. There were many women whose houses were being destroyed by puppet troops. The women set fire to their own houses to trap the puppet troops destroying their homes. Many old men burned incense in the houses of their ancestors and pledged to their ancestors to die protecting their houses and sacred places. Then, with knives in hand, they sat at the door of their house and waited for the puppet troops to come to destroy the house: "Please, fellow countrymen, if you wish to take tea with me you are welcome in my house; if you come to destroy my house, take care. I shall defend it with my life."

'As our people live on their own piece of land and on their rice fields, and they live in scattered spots, they are against these concentration camps. They resist the strategic hamlet, encircled by five barbed-wire fences, watched by patrolling puppet troops with machine-guns, dogs and look-out towers. In the hamlet, people were forced to pay high taxes and conform to forced labour, unpaid, at any time. People are forced to join Government organizations and youth are forcefully conscripted into the puppet army. They are forced, at gunpoint, to take weapons against other villagers, their brothers and sisters. Let me give you the example of Tan Cu village; 59 were herded into strategic hamlets. Three months later, thirty of them were dead. In Hoa Trung, of 400 people herded, 200 died. In Ben-Tuong hamlet, organized and directed personally by us officers, the people demonstrated during the visit of McNamara, for food, rice and freedom to return to their villages. People in the hamlets are forced to inform the secret police if anyone has a relative in the North, anyone had participated in the resistance against the French, or anyone who has spoken about peace or neutrality, about elections or democracy; or if anyone has criticized the Saigon puppet Government or us officers or the us Government.

'Most of the girls were raped by troops in the hamlets. Strategic hamlets were not only organized in the countryside,

but also applied to the cities. The girls in the cities were forced into teams of prostitutes for US troops. The Saigon Government forced, at pain of death, literally tens of thousands of young girls into camps to be used as perpetual instruments of official recreation for US troops.

'In order to force the labourers of the cities into the strategic hamlets, agents and troops burn down the people's houses. They send fire engines to the fire and spray not water but gasoline! To destroy everything! Due to the poverty suffered, many thousands of girls, and students as well, had to sell their bodies for food to the US soldiers. This is in addition to the force applied by the Government in organizing girls as forced-prostitutes. Poor and starving children rummage like rats amidst the garbage dumps for food. That is the life imposed in our cities of the South.

'As the organization of strategic hamlets was against the interests of our whole people, everywhere, in countryside or in the city, all resist—men, women, children, old people—resist bitterly as a matter of life and survival. As I have told you, they succeeded, at first, in herding us by brute force into the concentration camps of forced labour—their so-called strategic hamlets—but finally the people united together to fight against it. They have overthrown many strategic hamlets and turned them into fighting villages of resistance. When people do not allow children to take part in the struggle against the strategic hamlets, our children reply: "When US soldiers kill us they do not distinguish children from parents." The "strategic hamlet" now has been changed by McNamara into "new-settlement camps". In these camps, terrorism is far worse and far more atrocious. The struggle against being forced into them grows ever more fierce. People struggle to get out and the Government tries to force them in.

'Once they came to Binh Dinh province and shot dead a pregnant woman, and a bed-ridden woman, who had given birth two days ago, was shot dead at point-blank range. This is ordinary practice when herding our people, in order to terrorize them. I was told this by eye-witnesses. Twenty-two women, twenty-two children and six old men were shot down in cold blood to intimidate the people of the area. They took babies of two years

and tore them into pieces, literally, and threw the pieces into the bushes. They broke the heads of infants with poles of wood and threw the infants on a fire. A little boy I knew, named Zung, had his leg broken by a bullet at point-blank range and was then buried alive by US soldiers. Troops were committing other horrible atrocities. This was on December 22, 1965, in Tai Quang village. In this same raid, a family of seven was killed by US soldiers; another of nine was completely annihilated by raiding US troops. I know of so many such atrocities I could go on for hours. These are absolutely typical, everyday examples. The people are stirred to such hatred and outrage that all of them, every last one, resist US atrocities against them.

'I was herded again and again into these hamlets, after my release from the concentration camp. I have witnessed these crimes repeatedly in the hamlets. A man named Dong saw the families and he survived. Now he has been hospitalized, after his escape. This is a part of the story of what I have seen, what I have endured and what I have lived through.

'There are so many things I want to tell you, that I cannot because the people and the witnesses are still living in occupied areas. I would tell you of the bombardments, the fragmentation bombs, the gas, the chemicals, the napalm, and phosphorus, the poisons—the daily events of which these barbarous atrocities are a part—week after week in the South. I have seen it, I have endured it and struggled against it. I know people who have carried the victims to the local US officers responsible, to confront them.'

Madame Tho is under treatment. I was told later that she insists upon returning to the South, as soon as possible. No one considered this unusual.

More Vietnamese died between 1954 and 1959, the years of 'peace', than in the years 1960 to 1966, the years of popular resistance in the South and American bombardments in the North. But the Vietnamese, from the President and Prime Minister to the villagers who spoke to me of their sufferings, are patient and exceedingly gentle. Nothing was so harrowing as their gentleness.

They know that our people have been corrupted. Americans and Europeans have been the beneficiaries of the exploitation against which the people of Vietnam struggle.

During my talk with Premier Pham Van Dong, we dwelt on the level of consciousness in the United States and the possibilities of serious resistance. There were moments in the conversation when the weight of American responsibility and my feelings of shame and humiliation pained me too deeply, and I was silent. Pham Van Dong took my hand and said:

'My dear brother, the struggle is long and our people endure much. We are comrades in arms: you, Americans, who work to awaken your people and to resist your rulers and we, who struggle in the field. It is the same fight.'

Even while they expect little from us, they are moved and grateful for the little they receive, for they see the birth of an American resistance as one of the rewards for their sacrifice. An American emergence and an American consciousness of our place in the world and our relationship to our rulers will be the gift of the people of Vietnam to the people of the United States. The pity of the horror which has been borne by Vietnam is not a pity deserved by the Vietnamese. There is nothing pitiful about them. In their very suffering they are heroic. It is not passivity which marks them, but sacrifice and resistance. The pity lies in the cruel historic reality which renders the American people pathetic and acquiescent as this horror is perpetrated in their name. I feel certain that the American emergence of the next generation, and the generation after that, will trace its origins to the quarter century revolution in Vietnam: that great and liberating event to which we owe more than solidarity.

Bertrand Russell has said:

'The people of Vietnam are the world's soldiers for justice. Their struggle is epic, a permanent reminder of the heroism of which human beings are capable when dedicated to a noble ideal. Let us salute the people of Vietnam.'

GEORGE ALLEN & UNWIN LTD
London: 40 Museum Street, W.C.1

Auckland: P.O. Box 36013, Northcote Central, N4
Bombay: 15 Graham Road, Ballard Estate, Bombay 1
Barbados: P.O. Box 222, Bridgetown
Buenos Aires: Escritorio 454-459, Florida 165
Calcutta: 17 Chittaranjan Avenue, Calcutta 13
Cape Town: 68 Shortmarket Street
Hong Kong: 105 Wing On Mansions, 26 Hancow Road, Kowloon
Ibadan: P.O. Box 62
Karachi: Karachi Chambers, McLeod Road
Madras: Mohan Mansions, 38c Mount Road, Madras 6
Mexico: Villalongin 32-10, Piso, Mexico 5, DF
Nairobi: P.O. Box 4536
New Delhi: 13-14 Asaf Ali Road, New Delhi 1
Ontario: 81 Curlew Drive, Don Mills
Rio de Janiero: Caixa Postal 2537-Zc-00
São Paulo: Caixa Postal 8675
Singapore: 36c Prinsep Street, Singapore 7
Sydney: N.S.W.: Bradbury House, 55 York Street
Tokyo: P.O. Box 26, Kamata

BERTRAND RUSSELL

HUMAN KNOWLEDGE

'Bertrand Russell's latest book is of peculiar importance in that it is an exemplar, for the general reader, of Russell's special contribution to human knowledge. In it he applies with his usual lucidity and wit, the methods of inquiry, which he has done so much to develop, to the question of how we come to know whatever we do know about the universe.' RUPERT CRAWSHAY-WILLIAMS in *The Observer*.

'Lord Russell here develops his theory of knowledge, fully and comprehensively. He is at his very best: penetrating, acute, with a light but firm touch. Nevertheless the subject and the book are not altogether easy.' A. D. RITCHIE in *The Guardian*.

Demy 8vo

THE SCIENTIFIC OUTLOOK

'A book so full of life and wit and, gaiety and, let us add, wisdom and knowledge. . . . It is admirably written, and contains passages of singular beauty. . . . It is perhaps needless to say that the whole book is important.' *The Guardian*.

'Brilliantly witty.' *Times Literary Supplement*.

'It is an extraordinary gay and inspiring work.' *Daily Telegraph*.

Cr. 8vo

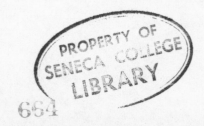